AERIAL ATLAS OF THE HOLY LAND

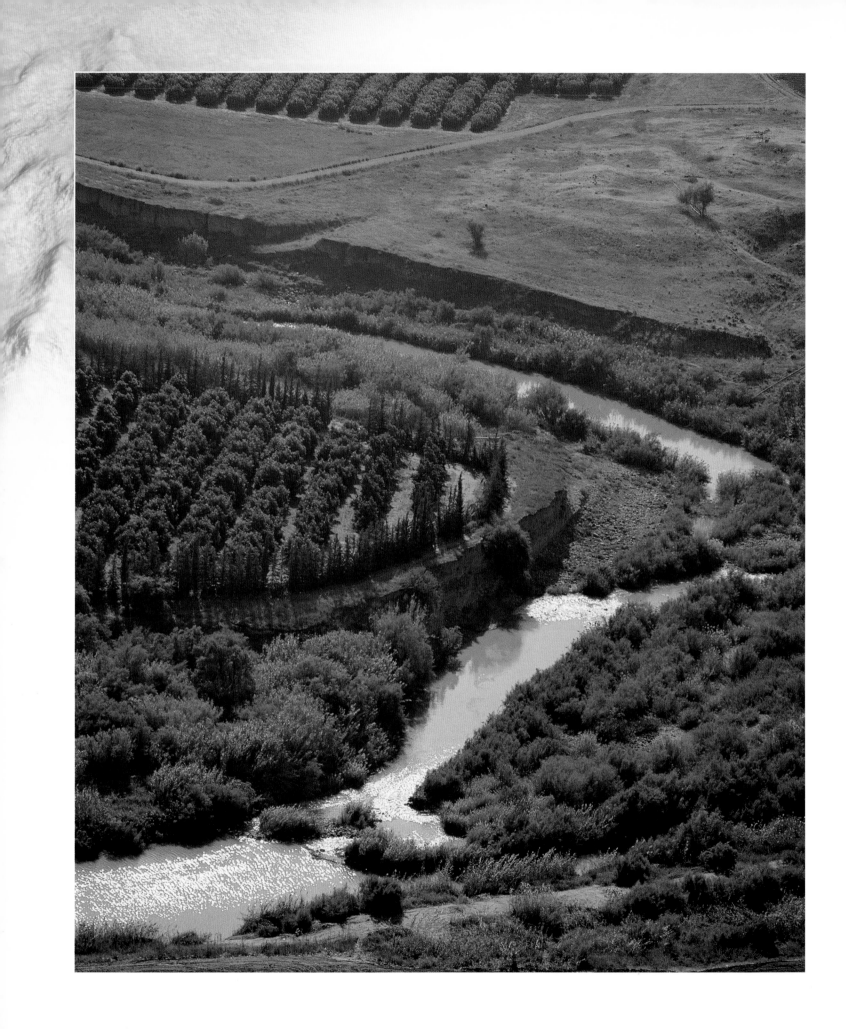

DISCOVER THE GREAT SITES OF
HISTORY FROM THE AIR

AERIAL ATLAS OF THE HOLY LAND

JOHN BOWKER

PHOTOGRAPHY BY
SONIA HALLIDAY
AND **BRYAN KNOX**

FIREFLY BOOKS

A FIREFLY BOOK

Published by Firefly Books Ltd. 2008

Copyright © 2008 Octopus Publishing Group Ltd.
Text © 2008 John Bowker
Photographs © 2008 Sonia Halliday Photographs, except those listed on
page 256

First printing

Publisher Cataloging-in-Publication Data (U.S.)

Bowker, John, 1935–
 Aerial atlas of the Holy Land : discover the great sites of history from
the air / John Bowker ; photography by Sonia Halliday and Brian Knox.
[256] p. : col. photos., maps ; cm.
Includes index.
ISBN-13: 978-1-55407-397-9
ISBN-10: 1-55407-397-9
Summary: A flight over the great historical sites of the Holy Land with an
explanation of their rich historical, biblical, and cultural significance.
Includes aerial photography and maps of sites of significance to Christians,
Jews, Muslims, and their surroundings.
1. Palestine — Historical geography — Maps. 2. Bible — Geography —
Aerial views. 3. Israel — Historical geography — Maps. I. Halliday, Sonia.
II. Knox, Brian. III. Title.
912.122 dc22 G2230.B695 2008

Library and Archives Canada Cataloguing in Publication

Bowker, John
 Aerial atlas of the Holy Lands [cartographic material] : discover the
great sites of history from the air / John Bowker.
Includes index.
ISBN-13: 978-1-55407-397-9
ISBN-10: 1-55407-397-9
 1. Bible — Geography — Aerial views. 2. Palestine — Aerial views.
3. Bible — Geography — Maps. 4. Palestine — Historical geography
—Maps. I. Title.
G2230.B62 2008 915.694 C2008-900286-5

Published in the United States by Published in Canada by
Firefly Books (U.S.) Inc. Firefly Books Ltd
P.O. Box 1338, Ellicott Station 66 Leek Crescent
Buffalo, New York 14205 Richmond Hill, Ontario L4B 1H1

Developed by Mitchell Beazley
An imprint of Octopus Publishing Group Ltd,
2–4 Heron Quays, London E14 4JP

For Mitchell Beazley
Commissioning Editor Peter Taylor **Project Editor** Georgina Atsiaris
Art Director Tim Foster **Copy Editor** Philip Hillyer
Deputy Art Director Yasia Williams-Leedham **Production Manager** Peter Hunt
Designer Colin Goody **Proofreader** Barry Gage
Indexer Margaret Cornell **Maps** Roger Stewart at KJA Artists

Cover Design: Erin R. Holmes

Printed and bound by Toppan Printing Company in China

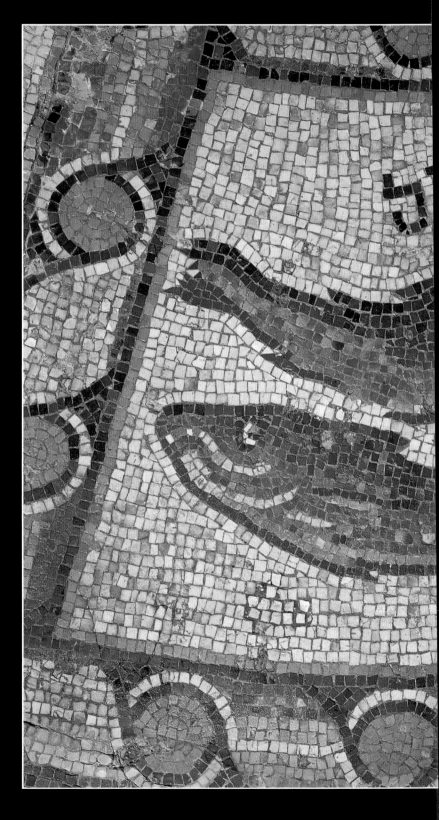

CONTENTS

Introduction 6
Plan of the Book and Major Sites 34
Modern Map of Israel 36

1. THE RIVER JORDAN 38

Mount Hermon and Banias 40
Hazor 46
The Sea of Galilee 52
Beth Shan 68
Jericho 74
Special Feature: Monasteries 82
The Dead Sea and Ein Gedi 90
Qumran 96
Masada 102

2. THE HILL COUNTRY 108

Mount Tabor 110
Nazareth, Sepphoris, and Cana 116
Samaria, Nablus, and Mount Gerizim 122
Jerusalem 130
The Mount of Olives 150
Bethlehem 160
Special Feature: Synagogues 166
Herodion 174
Lachish, Tel Miqne, Gezer, and Tel Arad 180
Hebron 186
Beer Sheba and the South 192

3. THE COASTAL PLAIN 198

Gaza and the Philistines 200
Ashkelon and Ashdod 206
Joppa and Aphek 212
Special Feature: The Crusades 218
Caesarea Maritima 226
Megiddo 232
Mount Carmel and Haifa 238

Bibliography and General Reading 244
Index 247
Acknowledgements 256

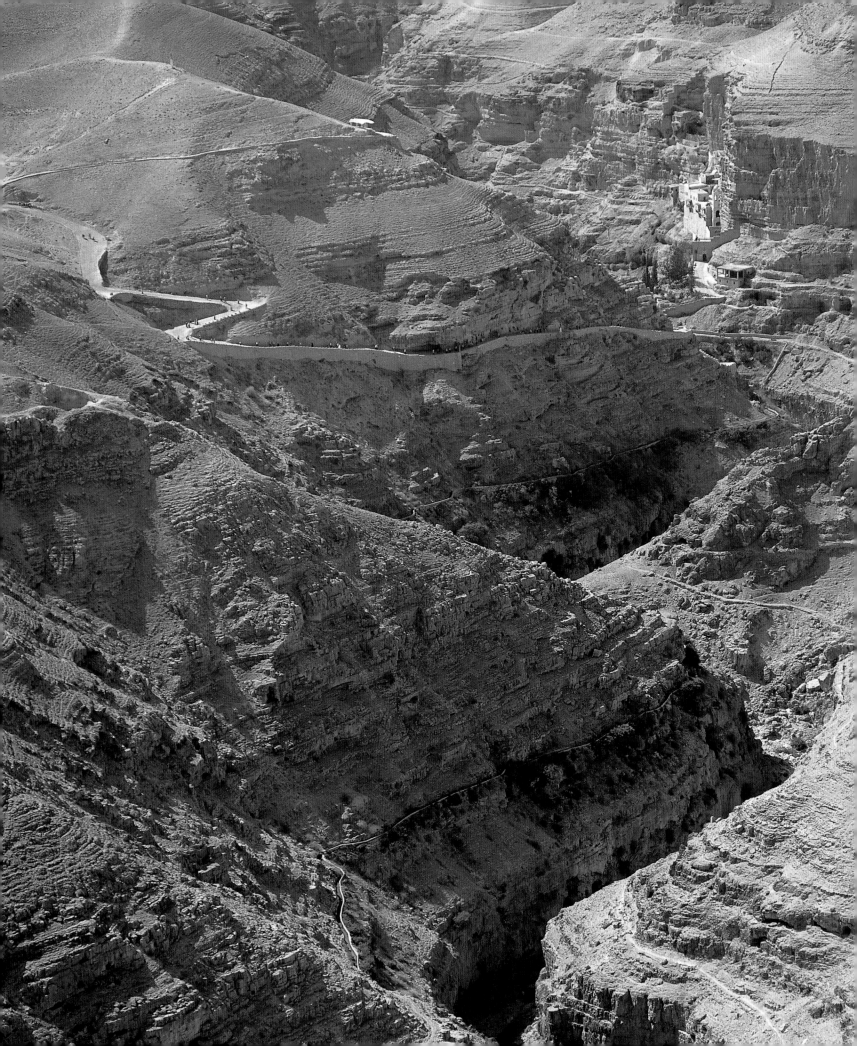

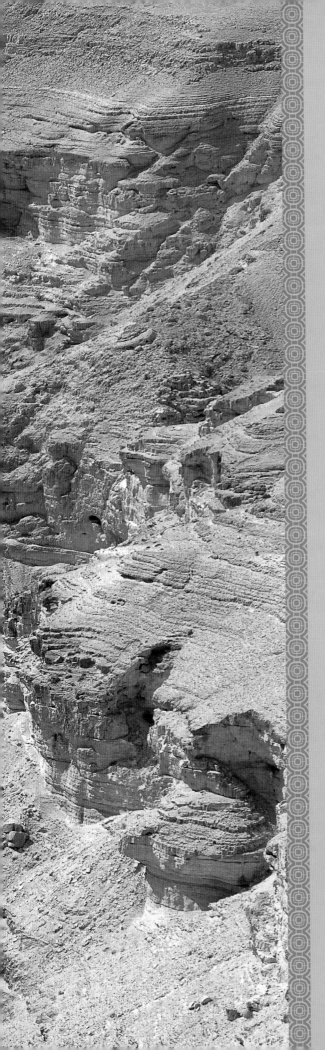

INTRODUCTION

The territory that has come to be known as the Holy Land is extremely small: it is about the same size as the state of Massachusetts or of New Hampshire – or, in the United Kingdom, of Wales. And yet, as the saying has it, "Palestine has the size of a county and the problems of a continent". The problems and the way they have been dealt with have left an indelible mark on the Holy Land in terms of both geography and architecture. What that means, however, cannot be understood without at least a background knowledge of the history of the Holy Land, and it is the purpose of this introduction to give that background, but only in so far as it is relevant to the illustrations in this book. In dealing with a history from about 2000 BCE to 1300 CE it is not possible to do more than indicate the very briefest outline.

LEFT The old desert road between Jerusalem and Jericho (foreground and middle distance) winds its way through the barren Wadi Qilt (see pages 72 and 74). In the background, to the west, is St George's monastery (see pages 76, 78 and 87).

Note on the text:
References to authors and books (apart from ancient texts) are given by the name and page number; full details can be found in the bibliography. See also page 256.

THE HISTORICAL BACKGROUND

THE STRATEGIC IMPORTANCE OF THE AREA

In part the problems alluded to on the previous page have arisen because the coastal edge of Canaan/Palestine/Judaea/Israel (to give it only four of its many different names) was the vital land bridge between North Africa (including Egypt) in the south, and Phoenicia, Syria, and the lands beyond in the north. This means that in the early part of this period Egypt and Phoenicia were constantly interacting, either as enemies or as allies, and the towns and settlements of the Holy Land were caught up in this, even if only by being made subjects of the one or of the other.

Initially Egypt and Phoenicia sought the control and stability that would enable trade, but when major powers like Assyria, Babylon, Persia, the Greek Seleucids (after Alexander the Great), and Rome also endeavoured to control the area, the issue particularly for Egypt became whether to seek allies in rebellion, or whether to overcome rivals in the area. As Bethylon (page 455) has summarized the point: "Trade between the Nile Delta and the Canaanite city-states of the Levant followed the political and military developments of the time … Once partners in trade, Egypt and Phoenicia would find themselves enemies in war and allies in rebellion by the time Alexander's Hellenistic armies took overall control."

The coastal plain was thus a vital trade route by land, and even the sea route in the Eastern Mediterranean required control of its harbours since otherwise piracy was a constant threat. One example among many is that of Zoilus, for whom see page 229.

The strategic importance of the area is one reason why so many battles were fought there. Duncan and Opatowski begin their account of "war in the Holy Land" with the simple sentence: "The Holy Land is the most fought-over region in the world" (page viii). It is why so many towns and settlements reveal, as they have been excavated, traces of strong fortification – and also of fire and destruction from occasions when they were overwhelmed.

JEWS, CHRISTIANS, AND MUSLIMS

There is, however, another reason why Palestine has had "the problems of a continent": it is because it is valued as holy and sacred land by three of the major religions of the world, Judaism, Christianity, and Islam.

These three religions are closely related to each other. They share many beliefs in common, and they regard themselves as descended from "the father of the faithful", Abraham, who is called in each religion "the friend of God" (see page 188). It would seem, therefore, as though each of these religions should affirm and value the other two, as in some respects and on occasion they do.

Far more often, however, these religions have seen themselves as correcting and completing what has come before them. Each of them has become what it is by displacing and supplanting what came before it.

Thus the religion eventually known as Judaism became what it is by driving out the Canaanites and others who were living in what the Jews (or the people who came later to be known as the Jews) took to be their "promised land", the land promised to them by God, the land now known as the Holy Land. The way in which they displaced and supplanted the Canaanites and other peoples in the land was not a gentle matter of persuasion. They were commanded to drive them out and destroy them. The Book of Deuteronomy records rules for the conduct of warfare against both distant towns and also towns in the Land that God is giving to his people. For towns far off they are commanded to put all males to the sword, but to "take as your booty the women, the children, livestock, and everything else in the town, all its spoil". (Deuteronomy 20.14):

> But as for the towns of these peoples that the Lord your God is giving you as an inheritance, you must not let anything that breathes remain alive. You shall annihilate them – the Hittites and the Amorites, the Canaanites and the Perizzites, the Hivites and the Jebusites – just as the Lord your God has commanded, so that they may not teach you to do all the abhorrent things that they do for their gods, and you thus sin against the Lord your God. (Deuteronomy 19.16–18)

The Book of Joshua then records how that command was carried out in the conquest of the land – see, for example, the account of the victories of Joshua in the south, in Joshua 10.28–43. This command of displacement has had long consequences that continue to the present day. It was, for example, this imperative to destroy any whom they found in the land that fuelled the passion of the Revisionist Zionists when they sought to recover Palestine as a home for the Jews after World War I. The early Zionists had had the same aim but they had hoped to achieve it by peaceful means. The revisionists, led by Vladimir Jabotinsky, believed that there could never be a peaceful accommodation with the Palestinian Arabs. Jabotinsky recognized that Palestine for the Palestinian Arabs was their native home-land, and that they would always fight for it if they could. He therefore argued that what he called "Zionist colonisation" would have to be imposed by force:

Any native people … will not voluntarily allow, not only a new master, but even a new partner. And so it is for the Arabs … Zionist colonisation, even the most restricted, must either be terminated or carried out in defiance of the will of the native population. This colonisation can, therefore, continue and develop only under the protection of a force independent of the local population – an iron wall which the native population cannot break through. This is, *in toto*, our policy towards the Arabs. (quoted in Brenner, pages 74–5)

For some at least there is a self-evident connection between the command to destroy the Canaanites and the iron wall of Jabotinsky. It makes intelligible much of the intransigence of the present-day conflict. Among the Revisionists were two men who later became Prime Ministers of Israel, Begin and Shamir. As the historian Lenni Brenner (page 82) has put it: "Classic Revisionism laid down the rules by which modern Revisionism still operates. Jabotinsky's followers still believe that only an iron wall can suppress their latter-day Canaanites, the Palestinians." It follows that Palestinian Arabs will be welcome in Israel but only in an Israeli, that is, Jewish, State.

That was one displacement whose consequences have affected the Holy Land down to the present day. The next displacement has had equally long consequences. Christians came into being because they believed that they were the completion of the purpose which God had begun among the Jews. God, in their view, had indeed made a covenant or agreement with his chosen people, but that old covenant (or Old Testament, to use a Latin word) has been brought to completion in a new covenant or New Testament.

The manner in which Christians supplanted and displaced the Jews was not a matter of gentle persuasion. One of the accounts of the trial of Jesus preceding his execution states that "the people as a whole", not just "the crowd", cried out, "His blood be on us and on our children" (Matthew 27.25). Christians, or at least some among them, believed from this that the Jews were guilty of executing God and were, as they put it, "Christ-killers". This belief that the Jews as

———————— ✳ ————————

BELOW "The iron wall" (see above) resembles the Separation/Anti-terrorist Fence (in Arabic, *jidar alfafl al'unsun*, the Fence of Racial Segregation) now being built along and inside the West Bank.

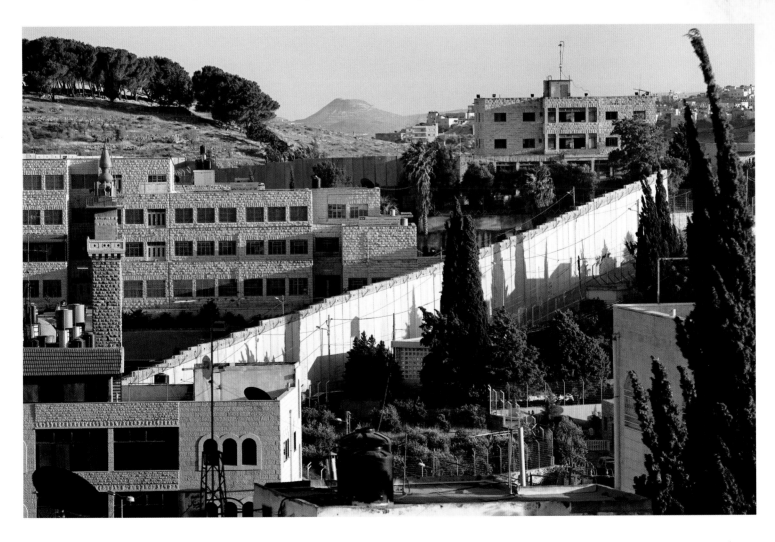

a whole had rejected the Son of God produced, not just anti-Semitism in a general way, but the ferocious persecutions that culminated in the Holocaust.

The way in which Islam displaced both Judaism and Christianity was equally not a matter of argument and persuasion alone. In Muslim belief, the Prophet Muhammad was one in a long sequence of earlier Jewish and Christian prophets. But whereas, in his view, Jews and Christians had compromised and corrupted the revelations they had received through their prophets, the revelation brought through Muhammad was faithfully preserved in what is now the Quran. Thus no other prophet or revelation is needed, before or after: the Quran is the final revelation and Muhammad is the Seal of the Prophets.

Jews and Christians are therefore respected as "the People of the Book" (Ahl alKitab) since they have received the same revelation as that which is in the Quran, even though they have corrupted what they received. Ideally, they should accept Muhammad and his message, and become Muslims, but if they do not, they can keep their faith but with a subordinate status under Muslim rule. Of course, that depends on their not offering any resistance to Muslims who are under command from God to make out of all the peoples and religions of the world a single Community or 'umma. If they do resist, it is right to attack them. Within 100 years of the death of Muhammad in 632, the Muslim conquests stretched from the Atlantic to the walls of China and included Palestine. It follows from this that Jews and Christians will be welcome to live in Palestine but only in a Palestinian, that is Muslim, State.

Even in so brief a summary it would seem that the repeated story of displacement is one of contest and conflict alone. Yet it has also been a story of respect and gratitude. Even if the later religions have been, in their own understanding, displacing the earlier, they have nevertheless recognized that God was at work in the history of those earlier religions. Even if the Jews regarded the Canaanites and others as those who worshipped false gods, they nevertheless received much from them, including much of their understanding of God; and both Christianity and Islam revere the Holy Land and the many places in it as part of God's purpose and story.

From this brief account it can be seen why the Holy Land is such a revered but also contested place. The purpose of this Introduction is to give a short summary of the history of the Holy Land, since without that background it is impossible to understand how its settlements, towns, and cities came into being as they did. Those terms, incidentally, are not used with any precision in this book: when does a settlement become a village, a village a town, a town a city? Adams made a well-known attempt to distinguish between towns and cities, based on evidence of the existence of hierarchies controlling productive resources, political and religious hierarchies, and complex divisions of labour, but even he warned

(page 143): "There is not one origin of cities, but as many as there are independent cultural traditions with an urban way of life." He also cautiously pointed out: "Even the term urban needs qualification: many of the qualities we think of as civilised have been attained by societies that failed to organise cities" (page 138).

THE EARLY HISTORY AND THE JEWISH BIBLE

The earliest records of the Jewish people are gathered in the Jewish Bible. That Bible is made up of three parts, Torah (the books from Genesis to Deuteronomy including the Laws which are also called Torah), Nebi'im (the Prophets, the books containing the words spoken through prophets and through historical writings), and Khetubim (the Writings containing Psalms and Proverbs and other reflections on God and life). From the initial letters of the three parts the Jewish Bible is often referred to as Tanach or Tanakh. Thus the important translation of the Jewish Bible made under the auspices of the Jewish Publication Society is called *Tanakh: a New Translation of the Holy Scriptures According to the Traditional Hebrew Text*. Christians call Tanach "the Old Testament" because they regard themselves as having received the New Testament in succession to, and in fulfilment of, the Old.

Tanach is an anthology of writings of many different kinds which come from a period of at least 1500 years. There are songs and hymns, words and oracles of prophets, historical narratives, codes of Law, rules for organizing worship, reflections on the meaning of suffering, and much more.

There is no agreement on when or how all this material was spoken, written, and put together. At one extreme, there are those who say that the whole process was guided and inspired by God, and that if the Bible is indeed "the Word of God" it cannot contain error; it is both infallible and inerrant.

That extreme position began to seem increasingly difficult from the mid 19th century onward to those who took seriously the implication of Milton's lines in *Paradise Lost* (7.176–9) about the way in which the Word of God has to be transmitted through human lives, words, and history:

> Immediate are the Acts of God, more swift
> Than time or motion, but to human ears
> Cannot without process of speech be told,
> So told as earthly notion can receive.

The obvious truth about Tanach is that God did not become vivid and real to the people of Israel as though their place and time in history were irrelevant: God became known to them in an utterly new way through the events that made them what they were. As soon as this was taken seriously by scholars it became clear that the Bible was not "inerrant" but was made up of narratives and words

that sometimes contradict each other, always show change and development, and occasionally claim clear impossibility.

To give only one example: in the mid 19th century, a Cambridge mathematician, J W Colenso, looked at the numbers involved in the Exodus from Egypt (on the Exodus, see page 14) and pointed out that those escaping from Egypt were not a small column of refugees of the kind that became so familiar in the 20th century. Taking the numbers in Tanach as inerrant, they amounted to 603,550 men of fighting age (Numbers 2.32). Put together with the old, the women, and the children, this would make a company of over 2 million people making the journey through the Wilderness. If that number of men stood before the door of the Tabernacle (tent of meeting), as they are commanded to do (Numbers 10.3), the resulting queue would be nearly 20 miles long (Colenso, page 33). "Similarly, if the priests alone had to eat the sin-offerings for the birth of children, each priest would have had to eat 88 pigeons a day" (Bowker, *The Religious Imagination*, page 62). Calculations of that kind may seem frivolous now, but at the time they highlighted the fact that the writing, recording, and gathering of the works in

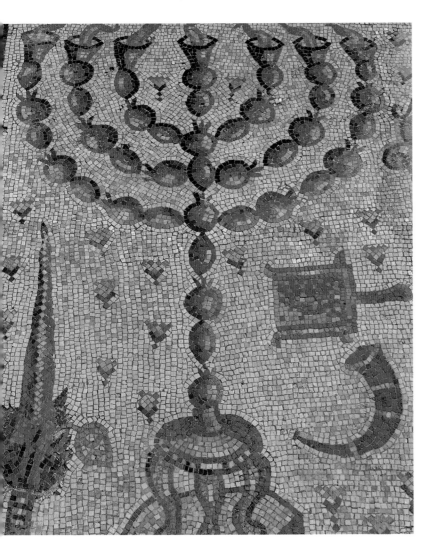

Tanach were not exempt from history but immersed within it, and are not immune from error.

At the other extreme, therefore, are those who doubt whether it is possible to recover much if anything that is securely historical from Tanach. Of course they accept that there was a history of a kinship group of tribes who became the people of Israel. But the writings in Tanach are an interpretation of that history, or arise from that history, in a way that is not primarily concerned with historical precision. The problem is that for most of the long period of that history very little external to that history has survived with which to check or compare it. There are no other continuous histories, and although there are annals and inscriptions from other nations which mention events and places, they cannot do more than exhibit (as they often do) that particular events in Tanach did indeed take place – and sometimes they do this in a very vivid way, as in the Lachish Letter quoted on page 182. In addition, there are many supporting archaeological excavations, but the interpretation of them is rarely beyond dispute.

Between those two extremes, it is essential to remember what Tanach is and what it contains. There is absolutely nothing like it in the ancient world. Of course its writings and beliefs resemble those that are found in the nations around them – they are not exempt from history. But just as Midas transformed everything he touched into gold, so those who spoke or wrote or gathered together the writings in Tanach transformed everything they touched around them into a new and breath-taking vision. They believed that God had entrusted to them a demanding and dramatic understanding of his name and nature, and that it was their task to keep faith with God made known to them in this way, both in law and life.

It was from this point of view that they interpreted their history. Tanach gathers the diverse and varied forms of those interpretations and constructs from them a brilliantly coherent epic telling the story, in many different ways, of how Israel became a land and a people under the hand of God, and of what that means for themselves and eventually for the whole world.

The Bible, therefore, cannot be understood unless it is realized that truth can be told as much through poetry as prose, as much through fiction as through fact. At an early age, the novelist Rumer Godden discovered with her sister "what we called 'truthful writing' which does not mean the stories or studies had to be true, only that the credibility was not distorted or manipulated, even in fantasies" (Godden, pages 47–8). Tanach is an interpretation of history not unlike those TV documentaries of recent years which reconstruct events by using film or other evidence but which also create scenes

LEFT Detail of a 4th-century mosaic from Hammath synagogue (see also page 171), showing the menora or seven-branched candlestick. Also shown are a *shofar* (ram's horn trumpet), *lulav* (palm branch), *ethrog* (citron) fruits, and an incense shovel.

in order to carry the story forward. It is then a serious issue to know with how much integrity the construction has taken place.

What is impressive about Tanach is the coherence and consistency of its contents, the fact that it does not attempt to suppress material which shows the people or individuals in a bad light, and above all the extraordinary way in which the vision of God is developed so profoundly through the course of time. What is consistent in that vision is the absolute conviction that there can only be one God, the One who God is (a belief known as monotheism) – in contrast to the many gods in the ancient world.

It is that dazzling sense of God which evoked the writings in Tanach and made them unique in the ancient or any other world. The Victorian portrait painter Henry Richmond was once asked whether he tried to paint his portraits truthfully. "Yes," he said, "The truth. But the truth lovingly told." Tanach tells the truth about a people and its relationship with God, and about the nature and purpose of God as they came to understand it. But it is the truth faithfully and thankfully told (see Bowker, *The Complete Bible Handbook* for this and for a general introduction to the Bible).

All this means that there are sharp and divisive issues concerning the use of the Bible in interpreting and understanding the Holy Land and the places in it. Quite apart from the issue of accuracy and reliability, there is also the issue of whether the Bible can or should be used to support political and geographical decisions at the present time. For example, does the Bible establish the right of Israel to the Land? Does it justify or even require its extension to the boundaries of "the Promised Land", and if so what exactly were the original boundaries? Does it require outsiders to support Israel on the basis of biblical prophecies?

These and other "hidden agendas" often control the ways in which the Land and the places in it are understood and interpreted. If the Holy Land seems to have been an almost continuous battlefield, so certainly is the interpretation of its early history. The dramatic consequences of this are shown by Keith Whitelam in a

———— ✳ ————

BELOW As it was: a tinted photograph of the Temple area, Jerusalem, *c.* 1906. The Dome of the Rock was restored to its current glory in the 1960s and 1990s (see pages 130 and 147). The Qubbat alMi'raj, the Dome of Ascent, (front and right of the Dome), commemorates Muhammad's ascent into heaven.

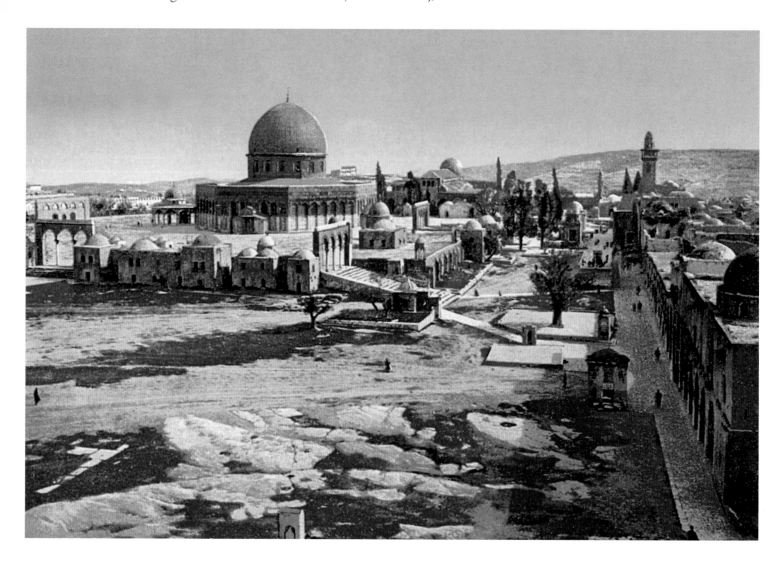

book deliberately and aggressively called *The Invention of Ancient Israel*, in which he chronicles the distorting assumptions of well-regarded biblical historians.

In looking, therefore, at the Holy Land and the places in it, and in trying to understand how they came to be as they are, Whitelam's fundamental point is that we need to remember the history that has *not* been told about the Land and who is entitled to live there – the subtitle of his book makes the point: *The Silencing of Palestinian History*. We know, for example, that there are Psalms (still recited in synagogues and churches, and therefore reinforcing attitudes) which rejoice in the way God slaughtered Egyptian children and Canaanites so that his people might escape and take over the Promised Land:

> He [the Lord] it was who struck down the firstborn of Egypt, both human beings and animals;
> he sent signs and wonders into your midst, O Egypt,
> against Pharaoh and all his servants.
> He struck down many nations and killed mighty kings –
> Sihon, king of the Amorites, and Og, king of Bashan,
> and all the kingdoms of Canaan –
> and gave their land as a heritage,
> a heritage to his people Israel.
> (Psalm 135.8–12; cf. Psalm 136 which celebrates the steadfast love of God in creation and in his destruction of Egyptians and those in the land of Canaan.)

What we do not have is history written from the point of view of Sihon, Og, and the Canaanites for whom the experience of God as they lost life and land would have been somewhat different. This means that in looking at the Holy Land it is always necessary to keep this contested history in mind, since without some knowledge of it, it is impossible to understand the surviving places and the earlier remains. Here, nothing more can be attempted than an extremely brief summary of the historical background, in order to make sense of the account of the individual places that appear in the photographs. It is not in any way a summary of the entire history, but only of those parts of it that are needed in order to understand the text accompanying the photographs. In any case, it is only one interpretation, and, for all the reasons I have summarized, there are plenty who would disagree and would offer a different interpretation.

THE FAMILY OF ABRAHAM

The people now known as the Jews began as an association of families (belonging to "a father's house", *bet ab*) and clans (*mishpahot*) who recognized a common ancestry. They often followed their own independent histories, but they remembered and respected their relationship and affinity with each other. For that reason they are called a "kinship group".

The common ancestors recognized in this kinship group were Abram/Abraham, his son Isaac, and his grandson Jacob. Jacob received the name Israel (a story in Genesis 32.22–32 tells how he received the name; a shorter account is given in Genesis 35.10), so that the kinship group is also known as the Bene Israel, the sons or descendants of Israel, hence the Israelites. Places associated with the three ancestors are revered to the present day: see, for example, Hebron (pages 186–91) and Beer Sheba (pages 192–7); for the journeys of Abraham to and within the Land, see the map on page 194.

Because the members of the kinship group, the Bene Israel, followed different, though interrelated, histories, Torah gathers together many of the memories and traditions of the individual families or clans. These include stories about the places where they worshipped and about the name and nature of the God who was worshipped there. In this way we know the names of important local shrines where the religion of the Israelites was formed long before the time of David when Jerusalem was captured. These include Shechem, Shiloh, and Bethel, and we know also the particular name of God associated with these ritual and cultic centres. From this we can see how close the contacts were with Canaanite beliefs, even though those beliefs and practices are attacked fiercely in the Bible. As Schoville concludes:

> Archaeology indicates that the monotheistic view did not completely conquer. Israel inherited the material culture of Canaan, along with the language of the Canaanites and their simplified writing system. It was difficult for Israel to resist the attraction of the Canaanite cult and worldview, with its emphasis on fertility. Ultimately, the majority of the Israelites succumbed to Canaanite influences, despite the warning cries of the prophets of the Lord. (pages 180–1)

The supreme God of the Canaanites and thus of the Bene Israel was known as El. He delegated to lesser gods the work that needs doing in the world. These lesser gods were known as Baals (Baalim), lords of storm and rain, of land and fertility. Others were known as Elohim, a plural word that means "gods", though later it came to be a word of inclusive majesty meaning simply God.

At particular places or shrines, El became local. Thus the name of God associated with Shechem was El-Elohe-Israel (El of the gods of Israel, or perhaps El, God of Israel, Genesis 33.20); in the Negev it was El-Roi or Roeh (God who sees, Genesis 16.13); in Jerusalem it was El Elyon (God most high, Genesis 14.19; 21.33); in Beer Sheba it was El'Olam (God everlasting, Genesis 21.33) – and there are many more.

As they followed their independent and often local histories, the family members of the Bene Israel might be nomads following their

herds, or farmers pursuing land-cultivation of a more settled kind – or they might do both, depending on circumstances and changes in climate. In times of crisis or threat they could call on each other and could expect to receive help. The help, though, did not always arrive, as in the threat at a later date from Hazor (see pages 46–51).

THE EXODUS

This pattern of semi-settled, semi-nomadic life in or on the edges of Canaan was totally changed, and indeed revolutionized, by a series of events that have come to be summarized as the Exodus and the wanderings in the wilderness, the memories and traditions of which have been gathered in the last four books of Torah (Exodus, Leviticus, Numbers, Deuteronomy).

Those memories and traditions recall how, at a time of prolonged famine, part of the Bene Israel, the families associated particularly with Joseph, made their way to Egypt and prospered. The narrative suggests that *all* the Bene Israel were in Egypt, but equally the narrative makes it clear that the significant history belonged to the families descended from Rachel (Joseph and Benjamin) and to Levi of the families descended from Leah. It seems likely, therefore, that many of the Bene Israel remained in Canaan and were only later rejoined by those who fled from Egypt.

They fled from Egypt because as immigrants they had come to be resented by the Egyptians who turned them into slave labourers: "they set taskmasters over them to oppress them with forced labour. They built supply cities, Pithom and Ramases, for Pharaoh" (Exodus 1.11). They were rescued by God under the leadership of Moses. But it was not "God" in the Canaanite understanding of El. It was God with an entirely new name and nature. In a dramatic encounter, Moses received a command to rescue the enslaved people in Egypt and lead them to the land of the Canaanites:

> Go and assemble the elders of Israel, and say to them, "The Lord, the God of your ancestors, the God of Abraham, of Isaac, and of Jacob, has appeared to me, saying: I have given heed to you and to what has been done to you in Egypt. I declare that I will bring you up out of the misery of Egypt, to the land of the Canaanites, the Hittites, the Amorites, the Hivites, and the Jebusites, a land flowing with milk and honey." (Exodus 3.16–17)

Moses, not surprisingly, asks what the specific and localized name of God or El is:

> Moses said to God, "If I come to the Israelites and say to them, 'The God of your ancestors has sent me to you,' and they ask me, 'What is his name?' what shall I say to them?" God said to Moses, "I AM WHO I AM". (Exodus 3.13–14)

This reply is an interpretation of the four letters that make up the name YHWH, the name often translated as "the Lord". We no longer know how this name of God was pronounced. It became too holy even to speak it, and many Jews to this day will simply say "HaShem", the Name, rather than make any attempt to pronounce the letters. In the biblical text, the vowels of the Hebrew word for "my Lord" (*adonai*) were inserted into those four letters to remind anyone reading the Bible not to try to pronounce the Name but to say "my Lord" instead. The English form Jehovah is thus a complete nonsense, since it tries to use the four letters YHWH and the inserted vowels as though it is a name. The convention outside the orthodox reverence of Judaism is to call YHWH Yahweh.

THE ISRAELITE SETTLEMENT

Those escaping from Egypt spent 40 years in the wilderness and desert during which time they entered into a new covenant with Yahweh as God, and they received the terms and conditions which they would have to keep as their side of the agreement. They received the promises of God to protect and preserve them so long as they keep the laws gathered in Torah. If, however, they do not they are warned that God will be what Stephen Crane called, in *The Red Badge of Courage*, "a deity laying about him with the bludgeon of correction".

When the people crossed the River Jordan (see page 39) they began both the conquest and the extension of their existing settlements in the land of Canaan. Some of the narratives in the books of Joshua and Judges suggest that this was a gradual and somewhat haphazard process, but others give the impression of a systematic and complete conquest.

Crucial to this process was the rebonding of the two parts of the Bene Israel: those returning from Egypt with an obligation to Yahweh, the worth of which had been demonstrated in the Exodus and in the wilderness; and those who had remained in the Land and felt a considerable loyalty to El and the Baalim who looked after their climate and land. The decision of the two parts to reunite under Yahweh in a formal covenant is recorded in Joshua 24, and from that time on Yahweh is so much the only and one God of the Bene Israel (and indeed of the whole world) that he gradually takes over the name and the function of El: Yahweh is El, and there is no other God beside him. This is the basic and fundamental statement of Jewish faith known as the Shema (from the Hebrew for the command, "Hear"): "Hear, O Israel, Yahweh our El, Yahweh is One" (or, "Hear, O Israel, the Lord our God the Lord is One").

Even so, many among the Bene Israel were very reluctant to abandon the Baalim who had looked after them for so long. The history of Israel becomes a long contest to insist that only Yahweh can be worshipped and served, and that all other so-called gods are an empty illusion (for examples of this contest see Carmel, page

THE SETTLEMENT OF THE TRIBES

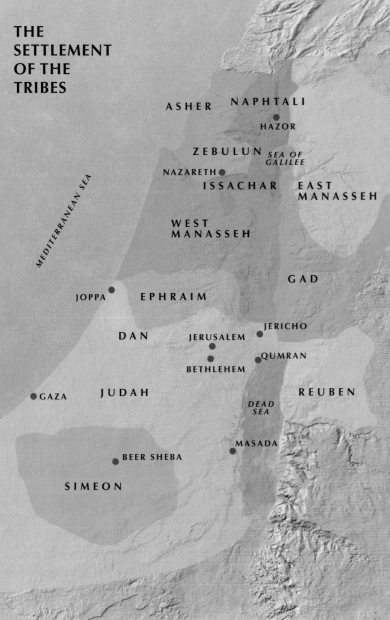

ASHER NAPHTALI
HAZOR
ZEBULUN *SEA OF GALILEE*
NAZARETH
ISSACHAR EAST MANASSEH
WEST MANASSEH
GAD
JOPPA EPHRAIM
JERICHO
DAN JERUSALEM
QUMRAN
BETHLEHEM
JUDAH REUBEN
DEAD SEA
GAZA
MASADA
BEER SHEBA
SIMEON
MEDITERRANEAN SEA

242, or the strong statement in Deuteronomy quoted on the same page. Many of the places photographed in this book feature in accounts of the Israelite settlement. Some of them bear traces of warfare that may come from this time. In Tanach there are two threads of narrative woven together. In one of them, the conquest is complete and thorough, and the areas in which the families or clans settled are laid out in a systematic way.

On the other hand, another thread of narrative makes it clear that by no means all the territory said, in the first thread, to have been captured was in fact taken. What is certainly clear is that the families or tribes of the Bene Israel continued to follow their own histories under their own leaders. Some of their memories and stories are collected in the Book of Judges, including those of Deborah (page 50) and of Samson (page 201). There remained the expectation, or at least the hope, that the members of

the Bene Israel would help each other at a time of crisis, but otherwise they pursued their own histories focused on their own shrines and holy places.

THE PHILISTINES, SAUL, AND DAVID

All this changed when the crisis threatening the Bene Israel became, not spasmodic and intermittent, but permanent. This happened when the Sea People and the Philistines (see page 204) began to take possession, first of the coastal plain, and then of territory further inland.

It seemed to Saul, one of the leaders among the Bene Israel, that a more permanent leader was needed to hold together a coalition against the Philistines and he took steps to introduce kingship as this kind of leadership. Tanach records how bitterly this kind of kingship was resisted, because the individual members of the Bene Israel valued their autonomy. However, the defence against the Philistines became increasingly desperate, and when David succeeded Saul, he took the innovation of kingship much further and made a success of it.

The great achievement of David was that he captured from the Jebusites the strong and already sacred town of Jerusalem. He took over (though also, Midas-like, he completely transformed) their ideas of kingship, and he made himself as king the mediator between God and the people. This was the beginning of the belief that the king is the specially commissioned servant of God known as haMashiach, "the anointed one", or in English letters, "the messiah". It was believed that through the messiah, the anointed king, God would bring protection and prosperity to his people. Initially, these hopes were centred on the particular kings who reigned in Jerusalem, but after a long experience of kings who failed them and let them down, the messianic hopes were transferred into the future and were centred on a King who will come in God's good time to renew and restore God's people.

David also made Jerusalem the capital city of the Bene Israel. This was a stroke of genius, because Jerusalem had not belonged to any one of the tribes, and he could therefore make it into an entirely neutral centre for the new and permanent coalition.

David and his son Solomon who succeeded him were successful in driving back the Philistines and in creating the beginnings of an empire. Solomon went further and built in Jerusalem the First Temple. Like the institution of kingship, the building of the Temple was fiercely resisted by some who said that it was an innovation and that God had not needed a house in which to live during all the years that he had led his people in the wilderness.

Even more serious than that opposition was the decision among the Northern tribes not to continue the coalition that David and Solomon had tried to create. When Solomon died, they formed their own kingdom in the North. From this moment onward, a strong

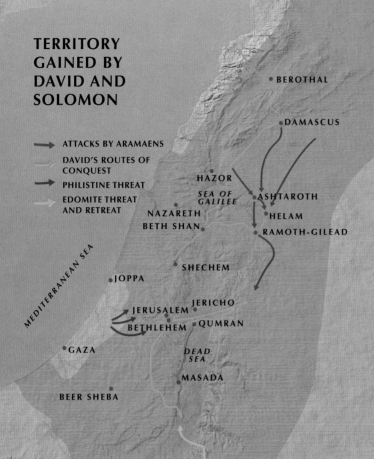

TERRITORY GAINED BY DAVID AND SOLOMON

→ ATTACKS BY ARAMAENS
→ DAVID'S ROUTES OF CONQUEST
→ PHILISTINE THREAT
→ EDOMITE THREAT AND RETREAT

BEROTHAL

DAMASCUS

HAZOR
SEA OF GALILEE
ASHTAROTH
NAZARETH
HELAM
BETH SHAN
RAMOTH-GILEAD

SHECHEM

JOPPA

MEDITERRANEAN SEA

JERUSALEM
JERICHO
BETHLEHEM
QUMRAN

GAZA
DEAD SEA

MASADA

BEER SHEBA

and made an alliance with Egypt which turned out to be worthless. The king of Assyria, Shalmaneser V, marched against Israel and captured the fortified capital of Samaria (page 124) after three years fighting (2 Kings 18.10). This was in the last year of his reign, 723 BCE, though his successor, Sargon II, claimed the victory in 722: on his own account, he deported 27,290 Israelite prisoners.

Sargon continued his campaigns particularly against the Philistines on the coast, but was not concerned with Jerusalem and Judah. However, when he was succeeded by his son, Sennacherib the king of Judah, Hezekiah, decided on independence from Assyria. The Assyrians launched two massive attacks against Jerusalem, but they had to be called off before the city could be taken, and these escapes were taken to demonstrate that Yahweh has protection of his holy city and Temple.

That, however, was soon to change. A new power was rising in Mesopotamia (see above), the Babylonians, and in 612 the Assyrian capital, Nineveh, fell to the combined armies of the Medians and Babylonians. The king of Judah, Josiah, saw the chance of freedom from the Assyrians and he decided to support the Babylonians. When the Egyptians marched along the coastal plain to go to the help of the Assyrians against the Babylonians, Josiah attempted to stop them at Megiddo (609). He may have held the Egyptians up, but they overwhelmed him (see page 125).

In any case, a pro-Babylon policy did Judah little good. In 605, Nebuchadnezzar, the crown prince of Babylon, was sent to drive back the Egyptians and to secure for the Babylonians the coastal plain. Nebuchadnezzar defeated the Egyptians at Carchemish (605), and the Babylonians in effect took control of Syria, Israel, and Judah. To bring Judah under his authority, he sent an army in 598 to seize Jerusalem and captured the king. Treasure from the Temple was sent to Babylon along with 3023 prisoners, but the king, Jehoiakim, died before he could be sent as a prisoner himself. Nebuchadnezzar therefore made a new expedition in 597 against the new king of Judah, Jehoiachin, who immediately surrendered and was taken to Babylon along with the remaining treasure from the Temple, 7000 prisoners, and all the skilled craftsmen that Nebuchadnezzar could find.

Nebuchadnezzar installed Zedekiah as a king who for eight years remained loyal to Babylonians, but then, against the advice of many around him (and particularly of the prophet Jeremiah), made an alliance with the Egyptians. Nebuchadnezzar moved against Judah and devastated the land. He laid siege to Jerusalem which fell in

division, and in the end conflict, developed between the Northern (known as Israel) and the Southern (known as Judah) tribes. On the way in which this developed into the split and hostility between Samaritans and Jews, see pages 127–9. The writings in Tanach come almost entirely from the South, and they describe the split as the rejection and abandonment of Yahweh by the North. In fact, the Northern tribes regarded themselves as remaining faithful to the original and age-old religion, since it was David and Solomon who had introduced the innovations of kingship and a temple.

THE ASSYRIANS AND THE BABYLONIANS

The independence of Israel in the North came to an end in the 8th century when the world-power of Assyria began to assert its authority in the area in order to secure access to the Mediterranean. Hoshea, the king of Israel, decided to resist Assyria

587. Jerusalem was looted and destroyed, and the Temple was burned down. Most of the population was transported into captivity in Babylonia, and so began the Exile.

THE EXILE AND POST-EXILIC PERIOD

When the Babylonians captured Jerusalem, they took the majority of its population into exile. It was the end of Jerusalem, for at least the foreseeable future, as the centre of Jewish life. Less than 50 years before, Josiah (the king who failed to stop the Egyptians at Megiddo), had tried to make the Temple in Jerusalem the centre of Jewish life and faith, the one place to which all the great pilgrimage festivals would be made. Previously it had been possible to celebrate them at the local shrines and cultic centres.

In 587 Jerusalem Temple was lying in ruins. Many at the time might have expected that the faith of the Jewish people would lie in ruins with it, since it was believed in the ancient world that if a people was defeated, so too were its gods. The gods of Babylon (there were thousands, including Tammuz, Bel, Nebo, and the great Marduk) had overwhelmed Yahweh, whose worshippers should now worship the superior gods of the Babylonians.

Exactly the reverse happened. The people in exile, remembering the Exodus and the promises that Yahweh had made, kept faith, and they trusted that Yahweh would restore them to Jerusalem. Nevertheless, their despair, as recorded in Psalm 137, was real.

> By the rivers of Babylon —
> there we sat down and there we wept
> when we remembered Zion.
> On the willows there we hung up our harps.
> For there our captors asked us for songs,
> and our tormentors asked for mirth, saying,
> "Sing us one of the songs of Zion!"
> How could we sing the Lord's song in a foreign land?
> If I forget you, O Jerusalem, let my right hand wither!
> Let my tongue cling to the roof of my mouth,
> if I do not remember you,
> if I do not set Jerusalem above my highest joy.
> (Psalm 137.1–6)

Even more dramatic was the way in which they mocked the useless gods of the Babylonians as they were carried past in religious processions:

> Bel bows down, Nebo stoops, their idols are on beasts and cattle; these things you carry are loaded as burdens on weary animals. They stoop, they bow down together; they cannot save the burden, but themselves go into captivity. (Isaiah 46.1–2)

Yet the fact remained that they were in exile, living far away from Jerusalem, and without access to the Temple. How could they sing the Lord's song in a strange land? They began to work out ways in which they could do what God required of them in keeping the terms of the covenant even without the Temple. Great stress was laid, for example, on keeping the sabbath, and it may be that at this time they began to form the assemblies that became the synagogues (on the origin and importance of synagogues, see pages 166–73; the importance of the sabbath is summarized in the saying of Ahad ha'Am, 1856–1927: "More than the Jews have kept the sabbath, the sabbath has kept the Jews.").

At the time when they captured and destroy Jerusalem, the Babylonians might well have seemed invincible, and yet the seeds of their own defeat had already been sown. Because they concentrated on establishing their empire in the north and west, they failed to notice that a people to the east were gathering strength. These were the Achemenians who, under their king Cyrus II (ruled c.559–530), were creating a new empire and were now known as the Parthians or Persians.

THE PERSIAN PERIOD

Cyrus entered Babylon in 539, and according to the Cyrus Cylinder he entered the city without a fight: he was welcomed as a liberator, not as a conqueror, and that was true elsewhere as well. He adopted a novel policy to strengthen and unify the massive empire that he now had to administer and control: he supported local peoples in looking after themselves according to their own beliefs and customs, so long as they remained loyal to him.

Following that policy, he sent the Jewish exiles back to Jerusalem, though some stayed in Mesopotamia, forming the foundation of the Jewish communities there that became so important when, much later, Jerusalem fell to the Romans.

The Persian empire maintained its control right across to the Mediterranean coast until the campaigns of Alexander the Great (356–323 BCE). Cyrus's successor, his son Cambyses II (529–522), extended the empire into Egypt, though conflict with Egypt continued intermittently, and Xerxes I (485–465) invaded Greece. The Persians were slowed down by the Spartans under Leonidas in the famous battle of Thermopylae (480), and they were finally driven back after the battle of Plataea in 479.

Little is known in detail of life in Judaea during the Persian period. The Temple was eventually rebuilt under two leaders, Ezra and Nehemiah, during the 5th century, and much greater emphasis was placed on the central role of the Temple and its authorities, above all the priests and the high priest.

The major issue facing them was to make sure that such a catastrophe as the Exile could not happen again. If the Exile was understood as a deserved punishment, then its repetition could

only be avoided if the people kept the laws of the covenant with care and attention. It became vital to define what it must mean to be the covenant people of Yahweh. That process of definition makes it possible to speak from this time on of Jews and Judaism.

Nehemiah 9 tells how this attention to detail led to the increasing separation of Jews from others. In Nehemiah 9.6–31 there is a long history of God's saving acts in relation to his people. He is described as "the great and mighty and awesome God, keeping covenant and steadfast love" (verse 32), and in chapter 10 the people renew their own side of the covenant commitment, including an avoidance of marriage with non-Jews and of trade with them on the sabbath. Indeed, "When the people heard the law, they separated from Israel all those of foreign descent" (13.3); and Nehemiah "cleansed them from everything foreign" (in relation to marriage, 13.30). The physical restoration of Jerusalem carries with it a willingness to enact the conditions of holiness as these are laid out in Torah. But this could only happen if everyone had a clear understanding of what the laws in Torah actually meant in practice.

The high priest and the priests in the Temple became vital in that endeavour. They could themselves maintain the rituals in the Temple as the Law required, but they could also monitor and interpret the laws so that their meaning and application could be worked out and followed by all people no matter what their own circumstances might be.

THE HELLENISTIC PERIOD

When Alexander the Great arrived in 332 BCE on Mount Scopus near Jerusalem (page 151), during the course of his conquest of Judah (or in Greek Judaea), he met the high priest of the day and bowed down before him. When Alexander's followers expressed amazement – since in general the world bowed down before Alexander – Alexander said that while he was still in Macedonia, before all his conquests, he had seen the high priest in a dream, and that the high priest had urged him to go into Asia where he would receive the empire of the Persians.

That story is told by Josephus (*Antiquities* 11.333–4), and it is not basically impossible since it is typical of Alexander's supportive attitude to the cults and beliefs of the people whom he conquered. In Egypt, for example, he went to the oracle at Amun where he arranged to have himself proclaimed son of the highest God of Egypt. He saw himself, and encouraged others to see him, as the divine ruler of the world.

The prediction that Alexander would acquire the empire of the Persians was correct. In 334 BCE he embarked on his campaign against Persia. In 332 he conquered Palestine, moving along the coastal plain into Egypt where he founded the city named after him, Alexandria. Samaria and Jerusalem wisely did not resist and they became part of Alexander's empire.

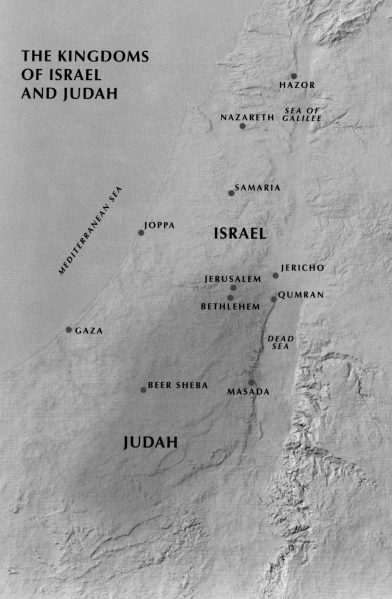

THE KINGDOMS OF ISRAEL AND JUDAH

HAZOR

NAZARETH *SEA OF GALILEE*

SAMARIA

MEDITERRANEAN SEA

JOPPA **ISRAEL**

JERICHO

JERUSALEM QUMRAN

BETHLEHEM

GAZA *DEAD SEA*

BEER SHEBA MASADA

JUDAH

When Alexander died in 323, there was competition and conflict among the Diadochoi ("successors") which led by 301 to three major areas of power and authority: Greece and Macedonia under the family of Antigonus; Egypt under the Ptolemies (Greek/Macedonian *ptolemaios* means "warrior": Ptolemy I was one of Alexander's most competent generals; Ptolemies were also known as the Lagoi or Lagids); Syria and Persia under the Seleucids.

Judaea was not in itself so strategically important as the coastal plain, but it had to be controlled in order to safeguard the coast. After Alexander's death, it had come under Egyptian control, but that control was challenged by the Seleucids in a long series of Egyptian–Syrian Wars. In the decisive battle of Panias/Paneas in 200 BCE the Seleucid king, Antiochus III, defeated the Egyptians, and the Egyptians were forced to withdraw from Palestine. The Seleucids became involved in disastrous conflicts with the Romans, who were beginning to expand into the Mediterranean, but Antiochus IV (175–164) restored good relations with Rome and then set about rebuilding the Seleucid empire.

He did this in part by pursuing a policy of Hellenization – that is to say, of creating unity and loyalty among the diverse peoples of the empire by imposing on them Greek ways of life, law and architecture. He called himself Ephiphanes ("manifestation", ie of God) and expected people to worship him as the manifestation on earth of the Olympian Zeus.

The crisis that this demand created in Judaea and Jerusalem was inevitable. The programme of Hellenization demanded the inclusion in the Temple of the Greek cult centred on Antiochus. This was not a big issue for those peoples who worshipped several gods anyway, but it was a total impossibility for the Jews who lived by the Shema (page 14) and recited it each day. Some among the Jews welcomed much that Hellenization brought with it, but for others many of the Greek practices were totally at odds with Torah; and in any case the outrage in the Temple was intolerable. Opposition began to gather round one particular family.

This was the family of Mattathias, a priest from Modein north-west of Jerusalem, who had five sons. The family became known as the Maccabeans from the name of the most prominent among the sons, Judas Maccabeus (Greek *makkabaios*, possibly from Hebrew *maqqabet*, "hammer"). They were also known as the Hasmoneans from the name of one of their ancestors, Hasmon.

THE HASMONEANS

In 167, Mattathias killed a Jew who was on his way to offer sacrifice at the Greek altar. The family fled into the deserts of Judah where they were joined by "the faithful", the Hasidim who were devoted to the Law. Mattathias died in 166, and the leadership of the revolt against the Seleucids was taken over by Judas who was, according to 1 Maccabees 3.4, "like a lion in his deeds". Judas drove out the Seleucids, removed "the abomination of desolation" from the Temple (ie, the Greek image), and in 164 restored the cult and ritual of the Jerusalem Temple. This rededication of the Temple is commemorated by Jews each year in the festival of Hanukkah.

The Syrians, however, had not in any way been overcome, and they returned in strength to defeat Judas at Beth-zecheriah, south-west of Jerusalem. But they were then diverted by the outbreak of civil war in Antioch. For a while the Maccabeans were successful, but in due course the Syrians returned once more, and in 161 Judas was defeated and killed at Elasa, north-west of Jerusalem.

Judas was succeeded by his brother Jonathan, who was initially a leader of small bands of resistance fighters in the desert. But the Syrians were more concerned to limit the power of Egypt and to keep control of the coastal plain, and this led them into repeated conflict with the Egyptians. The campaign that Antiochus conducted against Egypt from 170 to 168 is known now as the Sixth Syro-Egyptian War, and there were many more to come!

There were, however, more threats to the Syrians than from the Egyptians alone. Rome was beginning its expansion, and it sought increasingly to limit the power of the Syrians. In response, the Syrians saw in Jonathan a useful ally in distracting the Romans. With great skill, Jonathan exploited the rivalries between Syria, Egypt, and Rome, and as a result he and his surviving brothers were able to build up an empire that went eventually even further than the boundaries of the territory of David and Solomon. He himself was made high priest in Jerusalem in 152.

The Syrians, however, remained a powerful force, and they did not look kindly on the assertion of independent power by the Hasmoneans. In 143, the Syrian general Trypho defeated Jonathan at Beth Shan (Scythopolis, page 72) and had him executed. Jonathan was succeeded by his brother Simon (143–134) who continued the policy of exploiting rivalries among the Seleucids. He did this with such success that in 142 he gained for the Jews exemption from taxes. In effect, this was a declaration of independence, although it was still very much under Seleucid oversight. This means, as Fischer has shown in his analysis of the Seleucids and the Maccabeans, that the Hasmoneans were no longer rebels against the Seleucids but their political and military agents.

Nevertheless, the Hasmoneans were beginning to build an empire of their own and to create a period, however brief, of Jewish freedom. This memorable achievement was noted in 1 Maccabees 13.41–2: "In the one hundred and seventieth year the yoke of the Gentiles was removed from Israel, and the people began to write in their documents and contracts, 'In the first year of Simon the great high priest and commander and leader of the Jews.'"

Simon deliberately established a new dynasty in which the Hasmoneans became both high priests and rulers of the people (ethnarchs). Simon was succeeded by John Hyrcanus I (134–104) who was even more successful in extending the territory of the Hasmonean empire, including the destruction of Samaria and of the Temple on Mount Gerizim (page 126).

Hyrcanus I was succeeded by his son Aristobulus I, who went even further than anyone before him had dared and claimed to be king: high priests and kings were the two "special agents" of God, the two figures who were anointed as messiahs. In terms of territory, he went even further north than Samaria and conquered Galilee. He imposed "the laws of the Jews" (Josephus, *Antiquities* 13.318) on the inhabitants of Galilee and compelled the men to be circumcised. Galilee remained in many ways Hellenistic, but it became also from this time Jewish as well, thus creating the mix of "Jewish and Greek" that can be seen so obviously in the surviving remains of its towns and cities.

The process of expansion continued under Aristobulus's successor, Alexander Jannaeus (103–76). Josephus, in *Antiquities* 13.395–7, lists the many cities and territories that the Hasmoneans

now ruled, including places in this book such as Strato's Tower (pages 226–31), Joppa (pages 212–5), Jamnia (page 216), Ashdod (page 210), Gaza (pages 200–5), Carmel (pages 238–43), Mount Tabor (pages 110–5), Scythopolis (pages 68–73), and Gadara (page 59). The Hasmoneans controlled virtually all of the territory west of the Jordan from Idumaea to Ituraea with the exception of Ashkelon (pages 208–9) and Ptolemais, as well as much to the east of the Jordan from Mount Hermon to the Dead Sea.

The success and territorial expansion were exhilarating – and no one could forget that it had begun simply because one family of Jews and their supporters refused to compromise their faith and abandon Torah. The lesson to be drawn from this was that Yahweh gives success to those who keep faith with him through the covenant.

Despite, however, the exhilaration, there was a rising swell of unease. Were the later Hasmoneans being as faithful to God and Torah as Mattathias and his sons? Were they even remotely qualified by way of descent from "Zadok the high priest and David the king" to be either high priests or kings – let alone both at once? To a great extent the priests in the Temple cooperated with the Hasmoneans,

THE HASMONEAN EMPIRE

but others most certainly did not. They expressed their protest against what was going on in the Temple in many different ways, and it was this above all else which led to the different sects and parties among the Jews for the next 150 years, until the outbreak of the revolt against the Romans in 66 CE.

The basic issue was a fundamental one of authority: who has the authority to decide what the meaning of Torah and the practice of Judaism are as they are lived out in constantly changing circumstances? The basic command in Leviticus is that the Jews must be holy as God is holy, but what does it actually mean in practice to be holy in a Greek or Roman city on the shores of the Mediterranean, or for that matter anywhere else?

Torah itself is clear about the final authority in matters of uncertainty or dispute. Deuteronomy 17.8–10 states:

If a judicial decision is too difficult for you to make between one kind of bloodshed and another, one kind of legal right and another, or one kind of assault and another – any such matters of dispute in your towns – then you shall immediately go up to the place that the Lord your God will choose, where you shall consult with the levitical priests and the judge who is in office in those days; they shall announce to you the decision in the case. Carry out exactly the decision that they announce to you from the place that the Lord will choose, diligently observing everything they instruct you.

Of course it remains to be decided which place it is that the Lord has chosen, and also what person is meant by "the judge who is in office in those days". But while Jerusalem was standing the decision was not difficult: "the place" is Jerusalem and "the judge" is the high priest. But what happens if a particular high priest, or succession of high priests as happened in the case of the later Hasmoneans, is believed to be illegitimate? And what if the way in which the Temple and its rituals are run is thought to be wrong?

The answer of many was to protest against the Temple and its hierarchy, not just under the Hasmoneans but also after them under Herod and his successors, because all of them in their different ways seemed to cooperate too much with the occupying Romans. Examples of this dissent can be found at Qumran (pages 96–101), perhaps in the case of Jesus (pages 25–26), and in the building of an alternative Temple at Leontopolis in Egypt.

A more serious dissent can be seen in the emergence of a group known as "interpreters", or in Hebrew as *perushim*, hence the Greek word *pharisaioi* and the English word Pharisees. Although the Pharisees have come to be associated (mainly from Christian attacks on them) with over-rigorous legalism and hypocrisy, in fact they were very much on the side of ordinary people, trying to make

their lives liveable by their interpretations of the written law. Their interpretations were passed on by oral teaching which became known as "Torah by word of mouth" (in addition to written Torah), until from the 3rd century CE onward they were written down in the Mishnah and the Talmuds (see page 120). They are the foundations on which Judaism stands.

Before the fall of Jerusalem in 70 CE, the Pharisees more usually called themselves the Hakhamim, "the Wise". They became the Rabbis and are thus the foundation of Judaism as it is today. Ironically, they themselves attacked some of their own number whom they called Pharisees, but in another sense of the Hebrew word *perushim*, "separatists" – and they attacked them for much the same reason as they are attacked in the Christian Gospels: having started as those who explained to ordinary people how to keep Torah in everyday life, these extremists in effect went on to say, "And you must certainly keep it in every detail." In other words, this small group *did* become rigorist.

In their concern to make Torah liveable for all, the Hakhamim/ Rabbis developed the synagogues as an institution in parallel to the Temple for those who lived far from Jerusalem (on synagogues see pages 166–73. That is why, for example, so many of the remains of synagogues are found in Galilee; and they are found also from Rome to Mesopotamia. The tension between the Hakhamim/ Rabbis and the Temple authorities, who came to be known as Sadducees, was often considerable, since the Hakhamim/Rabbis disagreed, not just about matters of practice, but also about matters of belief (the surviving details of these disputes are given in Bowker, *Jesus and the Pharisees*, pages 53–76; passages from early texts containing references to *perushim*/pharisees are translated on pages 77–179).

Others disagreed with both Sadducees and Rabbis alike, and they created their own answers to the question of how exactly the Jewish people should live and what they should do if they were to keep faithfully the terms and conditions of the covenant with God.

The major consequence of this is that during the Hellenistic and Roman periods there was no such thing as "Judaism", if by that word is meant a single and uniform religion. There was certainly a profound sense of having a common ancestry, of being the descendants of Abraham, Isaac, and Jacob, and of being the inheritors of the promises of God. But on the question of how to keep faith with God there were many conflicting interpretations, from the community at Qumran (pages 98–9) at one extreme to the Zealots at another. The Zealots were those who remembered how in the past God had helped those who kept "zealously" to the Covenant; they therefore looked for a new messiah who, in battle if necessary, would set God's people free. (For a brief summary of the divisions among Jews at this time, see Bowker, *Beliefs*, page 22; in greater detail, Stone). It was this, in part, that lead inexorably to the disastrous conflict with Rome from 66 to 70 CE.

Those parties and conflicts were already beginning to form during the Hasmonean period. When Alexander Jannaeus died, he advised his widow (who succeeded him), Salome Alexandra (76–67), to support and seek support from the Hakhamim since they would bring the people onto her side. This she did, and the Rabbis later looked back on her reign as a golden (or more precisely a messianic) age. But the days of Hasmonean independence were coming to an end, for a new power had emerged in the Mediterranean world: the Romans.

THE ROMAN PERIOD

During the first century BCE, a period of turbulent conflicts and civil wars led to the transformation of Rome from a republican city state into an empire, as it led also to the emergence of Octavian as the Roman emperor, Augustus.

Initially this was not of much concern to the Hasmoneans in Judaea. However, in 64 BCE the Roman general Pompey arrived in Damascus in order to organize Seleucid Syria into a Roman province. There he received delegations from three different Jewish parties whose rivalry made it clear to Pompey that for security he must take control of Palestine and Jerusalem. Helped by one of the three "delegates", Hyrcanus II, Pompey captured Jerusalem in 63, and in a reckless moment actually entered the Holy of Holies (into which the High Priest alone ever entered, on the Day of Atonement). Expecting to find there the greatest treasure, he was amazed to find it virtually empty.

Judaea became once more a land under foreign domination. It was made by Pompey into part of the province of Syria. The area was a vital interest for the Romans, because Palestine, Phoenicia, and Syria formed the land bridge between Asia Minor and Egypt, and the coastal ports offered a base for protecting the eastern Mediterranean. That protection was essential because much of Rome's supply of grain came from Egypt and North Africa.

Pompey, therefore, appointed Gabinius (one of his most successful generals) as governor of Syria and gave him the task of rebuilding and fortifying strategic places. According to Josephus (*Antiquities* 14.88 and *War* 1.166), Gabinius rebuilt Samaria (page 124–5), Scythopolis (pages 68–73), Gaza (pages 200–5), and "quite a few others". It was equally important for the Romans for the defence of the area to find a local ruler whom they could trust and to whom they could delegate power. Pompey chose the Hasmonean Hyrcanus II who was allowed to remain high priest and (from 47 to 40) to govern as ethnarch a restricted area of Palestine as a client of Rome. He had as his adviser an Idumaean called Antipater who was effectively the ruler.

Henceforth the issue for the leaders and aspiring leaders of the Jews was how to secure endorsement and support from Rome. A key moment came in 47. Julius Caesar (100–44), who became

dictator in Rome from 46 to 44, defeated Pompey at the battle of Pharsalus in 48. Pompey fled by sea to Egypt, but was killed as he disembarked. Caesar pursued him to Egypt in order to secure Egyptian support, but in fact the Egyptian army rose against him. It besieged him in the Greek quarter where he would have perished but for the critical intervention of Antipater, who came to his rescue with Jewish troops.

Antipater was not a Jew, or at best he was only partly so: he was an Idumaean (a descendant of the Edomites, traditional and long-standing enemies of the Jews), and the Idumaeans, like the Galileans, had been forcibly converted to Judaism by John Hyrcanus I (134–104). Antipater had been the adviser and skilful supporter of Hyrcanus II, and now he emerged as the main link between Rome and Palestine. He secured support for Rome in any rebellions against them, and as a result he won many favours and advantages for the Jews in Palestine and throughout the Mediterranean world.

Julius Caesar, after he had been rescued by Antipater and his Jewish troops in Egypt, rewarded Hyrcanus II by making him, in 47, ethnarch of the Jews. But the greater rewards went to Antipater. He was made a Roman citizen, and he was then appointed procurator of the Roman Republic over the territory of the Jews (the word procurator means "financial agent" or "supervisor"). Antipater had two sons, Phasael and Herod (later to become Herod the Great), whom he made military governors (*strategoi*) of Judaea and Galilee.

When Caesar was assassinated in 44 BCE, a bid was made in Jerusalem to recover Jewish independence from the Idumaean usurpers, and Antipater was assassinated in 43. Herod, however, moved fast to secure his father's special relationship with Rome – but the tricky question for him was to decide who was the man to support in Rome.

Herod's first move was to support Cassius (one of those who had assassinated Caesar) when he arrived in Syria with a large army. Herod immediately raised money to support the legions and became an official "friend of Cassius". With this Roman protection he soon put down his opponents in Judaea, and then married into the Hasmonean family in order to legitimise himself.

However, a new Triumvirate in Rome, made up of Antony, Lepidus, and Octavian, moved against Cassius and defeated him at the battle of Philippi in 42. Mark Antony became ruler of the East, and Herod gained Antony's support by reminding him of the help he had received from Herod's father. Antony made Phasael and Herod tetrarchs (rulers of a fourth part) in Judaea.

At this point, Herod's link with Rome was greatly strengthened by what seemed at first sight to be his defeat. The last of the Hasmonean family, Antigonus, secured Parthian support to drive Herod out of Judaea, and Antigonus II ruled from 40 to 37. But the apparent disaster for Herod turned into a massive gain, because he took refuge in Rome where Antony and Octavian welcomed him as the protector of Roman interests in Palestine. In 40, the Senate named him as king over Judaea, and in return for special tribute he was given Samaria and other territories to be a part of his kingdom.

At that stage, it was a kingdom only on paper, but after three years fighting he defeated Antigonus and had him crucified and beheaded in Antioch. Herod now reigned as king from 37 to 4 BCE, depending entirely on his special relationship with Rome – Herod as an Idumaean was never welcomed or really even accepted by the Jews, though some were prepared to work with him.

Initially, Herod continued his support of Antony, though with one important reservation – a reservation that was again to save his life. Antony became infatuated with Cleopatra and began to think that with her help he could build up an independent eastern empire. Cleopatra, however, had her own ideas, and she began a series of attempts to regain Palestine and Syria for the Egyptians. Herod did everything he could to frustrate Cleopatra while still supporting Antony.

Then Octavian moved from Rome to challenge the burgeoning power of Antony and Cleopatra. He defeated Antony at the battle of Actium in 31. Herod found once again that he had backed the wrong Roman. However, he went immediately to meet Octavian at Rhodes, taking with him some Egyptian prisoners as a gift. He reminded Octavian of the support he had given him in the past, not least in his opposition to Cleopatra – and then, with a certain *insouciance*, he pointed out to Octavian how much Antony had valued Herod as an ally, and how much therefore Octavian would equally come to value Herod as an ally in the future.

Octavian saw the point; or more precisely, he saw Herod as a ruler whom he knew well and who would control for him the vital Mediterranean coast. Herod was confirmed as king with some added territories which later included Panias (pages 42–4). Secure in the support of Rome, Herod began to reign with confidence, never hesitating to have his opponents imprisoned or executed, including his own family if necessary. It was as a part of this confidence that he began his magnificent building programme.

HEROD TO THE JEWISH REVOLT

Herod ruled (37–4 BCE) in Palestine as a client king of the Romans. This gave protection to the Jews, not just in Palestine and Jerusalem, but also in the Diaspora (dispersion) where there were increasingly large Jewish communities. But it gave rise also to resentment among those Jews who saw this Idumaean despot, with his love of Hellenistic education and architecture, as a total contradiction of Torah.

When Herod died in 4 BCE, Rome placed Palestine under the administration of his sons: Archelaus was ethnarch of Judaea and Samaria until he was banished in 6 CE; Herod Antipas (who appears

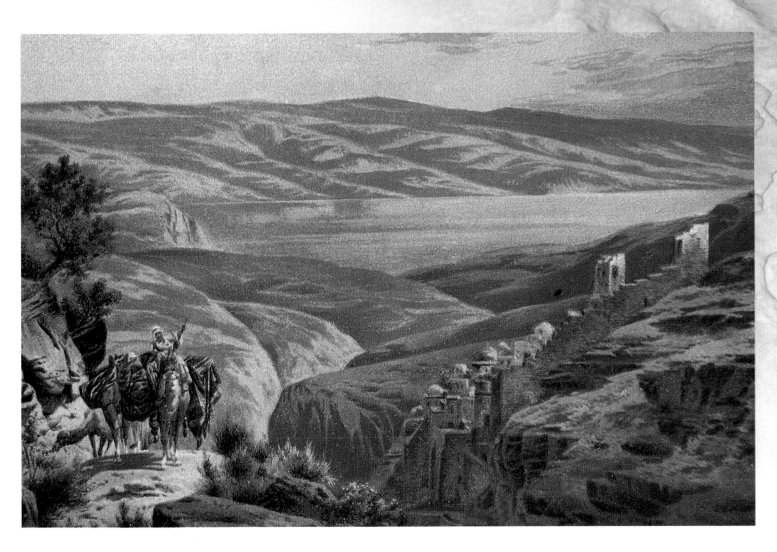

ABOVE As it was: a view of the Dead Sea painted *c.* 1900. The composition suggests a more human, even pastoral, landscape than modern photographs record (see pages 90 and 95). Mar Saba monastery is on the right (see pages 85 and 165).

———————— ✠ ————————

in the New Testament simply as Herod) was tetrarch of Galilee and Perea until he too was exiled in 39 CE; and Philip was tetrarch of northern Transjordan until he died in 34.

This settlement, however, was achieved only in the face of such violent opposition that Varus, the Roman governor of Syria, had to bring three legions to put down the unrest. Freedom fighters called Zealots emerged who remembered the Maccabees and the Hasmoneans, and who therefore sought a messiah who would lead them to the overthrow of the Idumaean usurpers (Herod and his family) and to freedom from Rome.

Because of this background of unrest, the Roman emperor, Augustus, decided in 6 BCE that he must impose his own authority on the area, and he therefore appointed the first of the procurators of Judaea: they were to govern the land as the personal representatives of the emperor. The Temple authorities were reorganized and aligned with the responsibilities of the Roman procurators as a kind of delegated local government.

Initially, the procurators served for three years, but the emperor Tiberius (Augustus's successor) extended the length of office on the grounds that, as he put it, flies swarm onto a wound and take their fill of blood: it is better then to leave them there because they will keep away other hungry flies (Josephus, *Antiquities* 18.174). That is why Pontius Pilate was procurator for 10 years, from 26 to 36.

Meanwhile Agrippa, a grandson of Herod the Great, had befriended in Rome the emperors Caligula and Claudius, and with their support he began to reassemble the original kingdom of Herod. He became king of what had been Philip's tetrarchy in 37, of that of Antipas after 40, and of all Palestine from 41 to 44. He followed the policy of Salome Alexandra long before (page 21) and cultivated the Hakhamim in order to win the support of the people. He tried to do this by strengthening the defences of Jerusalem, for which he began to construct a third wall slightly to the north of Herod's palace. The legate of Syria brought that project to an abrupt halt as soon as he heard about it.

HEROD'S TERRITORIES

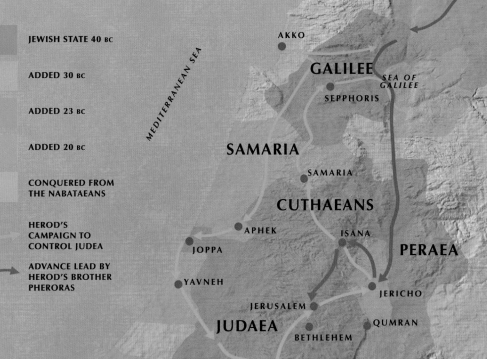

JEWISH STATE 40 BC

ADDED 30 BC

ADDED 23 BC

ADDED 20 BC

CONQUERED FROM THE NABATAEANS

HEROD'S CAMPAIGN TO CONTROL JUDEA

ADVANCE LEAD BY HEROD'S BROTHER PHERORAS

MEDITERRANEAN SEA

GAULANITIS

AKKO

GALILEE

SEA OF GALILEE

SEPPHORIS

SAMARIA

SAMARIA

CUTHAEANS

APHEK

ISANA

PERAEA

JOPPA

YAVNEH

JERICHO

JERUSALEM

QUMRAN

JUDAEA

BETHLEHEM

GAZA

HEBRON

DEAD SEA

IDUMAEA

MASADA

BEER SHEBA

When Agrippa I died in 44, Claudius decided that he would bring to an end the kingdom of Judaea, and he therefore brought Judaea back under direct Roman control. So began a second period of procurators whose jurisdiction was extended to include Galilee as well as Judaea and Samaria.

The imposition of direct Roman rule renewed the violent opposition among Zealots and other Jews, not just to the Romans, but to their Hellenized neighbours as well. In 61, there were riots and clashes between Jews and Greeks in Caesarea Maritima. The emperor Nero resolved the conflict in favour of the Greeks, but the quenched fire smouldered on until it broke out in new riots in 66. These riots and the Roman response to them ignited the 1st Jewish Revolt against Rome from 66 to 70.

Jerusalem fell in 70. The Temple of Herod, completed only a few years before, was destroyed, and a month later the upper city fell. Jerusalem was sacked but only partially destroyed. Far more effectively destroyed was the structure of Temple authority. Jews continued to live in Judaea, Samaria, and Galilee, but as in the time of the Exile long before (page 17), a way had again to be found of living as faithful and observant Jews without the Temple. The lead was taken by Johanan ben Zakkai (for this see page 216, and for the continuation of his work see pages 61–2). In this regard, the organization and building of synagogues became supremely important (see pages 166–73).

It was not that worship in the Temple area completely ceased. Between 73 and 132 some rebuilding and resettlement took place

in Jerusalem as there was no Roman prohibition against this. According to Epiphanius (*Panarion* 29.7), when the emperor Hadrian (76–138) visited Jerusalem he found seven poor synagogues and one small church. However, he saw that the Jews were not interested in assimilating into the Roman empire, and he therefore issued, in 132, a ban on circumcision, that most obvious way in which Jewish men were differentiated from others.

The 2nd Jewish Revolt began as an immediate response. It was led by Simeon ben Kosebah (for one of his letters, see page 94) who was derided by those who opposed his rebellion as bar Kozibah, "the son of a lie". However, he was acclaimed by his supporters (who included the revered rabbi Aqiba) as a messiah, and they called him instead bar Kokheba, "the son of a star". That play on his name was derived from Numbers 24.17, where the prophet Balaam declares: "A star [*kokhabh*] shall come out of Jacob, and a sceptre shall rise out of Israel."

The 2nd Jewish Revolt lasted from 132 until 135, but it was no more successful than the 1st. After it was put down, Jerusalem and the remains of the Temple were completely destroyed and ploughed up, and Jerusalem was rebuilt as a Roman city called Aelia Capitolina with a Gentile and Christian population.

JESUS AND THE RISE OF CHRISTIANITY

During this turbulent time, when there were so many different understandings of how Jews should live as God intended, there was one particular interpretation which had dramatic and far-reaching consequences. This was the one taught and enacted by Jesus.

Jesus appeared when he was about 30 years old as a teacher and healer in Galilee. In many ways he resembled other teachers and healers of the time, and yet he was profoundly different from them all. He taught, often in stories or parables, that God welcomes and supports all, even the worst of sinners, who seek him in trust and faith. Those who do so find that their lives and the whole world become entirely different: they become transformed by love. It was a common practice at that time to ask teachers and rabbis to sum up their understanding of God as briefly as possible (in what are known as *kelalim*, from the Hebrew *kol*, "all" or "everything"). Jesus put together two sentences from Tanach (Deuteronomy 6.5 and Leviticus 19.18) and said: "'You shall love the Lord your God with all your heart, and with all your soul, and with all your mind. This is the greatest and first commandment. And a second is like it: You shall love your neighbour as yourself.'" (Matthew 22.37–9).

The consequence of living a life enabled by God in this way is massive: it turns upside down the values by which the world in general lives: it makes the poor more important than the rich, those who make peace more important than politicians and soldiers, children more important than anybody; it means, as Jesus put it, that the first shall be last and the last first. It is the reason why Christians, no matter what their other faults may have been, have led the way in "giving to the hungry and the thirsty what they need, clothing the naked, caring for the sick and visiting those in prison" (see Matthew 25.31–46).

That is what Jesus meant by the coming of God's kingdom on earth both now and in the future, for which he taught his followers to pray. As well as teaching this, Jesus put it into action. He did this through actions which made the power of God effective in the world in many different ways. To describe this power, the early accounts of Jesus used the Greek word *dunamis*, a word that appears in English in such words as "dynamic", "dynamite", "dynamo". The dynamic of God was made visible in the life and ministry of Jesus, and above all in the way in which he healed people and pronounced that their sins have been forgiven.

Jesus therefore brought right into the centre of everyday life things that it was believed only God can do: the constant working out of the transforming truth of love, the healing of the sick, and the forgiveness of sins. There were those who saw all this and thought that it was outrageous for any human to do on earth what only God can do, but even they recognized that he was doing extraordinary things – so extraordinary that they dismissed him on the grounds that he was doing all this through the power of the devil, Beelzebub (page 184), in order to lead faithful Jews astray.

The works and words of Jesus, through which the power of God was brought into the world, were certainly dramatic. Even more remarkable was his insistence that these acts of God were completely unconditional: God's healing and forgiveness do not depend on keeping the laws of the covenant, although Jesus did in fact respect the covenant, nor do they depend on having the correct beliefs about God. All that is necessary is to have faith and trust in the goodness and generosity of God – a faith that is as possible for non-Jews as it is for Jews.

Jesus, therefore, brought God's power into the world in both word and act, but he never claimed to do any of these memorable things out of his own ability or strength. He said that they came to him from God whom he called Father. Indeed, he insisted that he was an ordinary man and not any kind of special creation like an angel or a messiah – although many speculated that perhaps he was a promised figure of that kind. Jesus called himself "the son of man", which means in the Bible "a human who has to die", but also one who, by keeping faith, will receive honour and reward from God after death (on the meaning of "the son of man" see page 44).

What a puzzle this was for those who first encountered Jesus! When he spoke and acted it seemed to be *God* who was speaking and acting through him in ways that lay far beyond ordinary human power. Some actually thought that in Jesus they had met God in Galilee and in Judaea. And yet Jesus spoke about God, and also

spoke to God in prayer, as Father, as one distinct from himself. That is why Christians came to believe in what they called the incarnation (from the Latin *in carne*, "in the flesh/body"): God wholly present in and through this particular human life without overwhelming that humanity, and without being in any way less than God – both God and man.

This was a bewildering and yet exhilarating belief. But was it true? Some thought it was outrageous, others could only say, "though I was blind, now I see" (John 9.25). But who was right? At that time decisions about the truth or falsity of a teacher could, among the Jews, only be made in the Temple at Jerusalem (on this see page 20). That is why Jesus made a deliberate move from Galilee to Jerusalem, knowing that if it was decided that he did not have the authority to teach and act as he was doing he would have to be be executed – since that is the penalty demanded in Deuteronomy (see page 156).

In due course that happened, though the penalty was put into effect by the Romans. And that should have been the end of the story, as it was for others executed by the Romans of whom we know nothing further. In the case of Jesus it was only the beginning of the story because, although his followers had no doubt that he had most certainly died on the cross, they had equally no doubt that in some way far past their understanding he was alive and among them still. This experience of Jesus alive after he was known to be dead is called by Christians "the resurrection". Through the resurrection they have found that Jesus continues to bring the reality and effect of God into their lives as much in the present as he had ever done for the people whom he met in Galilee and Judaea in the past.

It is often said now that Jesus was an ordinary teacher and healer who was only much later promoted into being the Son of God. That is certainly and clearly not true. From the very start Jesus was recognized by his followers as being, uniquely, the real presence of God in the world, and it is the very earliest writings in the New Testament, the letters of the first Christians, which give the highest status and titles to Jesus. They still called him by his human name, Jesus, but they claimed in many different ways that he is "the reflection of God's glory and the exact imprint of God's very being, and he sustains all things by his powerful word" (Hebrews 1.3). They believed that in Jesus God had been dwelling among them, full of grace and truth (John 1.1–18).

This brief background is necessary in order to understand Jesus in the geography of the Holy Land, and to understand why in particular Jesus moved from Galilee to Jerusalem – and beyond that why Christians value the places associated with Jesus as the places where God walked on earth. To those places they added those associated

with the family and followers of Jesus – with Mary, for example, and with the chosen followers of Jesus, the apostles such as Peter.

The *exact* location and identification of these places cannot always be known. This may be because that information is now lost, or because there may be competing claims (as, for example, in the case of Cana or of the Mount of the Transfiguration: see pages 120, 112–4), or because the records of where Jesus went do not always agree with each other (see, for example, pages 113 and 142).

This is because the accounts of the life of Jesus in the four Gospels in the New Testament are not day-by-day diaries. They are interpretations of what that life was and why it still remains important for all people. The four Gospels tell the same basic story, often using common material, but each gives to the story its own interpretation and emphasis. They all focus on the Passion narrative (the story of the last days of Jesus, of his examination and condemnation, and of his crucifixion – and, to a lesser extent, of events after his resurrection) in order to answer the question, how did it come about that someone who

RIGHT As it was: a scene on a postcard showing a bustling St David's Street in Jerusalem, near the Via Dolorossa, *c.* 1910. Compare the same part of Jerusalem today (see page 142).

was executed as a common criminal is nevertheless rightly recognized as God on earth?

So there may be uncertainty about the location of places in the life of Jesus, but there is no uncertainty about the impact of that life on those who met him long ago, and now equally on all who are drawn into that life by faith. It is thus a fundamental mistake to think that the worth and value of the Gospels depend on the historical accuracy of their detail. In that way the Gospels resemble Tanach (see page 10).

Christianity began as one interpretation among many at that time of what it should mean to be a faithful Jew. Early Christians, therefore, attended both synagogues and Temple, and struggled to decide how many laws in Torah should be obeyed by non-Jews (Gentiles) who, by faith alone, had entered into the new interpretation of the covenant. Some, like Peter, found it hard to understand how Gentiles could enter the covenant made with the Jews without keeping the laws.

It took the superb genius of Paul to see the point. He understood exactly the way in which Jesus had said that there can be as great faith outside the boundary of Israel as within. Since, as Paul wrote to the Christians in Rome (Romans 3.21–9), all have sinned and come short of the glory of God, there is no distinction between Jew and Gentile: both equally can have faith in God that God, as a consequence of the death of Jesus (understood as the necessary sacrifice to deal with sin) has cancelled the charge against them. Nothing, therefore, can ever separate those who have faith from the love of God. So Paul wrote (Romans 8.38–9): "For I am convinced that neither death, nor life, nor angels, nor rulers, nor things present, nor things to come, nor powers, nor height, nor depth, nor anything else in all creation, will be able to separate us from the love of God in Christ Jesus our Lord."

It sounds complicated when it is compressed in that way, but the way in which Paul built so faithfully on the life and teaching of Jesus transformed Christianity from being one interpretation of Judaism among many into an offer of salvation to the world. One consequence, however, was that Christians became increasingly separate and different from Jews, and this division became increasingly obvious from the time of the 1st Jewish Revolt onward.

THE END OF THE JEWISH REVOLT TO THE MUSLIM INVASION

When the emperor Hadrian finally put down the 2nd Jewish Revolt in 135, Judaea was called Syria Palaestina. Jerusalem was renamed Aelia Capitolina, and Jews were forbidden to enter what had been Jerusalem – or even, according to Eusebius (*Church History* 4.6.3), the country around. Jews still had to pay the Temple tax, but it was now diverted to the Roman deity, Jupiter Capitolinus.

Some Jewish Christians fled to Pella (page 72–3), but by this time Christian communities had begun to spread throughout the

PLACES ASSOCIATED WITH JESUS

empire. At first they seemed to be yet another of the many parties among the Jews. When Claudius expelled the Jews from Rome in about 49 CE, the historian Suetonius (*Life of Claudius* 25.4) claimed that he did this because of the constant disturbances which were occurring "at the instigation of Chrestus" – probably Christ, and perhaps disturbances caused by Christians seeking to convert Jews.

By the 2nd century Christians could be recognized as belonging to a distinct religion, but not what Romans called *religio licita*, a recognized religion. Pliny, whom the emperor Trajan had sent in about 110 to Bithynia to reorganize the province, wrote to Trajan expressing total uncertainty about how to deal with Christians whose "contagious superstition" had spread widely through the province. Trajan replied that they were not to be hunted down, but that they must be punished if they refused to worship Roman deities (Pliny, *Letters* 10.96, 97).

Other emperors were not so forbearing, and the number of martyrs increased greatly during the 2nd and 3rd centuries (for a translation of some of the accounts of these see Stevenson, pages 18–45). During the 3rd century the Roman empire came under

great pressure from both outside invaders and internal conflicts until in 284 the emperor Diocletian received an oracle from Apollo telling him that the troubles of the empire were to be blamed on Christians. The resulting persecution was severe indeed, especially in North Africa and in the East.

In this period of turmoil, rival emperors came forward, one of whom was Constantine. In 312 he invaded Italy and defeated his last rival, Maxentius, at the battle of Milvian Bridge (312). Perhaps under the influence of his Christian mother Helena who played a vitally important part in restoring and constructing Christian buildings in the Holy Land, perhaps under the influence of a dream of a cross and the words, "In this sign conqueror", he put on his standards the Greek letters χρ, an abbreviation of the word Christos, and he won the battle.

Although neither civil war nor persecution of Christians ended immediately it was a turning point in Christian history. It meant that Christianity was recognized and that Christians could play an increasing part in the government and administration of the empire.

As a consequence of Constantine's endorsement of Christianity, the 4th century has been called "the first true century in the history of the Judaic and Christian West" (Neusner in Stemberger page 1), but that would be true of the Christian East also. In 324 Constantine won the battle of Chrysopolis and became emperor of the whole Roman empire, East and West. He confirmed the authority of the East by setting up in 330 a new capital city for the East at Byzantium. He called the new city Constantinople, and he intended it to be "the Second Rome".

Once Christianity was recognized as an accepted religion, it became increasingly the religion of the empire. As it did so, the freedoms that the Jews had enjoyed up to that point began to be curtailed, although the Theodosian Code (16.8.13; the Theodosian Code is a compilation of laws and decrees issued by Roman emperors from 313 until 438) records a law dated 1 July 397 which states that "Jews shall be bound by their own ritual" and that their traditional privileges shall be maintained (Pharr, page 468).

On the other hand, there were other edicts limiting their freedoms, and the Theodosian Code (16.8.1, Pharr, page 467) records Constantine describing Judaism as "a feral and nefarious sect". His so-called Easter letter (325 CE) is even sharper, speaking of the Jews as Christ-murderers who "have stained their hands with a nefarious crime, and, as tainted people, are rightly blinded in their souls." (Eusebius, *Life of Constantine*, 3.18). The hatred of the Jews and the long history of anti-Semitism began.

Although Christianity had been endorsed by the emperor, it was constantly rent apart by people and parties, dividing even into separate Churches, who could not agree on fundamental issues of doctrine and authority (for a brief summary of these see Bowker, *Beliefs*, pages 42–8). The major split was between the Church of

Rome in the West and the Church in the East which was dominated by Greek Orthodoxy, but which was also much divided.

In the Holy Land, one visible consequence has been the number of different Churches that have controlled and supervised the holy places and buildings associated with Jesus, and these divisions continue to the present day. In Jerusalem, for example, there are six different Churches occupying the Church of the Holy Sepulchre – the Armenian, Coptic, Ethiopic, Greek Orthodox, Latin Catholic, and Syrian. As a result, the Church which should be one of the holiest places in Christendom is, as Anthony King has put it (page 69), "a strange building with a strange atmosphere": "For this ancient building is not owned by any one denomination or even by a united Church, but instead it is carved up into jealously – even fanatically – guarded areas."

These rivalries have been translated into other places and buildings in the Holy Land, though not on such an extreme scale. And yet, despite the many divisions and conflicts among the Churches, Christianity had now moved from being a persecuted sect to becoming the religion of the empire.

The visible consequence of the strengthening of Christianity was an increase in church building in the Holy Land. Churches begun in the time of Constantine were the Church of the Holy Sepulchre in Jerusalem (page 143), the church on the Mount of Olives (page 154) built over a cave in which Jesus after the resurrection is said to have taught his disciples, and the Church of the Nativity in Bethlehem (pages 162, 164). Constantine also removed the pagan cult at the Oaks of Mamre (page 196; on further church building during the 4th century, see Stemberger pages 48–85). Church building increased greatly from the 5th century onward. The work of Di Segni has shown that 57 churches were built between 350 and 800 compared with 22 secular or civic buildings; and in 951, alIstakhri wrote that during the previous century there had been 20 mosques built in Palestine compared with 60 churches.

A further consequence of devotion inspired by Christianity in the empire was an increase in the number of pilgrims to the Holy Land. Pilgrimage to the holy places of Christianity did not begin in the 4th century, but it certainly increased from that time on. Three accounts have survived (at least in part) from 4th-century pilgrims, and their descriptions of places in the Holy Land are invaluable. They are the Bordeaux Pilgrim (name unknown, who was in the Holy Land in the second half of the year 333), Egeria (around 400) and Paula with her daughter Eustochium (385–6). Texts can be found in *Itinera Hierosolymitana*, translations in Wilkinson.

Catering for the needs of pilgrims left an obvious mark on the Holy Land. So too did the advent of monasticism (see pages 82–9). Although the earliest of those who sought God in the desert were living as hermits or "solitaries", the practice began of grouping hermits into communities and of building monasteries.

ABOVE As it was: a tinted photograph *c.* 1906, showing the Garden of Gethsemane and the Russian Orthodox Church on the Mount of Olives. The Russian Church still dominates the view (see page 154).

———— ✠ ————

The Byzantine control of Palestine seemed secure until the Persian conquest from 614 to 628. Initially, until the Persians supported the Christians, the Jews welcomed the invasion and helped the Persians when they could – and this may account for the destruction of some churches in Galilee. Archaeologists have not found much from the Persian period, but Schick (pages 47–8) has warned against underestimating the effect of the Persian/Sasanian invasion: "One must not conclude that the Sasanian conquest was a minor event or that by 628 almost everything was again as it had been before the conquest. The Christian communities did not fully recover …. The Christian population suffered heavy blows, and the brief period of Byzantine restoration that followed was not long enough for their recovery to be complete."

THE MUSLIM INVASION

The Byzantine restoration after 628 did not last long, because a new threat was rising to the south, and was beginning to probe the Byzantine defences in Palestine and Syria. These raiders and invaders were the Arabs who, led by Muhammad (*c.*570–632), had become Muslim (the word *muslim* means loosely "one who enters into a condition of security and peace by giving allegiance to God").

Muhammad was born in Arabia in a town called Mecca, a town that was already a trading and pilgrimage centre for the surrounding tribes. While Muhammad was still a boy, he had several experiences of figures whom he later identified as angels. He was prompted by these to seek for the truth of God in a more serious way than the idols and gods of Mecca would allow. He was influenced in this by some people in Mecca who were called *hunafa'un*, or Hanifs: they had been and were impressed by the monotheism of the Jews in Arabia, and they claimed to be following "the religion of Abraham" (page 188).

Increasingly, Muhammad took himself to a cave on Mount Hira in order to search for God behind the many competing varieties of

religion and idolatry. It was there that he felt the strong pressure of God's messenger, the archangel Gabriel, insisting three times that he recite words given to him by God: these words continued to come to him throughout his life, and they are the words that constitute the Quran (for a summary of the distinctive beliefs of Islam, see Bowker, *Beliefs*, pages 68–90).

Muhammad came to believe that he was a prophet in the long line of Jewish and Christian prophets who spoke words that were not of their own making but came to them directly from God. Thus fundamentally Muhammad respected Jews and Christians as "the People of the Book", Ahl alKitab, since they had received the same revelation from God as himself. However, it is obvious that in Tanach and the New Testament the words spoken by the prophets are mixed up with much else, not least stories *about* the prophets. It seemed equally obvious to Muhammad that the Jews and Christians had confused and thus corrupted what had been entrusted to them.

Muhammad thus had a two-stranded approach, of conciliation or of conquest, to the Jews and Christians of Arabia. In both cases, the earliest communities seem to have arrived in Arabia as refugees, Jews taking refuge from conflicts culminating in the Roman destruction of Jerusalem and the devastation of Palestine, Christians taking refuge from persecutions by Romans or by fellow-Christians. Muhammad hoped that Jews and Christians would recognize him as one of their own prophets and would become Muslim, as indeed some did. If, however, they opposed him he attacked them and drove them out of their settlements, as happened to the Jews in Yathrib, Khaybar, and Fadak. In the case of one group, the Banu Qurayza, ibn Ishaq records that all the men were put to death and the women and children were sold or taken into slavery (*Ibn Hisham*, II, pages 233–54).

This two-fold approach of either conciliation or of conquest is based on the Quran, the revelations that Muhammad received. On the one hand, those Jews and Christians who "believe in what has been revealed [lit., "sent down"] to you and in what was revealed before you, . . . to them we will give a great reward" (4, 160/162). On the other hand is the command:

> Kill those who do not believe in God and the last day [of Judgement], and who do not forbid what God and his apostle have forbidden, and who do not live according to the true life-way [*din*, often but too narrowly translated "religion"] from among those who are the people of the

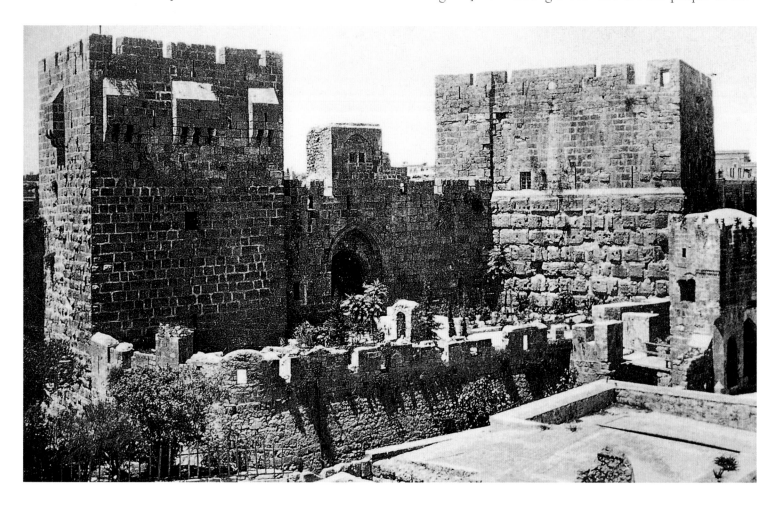

Book until they pay the *jizya* [lit., "compensation", in effect a poll-tax levied on those who do not accept Islam] with willingness and accept themselves as subdued. (9.29)

The two-stranded approach continued in the conquest of Palestine. The Muslims respected the Holy Land as the place where God's prophets had lived and worked, and they offered peaceful treaties to those towns or communities that did not resist, and they did not in general require them to abandon their own faith and practice. Many did in fact become Muslim, partly because of what Islam offered, partly because this opened the way to security and advancement in what rapidly became a Muslim province. The invading Muslims were frequently welcomed, and there is virtually no record of enforced conversion.

Muslim raids began on the southern edges of Palestine while Muhammad was still alive. In 629, three years before his death, the

———————— ✠ ————————

BELOW AND OPPOSITE LEFT The Citadel in Jerusalem photographed in 1906 (OPPOSITE LEFT), largely dates from the time of Suleiman. His 17th-century restoration and additions were built on a site first fortified in the 7th century BCE. The Citadel today (BELOW) is virtually unchanged in the last 100 years.

Byzantine army drove back a probing attack at Mu'ta, to the south and east of the Dead Sea, on the inland route to Syria. The Arabs were led by the famous general of the early campaigns, Khalid ibn alWalid. The account in *The Book of Campaigns* (alWaqidi, *Kitab alMaghazi* 755–69) suggests that he may have lost the battle by moving from his preferred raiding tactics to a more formal and fixed battle. Certainly, in any case, the Arabs reverted after this to their more usual raids.

In 634, they made an attack along the coastal plain, and they defeated the Byzantines, first at Dathin near Gaza, and second, about six months later, at Ajnadayn, slightly further to the north. Despite those successes, the Muslims decided that the inland route favoured their own raiding tactics better than the coastal plain, and in that same year, 634, they won a victory at Scythopolis (page 72) that opened the way into Syria. In 635 they captured Damascus.

The Byzantines at this time were still disorganized and weak after their long campaign against the Persians. Their emperor, Heraclius, had already realized (probably after his visit and pilgrimage to Jerusalem in 630 or 631) that the Arab Muslims were posing a new threat, even though many Arabs served in his own armies. But it took time to refocus on this new enemy, and it was

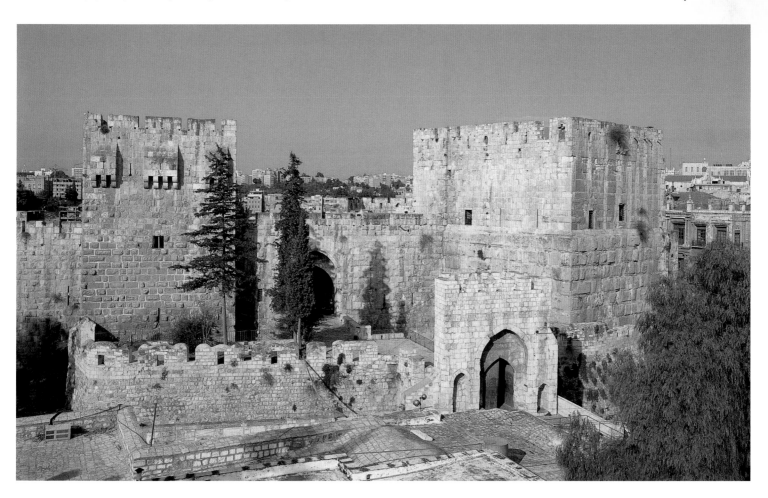

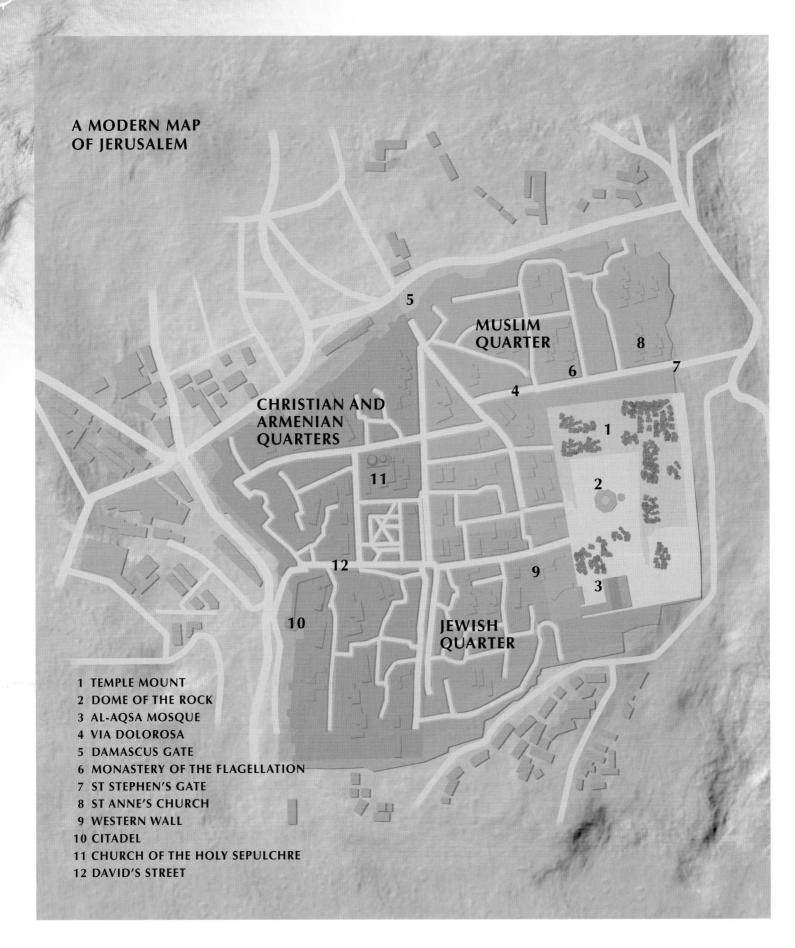

A MODERN MAP
OF JERUSALEM

MUSLIM
QUARTER

CHRISTIAN AND
ARMENIAN
QUARTERS

JEWISH
QUARTER

1 TEMPLE MOUNT
2 DOME OF THE ROCK
3 AL-AQSA MOSQUE
4 VIA DOLOROSA
5 DAMASCUS GATE
6 MONASTERY OF THE FLAGELLATION
7 ST STEPHEN'S GATE
8 ST ANNE'S CHURCH
9 WESTERN WALL
10 CITADEL
11 CHURCH OF THE HOLY SEPULCHRE
12 DAVID'S STREET

only after the capture of Damascus that Theodore, the emperor's brother, gathered together an army and moved against the invaders.

They were initially successful and drove the Muslims out of Damascus. The Muslims, however, fell back and enticed the Byzantines on to ground of their own choosing, on the River Yarmuk (pages 58, 60). There, in 636, they completely destroyed the Byzantine army. Kaegi (page 141) quoted the reaction of a near contemporary, Anastasius the Sinaite, as "the first and fearful and incurable fall of the Roman [Byzantine] army, I mean the bloodshed at Yarmuk", and he then commented: "A few decades after the battle Byzantines looked back to it as the turning point, after which full recovery was out of the question."

Following that success, the Muslims recaptured the bulk of Syria and then turned back on Palestine to attack it from both north and south. In 637 they captured and occupied Jerusalem, while in the same year they took Gaza (pages 200–5) and Ashkelon (pages 206–10). They completed the conquest of Palestine in 640 with the capture of Caesarea Maritima (pages 226–31).

In just under 10 years the Muslim Arabs had moved from being desert raiders to being the conquerors of Palestine. There is in general no evidence of towns or cities being destroyed (the only clear exception being that of Caesarea Maritima which fell after a prolonged resistance). Instead, they were offered terms of surrender: in return for security and the right for Christians to continue their worship, they had to surrender some property (especially to create space for the building of a mosque) and make payment of the annual poll-tax levied on non-Muslim citizens. In the record gathered by the Muslim Chroniclers, it is repeatedly said that the Muslims and the local peoples made peace – the Arabic word *sulh* which is of paramount importance now if Muslims and non-Muslims are going to find a way to live together. On the importance of this early discovery of a Domain of Peace (*dar asSulh*) in addition to the better known Domains of Islam and of War, see Bowker, *Beliefs*, page 77.

The recorded treaties vary from place to place, but the historian at Tabari recorded a typical example in the case of the treaty agreed with Lydda. It includes a guarantee that Christian churches together with their rituals will be preserved and that there will be no forcible conversion (ed. Guidi 2406–7).

Under the Ummayyad caliphs who ruled from Damascus (661–750), Palestine was turned into a province, coming to be known as Filistin. They did not, however, regard Jerusalem as a good or convenient site for the provincial capital. Instead, they built an entirely new capital at arRamlah (or simply Ramla/Ramle), just over 10 miles south-east of Jaffa.

The city was founded in about 715. Many buildings in nearby Lydda were pulled down in order to provide materials for the new city. By the 10th century Ramla had become very prosperous, and it was described by alMuqaddasi at that time as a fine city, well-built, with plenty of good water. That, however, was achieved only through the building of an elaborate system of cisterns to store rain-water the remains of which can still be seen. By that time it occupied a site of about a square mile. Its prosperity was shaken (literally) by the earthquake of 1033 which destroyed about two thirds of the city. Two further earthquakes, in 1068 and 1070, hindered the reconstruction. As Petersen points out (page 245), very little remains from the early Islamic period.

Shortly after this, in 1099, the campaigners of the 1st Crusade arrived to recapture the Holy Land from the Muslims (on the Crusades see pages 218–25). They took Ramla without a fight, finding the city deserted and the gates open. The Franks occupied Ramla for most of the next 250 years, building a moated castle and a large church. In 1266 the Muslims resumed control when Sultan Baybars reoccupied the city.

To judge from what can now be seen, the Islamic conquest did not make a major difference to the geography of places in the Holy Land, though mosques did increase in number after the end of the Crusades. Petersen concluded (page 25): "In general the conquerors appear to have aimed for minimal disturbance of the cities probably in realisation that their wealth was dependent on the continuity of economic life within the cities."

It is beyond the scope of this book to look at the changes that have been made to the places of the Holy Land down to the present day. From a Muslim point of view, the most drastic have been since the founding of the State of Israel (for an account of the consequences for Palestinian towns and villages, from a Palestinian point of view, see the Bibliography under *Sanctity Denied*, Abu Sitta, and Shehadeh).

It is a tragedy beyond the most despairing irony that Jews refer to the murder and destruction of the Jews in Europe as the Shoah, the Calamity; Arabs refer to the Israeli occupation of what they take to be their land, and to their treatment under the Israelis, as the Nakba, the Catastrophe. Two wrongs do not make a right: in this case they are creating a third calamity and catastrophe that may well turn out to be even more horrific than anything that has gone before.

The third disaster cannot possibly be averted except by those who, in their own distinct and different ways, have both been victims. Jews live in the name of God who "being compassionate forgives iniquity and does not destroy". Muslims live "in the name of God who is merciful, compassionate". The third disaster can only be turned away if those who have suffered so much can make a huge gift of generosity, far beyond any ordinary human power, to seek the good of those others who are also victims. Long ago the Psalmist encouraged us to pray for the peace of Jerusalem: "Pray for the peace of Jerusalem: may they prosper who love you" (Psalm 122.6). May that be our prayer and action now.

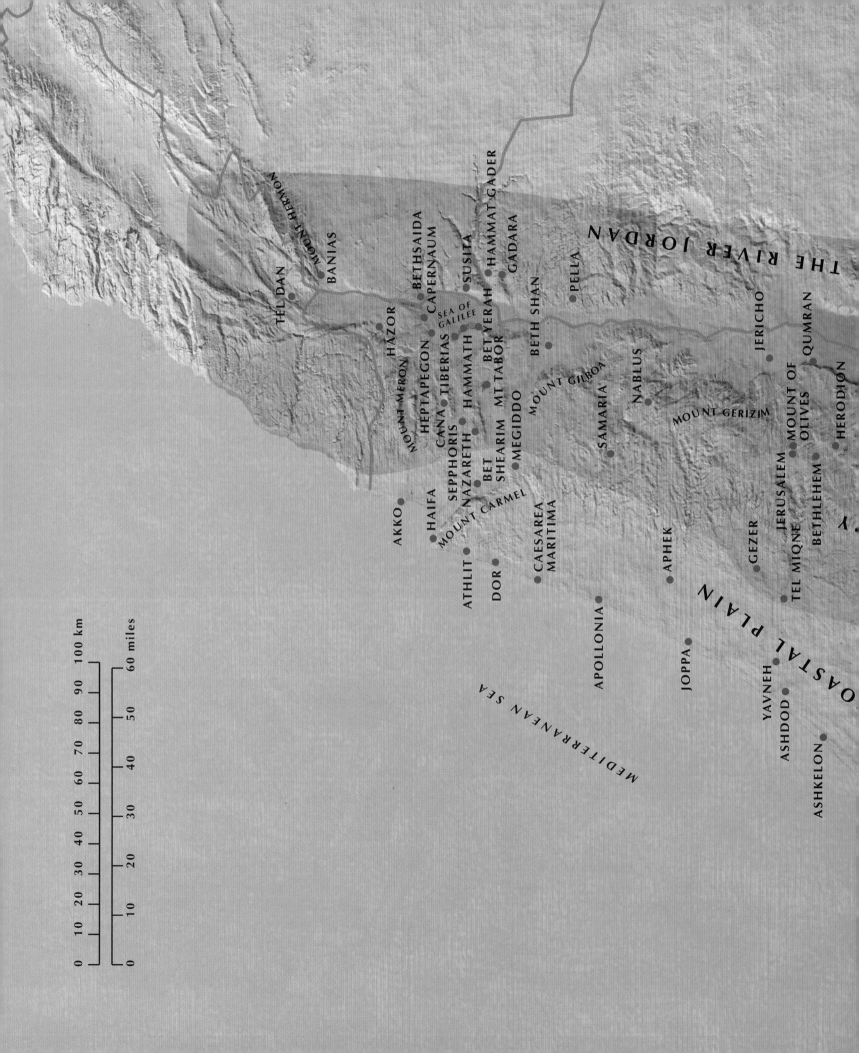

MOUNT HERMON

BANIAS

TEL DAN

HAZOR

MOUNT MERON

HEPTAPEGON

BETHSAIDA

CAPERNAUM

SUSITA

HAMMAT GADER

GADARA

SEA OF
GALILEE

CANA

TIBERIAS

HAMMATH

BET YERAH

SEPPHORIS

NAZARETH

BET
SHEARIM

MT TABOR

MEGIDDO

BETH SHAN

MOUNT GILBOA

PELLA

THE RIVER JORDAN

HAIFA

AKKO

MOUNT CARMEL

ATHLIT

DOR

CAESAREA
MARITIMA

SAMARIA

NABLUS

MOUNT GERIZIM

JERICHO

QUMRAN

MOUNT OF
OLIVES

HERODION

APHEK

GEZER

JERUSALEM

BETHLEHEM

TEL MIQNE

APOLLONIA

JOPPA

YAVNEH

ASHDOD

ASHKELON

COASTAL PLAIN

MEDITERRANEAN SEA

100 km
90
80
70
60
50
40
30
20
10
0

60 miles
50
40
30
20
10
0

THE PLAN OF THE BOOK

The land now known as Israel/Palestine is made up of three parallel strips of territory running from north to south. They are very different from each other:

The River Jordan The River Jordan rises in the mountains of south Lebanon and flows down part of the Rift Valley into the Dead Sea after passing through the Sea of Galilee.

The Hill Country This is the varied range of hilly and mountainous country which forms a kind of backbone down the centre, leading into the Negev desert.

The Coastal Plain This is the broad plain on the coast of the Mediterranean which is a natural land route between Egypt in the south and Asia Minor and Mesopotamia in the north and north-west.

According to tradition, the Israelites knew about these three kinds of territory even before they entered the Land. The book of Numbers tells how the Israelites, after the Exodus from Egypt, spent their time in the wilderness. While they were still there, Moses sent scouts ahead to find out what the land was like that God had promised to give them. The scouts came back with good and bad news: the land was very fertile, "flowing with milk and honey" but the many different people already living there were formidably strong. In this book we will follow in the steps of those early scouts and explore the Land in its three parts.

KEY

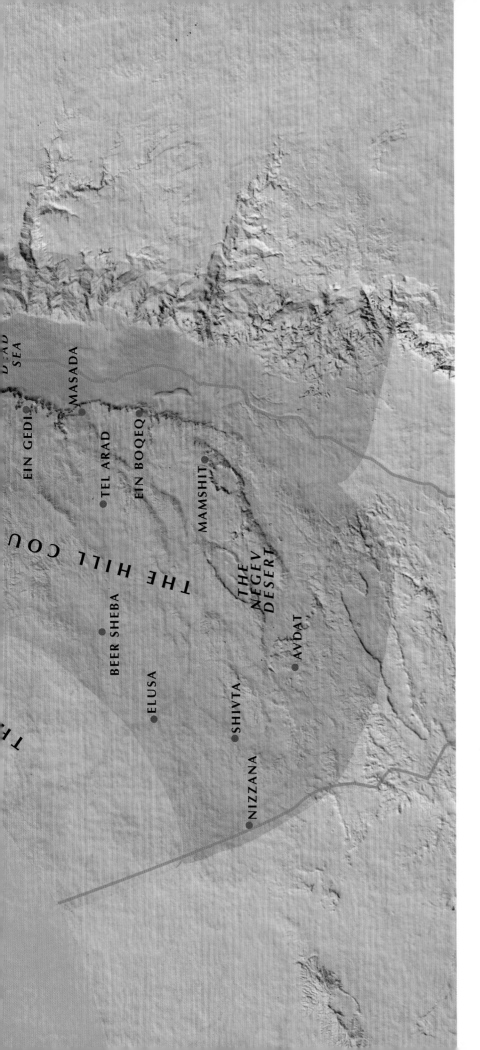

● Key site

◯ Town or city

• Place

⌒ Cave

▦ Fort

♛ Palace

⚑ Ruin or archaeological site

⚓ Port

✡ Synagogue, or Jewish site of importance

☪ Mosque, or Muslim site of importance

✜ Monastery, or Christian site of importance

🏰 Castle

◉ Spring or pool

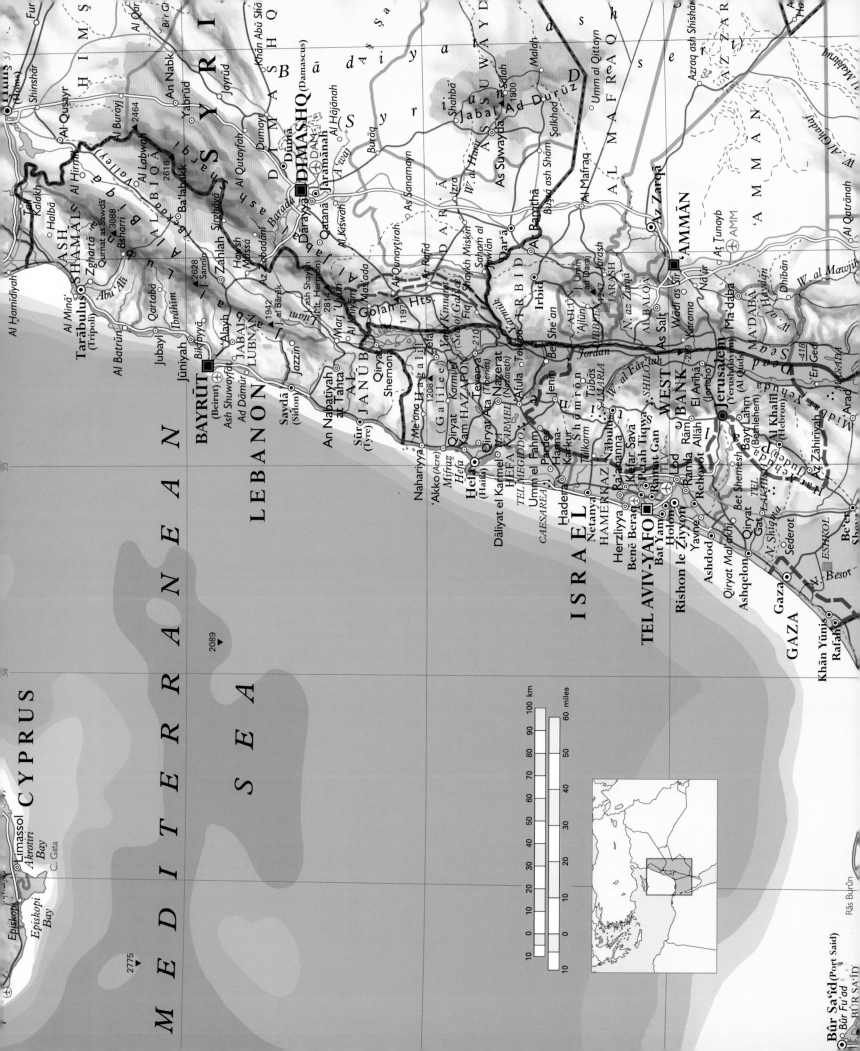

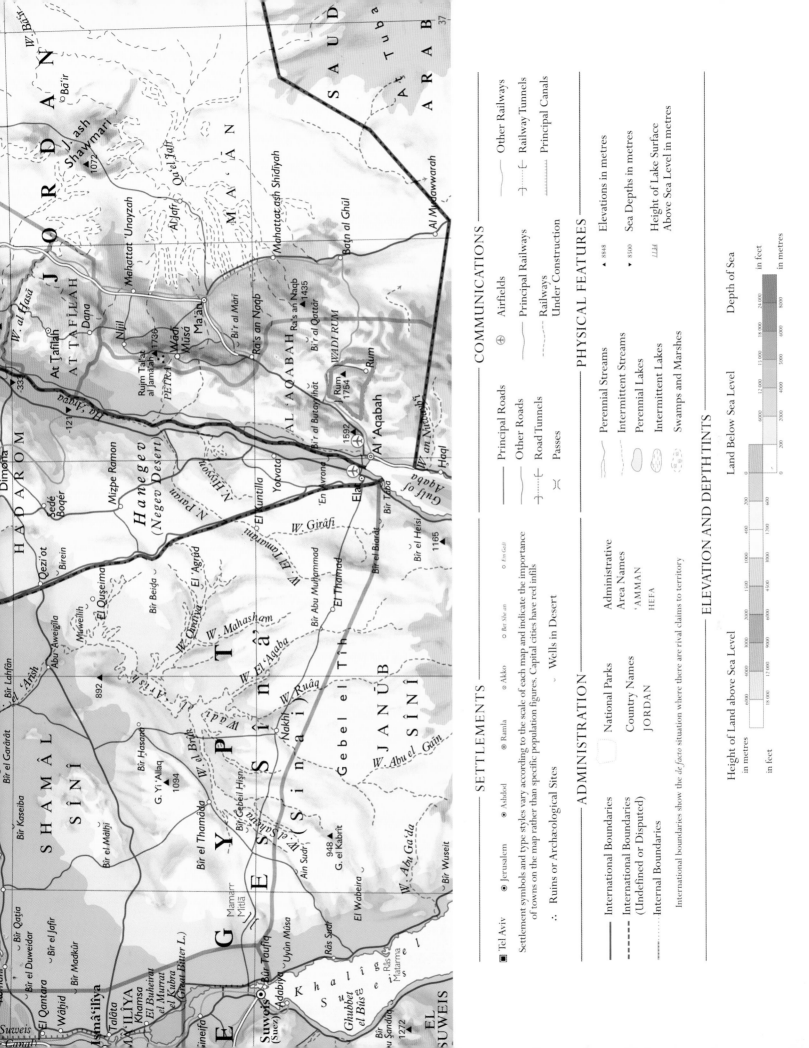

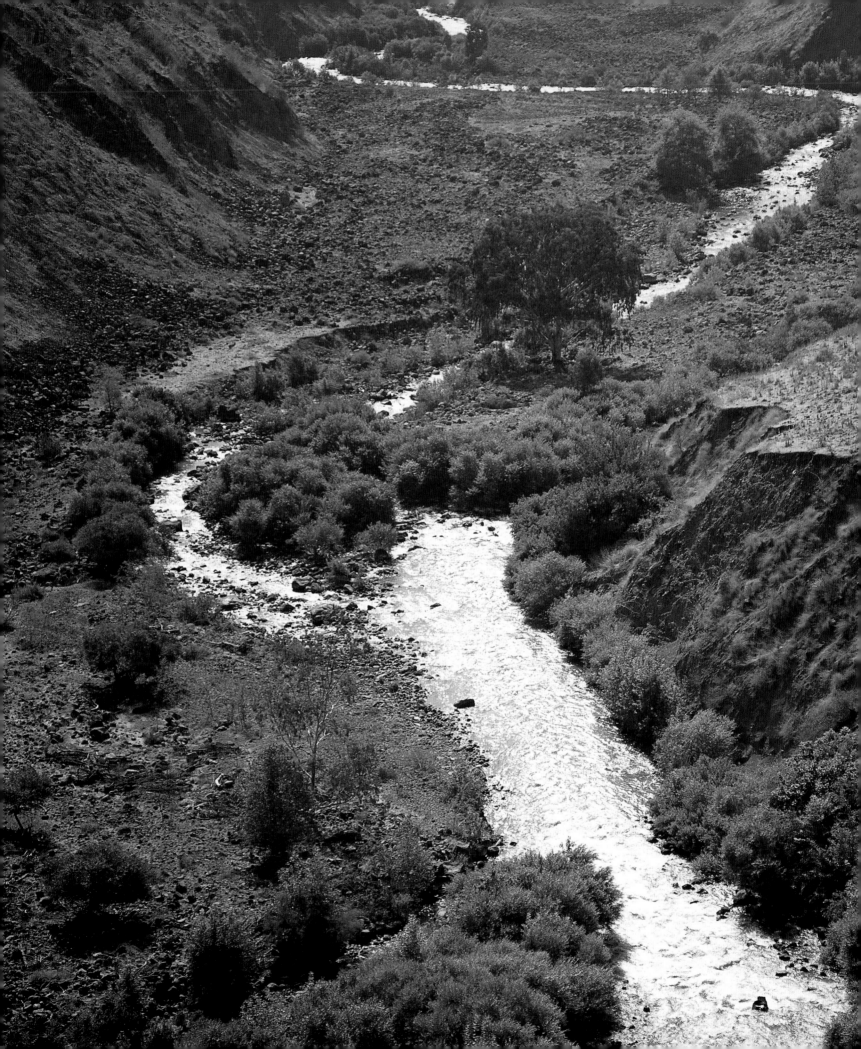

1 THE RIVER JORDAN

The River Jordan (Hebrew haYarden) flows along the
Rift Valley that separates Israel/Palestine and Jordan.
It runs from the mountains in south Lebanon,
through the Sea of Galilee and south to the Dead Sea,
forming a natural geographical boundary. It became,
therefore, the great eastern boundary of the
Promised Land. The actual crossing of the Jordan is
described in Joshua 3.13 as a miracle comparable
with the parting of the Sea during the Exodus.
"Crossing the Jordan" then became a widely-used
metaphor for the ordeal of 'crossing the river of
death', as in the African American "Deep River"
("Deep, deep river, my home is over Jordan, . . . that
promised land where all is peace") or in the Welsh
hymn "Guide me, O thou great Redeemer":

> When I tread the verge of Jordan,
> Bid my anxious fears subside;
> Death of death, and hell's destruction,
> Land me safe on Canaan's side.

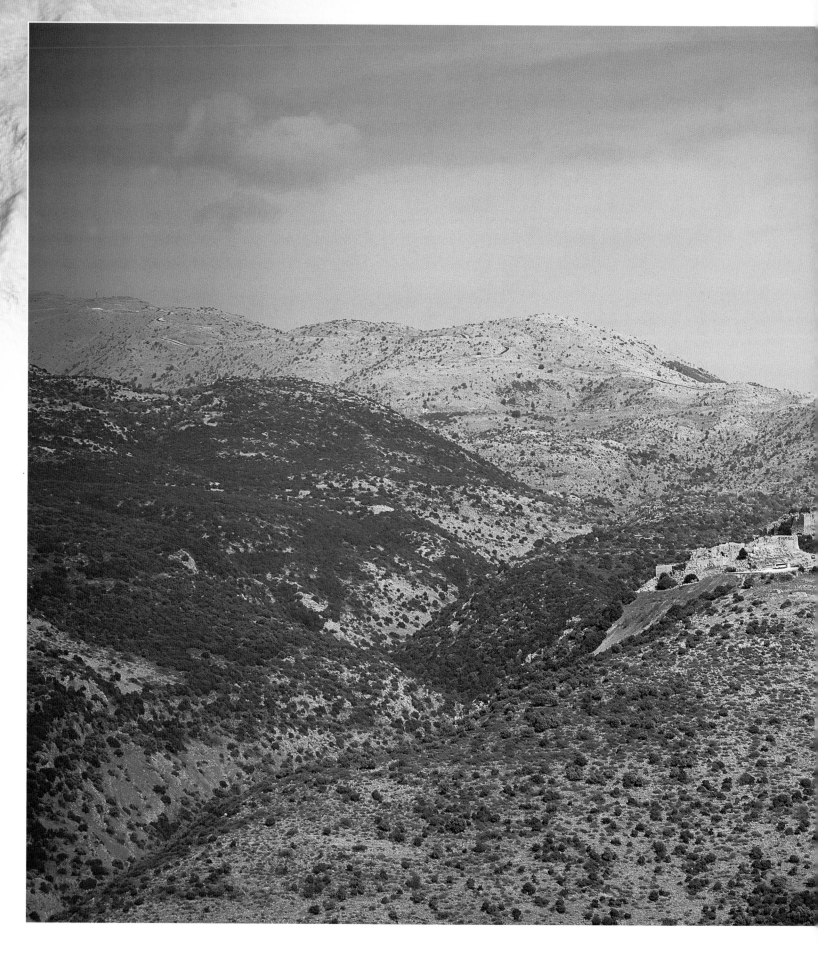

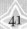

MOUNT HERMON AND BANIAS

CAESAREA PHILIPPI

LEFT Nimrud fortress may have been a Crusader foundation, but in its present form is a Muslim fort. It was constructed in the 13th century to defend the road to Damascus.

In every part of the world, mountains are revered as sacred places. As a kind of bridge from earth to heaven, mountains are places where the dawn of new light can first be seen, but where also volcanoes erupt with uncontrollable fury. In his book, *Sacred Mountains of the World*, Edwin Bernbaum wrote:

> As the highest and most dramatic features of the natural landscape, mountains have an extraordinary power to evoke the sacred. The ethereal rise of a ridge in mist, the glint of moonlight on an icy face, a flare of gold on a distant peak – such glimpses of transcendent beauty can reveal our world as a place of unimaginable mystery and splendour. In the fierce play of natural elements that swirl about their summits – thunder, lightning, wind, and clouds – mountains also embody powerful forces beyond our control, physical expressions of an awesome reality that can overwhelm us with feelings of wonder and fear. (page xiii)

That is certainly true for Jews, Christians, and Muslims, as their many sacred mountains make clear. In the Holy Land (and in this book) are Mount Hermon, Mount Carmel, Mount Gerizim, and Mount Tabor.

M ount Hermon (Hebrew "sacred" or "forbidden" mountain) is a three-peak summit about 30 miles north of the Sea of Galilee, close to Caesarea Philippi. It is over 9000 feet high, the highest part of the Lebanon mountain range. According to Deuteronomy 3.9, "the Sidonians call Hermon Sirion, while the Amorites call it Senir". All three names are used in the Bible (for example, Deuteronomy 4.48; 1 Chronicles 5.23).

The mountain seems to have been sacred to the Canaanites since it is associated with Baal, the Canaanite Lord God, in Judges 3.3 where the mountain is called Baal-hermon (cf. Baal-gad in Joshua 11.17). Mount Hermon was the northern limit of the conquests of Joshua.

In Mark 8.27, Jesus is said to have journeyed with his disciples "to the villages of Caesarea Philippi". Shortly after that ("six days later", 9.2), he went up to a high mountain to pray, and there the dazzling Transfiguration took place, when his clothes shone as white as snow

and a voice was heard from the clouds saying, "'This is my Son, the Beloved; listen to him!'" (9.7). Because this is the highest mountain near Caesarea Philippi, some have argued that Mount Hermon is the Mount of the Transfiguration. Since, however, the Gospels do not name the mountain, others have claimed that it is Mount Tabor (see pages 110–15) or even Mount Carmel (pages 238–42).

BANIAS (CAESAREA PHILIPPI)

Caesarea Philippi is a frontier town built on the southern slopes of Mount Hermon, close to one of the sources of the River Jordan.

When it is said that Jesus went "to the villages of Caesarea Philippi" (Mark 8.27; Matthew 16.13), it does not simply mean "villages in the area". It means more specifically "the villages under the jurisdiction of Caesarea Philippi". The point is fundamental in understanding the politics and local government of Palestine during the so-called Hellenistic period. This was the time from 315 BCE onward when the Seleucid ruler Antigonus first seized Palestine from Egyptian control. After this, possession of the land swung to and fro between the Greek Seleucids and the Egyptians, with the Seleucids ultimately prevailing. After the decisive victory in 200 BCE of Antiochus the Great over the Egyptian army commanded by Scopas, the whole of Palestine came under Seleucid control (see Introduction, page 14).

The Seleucids attempted to introduce Greek ways and customs into the territories under their control as a way of creating

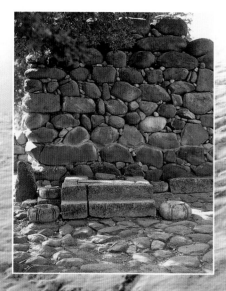

ABOVE This podium by the side of an Iron Age gateway at Tel Dan may have been the place where an idol or a ruler "sat". The custom of elders sitting beside city gates to settle disputes is mentioned a number of times in the Bible.

TEL DAN

BANIAS

RIGHT The River Banias, one of the four sources of the River Jordan (see page 45), emerges from springs at the foot of a limestone cave on Mount Hermon. These waterfalls, about two miles downstream, run through a park and nature reserve.

MOUNT HERMON

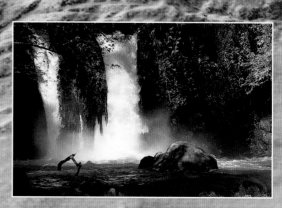

harmony throughout their empire. This is the process known as Hellenization, and it included the delegation of authority to city-states in a kind of "local government". Hellenism was much resented and resisted by orthodox and faithful Jews, because so much of it contradicted the laws in Torah. Eventually the resentment led to the Maccabean revolt (167–64, page 19), but in the far north, in Caesarea Philippi, that resentment was not important because the local population was largely non-Jewish, and Caesarea Philippi developed as a Hellenistic city with authority over the surrounding area.

Caesarea Philippi was known earlier as Panias, or, by a different pronunciation, Banias, its modern name. The Greek to *Paneion* means "the grotto dedicated to Pan". Pan was a Greek god of fertility who for that reason was portrayed with the horns, legs and ears of a goat. He was a god of the mountains, hills and fields who took delight in causing stampedes of cattle – and that is what produced eventually the English word "panic".

In 20 BCE Augustus ceded to Herod (the Great) the territory of Zenodorus which included Panias. Herod in gratitude dedicated to Augustus

a Temple of white marble near the head of the Jordan, in a place called Paneion, where there is a mountain rising very high into the air. At the side of it is an obscure valley, where there are high rocks that (by spouts of water falling on them) are made hollow, so that the water, standing in their concavity till they run over, falls down with a stream of such a depth that it has not yet been sounded. At the foot of this valley, on the outside, spring certain fountains which many think to be the head of the River Jordan. (Josephus, *War* 1.404–6).

Herod's son, Philip (the tetrarch of the area) then turned Panias into a splendid city calling it Kaisareia in honour of the Caesar Augustus. For that reason, the city came to be called Philip's Caesarea (Caesarea Philippi) in order to distinguish it from Caesarea on the coast (Caesarea Maritima, pages 226–31). Later, the name reverted to Panias and thence to the modern Banias.

It was while Jesus was working in the area that he challenged his disciples to tell him who they thought he was (Matthew 16.13–23; Mark 8.27–33; Luke 9.18–22). The challenge may seem at first sight strange, but the point was direct and simple. Jesus had been teaching and acting in ways that were so amazing that it seemed to many as though God himself was speaking and acting through him (see Introduction, page 25). But how could that possibly happen? In

BELOW Excavations at Banias, with the 3rd-century BCE grotto of Pan and rock-carved niches at the top left, beside the cave. The site includes two temples, a 1st-century palace, a bath house, and an 11th-century synagogue.

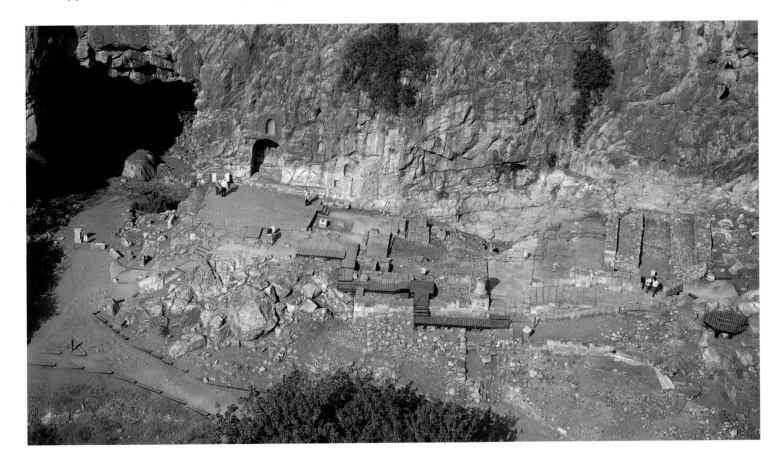

the past, it might have been through prophets like Elijah, or more recently like John the Baptist. Some people were saying exactly that, but what did his disciples think?

Peter said that it could only be because Jesus was the long-awaited Messiah restoring God's authority and power to the world. The response of Jesus was abrupt. He ordered his disciples not to speak about him in that way, and went on to say that it was as the Son of Man that he was doing and saying all these things.

"The Son of Man" was not a title of any kind. It was a Hebrew and Aramaic phrase (literally, "son of Adam") which comes from the Bible, where it has two meanings. In the Psalms and Job it means "everyone in the human condition", everyone, that is, who is born and who has to die – a mortal being: "O Lord, what are human beings that you regard them, or mortals that you think of them? They are like a breath; their days are like a passing shadow" (Psalm 144.3–4). Or again in Job 25.4–6:

> How can a mortal be righteous before God?
> How can one born of woman be pure?
> If even the moon is not bright
> and the stars are not pure in his sight,
> how much less a mortal, who is a maggot,
> and a son of man, who is a worm!

By using this phrase, Jesus was emphasizing that it was not as an extraordinary or special being that he was communicating the power and authority of God to the world; it was as a human being, as one therefore who has to die, that he was doing and saying all these amazing things. He was doing them as an ordinary human being who has to suffer and die like everyone else. The phrase is also used in exactly the same way in one of the Dead Sea Scrolls (see page 100).

There is, however, that other meaning of "the Son of Man" in the Bible, the very well-known one which allowed Jesus to speak, not just of a son of man (someone who has to die), but as the Son of Man, the one they all know about: this is the figure in Daniel 7.13 who represents those who keep faith with God, the Ancient of Days, even though they may suffer persecution and even martyrdom for their faith. After death they receive their reward:

> To him was given dominion
> and glory and kingship,
> that all peoples, nations, and languages
> should serve him.
> His dominion is an everlasting dominion
> that shall not pass away,
> and his kingship is one
> that shall never be destroyed (Daniel 7.14)

By using this phrase "the Son of Man", Jesus was claiming that God was indeed acting through him, but it was not through him as a special or exotic figure: it was as one who has to suffer and die, but who, he believed, will be rewarded after death.

TEL DAN (TEL AL-QADI)

The site of the Biblical Dan has been identified with Tel alQadi, "the mound of the judge". It is very near the headwaters of the River Jordan, and because it had an abundant supply of water it was settled at least as early as the Neolithic period (c.5000 BCE) and became a substantial city during the Early Bronze Age (3000 BCE). It was fortified from this time on with earth ramparts and stone-built strongholds.

The headwaters of the Jordan formed the northern limit of the early settlement of the kinship group, the Bene Jacob (the descendants of Israel/Jacob). The family of Dan had originally been allocated territory on the coast near Ekron, but that was a Philistine stronghold (page 182) and they could not hold it. They therefore migrated north and conquered a Canaanite stronghold called either Leshem (Joshua 19.47) or Laish (Judges 18.27; the name Laish appears in 19th-century Egyptian texts. The name was changed to Dan. The identification with Tel alQadi was confirmed by the discovery there of an inscription "To the god who is in Dan".

When the kingdom split after the death of Solomon (page 15), the Northern king, Jeroboam, felt that he could no longer allow anyone to go on pilgrimage to the Southern capital of Jerusalem. According to I Kings 12.25–29, he set up rival places of worship (it needs to be remembered, though, that this account was written in the South to paint the worst picture possible of the North):

> Then Jeroboam built Shechem in the hill country of Ephraim, and resided there; he went out from there and built Penuel. Then Jeroboam said to himself, "Now the kingdom may well revert to the house of David. If this people continues to go up to offer sacrifices in the house of the Lord at Jerusalem, the heart of this people will turn again to their master, King Rehoboam of Judah; they will kill me and return to King Rehoboam of Judah." So the king took counsel, and made two calves of gold. He said to the people, "You have gone up to Jerusalem long enough. Here are your gods, O Israel, who brought you up out of the land of Egypt." He set one in Bethel, and the other he put in Dan.

Dan and Bethel became the northern and southern limits of the Northern Kingdom, and Dan was heavily fortified. Much later, its importance was overshadowed by the building nearby of Caesarea Philippi.

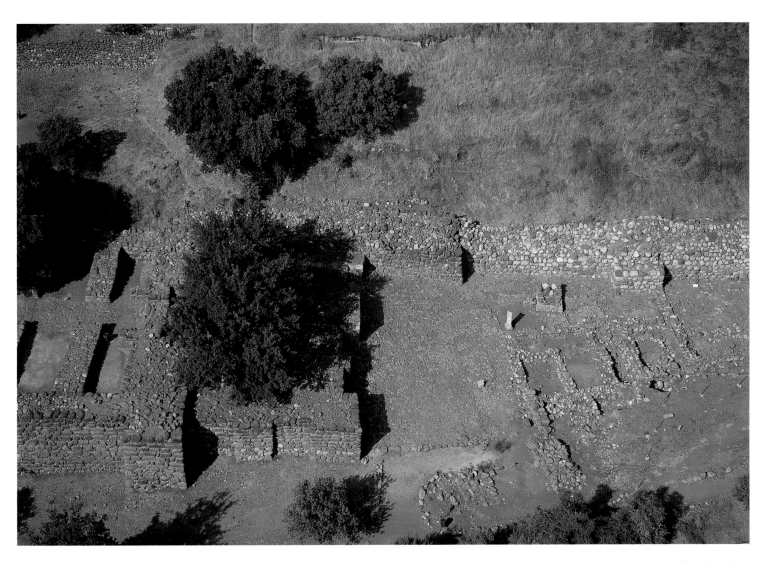

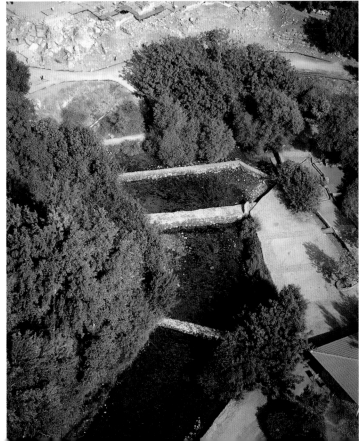

TOP The ruins at Tel Dan. The 10th-9th-century BCE city walls are 10 feet thick and would have been up to 40 feet high.

ABOVE A paved street at Tel Dan. Its width and condition suggests that it was a royal processional and ceremonial route.

RIGHT The easternmost source of the River Jordan, at Banias (see page 42).

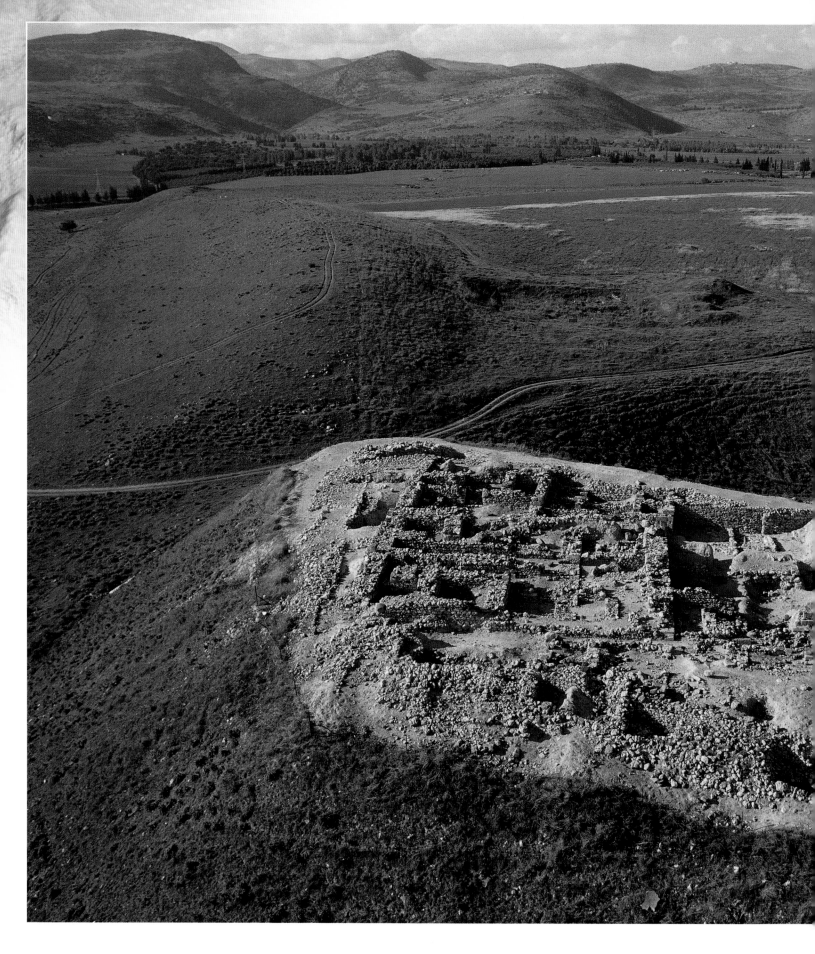

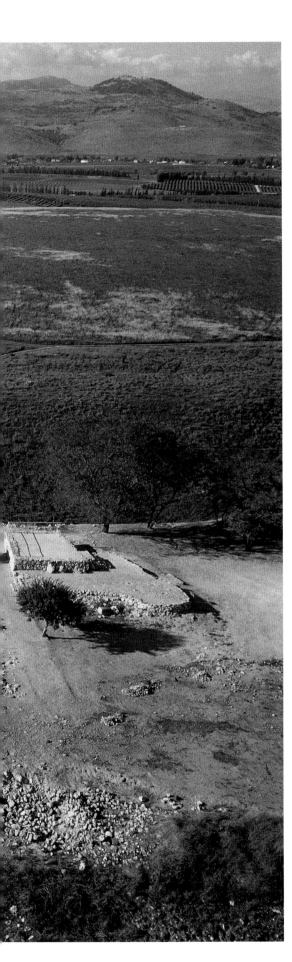

HAZOR

TEL AL-KEDAH

Hazor is in Upper Galilee about four miles south of Lake Huleh and 10 miles north of the Sea of Galilee. It is the largest Tel in Israel and archaeologists have found 22 strata of occupation on two different levels. The upper city was strongly fortified, and when the Assyrians were threatening their attack (page 16), the houses round the central stronghold were destroyed and a new defensive wall was built. In the lower city a large Temple had a central shrine not unlike the Holy of Holies in the Jerusalem Temple. Notable also in Hazor was the construction of an elaborate system of water supply and storage. Both Hazor and Dan (see page 44) were destroyed by the Assyrians in the 8th century.

LEFT Aerial view of the 30-acre upper city of Hazor, looking north. The city was strategically located on ancient trade routes from the north, east and west.

MEDITERRANEAN SEA

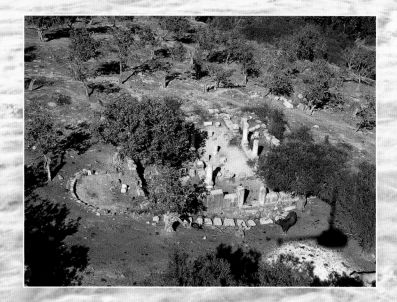

LEFT Gush Halav synagogue from
the south, showing the main
entrance facing Jerusalem. It was
constructed in the Roman period,
around 250 CE, as can be seen from
the surviving rows of columns.

TEL QEDESH

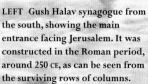 **BARAM**

 GUSH HALAV

 HAZOR

 MERON

KIRBET SHEMA

 BIRIA

MOUNT MERON

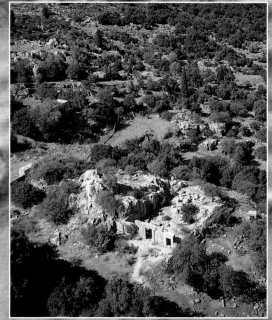

NAHAL AMMUD

LEFT Meroth synagogue
dates from the 3rd-4th
century CE. The scale of the
basalt main doorways, facing
Jerusalem, suggests that this
was the largest synagogue in
the Holy Land.

SEA OF GALI

azor was an important Canaanite city whose name means "enclosed" or "enclosure". It was built in two parts, an upper Tel and a lower plateau, both of which have been explored extensively by archaeologists. It was in a commanding position at the centre of trade routes into the north of Canaan, and the size of the town (more than 200 acres in extent) indicates its importance.

Its frequent mention in the Mari texts shows that from an early date there were close trading links, especially in tin, with Mesopotamia (Mari, present-day Tel alHariri, is the name of an ancient city on the Euphrates close to the modern frontier between Syria and Iraq; the many documents found there

come from a period before it was destroyed by the Babylonian Hammurabi in 1765 BCE). Hazor also appears frequently in Egyptian lists, and in the Tel elAmarna letters (on these see page 162) the ruler of Hazor is called "king"; in his own letters to Egypt, he expresses loyalty to the Pharaohs of Egypt.

Hazor was fortified by the Canaanites, and it was the centre of a defensive alliance of the Canaanites against the invading Israelites, under its king, Jabin: for the account in Joshua see box page 50.

A different account of the defeat of Jabin is given in Judges 4 which records the vivid episode in which Jabin's general Sisera is destroyed. It is followed in ch. 5 by the triumph Song of Deborah which mocks the families/clans of the kinship group, the Bene Israel, who failed to come to the battle (the memory of the names is slightly blurred in I Samuel 12.9–11):

BELOW Hazor Tel, with the upper city to the left and the 170-acre lower city to the right. Both were virtually abandoned after the 8th-century BCE Assyrian destruction.

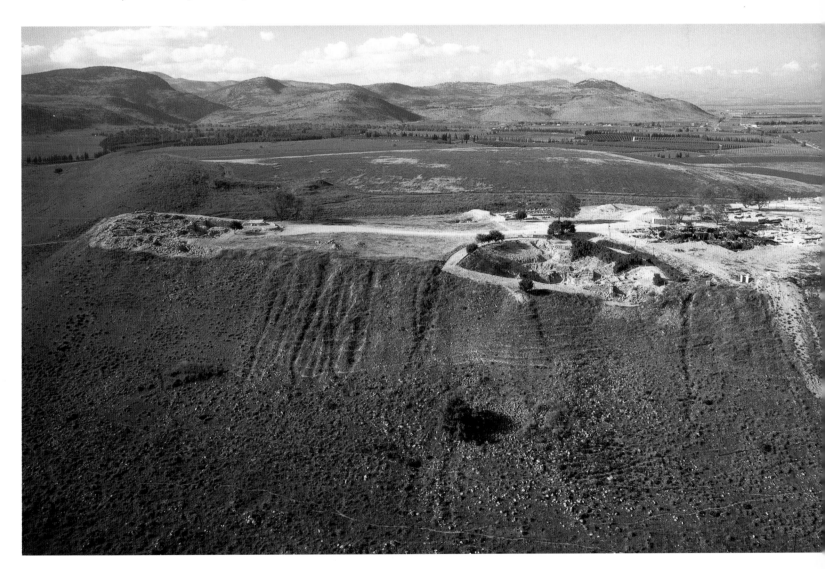

THE TAKING OF HAZOR

When King Jabin of Hazor heard of this [the many victories of Joshua], he sent to King Jobab of Madon, to the king of Shimron, to the king of Achshaph, and to the kings who were in the northern hill country, and in the Arabah south of Chinneroth, and in the lowland, and in Naphoth-dor on the west, to the Canaanites in the east and the west, the Amorites, the Hittites, the Perizzites, and the Jebusites in the hill country, and the Hivites under Hermon in the land of Mizpah. They came out, with all their troops, a great army, in number like the sand on the seashore, with very many horses and chariots. All these kings joined their forces, and came and camped together at the waters of Merom, to fight with Israel.

And the Lord said to Joshua, "Do not be afraid of them, for tomorrow at this time I will hand over all of them, slain, to Israel; you shall hamstring their horses, and burn their chariots with fire." So Joshua came suddenly upon them with all his fighting force, by the waters of Merom, and fell upon them. And the Lord handed them over to Israel, who attacked them and chased them as far as Great Sidon and Misrephoth-maim, and eastward as far as the valley of Mizpeh. They struck them down, until they had left no one remaining. And Joshua did to them as the Lord commanded him; he hamstrung their horses, and burned their chariots with fire.

Joshua turned back at that time, and took Hazor, and struck its king down with the sword. Before that time Hazor was the head of all those kingdoms. And they put to the sword all who were in it, utterly destroying them; there was no one left who breathed, and he burned Hazor with fire. (Joshua 11.1–11)

Among the clans of Reuben
there were great searchings of heart . . .
Gilead [Gad?] stayed beyond the Jordan;
and Dan, why did he abide with the ships?
Asher sat still at the coast of the sea,
settling down by his landings. . . .
Curse Meroz, says the angel of the Lord,
curse bitterly its inhabitants,
because they did not come to the help of the Lord,
to the help of the Lord against the mighty.
(Judges 5.15, 17, 23)

Solomon strengthened and fortified Hazor, repairing the elaborate system for the provision of water which had first been built in the 10th century BCE. Hazor was supplied with water from two springs which arise at the southern end of the Tel. A pier and tunnel of nearly 100 feet were cut through to a pool from which water was drawn. A monumental gate was built at the exit from the city to the pool. The Hazor tunnel is only one of several that have been found elsewhere. Other early examples are at Gezer (page 184) and Megiddo (page 234), and at Jerusalem itself.

Despite the fortifications, Hazor was captured by Tiglath-pileser III during the Assyrian invasion in the 8th century, and its people were carried into captivity (2 Kings 15.29). Excavations have revealed visible signs both of defensive improvisation at the time, and of its destruction. The Assyrians razed the city to the ground, and it did not recover.

———— ✳ ————

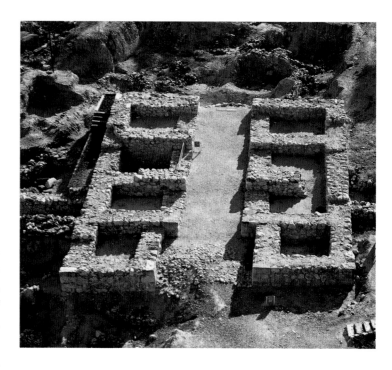

ABOVE The 10th-century BCE Gate at Hazor. It consisted of six chambers (guardrooms) protected by two towers. Similar gates from this period have been discovered at Megiddo and Gezer.

OPPOSITE TOP LEFT The 10th-century BCE rock-cut water shaft at Hazor. It connects with a sloping tunnel that goes down to the natural water level about 100 feet below ground, thus guaranteeing supply in siege time.

OPPOSITE TOP RIGHT Tel Qedesh 2nd-3rd century CE Roman temple, six miles north-west of Hazor. It lies to the east of the ancient 20–25 acre Canaanite Tel.

OPPOSITE BOTTOM Baram 4th-century CE synagogue is set high up in the mountains, close to the Lebanese border. This view from the south shows the portico in front of the main entrance. The columns in the prayer hall would have supported the second floor and the roof.

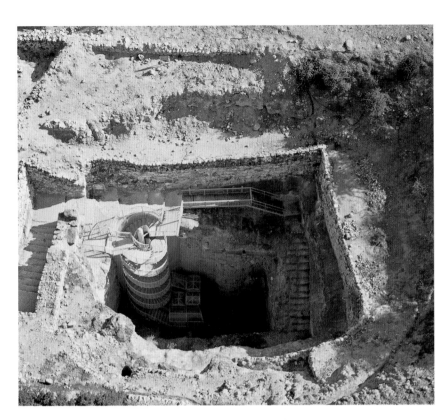

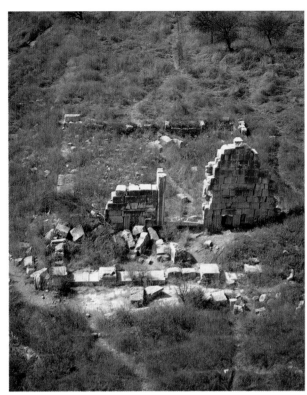

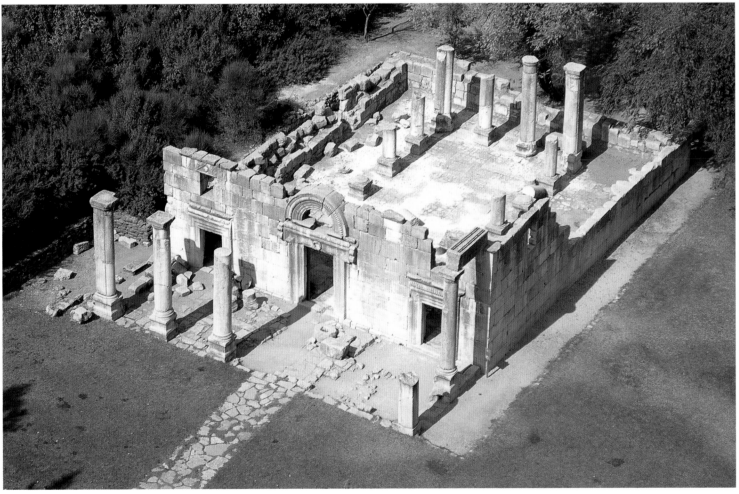

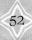

LEFT Fishermen on the Sea of Galilee, in the early morning. The calm can be deceptive. The lake's position, surrounded by hills, makes it liable to sudden storms, now as in biblical times.

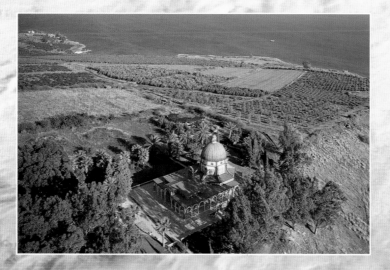

ABOVE The Church of the Sermon on the Mount, built in 1938. Designed by the Italian architect, Antonio Barluzzi, its octagonal shape symbolizes the eight Beatitiudes.

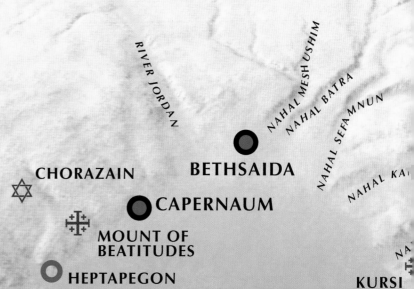

RIVER JORDAN

NAHAL MESH USHIM

NAHAL BATRA

NAHAL SEFAMNUN

NAHAL KA...

NAHAL KA...

CHORAZAIN

BETHSAIDA

CAPERNAUM

MOUNT OF BEATITUDES

HEPTAPEGON

KURSI

AMUD CAVE

GINNOSAR

NAHAL ZALMON

MAGDALA

SEA OF GALILEE

ARBEL PASS

TIBERIAS

HAMMATH

MOUNT BERENICE

BELOW The walls of modern Tiberias, the new city built to the north of the old after the 11th-century CE earthquake.

BELOW A fisherman catches two "St Peter's" fish as he casts his net on the Sea of Galilee in age-old fashion.

BET YERA

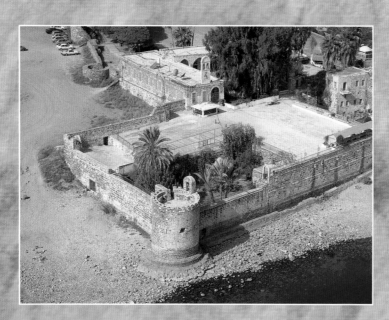

RIVER JORDAN

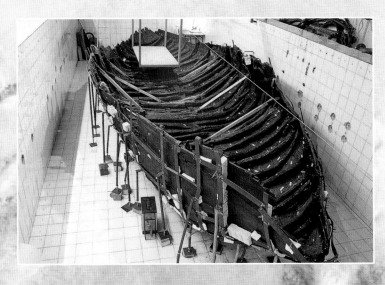

ABOVE The "Jesus boat" in the Yigal Allon Museum. It is 25 feet long, seven and a half feet wide and would have had a crew of five, with room for 15 passengers.

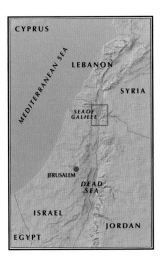

The Sea of Galilee has been known by many different names at different times, among them: the Sea of Chinnereth (also Chinneroth, Kinneret, perhaps from its shape which resembles a harp, Hebrew *kinnor*), Sea of Tiberias; Lake/Waters of Gennesar/Gennesarat; and sometimes simply as the Lake or the Sea. It is about 40,000 acres in extent, being 13 miles long and about 8½ miles wide at its furthest width.

There are seven major periods of occupation: pre-historic; pre-Israelite settlement, especially Canaanite; Israelite (falling at times to outside invaders like the Assyrians); Hellenistic (including outside invaders like the Greeks and Egyptians); Roman; Byzantine; and Muslim. All of these have left their mark on the area, and many of them overlap on the same site. In recent years, the most obvious consequence for the Sea of Galilee has been major water extraction at the north end from the River Jordan.

THE SEA OF GALILEE, NORTH

BETHSAIDA

The Jordan enters the Sea of Galilee in the north near a town (and at times a city) called Bethsaida. The name means "the house of the fisherman", a reminder of the massive importance of fish and fishing in the Sea, not just as food, but also as an industry — a good account of this is given by M. Nun (see Bibliography).

There were many inlets strung like a necklace around the Sea harbouring small boats. A general indication of their size is given by Josephus (*War* II.635) when he records how John of Gischala gathered a fleet in order to support the rebellion of Tiberias during the 1st Jewish Revolt (66–70): "Then taking all the boats that were in the lake, in number 230, and in every one of them four sailors, he speedily sailed to Tiberias." The remains of boats have been found around the Sea — three from the 1st century CE, for example, about 1 mile north of Magdala. The best-known and best-preserved example was discovered also in 1986 on the eastern shore. It was moved to the Yigal Allon Museum near present-day Kibbutz Ginosar, where it is now on exhibition. It comes from a time between the 1st century BCE and the 1st century CE. It has been called "the Jesus boat", although it has no

MAKH

SUSITA

HAMMAT GADER

GADARA

NAHAL YARMUK

WADI ARAB

proven connection with Jesus; on the other hand, the name draws attention to the rarity of finding any artefact of this kind from so early a date.

It was from fishermen around the Sea that Jesus called some of his close disciples, the so-called Twelve: Simon, Andrew, James and John (Mark 1.16–20; Matthew 4.18–22; Luke 5.1–11), and Philip and Nathaniel (John 1.43–51, where it is said that Bethsaida was Philip's home).

Bethsaida has a long and ancient history, but the exact site of Bethsaida has not until recently been clear. Three sites have been proposed. The first is the ruin close to the shore known as Khirbet alMes'adiye, mainly on the grounds that the name contains the letters of Saida. Far more likely is the second possibility which was first claimed in 1838 by Edward Robinson. He identified as Bethsaida a mound further inland which had no name: it is thus known simply as atTel/etTell which means "the mound". It is not particularly high (about 80 feet), but it is prominent in the area, and it is therefore a good defensive position.

This identification was challenged by Gotlieb Schumacher at the end of the 19th-century, who pointed out that atTel is 1½ miles from the shore of the Sea and nearly half a mile from the Jordan – a strange site for a place called "the house of the fisherman". He therefore proposed the third possibility, a ruin nearer the shore called alAraj. His views seem to be supported by the first excavations at atTel, of which the report said "The ruins cover a great part of the tel. They are most extensive, but consist, as far as one can see, only of unhewn volcanic rock without any clear sign of ancient architecture."

The debate has now been transformed by the excavations of atTel begun in 1987, because these have demonstrated that alAraj is not earlier than the Byzantine period, and that the unencouraging earliest reports from atTel were premature: archaeology there has revealed a complex town, then city, going back to the Iron Age. To the question why it is so far from the Jordan and the Sea, the answer given by Shroder and Inbar (in Arav and Freund, *Bethsaida*) is that the course of the river and the shoreline itself have changed. And in fact one of the houses excavated has been called "The Fisherman's House" because so many items connected with fishing were found there, including a fish hook which was still only half made.

The long history of Bethsaida began in the Iron Age (10th century BCE) when strong fortifications were built like those at Hazor, Dan, and Megiddo. The Assyrian invasion in 734 BCE conquered the area and destroyed Bethsaida. It did not recover until the expansion of trade during the Hellenistic period, when the population was mainly non-Jewish – and many Seleucid coins have been found on the site.

The Hasmonean expansion of their territory included the conquest of Galilee and the surrounding area by Alexander Jannaeus (84–83 BCE). Bethsaida became Jewish once more, but it remained Hellenistic. Thus Philip and Andrew, two of the disciples of Jesus from this area, have Greek names with no Hebrew or Aramaic equivalent, and both spoke Greek (John 12.20–21). It was still a small fishing village, but according to Josephus, Philip, the son of Herod the Great, transformed the village into a city, making it a formal Greek *polis*, "city", and he called it Bethsaida-Julias. Josephus (*Antiquities* 18.28) says that this was in honour of the daughter of the emperor Augustus, but it is far more likely to have been in honour of his wife, Livia/Julia, who was also the mother of his successor, Tiberius. The city was destroyed in the 1st Jewish Revolt.

BETHSAIDA IN THE MINISTRY OF JESUS

Jesus worked in the area of Bethsaida, performing many of his healing acts: see, for example, Mark 8.22-5: Jesus put saliva on the eyes of a blind man and laid his hands on him, and the blind man cried out in amazement, "I can see people, but they look like trees walking!". In addition to the call of some of his disciples (see above), it was to Bethsaida that he set out after the feeding of the 5000: "Immediately he made his disciples get into the boat and go on ahead to the other side, to Bethsaida, while he dismissed the crowd" (Mark 6.45). It was on this occasion that the storm blew up and that Jesus made the wind cease. According to Luke, however, the feeding of the 5000 took place at Bethsaida itself: "On their return [from a mission on which Jesus had sent them] the apostles told Jesus all they had done. He took them with him and withdrew privately to a city called Bethsaida" (Luke 9.10), where the feeding then took place.

Despite the impressive works of Jesus and of his disciples, the people of Bethsaida remained unimpressed, and Jesus linked three cities in the area in condemnation:

Woe to you, Chorazin! Woe to you, Bethsaida! For if the deeds of power done in you had been done in Tyre and Sidon, they would have repented long ago, sitting in sackcloth and ashes. But at the judgment it will be more tolerable for Tyre and Sidon than for you. And you, Capernaum, will you be exalted to heaven? No, you will be brought down to Hades. (Luke 10.13–15; cf. Matthew 11.21–24)

KURSI
See page 89.

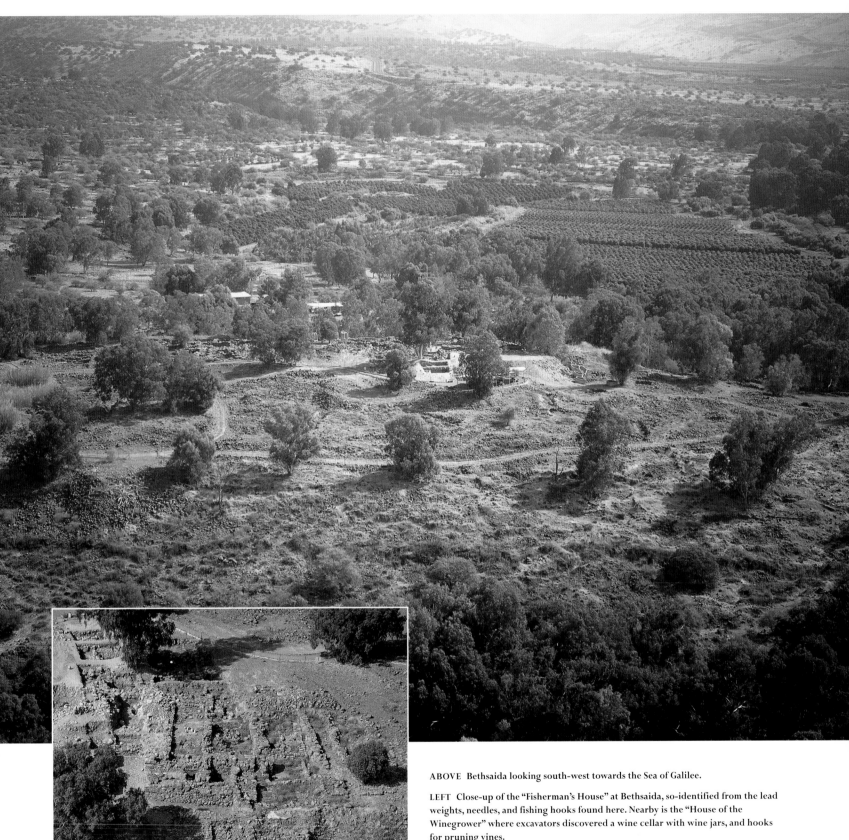

ABOVE Bethsaida looking south-west towards the Sea of Galilee.

LEFT Close-up of the "Fisherman's House" at Bethsaida, so-identified from the lead weights, needles, and fishing hooks found here. Nearby is the "House of the Winegrower" where excavators discovered a wine cellar with wine jars, and hooks for pruning vines.

THE SEA OF GALILEE, SOUTH

SUSITA (HIPPOS)

Susita is a Greek city on a high promontory overlooking the Sea of Galilee. Its name is derived from the Aramaic *susita*, "a horse", hence the Greek name Hippos. The Arabic name is Kalat alHusn. It was founded during the Hellenistic period, but it became part of the Hasmonean empire when it was captured by Alexander Jannaeus. It was set free from Jewish control by Pompey during his invasion in 63 BCE, and in 30 BCE it was given by Augustus to Herod. At this stage it had its own harbour, and it was one of the cities of the Decapolis: the Decapolis was a group of 10 Hellenistic cities to the east of Samaria through which the Romans hoped to extend their influence and control; Pliny the Elder listed them as Damascus, Philadelphia, Raphana, Scythopolis, Gadara, Hippos, Dion, Pella, Gerasa, and Canatha. During the 1st Jewish Revolt, the Jews made an unsuccessful attempt to capture the city from its Greek inhabitants. During the Byzantine period, it was the seat of a bishop, but it was captured by the Arabs in 635 CE without a fight. Not long afterwards the site was abandoned.

HAMMAT GADER

South of the Sea of Galilee, the River Yarmuk joins the Jordan. Close to the confluence the Romans built spectacular baths at Hammat Gader which attracted people from as far away as Athens and Rome. They were taking advantage of the natural hot springs. However, the baths were largely destroyed by earthquakes at the end of the Byzantine period, though the remains can still be seen.

They were repaired in the 7th century by a Muslim caliph Muawiyya I (661–80) – by a Muslim, because it was near here in 636 that the major and decisive battle took place which drove the Byzantines out of Syria.

The first Arab (and Muslim) raids into the Holy Land had begun even during Muhammad's life-time (see page 31). Success led to the raids becoming more extensive, and after early setbacks the Byzantine emperor Heraclius decided to clear the Land and make it safe for the empire. He sent an army of 50,000 men under his brother Theodore to drive the Arabs out. The two armies met near the junction of the rivers Yarmuk and arRuqqad. The Byzantines were driven down into the valley and the river, and there they were slaughtered.

This was the decisive battle that secured Syria and the Holy Land for the Muslims. When Heraclius heard the news, he lamented, "Farewell, Syria, what a fine country you are for the enemy!"

GADARA (UMM QEIS)

Gadara lies about six miles south-east of Hippos. It was one of the cities of the Decapolis (see left) and seems to have had only a small Jewish population. It was for a time a popular centre for Greek poets and philosophers. One of them, Meleager of Gadara (1st century BCE), who called Gadara "Athens in Syria", actually mentions the Jewish sabbath: "If your love is a keeper of the sabbath, no surprises: not even love burns hot on cold sabbaths." Jesus is reported to have ministered in the area of the Decapolis (Matthew 4.25; Mark 7.31), and to have healed here a man possessed by an unclean spirit (Mark 5.1–10): when the unclean spirits left the man, they were sent instead into a herd of swine who rushed down the cliff into the sea – hence the expression, rushing like the Gadarene swine. However, there is great uncertainty in the manuscripts about the name of the place where this happened: some say "the country of the Gerasenes" (but that, modern Jerash, is more than 30 miles from the Sea); others have Gergesenes, others have Gadarenes (though Gadara itself is some distance from the Sea). The site has even been claimed for Kursi (pages 54 and 89).

BETH YERAH (KHIRBET AL-KERAK)

Beth Yerah lies at the southern end of the Sea of Galilee between the two points, ancient and modern, where the River Jordan flows out toward the Dead Sea. It is thought also to be the city built by the Egyptian Ptolemy II called Philoteria, and perhaps the town called by Josephus Sennaberis which he described as the northern limit of the Jordan Valley and the place where the Roman general Vespasian (later emperor) camped not far from Tiberias (*War* 3.447). Human settlement goes back to the Early Bronze Age, and it became a strongly fortified town. After a period when it seems to have been abandoned, it was rebuilt during the Hellenistic period. Excavations have revealed a Roman bath and a synagogue from which mosaics have survived. During the Byzantine period, a church was built, and although it was destroyed during the Arab conquest, houses were built on the ruins during the early Islamic period.

HAMMATH (HAMTHA)

Hammath is also known as Hammat Tiberias because it is only just south of Tiberias. It was a fortified town that became known in Roman and Byzantine times as Hamtha because of its "hot springs"; in its Greek form it appears as Ammatous. It was renowned for its

OPPOSITE The road to Susita winds up a steep-sided hillside 1150 feet above the Sea of Galilee. The surrounding gorges form a natural defence.

OPPOSITE INSET On the flat, diamond shaped summit of the hill of Susita are archaeological remains dating from Jewish, Roman, and Byzantine times.

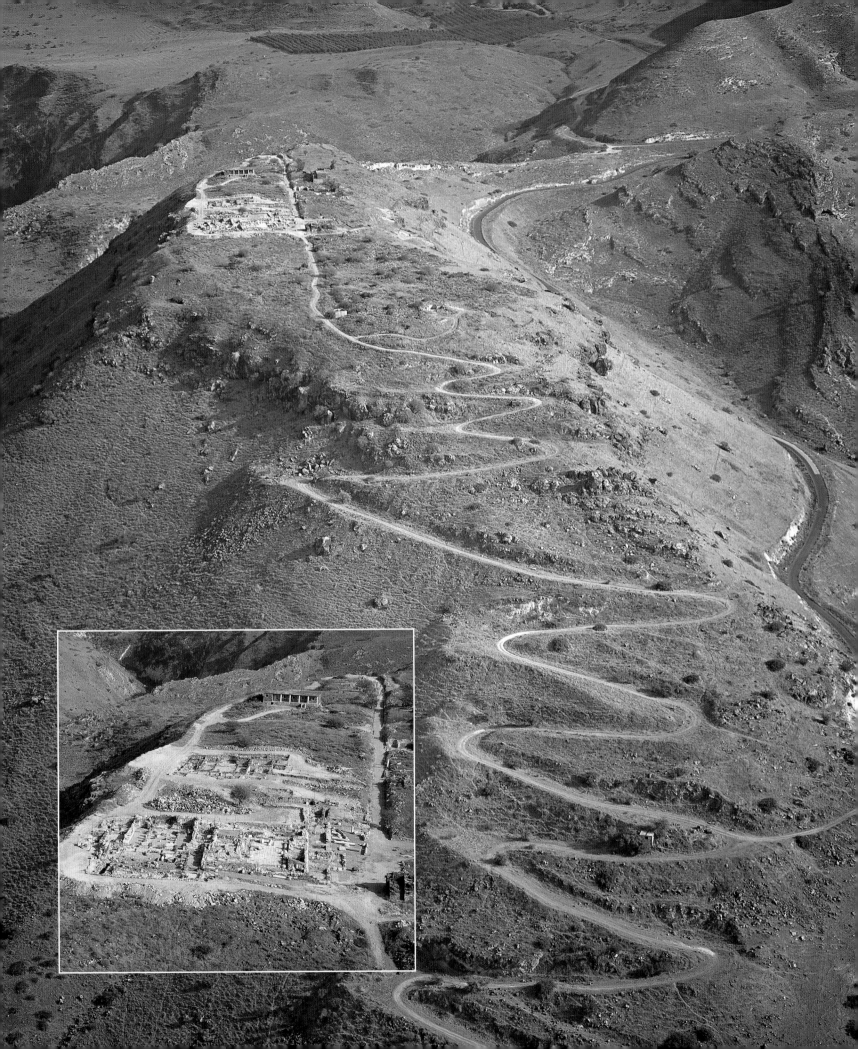

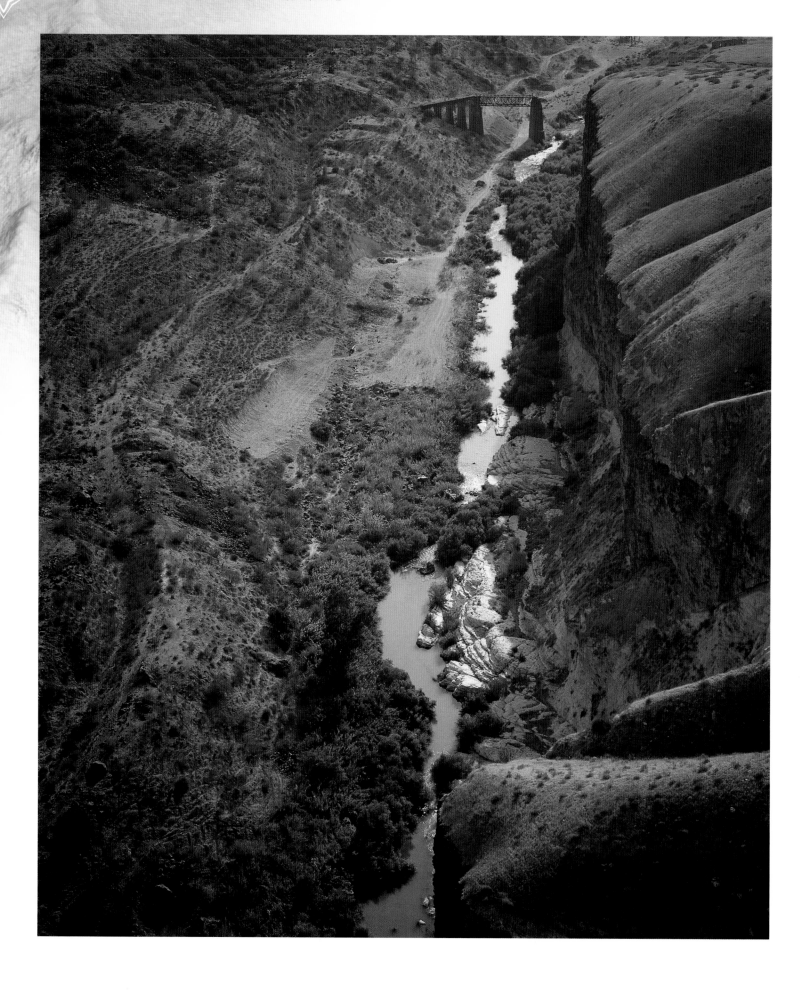

health-giving properties (see, for example, Josephus, *Life* 85) as it still is to the present day. Its closeness to Tiberias was important in the 3rd century CE when both became a major centre of Jewish learning. Excavations have revealed two substantial synagogues, at least one of which still continued in use after the Muslim conquest.

TIBERIAS

Tiberias was founded by Herod Antipas in about 20 CE in honour of his friend, the emperor Tiberius: "But Herod the tetrarch being entertained into Tiberius's friendship, built a city in honour of his name and called it Tiberias. He planted it in the most fruitful part of Galilee, hard by the lake Gennesaritis, and near to the natural baths in the village called Ammathus [ie, Hammath]" (Josephus, *Antiquities* 18.36). It was built as a straightforward Roman city with well-planned streets intersecting at right angles with each other, and with many public buildings including a stadium on the seashore

OPPOSITE The Yarmuk River valley near Hammat Gader. The Yarmuk is the largest eastern tributary of the River Jordan, which it enters about four miles south of the Sea of Galilee.

BELOW The Roman baths at Hammat Gader. The complex includes hot and cold rooms and several pools. The hottest springs can reach a temperature of 125°F.

and a large synagogue. Herod also built his own retreat on a high hill where he espoused Greek art, including the setting up of statues which provoked the opposition of orthodox Jews. Josephus was actually commissioned by Jewish leaders in Sepphoris "to pursue the destruction of the palace built by Herod the tetrarch since it contained shapes of living animals, such a way of building being forbidden by the laws" (*Life* 65). Tiberias was the capital city of Galilee until Nero separated it from the surrounding area and gave it to Agrippa II in 61 CE. As a result, during the 1st Jewish Revolt the people were anti-Roman, but the leaders remained loyal to Agrippa and the Romans, so that when the city surrendered to Vespasian, he did not destroy it. After the 2nd Jewish Revolt (the Bar Kokhba Revolt, 132–5), the Roman character of the city was emphasized, but it nevertheless became gradually a major centre of Jewish learning. In Hakkam Rabbi Street are the tombs of some of the greatest Jewish teachers, including Johanan ben Zakkai (1st century CE) and Maimonides (12th century).

The development of Jewish learning in Tiberias was led by Rabbi Johanan ben Nappaha (180–279), the pupil of Rabbi Judah haNasi whose great work at Sepphoris he continued. Where Judah haNasi had made the crucial start in gathering the Mishnah, Rabbi Johanan began the process of further commentary and organisation that led

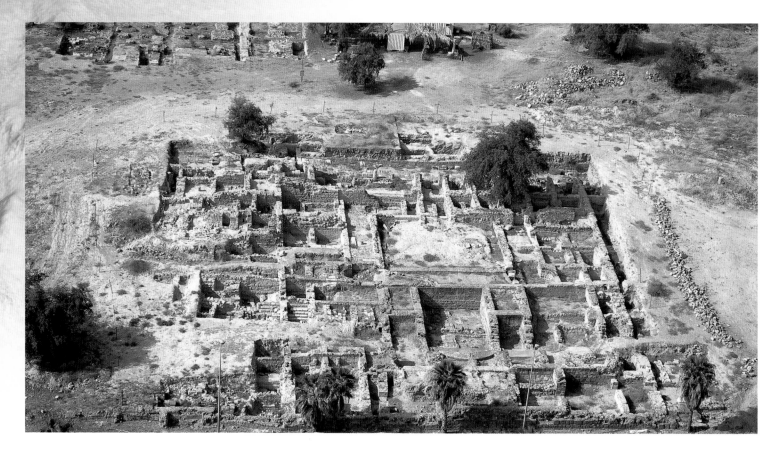

first to the Palestinian, then eventually to the Babylonian Talmud (on the meaning of these terms and their importance, see Sepphoris, page 120). The buildings of Jerusalem and the Temple had gone, but the building of Judaism had begun.

MOUNT BERENICE (QASR BINT AL-MALIK)

Dominating ancient Tiberias is Mount Berenice, whose Arabic name is Qasr Bint alMalik, the palace of the daughter of the king. This name originated from the belief that this was the site of the palace of Berenice, the daughter of Agrippa I who, after the death of her second husband, lived with her brother Agrippa II (Acts 25.13). Since Josephus had reported that the roof was made partly of gold (*Life* 66), the first excavators hoped that they might find rich spoils. All they found, however, were the remains of a Christian church.

Tiberias remained an important Muslim city, and excavations in 1998 revealed part of a street with a drain beneath it, and several houses from the Abbasid period. Beneath one of them a vast hoard of bronze artefacts was found including lamps and jewellery.

————————— ✳ —————————

TOP Remains of a pillared building adjacent to the Byzantine-era bathhouse. The building was previously believed to be a covered market, but has recently been identified as the possible remains of the Friday mosque from the early Islamic period, 7–11th century.

RIGHT The Anchor Church on Mount Berenice, overlooking the Sea of Galilee. The church, which was destroyed in the 12th century, is named after the anchor inscribed on a basalt stone found under the altar.

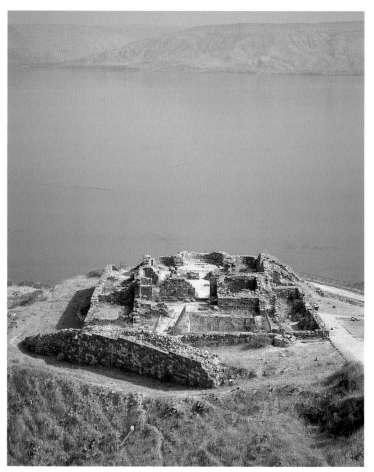

THE SEA OF GALILEE, NORTH–WEST

MAGDALA (TARICHEAE/MIGDAL NUNAYAH)

About three miles north of Tiberias is another prosperous city which, from the start, had two names, a Semitic and a Greek: Magdala is an abbreviation of *migdal nunayah*, "the tower of the fish/fishermen"; the Greek *tarichos* means "salted/dried fish".

The names indicate that Magdala's prosperity was based on the Sea, but it did not depend on that alone: it was on an important trade route coming from the coast and linking up with a road down the Jordan Valley. Fishing, nevertheless, was important, and surveys have shown the remains underwater of a harbour and jetty of considerable size, with the remains of what may have been a lighthouse – possibly the tower (*migdal*) that gave the town its name.

The date of the city's foundation is not known. It was certainly flourishing during the 1st century BCE, and Cassius plundered it in 53 BCE during his short-lived attempt to establish a power base in Galilee (for this see page 22). The city, however, soon recovered to become an extensive Hellenistic and Roman centre. Nero gave Tiberias, Julias, and Magdala to Agrippa I, and the links with Rome meant that few were enthusiastic supporters of the 1st Jewish Revolt. One of the rebels nevertheless made Magdala his base, and one of the few major battles on the Sea of Galilee took place just off the coast. After victory, Vespasian did not destroy Magdala but simply sold the rebels into slavery.

It is likely that "Mary, called Magdalene, from whom seven demons had gone out" (Luke 8.3) who, according to John 20.1, was the first witness that the resurrection had happened, came from Magdala, hence her name; but the name Magdala is very insecure in the manuscripts of Matthew 15.39 and Mark 8.10, where the major manuscripts have "the district of Dalmanutha".

THE GALILEAN CAVES (AMUD AND ARBELA)

Fresh water and the consequently fertile land mean that the hills around the Sea have caves in which traces of very early human

BELOW The 1st-4th century CE ruins at Magdala. The courtyard mosaics found here indicate the city's prosperity. The pickled fish of Galilee were known throughout the Roman and Greek world. Large quantities were taken up to Jerusalem at festival time and barrels were transported around the Mediterranean.

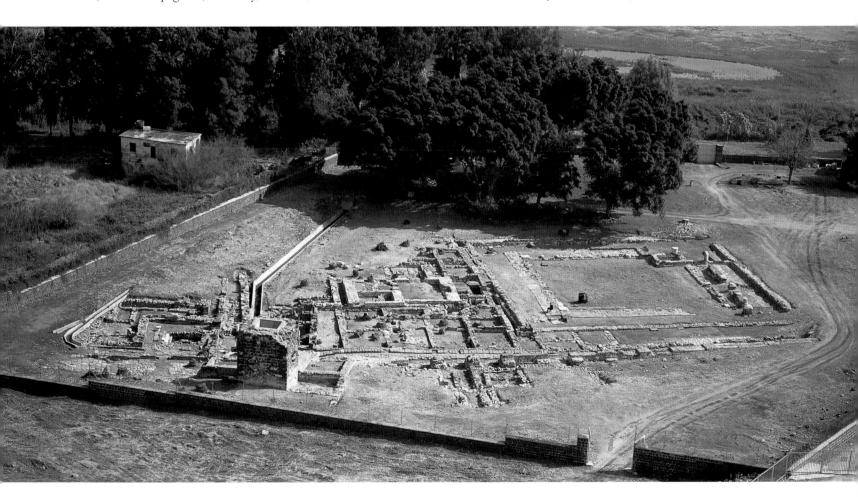

habitation have been found. The Plain of Ginnosar to the north of Tiberias is divided into three parts by two streams, Nahal Amud and Nahal Zalmon. The Caves of Amud (Mearat Amira) are three prehistoric caves, of which one, the Zuttiyeh cave, produced a skull fragment from the Palaeolithic period, while in the Amud cave was found an almost complete skeleton of an adult Neanderthal man from the same period.

As at Qumran, so here: the caves had many uses. For example, in the plain at Arbel/Arbela several battles were fought and the caves of Arbel were a last refuge for those who had been defeated: in 161 BCE the Syrian general Bacchides overwhelmed some of the Maccabean rebels, the last of whom were slaughtered in these caves. Exactly the same happened when Herod the Great defeated Antigonus and killed the last of his supporters in the caves of Arbel.

HEPTAPEGON (TABGHA)

Heptapegon ("seven springs"), abbreviated in Arabic into Tabgha, lies about midway between Ginnosar and Capernaum. It became identified by Christians with the site of several important episodes in the ministry of Jesus, as the 4th-century pilgrim, Egeria, discovered:

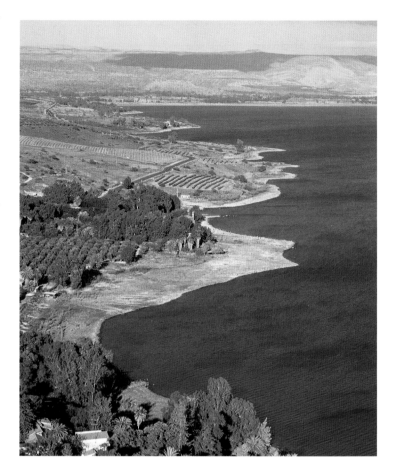

> Not far away from Capernaum are some stone steps where the Lord stood. And in the same place by the sea is a grassy field with plenty of hay and many palm trees. By them are seven springs, each flowing strongly. And this is the field where the Lord fed the people with the five loaves and the two fishes. In fact the stone on which the Lord placed the bread has now been made into an altar. People who go there take away small pieces of the stone to bring them prosperity, and they are very effective. Past the walls of this church goes the public highway on which the Apostle Matthew had his place of custom. Near there on a mountain is the cave to which the Saviour climbed and spoke the Beattitudes. (trans. Wilkinson 2002)

On the field there has now been built the Church of the Multiplication of the Loaves and Fishes (see Matthew 14.13–21; Mark 6.30–44; Luke 9.10–17). Closer to the shore are the ruins of a 4th-century church which is thought to have been the first commemoration of the Sermon on the Mount (Matthew 5–7). However, since Matthew says that Jesus "went up the mountain" for this address to the crowds, a new church was built in 1938 on the hill behind the town that is now known as the Mount of Beatitudes.

A little earlier, in 1933, another small church was built to commemorate the resurrection appearance of Jesus to Peter and the other disciples who had been fishing, recorded in John 21.9–14:

When they had gone ashore, they saw a charcoal fire there, with fish on it, and bread. Jesus said to them, "Bring some of the fish that you have just caught." So Simon Peter went aboard and hauled the net ashore, full of large fish, a hundred and fifty-three of them; and though there were so many, the net was not torn. Jesus said to them, "Come and have breakfast." Now none of the disciples dared to ask him, "Who are you?" because they knew it was the Lord. Jesus came and took the bread and gave it to them, and did the same with the fish. This was now the third time that Jesus appeared to the disciples after he was raised from the dead.

TOP Aerial view of the coastline along the Sea of Galilee. The fertile and well-watered land here is in stark contrast to the desert around the Dead Sea.

OPPOSITE TOP The white limestone 4th-century synagogue at Capernaum was built with the help of local Gentiles. In the background is a modern awning protecting the 5th-century Byzantine church built over the supposed house of Simon Peter.

OPPOSITE BOTTOM LEFT A rare representation of the Ark of the Covenant found in the Capernaum synagogue. The carving recalls David taking the Ark on a wheeled cart to Jerusalem (see page 134).

OPPOSITE BOTTOM RIGHT A Roman mile marker at Capernaum synagogue. It measures distances along the Via Maris or "Way of the Sea" (see page 214), an ancient international route running from Egypt to Babylon along the Mediterranean coast.

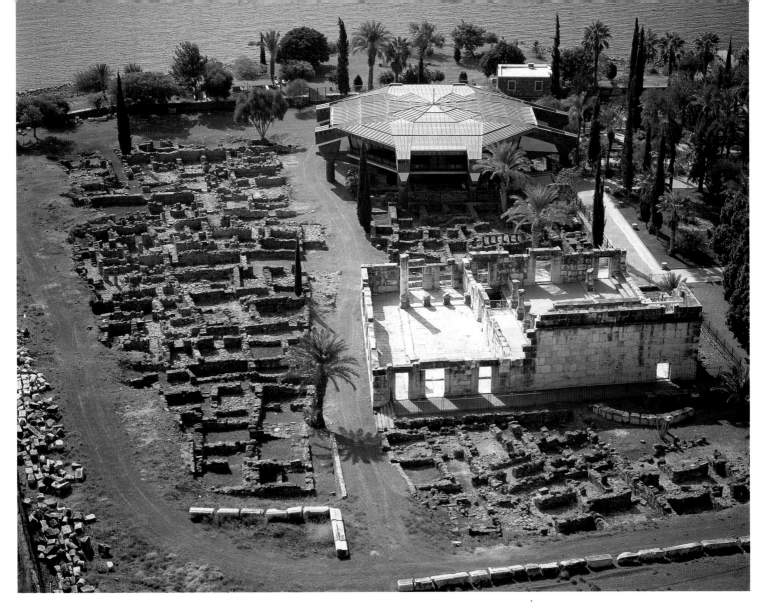

CAPERNAUM (KEFAR NAHUM/TEL HUM)

Capernaum was a major centre, partly because it stood on the trade-route from the Mediterranean to Damascus, but even more because of the abundance of fish in the Sea of Galilee and the fertility of the land all around. It was described by Josephus who knew the area well in enthusiastic words (*War* 3.516–21):

> By the lake of Gennesar there borders a country of the same name, naturally beautiful and admirable; for there is no kind of plant which will not grow there, and the inhabitants have replenished it with plants and trees of all sorts. The temperature of the air well agrees with all sort of fruit trees, for there is an infinite company of nut-trees, which of all trees especially require a cold soil. There is also an abundance of palms which desire great heat, likewise great store of figs and olives which require a temperate air. One may justly say that through a bounty of nature very different and opposite qualities are here together united, and at one time, as it were, all differences of the seasons of the year conjoin for good purpose …. Besides the temperature of the air, it is also watered by a plentiful fountain called Capernaum.

Capernaum was one of the three places condemned by Jesus because of its lack of faith (on this see page 56). Yet it was here that Jesus exercised much of his recorded ministry. No other places are mentioned so often in the New Testament except for Jerusalem.

Traces of human habitation go back to about the 13th century BCE, but the traces only become significant in the 2nd and 1st centuries. When Herod the Great died, Capernaum was on the border between the territory of his sons Philip and Herod Antipas. It therefore had a Customs post (Matthew 9.9) and a small Roman garrison: on one occasion when Jesus entered Capernaum (Matthew 8.5; Luke 7.1; John 4.46), a centurion appealed to him to heal one of his servants or slaves. These together do not mean that there was any large Roman presence in Capernaum at this early date, though Capernaum did become a much more Romanized city after the time of the emperor Hadrian (76–138).

According to Matthew 4.13, Jesus began his public ministry at Capernaum: "He left Nazareth and made his home in Capernaum by the sea". Although that was written in part to show how Jesus fulfilled a prophecy from Isaiah 9.1–2, Capernaum was so much the base of his activity that it could be referred to as "his own town" (eg, Matthew 9.1). At the very beginning of his ministry, after his call of the first disciples, he taught in the synagogue at Capernaum and then lodged at the house of Simon Peter and Andrew (Mark 1.16–29).

Both a synagogue and a house claimed to be that of Peter are dramatically visible in old Capernaum. The synagogue is magnificent in its own right, but it cannot be the synagogue known to Jesus – even though it may be on an older foundation – because it was built at some time around the mid 4th century CE. It was clearly of great importance for the Jews, because it is 65 feet long and it was built to a height of two storeys.

The House of Peter, found during excavations between 1968 and 1985, is a part of a complex of buildings that were flattened in the 5th century in order to build an octagonal church: the foundations of the church remain visible. The reasons for thinking that it may have been the house of Peter are partly the church itself, since churches were built over sacred places, partly because pilgrims and tradition made this identification from an early date, and also because the walls were plastered allowing graffiti (more than 130) to be scratched into the plaster from the 2nd century onward acclaiming Jesus as Lord and Christ, with one of them possibly naming Peter. The narrow walls are likely to have supported nothing more than a roof thatched with reeds from the lake, exactly as the healing episode in Mark 2.1–12 requires.

In about 374 the historian Epiphanius described Capernaum as a city of Jews who tried to keep out Gentiles, Samaritans, and Christians, but the Christians and Jews continued to live side by side. Egeria made Capernaum part of her pilgrimage and visited there sometime between 381 and 384. Of Capernaum she later wrote, "In Capernaum the house of the prince of the apostles [Peter] has been made into a church, with its original walls still standing …. There is also the synagogue where the Lord cured a man possessed by the devil [Mark 1.23]. The way in is up many stairs, and it is made of dressed stone."

Tensions, however, increased in the 7th century, with the Jews destroying a church and the Christians, in revenge, destroying the synagogue in 629. Much of the original Capernaum was destroyed and a new town was built a little to the east. The Muslims took over Capernaum in 638 in a peaceful transition, but even that was destroyed by an earthquake in 746, and the site was abandoned in the 11th century.

CHORAZAIN (KHIRBET KARAZE)

Chorazain lies just over two miles north of Capernaum; with Bethsaida and Capernaum, Chorazain is one of the three places condemned by Jesus for lack of faith (for this see page 56). It certainly did not lack Jewish faith, because it is the site of a major synagogue, typical of the style found elsewhere in Galilee. The synagogue and the town around it have been excavated and restored in an impressive way, but this was not the Chorazain of the time of Jesus – indeed, some argue that this was not the original Chorazain at all. The remains of the town around are dated from the 2nd century CE onward, with only a few traces of 1st-century occupation. The synagogue itself comes from about the 4th century.

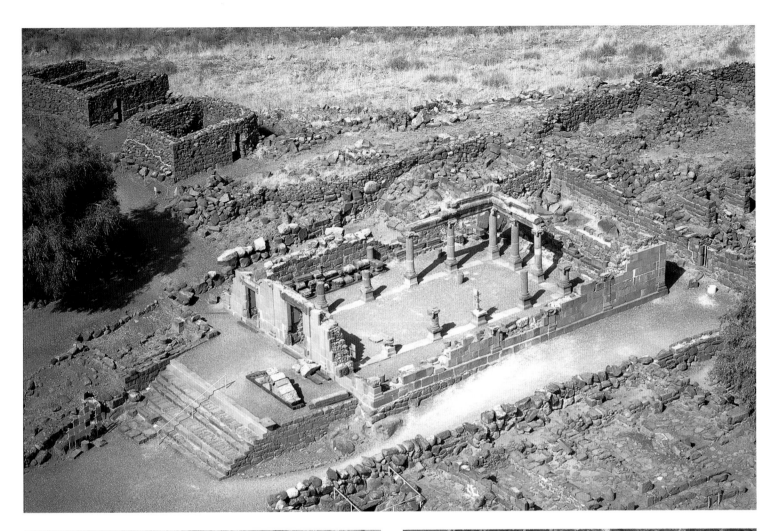

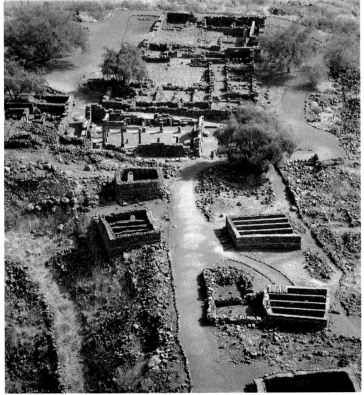

TOP The 4th-century Chorazain synagogue from the east, showing the entrances facing south, towards Jerusalem. It is built from local black basalt and measures about 70 feet by 50 feet.

ABOVE The basalt "Throne of Moses" found in the Chorazain synagogue. It was used during the reading of the Torah, the Law of Moses.

LEFT The Chorazain synagogue has a commanding position at the centre of the town, close to the remains of two large public buildings. The house in the foreground dates from the 2nd-4th century.

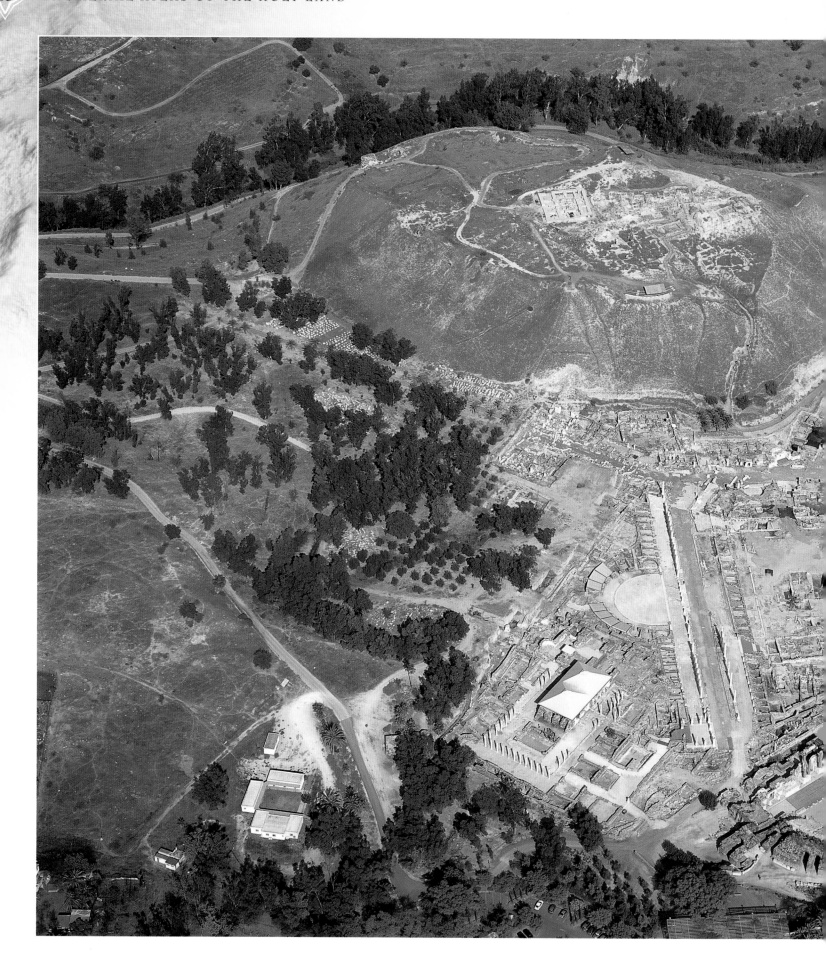

BETH SHAN

BAISAN/SCYTHOPOLIS

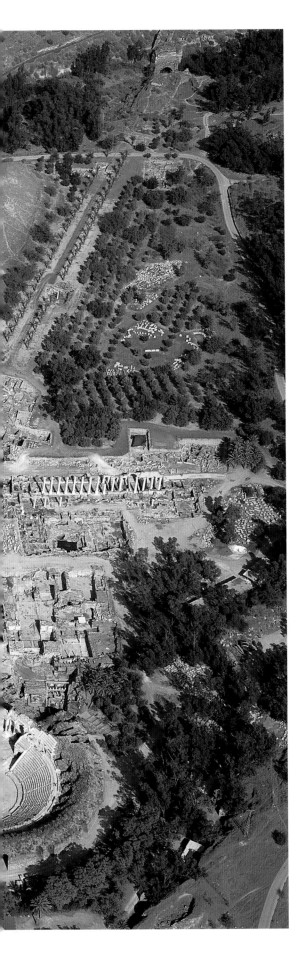

Beth Shan lies west of the River Jordan, about 15 miles south of the Sea of Galilee. The site was of great importance from a very early period until the city was destroyed by an earthquake in the 8th century CE. It is in a fertile valley well supplied with water, and the many centuries of continuous habitation mean that it is extremely rich in archaeological remains. Two sites in the area are associated with early Christianity. One of these is Pella to which some Christians fled after the failure of the first Jewish Revolt and the fall of Jerusalem to the Romans (70 CE). The second is Bethabara which, according to early tradition, was the site of the baptism of Jesus by John. There is, however, no agreement on the original site of Bethabara.

LEFT Aerial view of Beth shan from the south-west. Settlement moved from the Tel in the background to the valley in the Hellenistic period. Public buildings in the excavated city of Scythopolis include Roman baths (front left), a theatre (front right), and arcaded streets with workshops (centre right).

The site of Beth Shan is now marked by the mound Tel alHusn, the great size of which (150 feet high and 10 acres in extent) indicates the importance of the place while it was inhabited. It is in a fertile area with the River Harod giving it a continuous supply of water, and it lay at a decisively strategic point on the most naturally easy route from east to west.

The site was occupied continuously from the Chalcolithic period (c.3500) onward until it was destroyed by a huge earthquake in 749 CE. Some Neolithic pottery has been found there similar to the finds at Jericho, along with some copper tools.

The remains of the first town on the site came from the Early Bronze Age (3000–2400 BCE), indicating a town with well laid-out streets, public buildings and private houses. This town continued to be occupied through the Middle Bronze Age (2000–1550).

The earliest mention of Beth Shan outside the Bible occurs in the list of cities conquered by Thutmoses III (1468 BCE), and after this date the remains show traces of Egyptian presence and influence, including a wall plaque containing the name of Thutmoses III. Beth Shan is mentioned once in the Tel elAmarna letters (on these see page 162). The Mekal stele was found in layer IX of the excavations: it is a stone monument set up by an Egyptian official in memory of his father, and it displays a seated Egyptian god whose dress and appearance are Canaanite. Beth Shan became a centre of Egyptian administration, second only to Gaza.

At the time of the Israelite conquest and settlement, Beth Shan was allocated to Manasseh, but in fact the Israelites were unable to take Beth Shan because the Canaanites living there were too strong. Even when the Israelites gained supremacy they could not eradicate the Canaanites (see Judges 1.27–29).

At some time (probably in the 11th century) the Philistines captured Beth Shan and it became their main stronghold in the east. Two temples of this period have been found, the smaller of which was dedicated to the goddess Anat.

———————— ❖ ————————

OPPOSITE Ruins of the theatre at Scythopolis, viewed from the stage. There were three tiers of seats, of which only the lower one survives. The stage was decorated with imported marble and granite, and backed by a colonnaded wall.

OPPOSITE INSET The public latrines at Scythopolis, near one of the baths. The seats are located along the walls, above drainage channels.

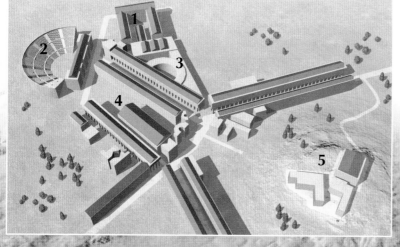

1 BATHS
2 THEATRE
3 ODEON
4 BASILICA
5 TEMPLE PRECINCT

An artist's reconstruction of the city of Beth Shan, based on archaeological finds.

BELVOIR

NAHAL HEROD

N

MOUNT GILBOA

BETH SHAN

RIVER JORDAN

PELLA

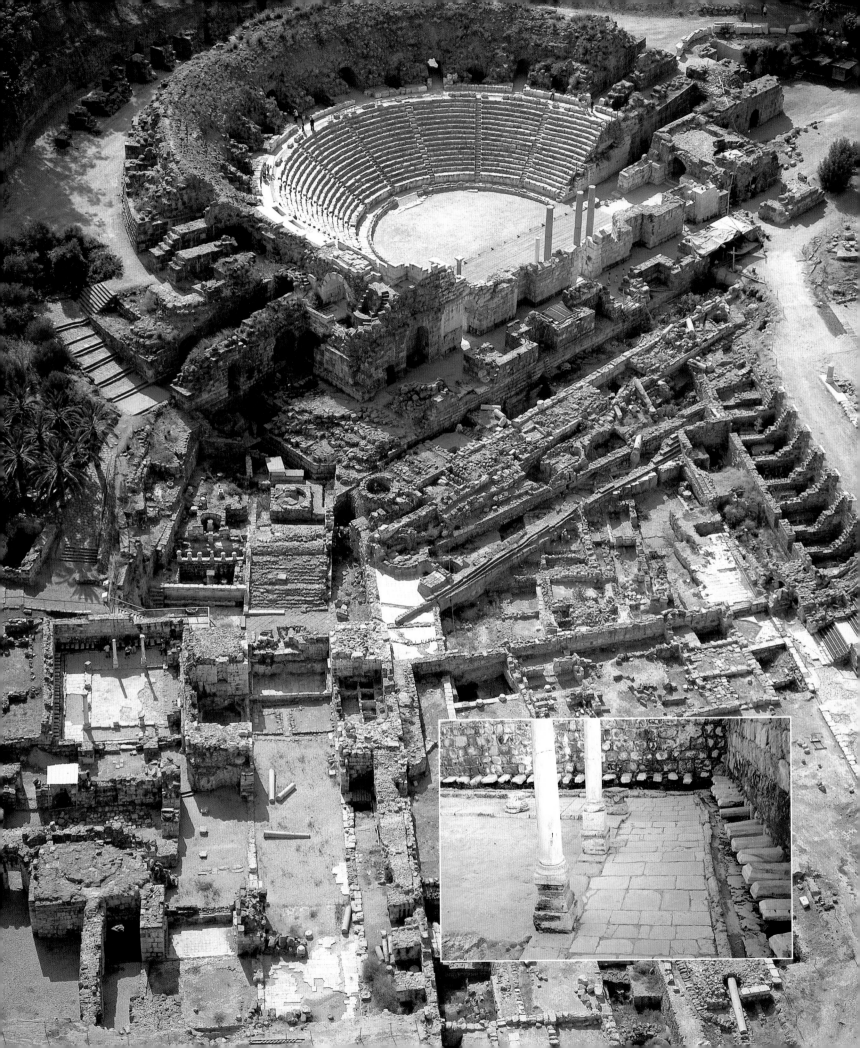

In the conflict with the Philistines that led to the death of Saul, David was actually found employed by Achish as a mercenary in the Philistine army:

> Now the Philistines gathered all their forces at Aphek, while the Israelites were encamped by the fountain that is in Jezreel. As the lords of the Philistines were passing on by hundreds and by thousands, and David and his men were passing on in the rear with Achish, the commanders of the Philistines said, "What are these Hebrews doing here?" Achish said to the commanders of the Philistines, "Is this not David, the servant of King Saul of Israel, who has been with me now for days and years? Since he deserted to me I have found no fault in him to this day." (1 Samuel 29.1–3)

But the Philistines could not bring themselves to trust David, feeling that he might turn against them in the battle. They said, "Is this not David, of whom they sing to one another in dances, 'Saul has killed his thousands, and David his ten thousands'?" (verse 5).

So David went his way, and Saul went to the battle where, in defeat, he fell on his sword and killed himself. When the Philistines defeated Saul "they found Saul and his three sons fallen on Mount Gilboa" (1 Samuel 31.8). They then fastened their dead bodies to the city wall of Beth Shan, evoking from David his famous and often quoted lament (2 Samuel 1.19–27).

Apart from a brief mention that Beth Shan was part of Solomon's empire (I Kings 4.12), Beth Shan no longer plays an important part in the biblical period. From the Hellenistic period onward, Beth Shan was called Scythopolis, the city of Scythians.

DAVID'S LAMENT

The beauty of Israel is slain upon thy high places:
How are the mighty fallen!
Tell it not in Gath,
Publish it not in the streets of Askelon;
Lest the daughters of the Philistines rejoice,
Lest the daughters of the uncircumcised triumph
Saul and Jonathan were lovely and pleasant in their lives,
And in their death they were not divided: ...
O Jonathan, thou wast slain in thine high places,
I am distressed for thee, my brother Jonathan:
Very pleasant hast thou been unto me:
Thy love to me was wonderful,
Passing the love of women.
How are the mighty fallen,
And the weapons of war perished!
(2 Samuel 1.19–20, 23, 25–7)

At about this time the city was moved from the Tel to the valley. Briefly it was called Nysa, suggesting that the cult of Dionysus was practised here. It was destroyed by John Hyrcanus in 107 BCE. Hyrcanus at the time was trying to extend the Hasmonean empire by bringing Samaria under his control:

> And so Hyrcanus captured the city after besieging it for a year, but not being content with that alone, he effaced it entirely and left it to be swept away by the mountain-torrents, for he dug beneath it until it fell into the beds of the torrents, and so removed all signs of its ever having been a city. (Josephus, *Antiquities* 13.280)

He then turned his attention to Scythopolis:

> Not allowing the flowing tide of success to cool their ardour, they proceeded with their army to Scythopolis, overran that district, and laid waste the whole country this side of Mount Carmel. (Josephus, *War* 1.66)

Scythopolis did not remain a ruin for long, and in its rebuilt form it soon became a substantial Roman city. After the Roman general Pompey invaded (see page 21), he made the city part of the Decapolis, a league of cities to serve as centres of Roman power and influence.

In the Byzantine period, Scythopolis became the capital of the province of Palestina Secunda, and it was called "the city of many churches". All the same, it remained a city with a Jewish population, and two synagogues have been found of the 5th and 6th centuries. Scythopolis came under Muslim rule by 636, and possibly as early as 634 when Khalid ibn alWalid defeated a Byzantine army nearby. The inhabitants had to give half the houses in the city to the Arabs as tribute, as well as money and crops. alMuqaddasi described the city in the 10th century as prosperous and as growing rice from a large area. After the Arab conquest, the city reverted to its original name, though in an Arabic form, Beisan. The Crusaders captured the city (which they called Bethsan), but after the battle at the Horns of Hattin it reverted to the Muslims. It was destroyed by the earthquake of 749.

PELLA (KHIRBET FAHIL)

Halfway between the Sea of Galilee and the Dead Sea, to the west of the Jordan, are the remains of Pella, the present day Khirbet Fahil. This is an extremely old settlement, inhabited since at least Chalcolithic times (3000 BCE). It was a Canaanite town mentioned in the Tel elAmarna letters (for which see page 162) as Pehel. It became part of the kingdom of the Hasmoneans, but it was then captured by Pompey during his invasion in 63 BCE (page 21). It was to Pella that Christians fled from Jerusalem at the outbreak of the

1st Jewish Revolt. According to Eusebius (*Church History* 4.6.3) they received a warning from God to do so, and it is thought that in Pella there may have persisted for some centuries a form of Jewish Christianity – ie, of Christians who remained observant Jews, so far as they could, but who accepted that Jesus is the Christ or Messiah.

BETHABARA

For Christians, the waters of the River Jordan have been almost sacrosanct because it was here that John baptized Jesus. The exact site is not known. According to John 1.28, the baptisms of John "took place in Bethany across the Jordan", but the exact place is uncertain. Traditionally it was at Bethabara, but even then some early Christians (including Eusebius, *Onomasticon* 58.18) placed Bethabara east of the Jordan, whereas the emperor Athanasius (491–518) built a church in honour of John the Baptist to the west.

⛭

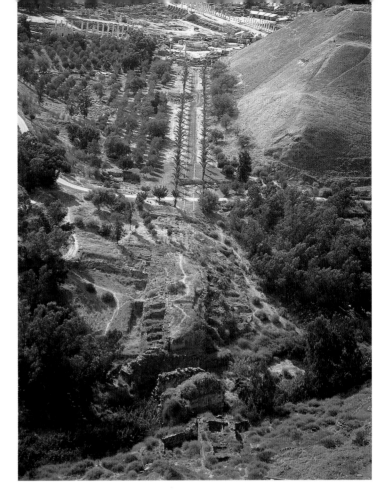

RIGHT An aerial view of Valley street, which led to a roman bridge, the remains of which can be seen in the foreground. The Tel can be seen on the right.

BELOW Pella city on the slopes of the Gilead Heights. In the foreground are the ruins of the 4th-century basilica. It was destroyed by an earthquake in 747, along with most of the centre of the town, which was abandoned.

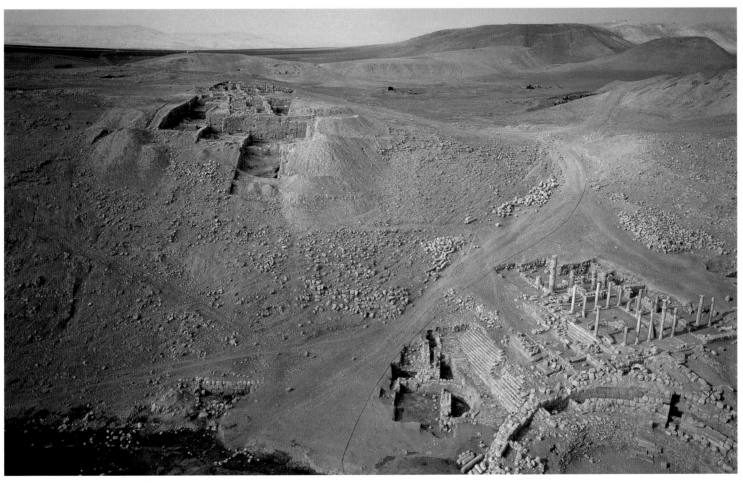

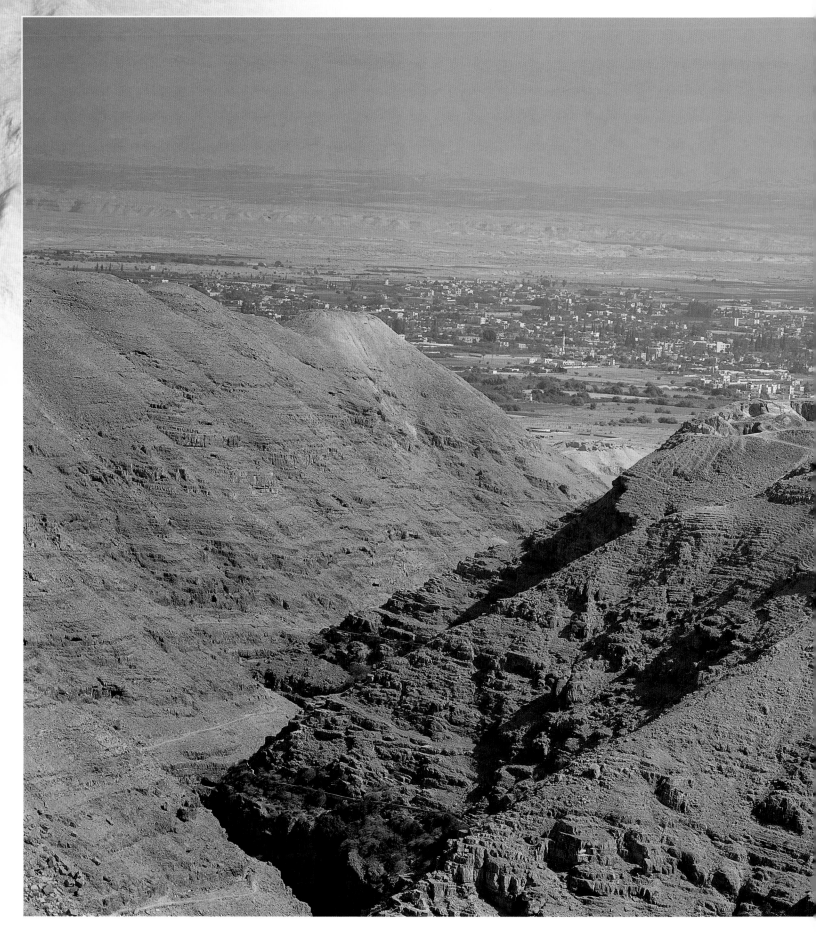

JERICHO

Jericho is an extremely fertile area six miles north of the Dead Sea. There have been three different settlements or towns in the area, close to each other. The earliest occupation was a small Mesolithic shrine (*c.*9000 BCE) close to the prolific spring, Ein asSultan. A larger Neolithic settlement (*c.*8000–4000) has been called "the oldest walled town in the world". In the Early Bronze Age (*c.*3200–2000), Jericho was resettled as a prosperous town, defended by strong walls on a high embankment. This was the city overthrown by Joshua, with the dramatic destruction of its walls. This site was abandoned, and a new Jericho was developed, familiar to Jesus and therefore sometimes called "New Testament Jericho". Nearby, the Hasmoneans and Herod built palaces and gardens. During the Byzantine period, monasteries were built in the area including Our Lady of Kalamon at Deir Halja, the monastery of the Mount of Temptation, and St George of Koziba in the Wadi Qilt. Jericho's importance to the Muslims can be seen in the nearby Nabi Musa (tomb of Moses) and in the remains of a large hunting lodge (known as Khirbet alMafjar, or more popularly as Hisham's Palace) built during the 8th century CE by an Umayyad ruler.

LEFT Jericho, from the Wadi Qilt, a long canyon stretching from the spring of Ein Farah, south of the Jerusalem suburb of Anata, down to Jericho in the east. The Nahal Perat flows from the Wadi Qilt past Jericho.

ABOVE Interior of the Monastery of the Temptation, built over the cave where Jesus is said to have undergone his testing. The rock is thought to be where he sat.

HISHAM'S
PALACE

DOQ

MONASTERY OF
THE TEMPTATION

JERICHO

TEL ES-SULTAN

NAHAL PER

ST GEORGE'S MONASTERY

KYPROS
KANNA

WADI QILT

INN OF
THE GOOD
SAMARITAN

BELOW Nabi Musa mosque is located to the south of the Jerusalem–Jericho road. According to Muslim tradition it is the site of Moses' tomb, which the Bible says is at an unknown spot on Mount Nebo, on the other side of the Jordan valley. The large burial ground outside the walls of Nabi Musa is reserved for Muslim pilgrims.

NABI MUSA

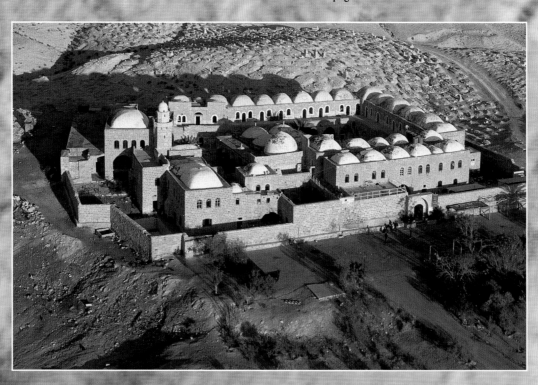

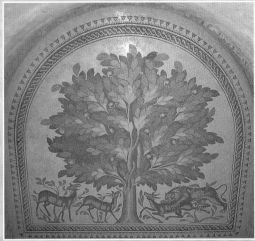

ABOVE 8th-century mosaic floor in
the reception room in Hisham's
Palace. The design, with a fruit tree,
lion, and gazelles has tassles round the
edge, in imitation of a carpet.

ST GERASIMUS
CHURCH

**POSSIBLE
SITE OF
JESUS'
BAPTISM**

DEAD SEA

RIGHT Wadi Qilt,
looking east, wending
its way between the
Judaean hills of
infertile Senonian
Chalk. It was in an area
of this kind that the
40 days of Jesus' fast
and testing took place
just after his baptism.

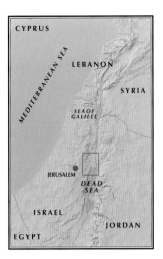

In the biblical narrative, Jericho was the first step in the conquest and settlement of Canaan. Joshua chapter 3 tells how Joshua and "the entire nation" crossed the Jordan, and chapter 6 tells how "Joshua fit de battle of Jericho, Jericho, Jericho, Joshua fit de battle of Jericho, An' de walls come tumblin' down." (*Songs of Zion*, 96).

Nothing remains of the city of those times beyond a mound 70 feet high and about 10 acres in extent known as Tel asSultan. Archaeologists have sought evidence of a catastrophic destruction of walls on the site of the old city, and J Garstang believed that he had found the ruin of a large wall of mud bricks, dating from 1400 BCE. The later work of Kathleen Kenyon showed that this wall was much earlier, being in fact the remains of two walls from the Early Bronze Age. In her view, constant erosion has removed all evidence, though she argued on other grounds for a date at the end of the 14th century BCE for the Israelite invasion. A date *c*.1200 is now usually thought more probable.

After the destruction, Jericho was unoccupied for four centuries. An oath of Joshua was recorded cursing anyone who rebuilt the city:

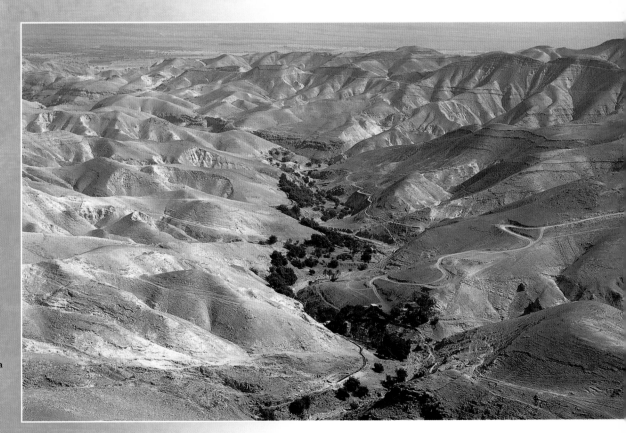

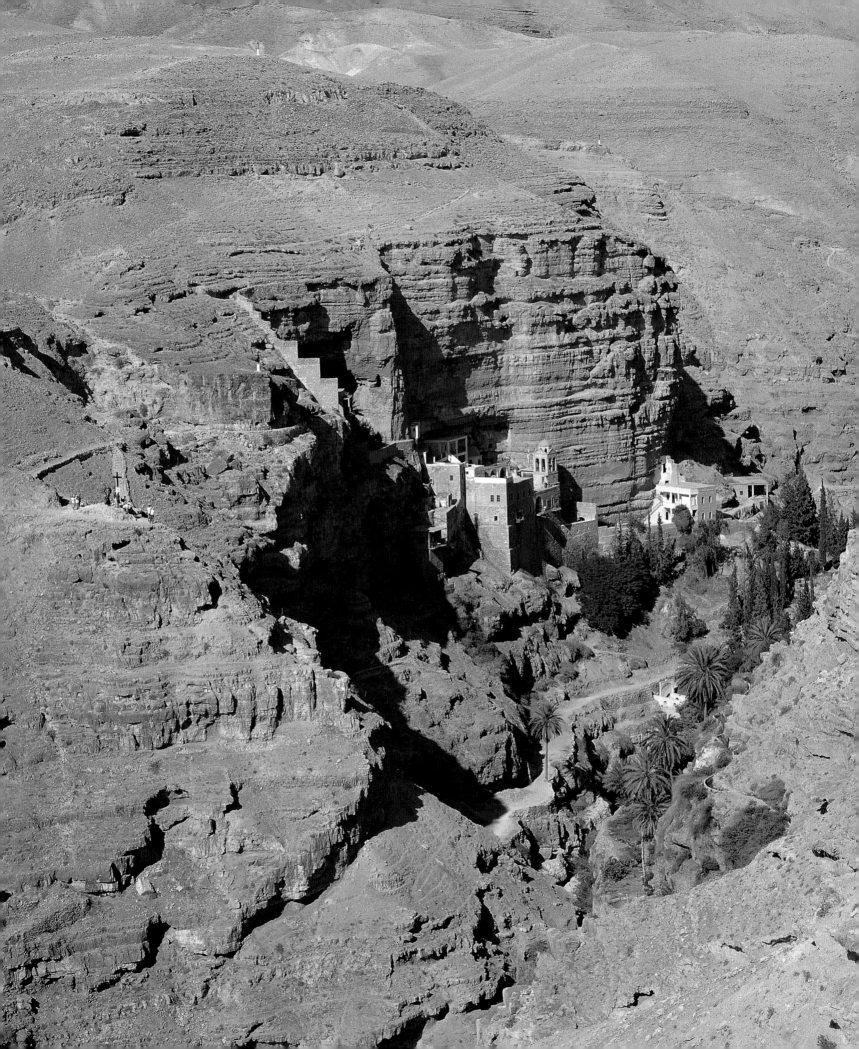

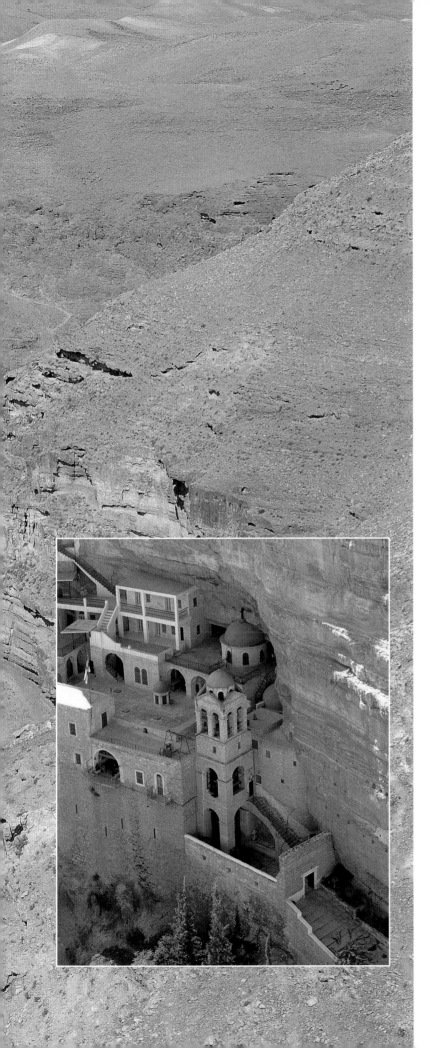

Cursed before the Lord be anyone who tries
to build this city – this Jericho!
At the cost of his firstborn he shall lay its foundation,
and at the cost of his youngest he shall set up its gates!
(Joshua 6.26)

During the reign of Ahab (*c.*869–850), Hiel of Bethel rebuilt Jericho, but he lost his two sons exactly as the curse demanded (1 Kings 16.34): "Hiel of Bethel built Jericho; he laid its foundation at the cost of Abiram his firstborn, and set up its gates at the cost of his youngest son Segub, according to the word of the Lord, which he spoke by Joshua son of Nun."

The area of Jericho was well known for its fertility, It was called in Deuteronomy 34.3 "the valley of Jericho, the city of palm trees", and Strabo (*d.*20 BCE) described it as "full of houses and rich in fruit trees, especially palms". Its prosperity attracted the Hasmoneans, and Alexander Jannaeus (103–76) began the building of a palace north of Wadi Qilt.

This was extended by Herod in his usual grand and ambitious style. To the buildings on the north bank he added a magnificent guesthouse, while on the southern edge of the Wadi, he built his own palace with a fine sunken garden. Later, he built a further palace for himself beyond the guesthouse on the north bank.

The whole site is now known as Tulul alAlaiq, and while the structures have eroded and disappeared, enough remains of the foundations and the mosaic floors to indicate the grandeur of the buildings and the splendour of Herod's Court.

Herod built also for the entertainment of himself and his guests. At Tel asSamrat nearby, he built a theatre and a hippodrome, the remains of which have survived. It was here that the bizarre events took place just before the death of the widely unpopular Herod the Great in 4 BCE (see box page 80).

Knowing how unpopular he was, Herod made his way back to Jericho and assembled in his newly-built hippodrome leading men from the whole of Judaea. He then commanded that they should be killed as soon as he himself died, and in that way he could be sure that there would be weeping and mourning throughout the whole country. Herod's plan did not prevail: when he died five days later, the prisoners were released.

Jericho was well known to Jesus. He was baptized in the Jordan nearby, and his temptation or testing at the outset of his ministry took place in the wilderness not far away (Matthew 4.1–11; Mark

LEFT St George's Greek Orthodox Monastery, tucked into the hillside of the Wadi Qilt, about 8–10 miles north-east of Jerusalem. Founded in the 5th century, it was destroyed and rebuilt several times. The present buildings date from 1871–1901.

LEFT INSET Detail of the entrance fortifications constructed to protect the monastery against raids.

THE DEATH OF HEROD

The king's sickness spread over his whole body, and he was afflicted with most grievous pains, for he had a great fever, and an itch over all his body which was intolerable, as well as a daily colic. His feet were swelled as though he had the dropsy, and his belly also was swelled, and his privy members putrefied, so that the worms bred in the putrefying places. He was also grievously tormented with difficulty of breath and a convulsion of the whole body Herod, notwithstanding that he was afflicted with so many and grievous sicknesses, was still desirous to live, and sought remedy in hope of health. At last he passed over Jordan where he used the warm waters of Callirrhoe which run into the Lake Asphaltitis [the Dead Sea] and which are so sweet that they are also used for drink. There the physicians caused his body to be bathed in hot oil, but by this he was so weakened that his senses failed and he was as though he were dead. Those about him were so troubled that with their loud cries they caused him to look up; and now despairing of life, he caused 50 drachmas to be distributed to every soldier, and great sums of money to the captains and his friends. (Josephus, *War* 1.656)

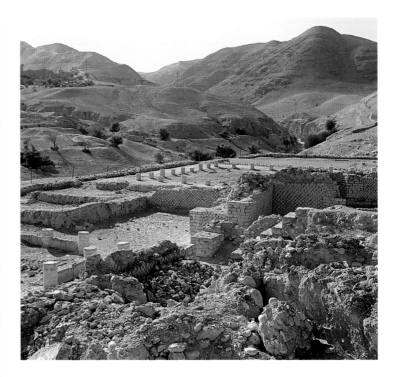

1.12–13; Luke 4.1–13). The Mount of Temptation is now identified with Jebel Quruntul, although pilgrims to the Holy Land did not make this identification until the 12th century. In the 19th century, a monastery was built in a dramatic location in the cliff-side (see page 82).

Directly above the monastery is the fortress of Doq. This high point has been identified as the summit to which Jesus was taken up during his temptations and from which he was shown the kingdoms of the world. Certainly there is an extensive view from the summit, and a church was begun at the end of the 19th century in commemoration of this. However, the identification is uncertain, and the church was never completed. It was a strong defensive position, and some traces can still be seen of the fortress that was built here during the 2nd century BCE. Not much remains, not least because the stones from the fortress were used to build the laura of Douka — a laura, also known as lavra, is a community of those who have withdrawn from the world to live a solitary life in prayer: they live separately but under the care of a single abbot.

Later in his life and ministry, Jesus moved from Galilee to Jerusalem via the Jordan valley and Jericho. It was on the road from Jericho to Jerusalem that Jesus set the parable of the good

Samaritan (Luke 10.25–37). While at Jericho, he healed blind Bartimaeus and possibly others. Luke has a short section of his own material dealing with Jesus in Jericho, including the parable of the pounds (Luke 19.11–27), as well as the revealing and dramatic visit to the house of Zacchaeus.

Khirbet alMafjar is located just north of Jericho and shows how highly valued this area was by the Umayyad caliphs. It was a hunting lodge built in a grand and extravagant style. Since it was once thought to have been built by Hisham ibn Abd ulMalik (724–43), it is commonly called Hisham's Palace. Hisham, however, was a strict and austere Muslim, whereas his successor, alWalid ibn Yazid (743–4), was the exact opposite and is more likely to have begun the project. In fact, the palace was never finished, and although an attempt was made in the 12th century to rebuild it, it was never completed. From that time on, it was a useful source of cut and prepared stones for the people of Jericho.

———————— ✠ ————————

TOP Fragmentary ruins of Herod's Palace, on the north side of Nahal Perat. It was built in three stages and covered extensive areas on both sides of the Wadi Qilt, with a bridge connecting the two parts.

OPPOSITE TOP The main courtyard of Hisham's Palace, the hunting lodge of Khirbet alMafjar. The courtyard is surrounded by a bath house, banqueting hall, and a mosque. The complex was destroyed by an earthquake in 847 CE.

OPPOSITE BOTTOM LEFT Close-up of the rose window reerected by archaeologists in the main courtyard of Hisham's Palace.

OPPOSITE BOTTOM RIGHT Detail of carved arches in Hisham's Palace. The decoration includes acanthus leaves, a symbol of Paradise.

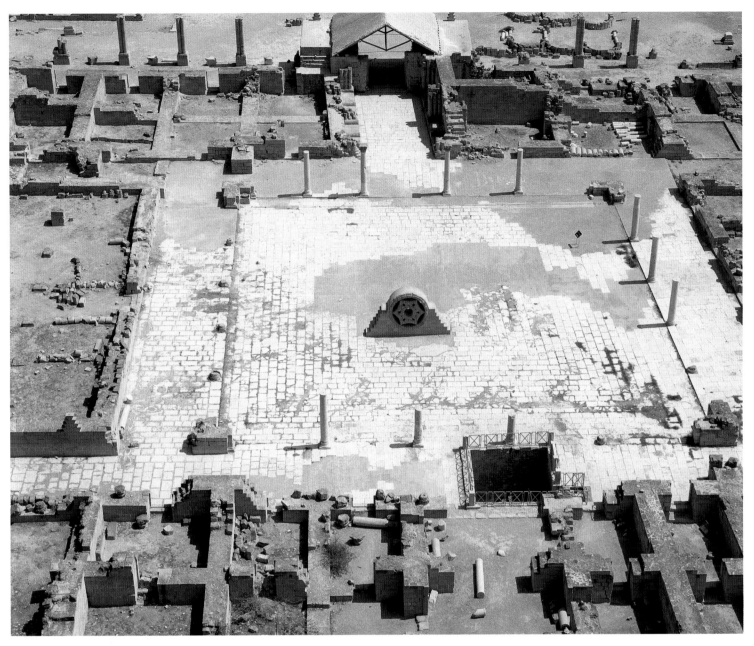

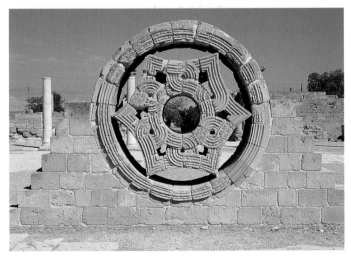

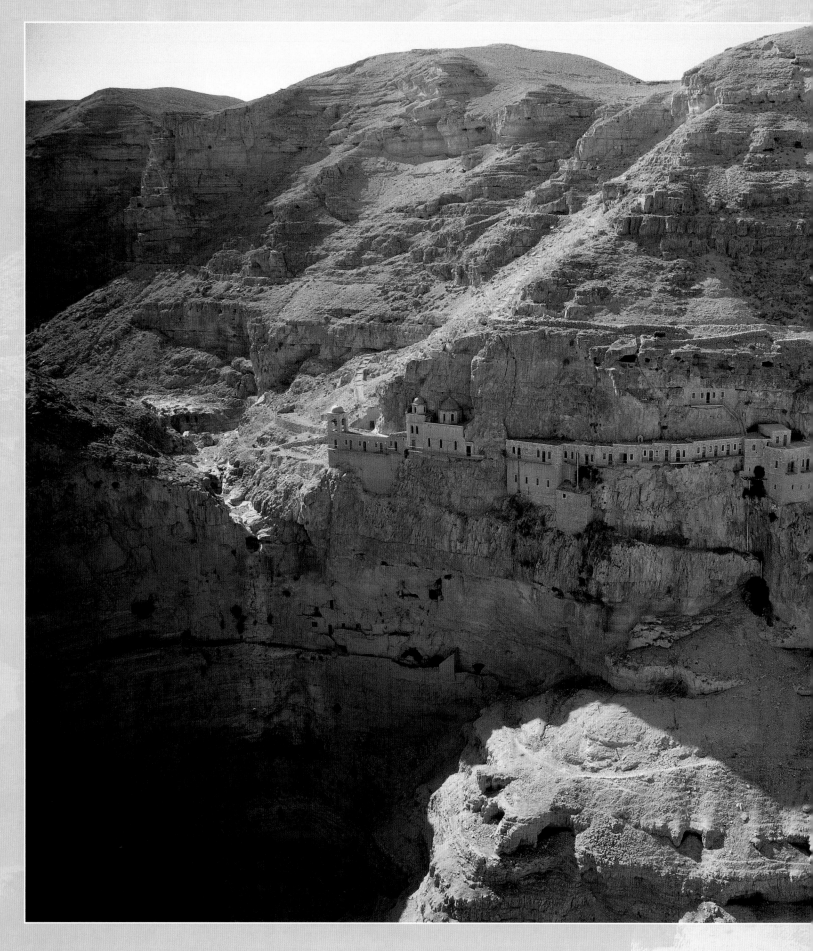

MONASTERIES

LEFT The Monastery of the Temptation, Deir Quruntul, was rebuilt between 1874 and 1904, on the site of a 12th-century church. As well as the cave-church associated with Jesus' temptations (see page 80), there is a cave connected with Elijah. The monastery is now accessible by cable car, as well as by the narrow winding path (see map, page 76).

As obvious in the Holy Land as the remains of the Crusader castles are the remains from a different war — or perhaps more accurately the remains from a different aspect of the same war. The remains are those of monasteries, an important difference being that some of them are not ruins but living communities maintaining the same commitment to God as those who built them 1500 years ago. The warfare in which both Crusaders and monks were engaged was the battle against whatever was perceived to be evil or contrary to the will of God. The warfare of the Crusaders was against external enemies, or those whom they perceived to be enemies, threatening the lands of Christendom. The warfare of the monks was against internal enemies, or those whom they took to be assailing the inner life of the spirit. Those assailants were often described in vivid and pictorial terms as devils or agents of the devil. The battleground was inside the boundaries of the soul and body, and the place chosen for the fight was the desert. It was there that Jesus went at the outset of his ministry in order to overcome the temptations of the devil, and his followers began to follow his example.

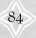

The word "monk" is derived from the Greek *monos* "alone", *monazo* "I live alone", and *monachos* "solitary". Christian monasticism began with those who sought to leave the world in order to arrive in heaven. They looked back to the experience of Jesus who began his ministry in the world by retreating from the world into the Judean desert or wilderness where he grappled with the testings or temptations of the devil (Matthew 4.1–11; Mark 1.12–13; Luke 4.1–13).

The early followers of Jesus followed his example in fighting against "the devil and all his works". They remembered his words, "And everyone who has left houses or brothers or sisters or children, or fields for my name's sake will receive a hundredfold, and will inherit eternal life" (Matthew 19.29). To do this they lived an ascetic life (from the Greek word *askesis*, "exercise" or "training") deliberately giving up everything that might weaken or compromise their fight against the devil. One of the earliest writers to describe this battle was Evagrius Pontikos (Evagrius the Solitary) who lived in the second half of the 4th century (see box page 86).

Christians were by no means the first to believe that by training and discipline their lives could be made into something of greater beauty and goodness. The word "asceticism" was used by Greeks and Romans to speak of moral training, often involving abstinence from debilitating pleasures:

Men are often called intelligent wrongly. Intelligent men are not those who are erudite in the sayings and books of the wise men of old, but those who have an intelligent soul and can discriminate between good and evil The truly intelligent man pursues one sole objective: to obey and to conform to the God of all. ("On the Character of Men and on the Virtuous Life", in Palmer, *The Philokalia* I, page 329; this work was so close to the aims of the monks that it was attributed to Antony – see below – though in fact there is nothing specifically Christian in it at all)

The background, therefore, of Christian monasticism is clear in a general way, but the details of its origins in Syria and Egypt are uncertain. It seems to have begun in the practice of people living ascetic lives on the edges of towns and villages. The earliest use of

OPPOSITE Mar Saba Monastery, about 7½ miles east of Bethlehem (see map, page 162), perched above the Kidron Valley. Its water supply, adequate for up to 8000 monks in the 8th century, is maintained by 14 rainwater cisterns and two aqueducts.

BELOW The Monastery of the Cross, west Jerusalem, is an 11th-century fortified monastery constructed by Georgian monks on the site of a 5th-century Byzantine building. The bell tower dates from the 19th century. The monastery stands in the wood in which, says tradition, grew the tree that became the cross on which Jesus was crucified.

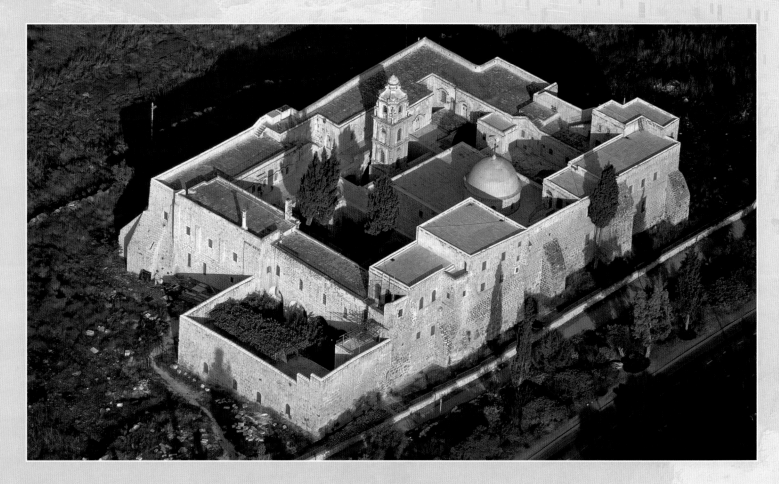

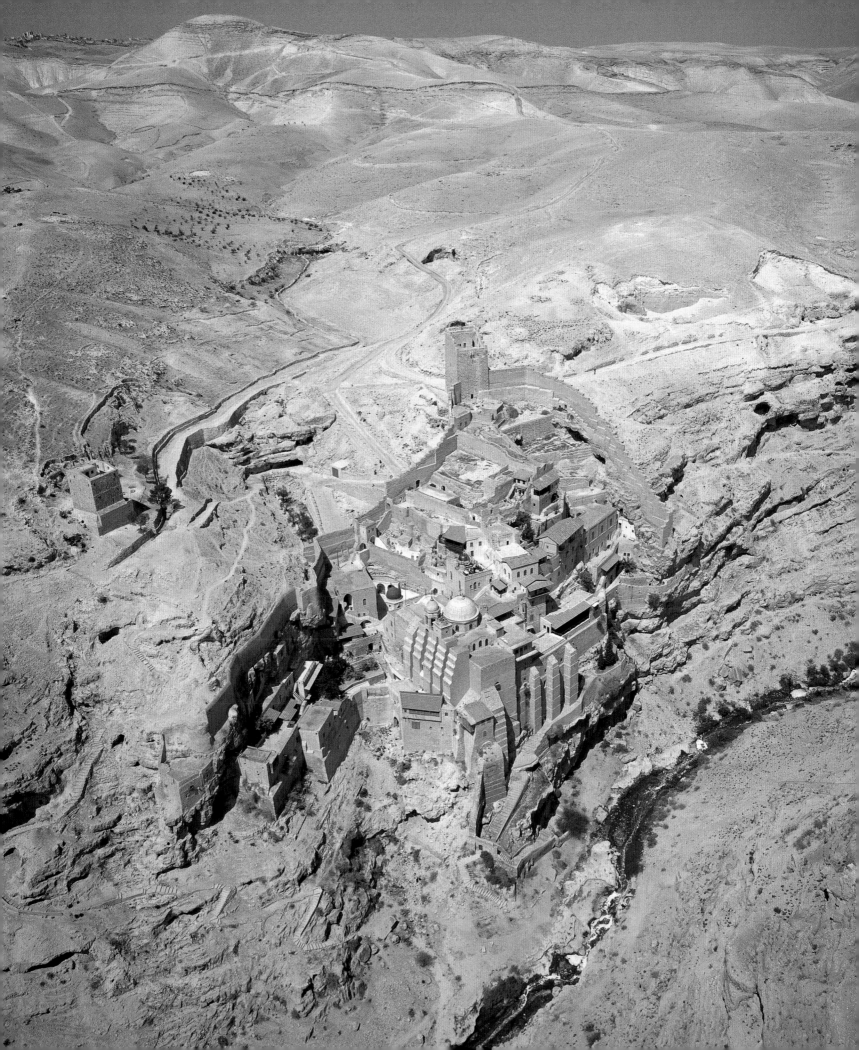

THE SPIRITUAL BATTLE

Of the demons opposing us in the practice of the ascetic life, there are three groups who fight in the front line: those entrusted with the appetites of gluttony, those who suggest avaricious thoughts, and those who incite us to seek the esteem of men. All the other demons follow behind and in their turn attack those already wounded by the first three groups. For one does not fall into the power of the demon of unchastity, unless one has first fallen because of the demon of gluttony; nor is one's anger aroused unless one is fighting for food or material possessions or the esteem of men... In short, no one can fall into the power of any demon, unless he has been wounded by those of the front line. ("Texts on Discrimination in Respect of Passions and Thoughts", 1, in Palmer, The *Philokalia* I, page 38; Evagrius then points out that these were the three temptations of Jesus in the wilderness).

the word *monachoi* occurs in a papyrus dating from 324, but even before that (toward the end of the 3rd century) the practice had begun of an even greater withdrawal from the world of society into the desert. This withdrawal was known as *anachoresis*, from which in English the people involved have come to be called "anchorites".

This withdrawal into the desert may have been prompted in part by the Roman persecution of Christians at various times during the first three centuries, but it was prompted also by a realization that a complete self-offering of oneself to God does not happen by chance, still less does it happen in the vague hope that temptations will somehow disappear. It requires deliberate choice and decision.

It may, of course, seem at first sight as though all this is very selfish, escaping into the desert to seek one's own salvation. In fact it was emphasized that this was done on behalf of the whole community, and that the prayers of the monks acted as a protective wall surrounding those still living in the world. In the words of an early work at the end of the 4th century, *Historia Monachorum* (prologue 10), "There is no village or town in Egypt or the Thebaid that is not surrounded by hermitages (Greek, *monasterioi*) as though by walls, and the people rest secure on the prayers of the monks as if on God." Furthermore, although the main work of the monks was prayer, they were required also to be hospitable, to care for the sick and to sustain the poor. They were pioneers of a genuinely "welfare state".

The *monachoi* began to emerge in both Syria and Egypt during the 3rd century. It was a vocation and a way of life that was as much open to women as to men. They became more widely known

through the life of one of them written by the renowned bishop and teacher, Athanasius (*c*.296–373). This was *The Life of Antony* whom Athanasius called "the physician for the whole of Egypt"; he was also called "the Father of the Monks".

For Antony the ascetic life is not for the purpose either of achieving spiritual experiences or of demonstrating heroic extremes of self-denial, though both might occur. The only point of leaving the world is to draw nearer to God. He once said, "Some have afflicted their bodies by asceticism, but they lacked discernment, and so they are far from God" (Ward, page 13).

To withdraw, therefore, into the desert was necessary in order that there might be a cutting out of all that holds people back until there is a complete transformation of their entire being. The purpose of the desert is not the absence of people but the presence of God. Ascetics move into a condition where there are no distractions or evasions, and where therefore they can be completely purged until they become *epigeios theos*, "earthed God", as one of the greatest of them, Macarius of Egypt (*c*.300–*c*.390), was described.

Not all the ascetics went into a solitary life. Some joined together in communities called *coenobia* (or in English "coenobite"). They were gathered, often fairly loosely, round a Father, a senior guide and teacher known as Abba – hence eventually the English word "abbot" for the head of certain religious communities.

The pioneer of the coenobitic communities was Pachomius (*c*.290–346, also in Egypt) because he was the first to impose a common rule of life on the anchorites in any community. Parts of his rule survive and led to the writing of others, the most influential being that of Basil (*c*.330–79) who was himself an anchorite for about six years in Egypt. His Rule (*Asceticon*; he also made an earlier attempt known as the Moral Rules, *Moralia*) became the foundation of the subsequent Rules governing monastic communities in the Eastern Church – or, as it came to be known, the Orthodox Church in its various related forms.

Orthodox Monasticism in its solitary and communal versions developed widely beyond Syria and Egypt, especially in Greece and Palestine. The individual anchorites lived in Lauras (Greek *lavra*, "street") which were also known as *sketes*. They lived separately and therefore in solitude, but they were under the supervision of an abbot. They flourished in Palestine from the early 4th century onward (for an account of early monasticism in Palestine see

OPPOSITE TOP St George's Monastery, Wadi Qilt (page 78), is on three levels. There are 6th-century mosaics in the churches of St John and St George, and 12th-century ones in the main church, which is dedicated to the Blessed Virgin (see map, page 76).

OPPOSITE BOTTOM The 6th-century Mar Elias Greek Orthodox monastery, rebuilt in 1160 by the emperor Manuel I Comnenus, is about three miles north of Bethlehem on the Jerusalem road. Tradition connects it with Elijah, the 5th-century Egyptian monk St Elias and the 14th-century Bishop Elias of Bethlehem.

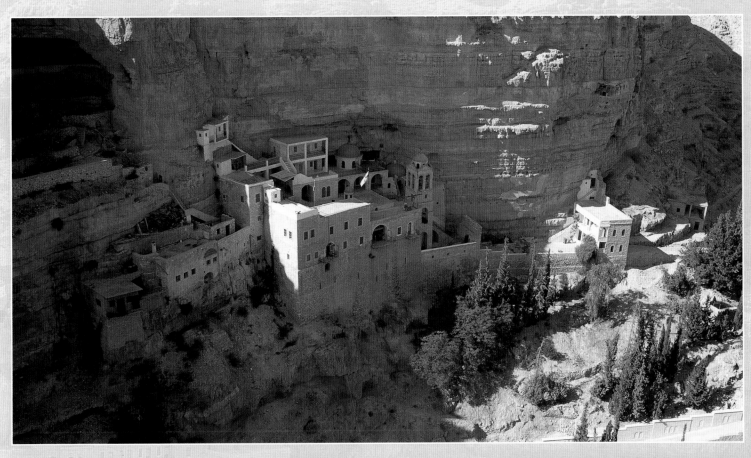

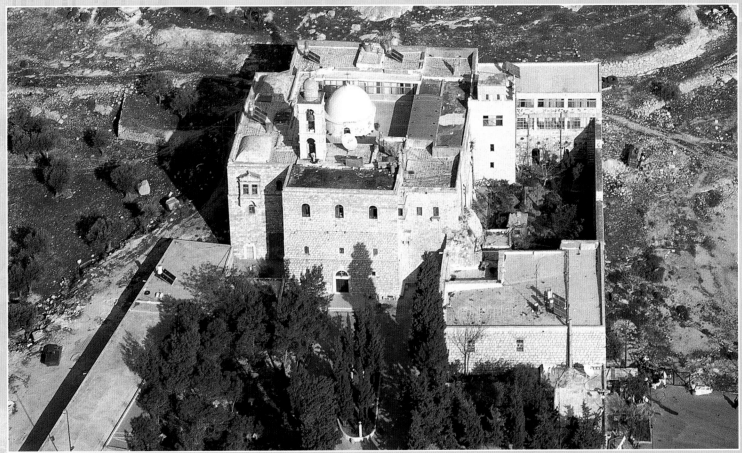

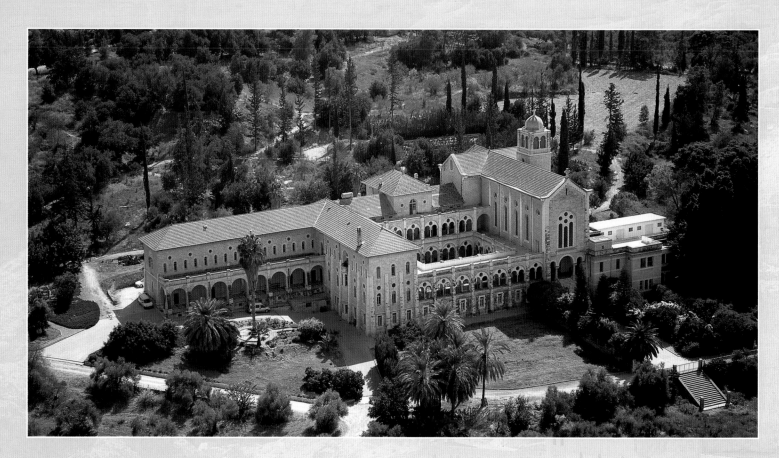

Stemberger, pages 115–19). One of the most famous is Mar Saba (see map, page 162), the Great Lavra (*Megiste Laura*) which was founded by St Sabas (439–532) in 479.

Other anchorites or monks lived in monasteries which were called either coenobitic (living together under a common rule) or idiorrhythmic (from two Greek words meaning "following the rhythm/pattern of one's own way") in which there was greater freedom, under supervision, to follow an individual way. The best-known place where both lavras and monasteries are gathered is Mount Athos, a Greek peninsula stretching into the Aegean Sea. Even earlier than Mount Athos (the first settlements there were made in about the 7th century) were the lavras and monasteries of the Holy Land: some survive only as ruins and remains, but some are still active. They are a mark of the pervasive presence and importance of the Orthodox Church in the Holy Land, not least in the use and ordering of many of the holy places.

Equally pervasive in the Holy Land has been the presence of the Western Church, and again this is in part through monastic and religious institutions (for example, the Hospitallers and the Templars, page 224). A major influence in the move of monasticism to the West was John Cassian (*c*.360–*c*.430). He joined a monastery in Bethlehem when he was a young man, but he left in about 385 in order to learn about monasticism in Egypt where he came under the influence of Evagrius (see above). By about 415 he had moved to the south of France where he founded two monasteries. He then wrote *The Institutes* summarizing the rules that should govern monastic life. This became the basis for many subsequent Rules, especially that of St Benedict (*c*.480– *c*.550). The Rules of all the early Orders in the Western Church except for the Carthusians are based on the Rule of St Benedict.

In contrast to the Eastern or Orthodox Church, the development of monasticism in the West led to the formation of monastic and religious Orders. In each of these, the members may be widely dispersed around the world but all of them are living under a common Rule. From the early monastic origins other communities developed, notably those whose members are known as Friars (*fratres*, "brothers"). Unlike many monks, they are not bound to one place by a vow of stability, and they work or beg to support themselves. Among them, the Franciscans, the Dominicans, and the Carmelites (see page 243) have had a notable presence in the Holy Land.

———————— ✠ ————————

TOP The Cistercian monastery at Latrun, near Emmaus, five miles south-east of Gezer (see map, page 182) was established in 1890. It was destroyed in World War I and rebuilt from 1927. The monks sell honey, olive oil, and wine from their vineyards.

OPPOSITE The 5th-7th century Byzantine monastery complex at Kursi (see map, page 54), looking along the basalt-slabbed road leading to the church. The monastery is on the east shore of the Sea of Galilee, near where Jesus is said to have cast out demons (see Matthew 8:28–34).

OPPOSITE INSET Detail of a bird mosaic from Kursi monastery. Other panels are decorated with fruit and fish. The mosaics of animals were deliberately defaced, probably by members of the 7th-century iconoclastic movement.

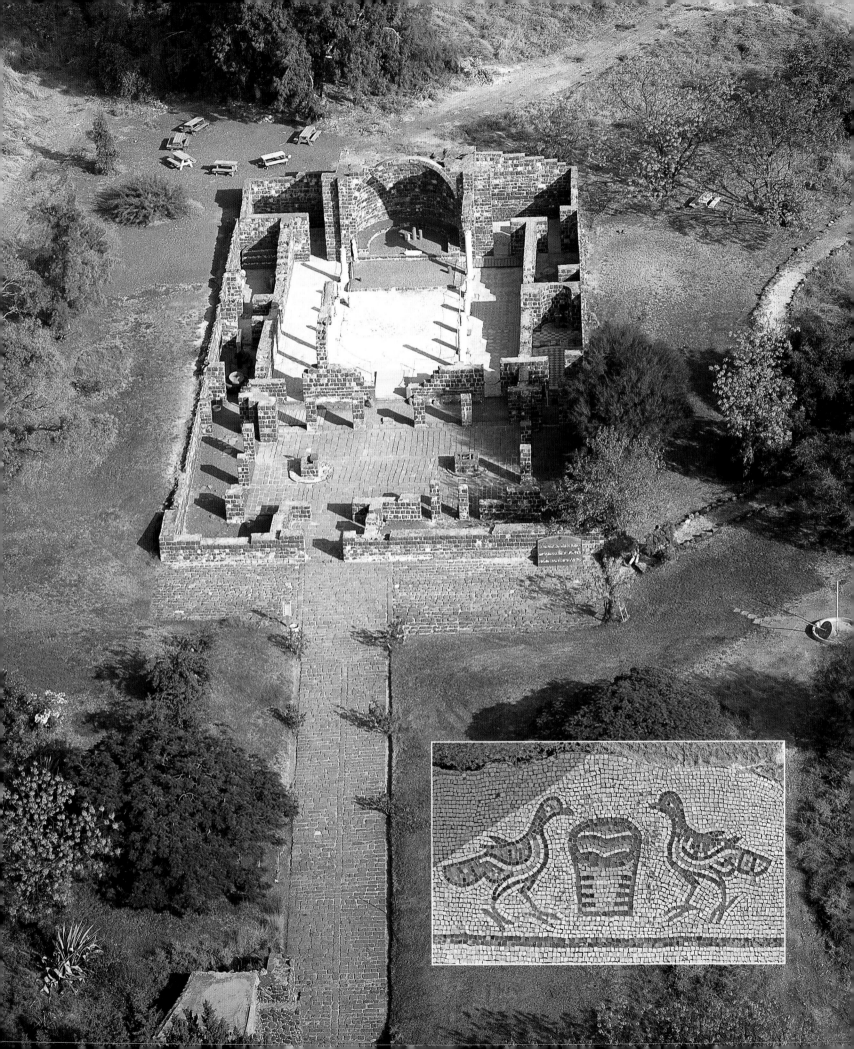

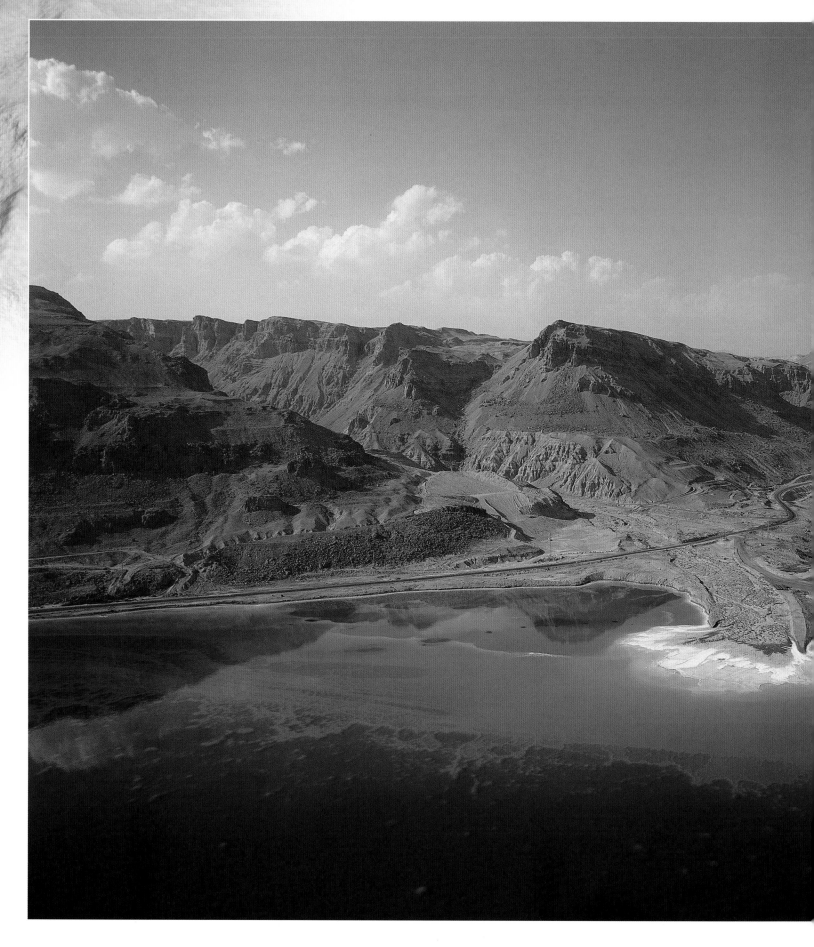

THE DEAD SEA AND EIN GEDI

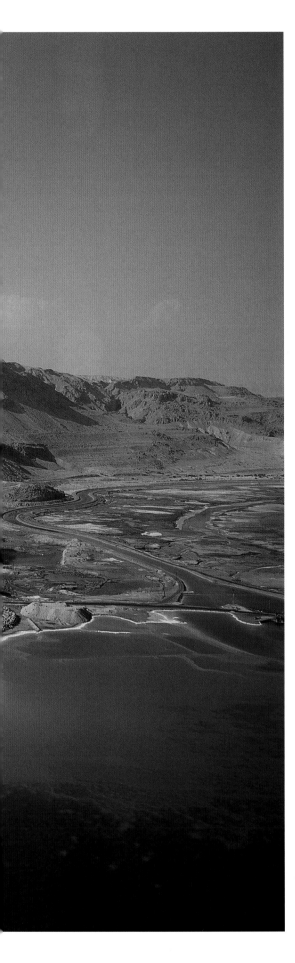

The Dead Sea is the lake into which the River Jordan flows. It is about 50 miles long and 10 miles wide, and it lies 1294 feet below sea level. Because of constant evaporation and very little rainfall, it has a high mineral content. Its biblical names include the Salt Sea, the Sea of Arabah, the Eastern Sea, and the Sea of Sodom. It was called by the Romans Lacus Asphaltitis because of the lumps of bitumen asphalt which sometimes float ashore. On its shores are Qumran (pages 96–101) and Masada (pages 102–107), and two oases with their own springs and streams, Ein Gedi and Ein Boqeq. Near the Dead Sea were the towns of Sodom and Gomorrah, destroyed for their betrayal of the customs and laws of hospitality (Genesis 19.1–11), but their remains and therefore their site have never been found. The Victorian painter, Holman Hunt, descended to the Dead Sea to paint the background for his famous work "The Scapegoat" (see Leviticus 16.6–11), in order to get exact detail of the wilderness. As a result, John Ruskin said, "The purple mountains had been painted crag by crag and the pale ashes of Gomorra grain by grain."

LEFT The Dead Sea shore, between Ein Gedi and Qumran, showing the shallows and salts left by constant evaporation and water extraction. The water temperature reaches 100°F in the summer months. Only a few bacteria can survive in the high concentration of salts and minerals.

WADI ZORQUA ◎ CALLIRRHOE

QUMRAN

DEAD SEA

◉ EIN GEDI

NAHAL ARUGOTH

HEVER CAVES

NAHAL HEVER

NAHAL ZEELIM

▦ MASAD

ABOVE Ein Gedi is the largest oasis along the western shore of the Dead Sea, about 11 miles north of Masada. The ruins beside the oasis reveal almost continuous occupation, and include the remains of a Roman-Byzantine synagogue with impressive 5th-century mosaics.

LEFT Salt pillars on the southern shoreline of the Dead Sea. As the sea has no exit, water is only lost through high rates of evaporation which leaves behind large quantities of solid mass, including salt.

The water level of the Dead Sea used to be maintained by the inflow of rivers, mainly the Jordan, Arnon, Zered, and Kidron, but some smaller rivers as well (see, eg, Ein Gedi below). At present that level is dropping because of increasing water extraction from the rivers. Although the area around is mountainous and largely barren, the small springs and streams allowed human habitation in various places, encouraged by the trade in asphalt which was used in building and shipbuilding, and also for medicine and embalming (in Egypt). Two oases of particular importance were those of Callirrhoe and Ein Gedi.

CALLIRRHOE

Callirrhoe (Greek, "good spring") is on the north-eastern shore of the Dead Sea, and it was famous, even in the Roman world, for its hot mineral springs. It was here that Herod, according to Josephus (see page 80), went in the desperate days of his final illness:

He passed over Jordan where he used the warm waters of Callirrhoe which run into the Lake Asphaltitis [the Dead Sea] and which are so sweet that they are also used for drink. There the physicians caused his body to be bathed in hot oil, but by this he was so weakened that his senses failed and he was as though he were dead.

Earlier, Herod built here a palace and harbour the remains of which have been found.

EIN GEDI

Ein Gedi (also En Gedi) is on the western shore of the Dead Sea, made habitable by two streams, Nahal Arugoth and Nahal Hever (sometimes called Nahal David because of David's connection with the place and David's Pool). The name means in Hebrew "spring of the young goat", and for more than 3000 years its fruitful prosperity has been renowned. In the Bible, in the Song of Songs, the beauty of the poet's loved one is compared to the place: "My beloved is to me a cluster of henna blossoms in the vineyards of En-Gedi" (1.14). In Jewish imagination, Ein Gedi was a place of perfection and a resource of all that is good (see, for example, Ezekiel 47.10). It appears in the hymn praising Wisdom, in Ecclesiasticus (Sirach) 24.13–14. Wisdom says

RIGHT The Apple of Sodom, first described by Josephus, grows on the borders of the Dead Sea. The ripe fruit looks ready to eat, but "dissolves into smoke and ashes" when plucked, as it is largely filled with air.

EIN BOQEQ

NAHAL PARSA

NAHAL BOQEQ

POSSIBLE SITE OF SODOM

> I grew tall like a cedar in Lebanon,
> and like a cypress on the heights of Hermon.
> I grew tall like a palm tree in En-gedi,
> like a fair olive tree in the field,
> and like rose bushes in Jericho;

Because of the natural resources, especially water, the site was occupied at least as early as the time of the Canaanites: there are the remains (stone foundations) of a Canaanite temple dating from about 3000 BCE. It was here that David took refuge from Saul and, in a dramatic and vivid episode, spared Saul's life. As a result, they were reconciled. The episode began with Saul in pursuit of David, coming very close to capturing him. Then he received news that the Philistines were raiding his land, so he withdrew (see box below).

The first Jewish occupation of Ein Gedi seems to have begun in the 7th century BCE. It became an important centre for the Hasmonaeans, and a fort was built nearby dating from that time. This was destroyed by the Romans on their way to attack Masada, and Pliny in his *Natural History* (1st century) lamented the desolation of the once prosperous place: "Its groves of palm trees are, like Jerusalem, a heap of ashes."

The Romans in their turn built a fort, the remains of which go back to the 2nd century CE. During Bar Kokhba's revolt against Rome (132–5), the area became a centre for resistance. In 1960, the exploration of caves on the Nahal Hever began during which important finds were made in the so-called Cave of Letters and Cave of Horrors.

The caves were used by the resistance fighters to take refuge, but the Romans built a camp on the cliffs above them. The discovery of the skeletons of those whom they starved to death led to the name of "Horrors". In another cave, immediately below the camp, were also found many objects, including letters (hence the name given to this cave) hidden in a waterskin along with other precious items. The letters come directly from those involved in the Revolt. One, for example, is a complaint to "the men of Ein Gedi": "From Shimeon bar Kosiba to the men of En Gedi, to Masabala and to Yehonathan bar Beayan, peace. In comfort you sit, eat and drink from the property of the House of Israel, and care nothing for your brothers."

Despite the disaster of the 2nd Revolt, Jewish occupation continued. It was of a sufficient size for a synagogue to be built. The surviving remains date from the 5th century CE, although a synagogue was first constructed in about the 2nd century. There is a mosaic floor and also an inscription which is unusual: it combines Jewish names with the signs of the zodiac, and lays down careful rules governing relations with non-Jews. Further to the west, the Byzantines built a fort.

Ein Gedi is today a popular tourist site and nature reserve.

TOP RIGHT The 250-acre oasis at Ein Gedi, with ancient ruins to the bottom left foreground. The oasis was historically famous for dates, therapeutic, and aromatic plants. Today it is the location of a kibbutz, national park, and botanical garden.

BOTTOM RIGHT The Dead Sea coastline, with pools left by receding water, due to the diversion and extraction of incoming water in recent decades. The result is that the southern end is very shallow, except where it is channelled by aqueducts for the purpose of extracting minerals.

DAVID SPARES SAUL'S LIFE

David then went up from there, and lived in the strongholds of En-gedi. When Saul returned from following the Philistines, he was told, "David is in the wilderness of En-gedi." Then Saul took three thousand chosen men out of all Israel, and went to look for David and his men in the direction of the Rocks of the Wild Goats. He came to the sheepfolds beside the road, where there was a cave; and Saul went in to relieve himself. Now David and his men were sitting in the innermost parts of the cave. The men of David said to him, "Here is the day of which the Lord said to you, 'I will give your enemy into your hand, and you shall do to him as it seems good to you.'" Then David went and stealthily cut off a corner of Saul's cloak…Then Saul got up and left the cave, and went on his way.

Afterwards David also rose up and went out of the cave and called after Saul, "My lord the king!" When Saul looked behind him, David bowed with his face to the ground, and did obeisance. David said to Saul, "…See, my father, see the corner of your cloak in my hand; for by the fact that I cut off a corner of your cloak, and did not kill you, you may know for certain that there is no wrong or treason in my hands. I have not sinned against you, though you are hunting me to take my life… As the ancient proverb says, 'Out of the wicked comes forth wickedness'; but my hand shall not be against you…" When David had finished speaking these words to Saul, Saul said, "Is this your voice, my son David?" Saul lifted up his voice and wept. He said to David, "You are more righteous than I; for you have repaid me good, whereas I have repaid you evil … So may the Lord reward you with good for what you have done to me this day."
(1 Samuel 23.29–24.4; 24.7–9, 11, 13, 16–17, 19)

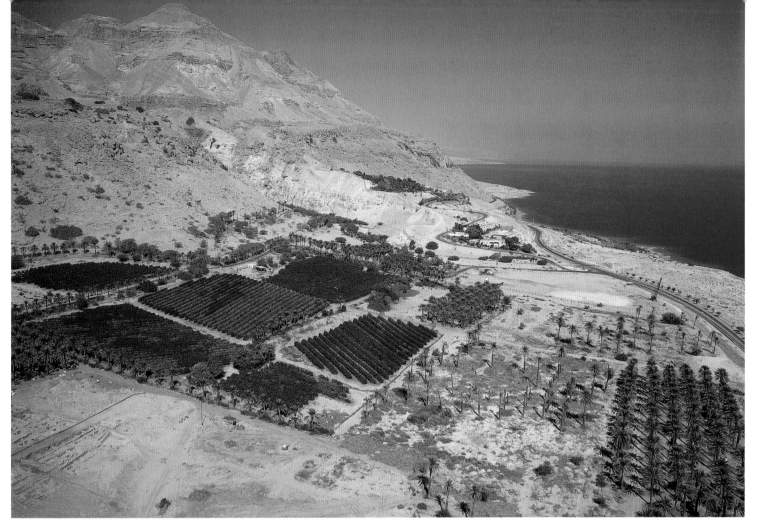

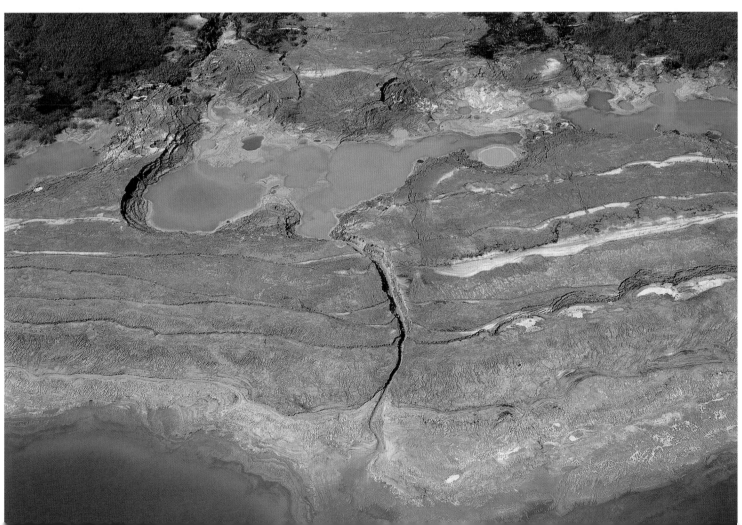

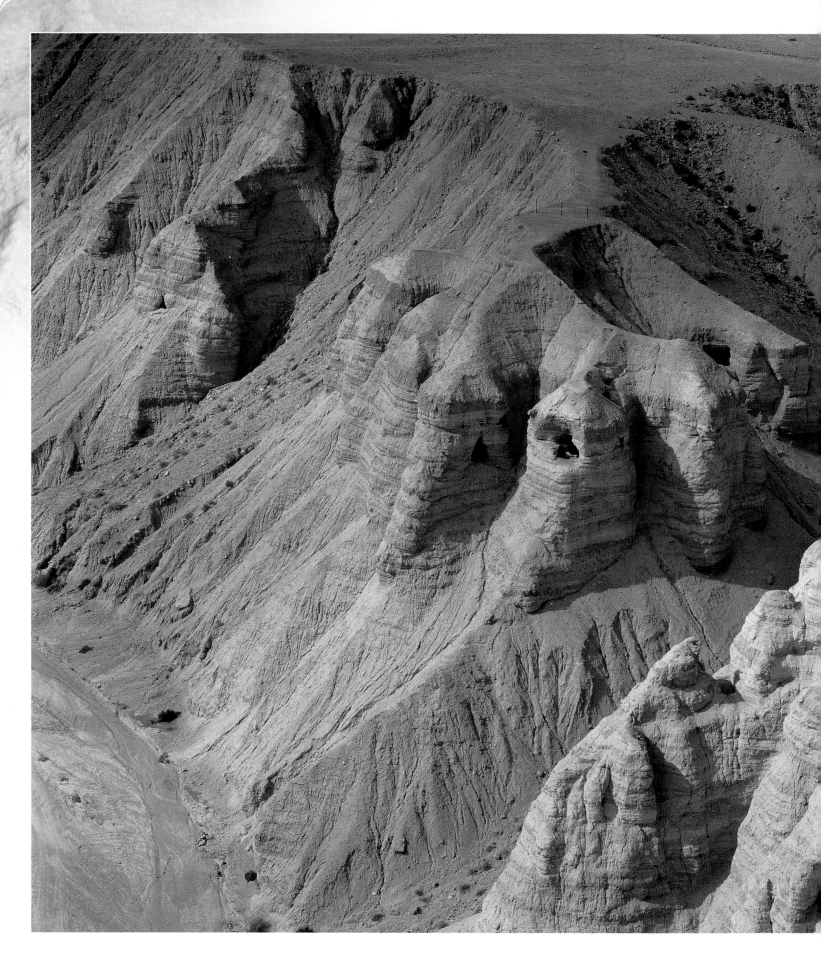

QUMRAN

The ruins of Qumran, Khirbet Qumran, are on the shores of the Dead Sea at its far northwest end. The Dead Sea is remote and inhospitable, despite a few oases like Ein Gedi (see pages 93–4) and Ein Boqeq, now a resort, with their springs of water – the word *ain* means "spring" or "well". Because it was so remote, it proved to be a good refuge. For example, near its southern end, Herod built his formidable fortress and palace at Masada (see pages 104–107). But the Dead Sea was a refuge also for people who were the complete opposite of Herod. They were people who sought to escape from the uncleanness and temptations of the world in order to find God. Among them were those who built a community at Qumran. It was near Qumran in 1947 that the famous Dead Sea Scrolls were found. Far-fetched and in fact absurd claims have sometimes been made about them – for example, that they make Christian claims about Jesus untrue. Whereas in truth the Scrolls offer unique insight into the beliefs and practices of a small Jewish community, both before and at the time of Jesus, who sought God by living in this remote place.

LEFT Aerial view of some of the Qumran caves from the southeast. The Dead Sea Scrolls were found in seven caves close to the settlement at Qumran (see the track leading off to the right), and in four caves further away.

Khirbet Qumran is on the north-west side of the Dead Sea. To the north and west are deep ravines, and to the south is the Wadi Qumran. The site was inhabited from early times (the oldest occupation so far found was in the Iron Age II period). It was supplied with water from a spring, Ain Feshkha, one and a half miles to the south.

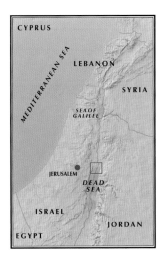

Qumran was abandoned during the Hellenistic period. Its gradual resettlement was largely destroyed by John Hyrcanus I during the course of his campaigns to extend the Hasmonean empire. It was then again destroyed by an earthquake and an ensuing fire in 31 BCE. It was, Josephus records (*Antiquities* 15.121), "an earthquake in Judaea of a kind not seen before". The new settlement was built on the same plan, but this too was destroyed by the Romans in 68 CE as they moved to secure Judaea during the 1st Jewish Revolt.

The site sustained a complex range of buildings on an area roughly 100 x 100 yards. To the east there is a cemetery containing more than 1000 bodies, all of males except for some women and possibly one child at the side. It is important to note that according to what Zias (page 452) calls "five defining Islamic burial traditions", some of the burials are post-Byzantine Bedouin burials.

The site was of interest to archaeologists from an early date: a Frenchman, Clermont-Ganneau, had explored the cemetery in 1873. But interest was dramatically transformed in 1947 by a Bedouin shepherd, Muhammad adDib (the Wolf). He was looking for a lost sheep, and he threw his stone into a cave about three-quarters of a mile north of Khirbet Qumran. Hearing the sound of a breaking pot, he looked into the cave and found the first of the ancient manuscripts that have subsequently been known as the Dead Sea Scrolls. Eventually many more caves were found containing further manuscripts and fragments: seven were close to Khirbet Qumran, four (like the first cave) were further away.

THE DEAD SEA SCROLLS

The Scrolls were an extraordinary find. They include all books of the Bible (except for Esther) far pre-dating any other manuscripts, commentaries on books of the Bible, many non-biblical books, prayers, hymns and liturgies, and texts containing the beliefs of a new religious community together with rules for its conduct – the so-called Sectarian Documents.

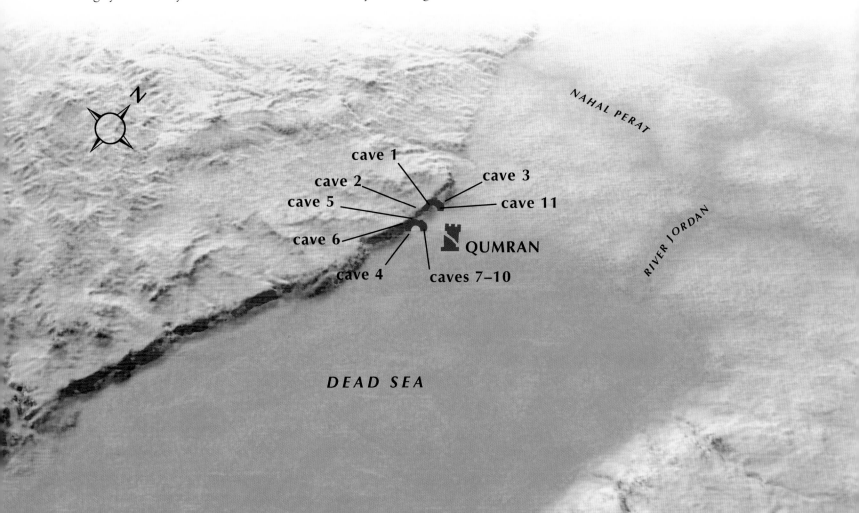

Most of the texts (apart, obviously, from the books of the Bible) were entirely new and unknown – though not quite all: at the end of the 19th century, two remarkable Scottish women, Miss Gibson and Miss Lewes, alerted the Jewish scholar, Solomon Schechter, to a large hoard of manuscripts and fragments that they had found in a genizah in Cairo, including one of a text subsequently found in several manuscripts among the Dead Sea Scrolls.

A genizah is a room or cupboard in a synagogue where texts of books are placed which are no longer in use but which contain the written name of God and are therefore too holy to be thrown away or destroyed. In 1896, Schechter went to Cairo and was overwhelmed by the mass of material that he found. Among the manuscripts was the Damascus Document which at the time was unknown, but which has also turned up at Qumran in caves 4, 5, and 6.

The period during which the Scrolls were produced has gradually been established, by improving techniques of radiocarbon dating, as running from about 200 BCE to 70 CE, with the majority having been written during the 1st century BCE.

The Sectarian Documents found at Qumran reveal a sect that believed itself to be the true Israel. They had had to separate themselves from the mainstreams of Judaism, above all from the Temple: the Temple had been taken over by illegitimate high priests and priests from the time of the Hasmoneans onward (on this, see the Introduction, page 19), and the sect looked forward to a mighty war when the usurpers in the Temple in Jerusalem would be

BELOW The ruins of Qumran from the east (see the close-up on page 101). The entrance to one of the hillside caves where the Scrolls were discovered is just to the left of the centre of the picture.

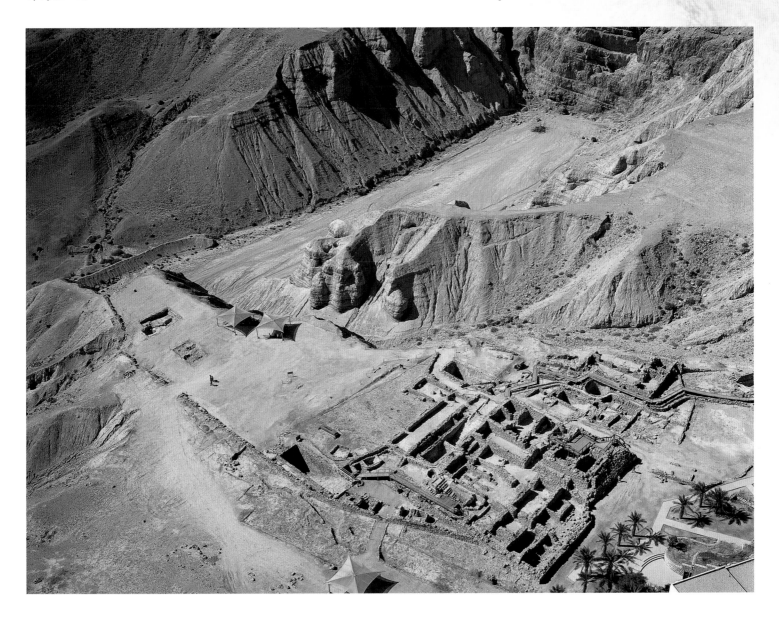

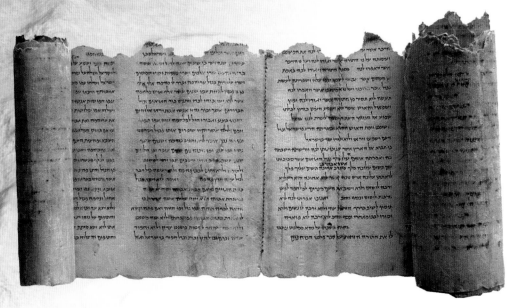

LEFT Close-up of part of the Temple Scroll found in cave 11 at Qumran. It is a collection of laws relating to worship and the Temple. The Scroll is 28 feet long, the longest so far discovered. Many of the 800 or so documents found since 1947 are just tiny fragments.

OPPOSITE TOP The excavations at Qumran from the west, looking over the water supply system towards the tower (top left). To the right of the tower is the bench room and Scriptorium where the Scrolls may have been written.

OPPOSITE RIGHT The cistern complex at Qumran from the south, which stored water brought from the Wadi Qumran by an aqueduct. Some of the cisterns seem to be associated with a potter's shop and workshops, others with ritual bathing.

thrown out and the true Israel (the community) would be restored in triumph to its legitimate place.

This means that the sect of these documents was trying to obey one of the most fundamental commands given by God to the Jews. It is the command to be holy: "For I am the Lord your God; sanctify yourselves therefore, and be holy, for I am holy …. For I am the Lord who brought you up from the land of Egypt, to be your God; you shall be holy, for I am holy" (Leviticus 11.44, 47). But what does it mean in practice to be holy? Being close to the holiness of God means keeping away from all that is abhorrent to him, from all that is unclean and unholy – and that is easier to achieve, or at least to attempt, in the wilderness than it is in a Hellenistic city, let alone in the company of Roman soldiers or of Herod.

That is why one of the Sectarian Documents, The Community Rule, states (IQSerakim 8.13) that those who become members of the community according to the Rule "will separate themselves from wherever the wicked live in order to go into the wilderness to prepare there the way of him [God], as it is written, In the wilderness prepare the way [] make straight in the desert a highway for our God". (Isaiah 40.3; compare the application of the same text from Isaiah to John the Baptist in Matthew 3.3; Mark 1.3; Luke 3.4).

The Qumran sect was not alone in seeking holiness in the desert. Three authors of the 1st century CE, the Jewish writers Philo and Josephus, and the Roman author Pliny the Elder, have left accounts of a religious movement of the period called the Essenes. Although there are many points of difference between the accounts of those authors and of the sectarians themselves, there are enough similarities to lead many people to the conclusion that the Sect and the Essenes are the same – or at least that they were extremely closely associated; and that Khirbet Qumran, the ruin at Qumran, was the home of the Essene sect: Pliny the Elder actually states

(*Natural History* 5.73) that the Essenes lived just north of Ein Gedi (see pages 92–93).

An association between the sect and the Essenes is clear, but some caution is needed before stating, as many books do, that the sect at Qumran was an Essene community whose members built a community centre on the shores of the Dead Sea near which they hid their documents when the Roman army drew near. It may conversely be the case, as some have argued, that the site was originally a kind of country estate for the Hasmoneans, who used it for producing oil and honey from dates, and that only later was it handed over to the Essenes – perhaps by Herod who had by then built for himself more exotic retreats nearby, as, for example, at Herodion (pages 174–179) and Masada (pages 102–107).

It is also unwise to assume that the texts found in the Caves necessarily express the beliefs of the Community that put them there. Texts can be collected or copied in a "library" that do not necessarily express the views of those who collected or copied them. Other manuscripts have been found even further away, for example in the Wadi Murabbaat, half-way between Khirbet Qumran and Ein Gedi, and much nearer Herodion.

What in fact seems likely is that the area of the Dead Sea was a brilliant hiding place for any seeking refuge from those with whom they had come in conflict, and especially with the Jewish, Herodian, and Roman authorities who were running the Temple and Judaea at this time. Whatever its "country estate" origins may have been, it became a kind of right-wing refugee camp where the Sectarians took in those who were "on the run". Thus it is not surprising that the Damascus Document turns up in both Qumran and Cairo, because the Zealots, the extreme resistance fighters against the Romans, fled to both taking their documents with them. The Sect is in many ways identifiable with the Essenes, but it contained a mixed bag of other memories (and texts) as well.

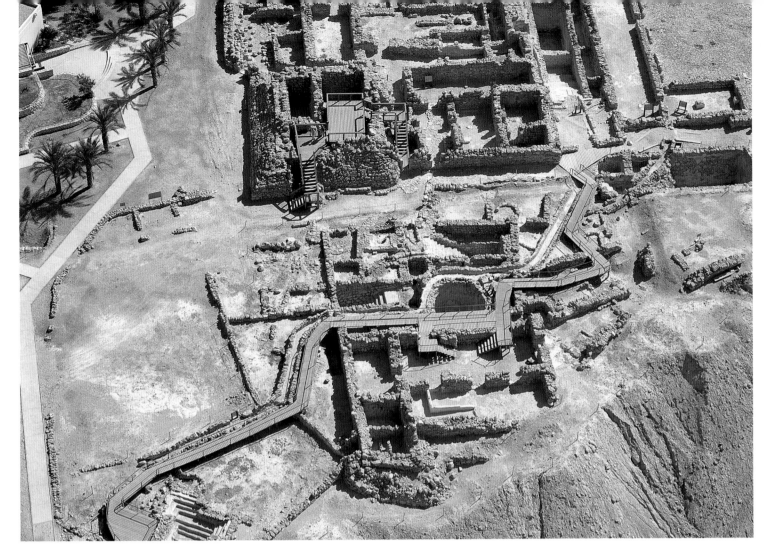

What is certainly clear is that the Sectarian Documents accept that all humans are as nothing before God, but that by God's power the faithful among them will receive their triumphant reward. The Community Rule ends (IQSerakim 11.20–3):

> Who can contain your glory, and what is a son of man [confirming one part of the sense in which Jesus used the phrase, page 44; some translations have here "the son of man", but that is wrong, because the word "the" has been added later] in the midst of your wonderful deeds? What shall one born of a woman amount to before you, moulded from dust and his body the food of worms? He is a shape fashioned together heading for the dust. What shall a moulded shape answer, and what advice will it understand?

In contrast, the War Scroll (much damaged though it is) ends with a hymn of triumph (IQMilhamah 19.1, 4):

> Our mighty one is holy and the king of glory is with us …. Lay your hand on the neck of your enemies, and your feet [on the slain]. Strike down the nations that oppose you and with your sword eat up flesh.

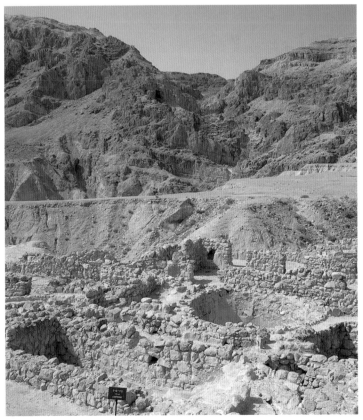

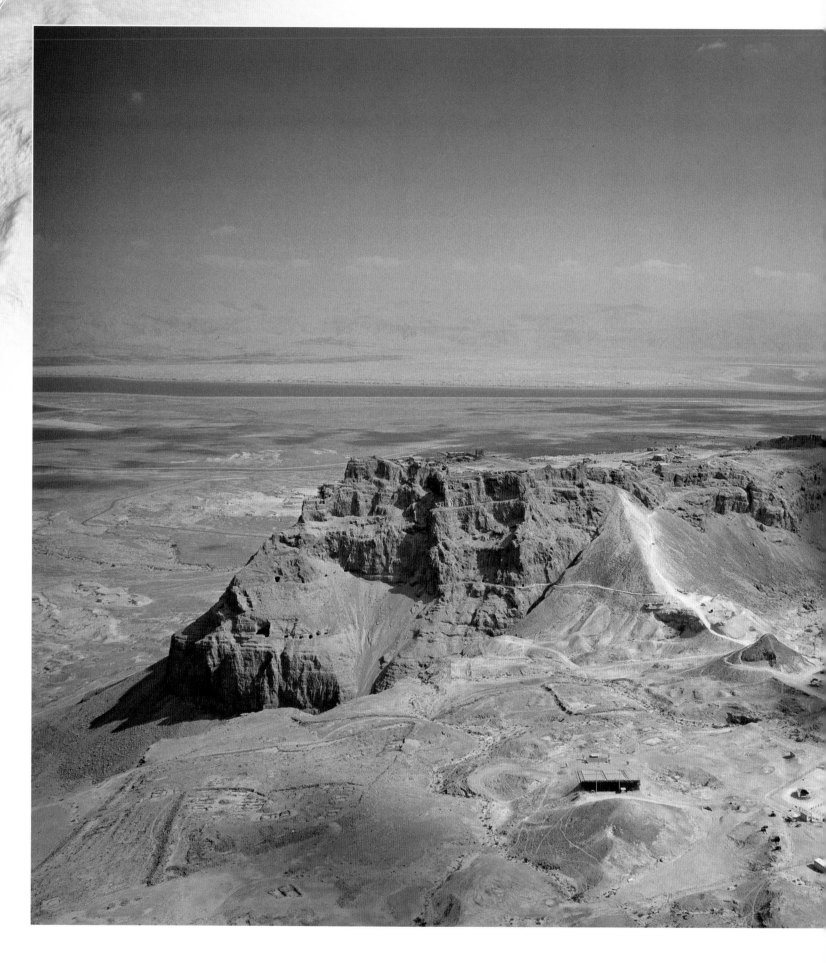

MASADA

Masada, like Jerusalem, exists as much in memory and imagination as it does on the ground. It is the place where the final defence was made against the Romans after the failure of the 1st Jewish Revolt in 70 CE. Masada held out until 72–3, and, according to accounts of the time, its defenders when it eventually fell killed themselves rather than surrender. Masada became a symbol of Jewish resistance particularly against overwhelming odds. So, for example, when Jews fled from persecution in Europe (long before Hitler), they went to Palestine in one Aliyah after another – Aliyah means "going up", especially to the Holy Land, as in Genesis 13.1, "Abram went up from Egypt." In the 3rd Aliyah after World War I, Yitzhak Lamdan arrived in Palestine from the Ukraine, and he wrote an epic poem, *Masada*:

> He was writing of the people he knew, the youngsters who had returned to the Holy Land on a prayer and a herring skin, with empty pockets, famished bellies, and in their hearts a dream of the secular Utopia they would create in the Jewish National Home. For Lamdan, then, the epic of Masada was the epic of the Third Aliyah. (Sacher, *A History of Israel*, page 152)

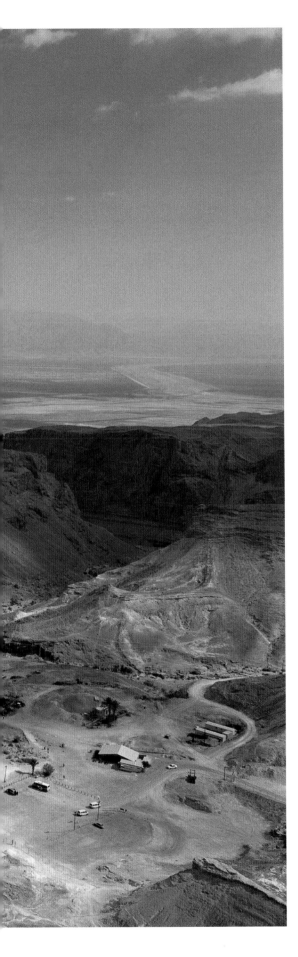

LEFT Masada, looking towards the Dead Sea. The 328 feet ramp in the centre was constructed by the Romans in 72–3 CE because the cliffs and defences were otherwise impregnable.

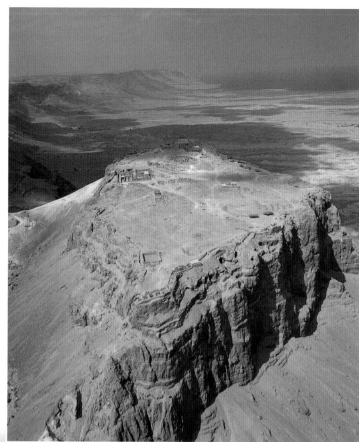

Masada (Hebrew for "stronghold") is a natural stronghold, a rock rising out of the Judaean desert to a height of 1300 feet. It is near the western shore of the Dead Sea, about 12 miles south of Ein Gedi (see pages 92–93).

Although in itself it seemed impregnable, it was not near any centre of population, and as a result it was not fortified until the Hasmonean period. Josephus (*War* 7.285) says that the first fort was built by Jonathan. That was the name of the brother of Judas Maccabaeus, the leader of the Maccabean revolt (167–164), but it was also the name in Hebrew of Alexander Jannaeus (103–76), who is far more likely to have

�֎

LEFT Masada from the south. The virtually flat summit is about 710 x 328 yards. Thanks to the dry climate, delicate items, including prayer shawls, wicker baskets, and scrolls, have been preserved in the ruins.

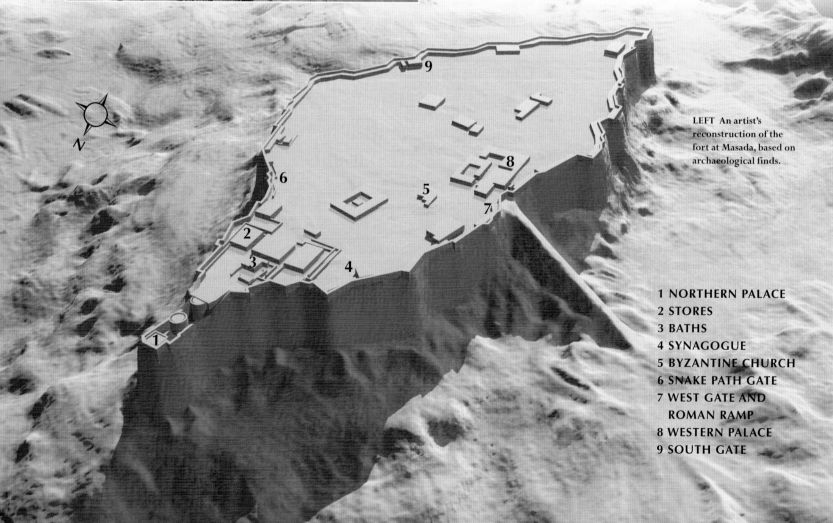

LEFT An artist's reconstruction of the fort at Masada, based on archaeological finds.

1 NORTHERN PALACE
2 STORES
3 BATHS
4 SYNAGOGUE
5 BYZANTINE CHURCH
6 SNAKE PATH GATE
7 WEST GATE AND
 ROMAN RAMP
8 WESTERN PALACE
9 SOUTH GATE

been the builder. Josephus also described the natural strength of Masada (see box right).

Having said that the first fortress was built by Jonathan, Josephus then added that "Herod after him bestowed great labour and cost in fortifying it" – as indeed he did! He turned it into a walled and fortified citadel of immense strength and corresponding splendour. Provision was made for a strong garrison to endure a long siege, but the main construction was of a complex of palace buildings for Herod and his family. Of all this, Josephus has left a careful description (see box page 106) though one that is not entirely confirmed by excavation.

That final resistance proved daunting indeed. After Jerusalem fell to the Romans in 70, the Zealots did not give up. They became resistance fighters, and took refuge, some in Egypt, but others less far away in the caves around the Dead Sea. Even more defiantly, they took over Masada where they intended to make a last stand.

The Romans moved first against Herodion and another natural stronghold, Machaerus. It was not until 72 (or perhaps, as most

———————— ❈ ————————

BELOW The northern end of Masada from the west, showing Herod's northern or "suspended palace" extending down the mountain on three levels, almost 120 feet apart. He also built another palace on the west.

MASADA'S NATURAL STRENGTH

It is a huge rock, very high on every side, and the valley below is so deep that one can scarce see the bottom, all rocky and inaccessible even to animals. The only exception are two places where there is a difficult passage to it, one from the lake Asphaltitis [the Dead Sea] towards the east, and the easier of the two on the west side. The first is called "the snake", taking its name from its narrowness and the crooked turnings: for the rock seems as it were broken in sunder, and by little and little often returns again into itself, and is by degrees extended in length, so that he who goes that way can make no haste, but must first step with one foot first upon one place, and the other upon another, and must stand upon one foot while he removes the other. Anyone who falls is sure to be killed in the fall, for there is such a ravine on either side between the rocks that it is able to terrify the boldest man alive. When one has gone 30 furlongs by this way one comes to the top of the hill, which is not steep but has a flat plain upon it. (Josephus, *War* 7.280–4)

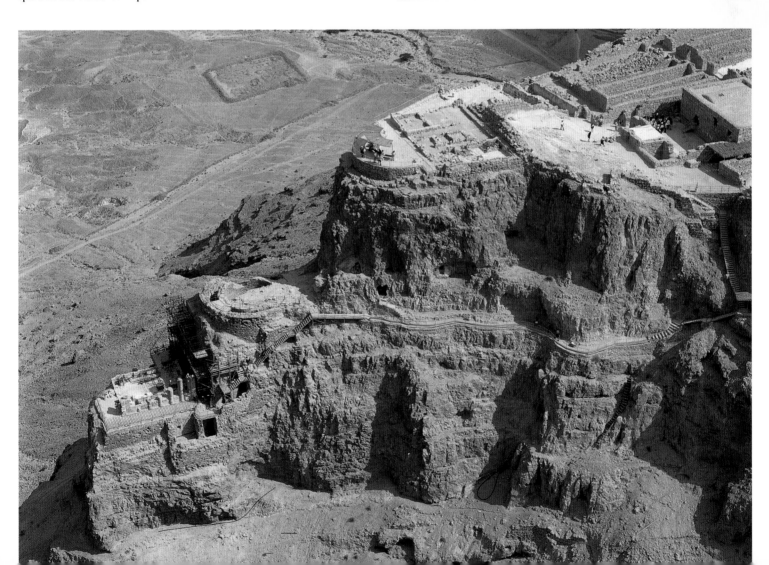

HEROD'S PALACE AT MASADA

Herod built in this place a palace for himself, the way to which was on the west side within the castle wall, whose prospect was towards the north. He surrounded this with a very strong wall, in the corners of which he built four very firm towers. It was very sumptuous within, having various rooms, galleries and baths, supported in every place with pillars, every one of which was made of a single stone …. For every house, and in the top of the hill, and round about the palace, he hewed many cisterns out of the rock to hold water, so that by this means water was as plentiful as though they had had fountains within the castle …. Thus was this fortress strengthened both by art and nature. The provision within the castle was admirable for its abundant plenty, for there was corn sufficient for many years, besides wine and oil, and all sorts of pulse, and great quantity of dates, … and the Romans found the remains of the fruits had not corrupted. There was also found all manner of armour in great quantity which Herod had made, and which would have armed 10,000 men; also much unwrought iron, brass and lead, so that one may judge the provision to have been made for some great cause. It is reported that Herod prepared that castle for his refuge, when he doubted two great dangers: first, that the people of the Jews would depose him, and create as kings those whose ancestors had before reigned. The other, which was more considerable, arose from his fear of Cleopatra, queen of Egypt, who without concealing her intent often requested Antony that Herod might be slain, and that she might have the kingdom of the Jews given to her. And it was a great marvel that Antony, doting so upon her, did not fulfil her request. Herod upon these apprehensions built Masada, and left it so furnished that without taking it the Romans could not put an end to the war against the Jews. (Josephus, *War* 7.286–303)

think, 73) that Flavius Silva arrived at Masada. It was impossible to take such a place by direct attack, so he began a long siege. To reach the walls on the summit, he built a huge ramp upward (it can still be seen). At last he could attack, but, having breached the wall, the Romans returned to their camp for the night. Before they came back next day, the defenders killed their wives and children, and then they killed each other and themselves. When the Romans returned, "they encountered the mass of the slain, but instead of exulting as over enemies, they admired the nobility of their resolve and the contempt of death displayed by so many in carrying it, unwavering, into execution" (Josephus, *War* 7.406).

The account of Josephus (he was not there himself) is thought now by many to have been over-dramatized and exaggerated, but that is completely irrelevant to the image of Masada as the final heroic defiance against overwhelming odds. When Yigael Yadin excavated Masada, he commented:

An archaeological dig here was unlike an excavation at any other site of antiquity. Its scientific importance was known to be great. But more than that, Masada represents for all of us in Israel and for many elsewhere, archaeologists and laymen, a symbol of courage, a monument of our great national figures, heroes who chose death over a life of physical and moral serfdom. (Yadin, page 13)

"Never again shall Masada fall", a line from Lamdan's epic poem (below) became a slogan of Israel's independence, and Masada was chosen in 1948 as the place where the ceremony should take place for the swearing-in of the Israeli Defence Forces. Subsequently Yadin's interpretation of the evidence has been challenged and questioned (see, for example, Zerubavel or Schwartz), but that is irrelevant to the image of Masada in the unfolding history of Israel. Howard Sacher (quoted above, page 103) took his *A History of Israel* down to the end of the Yom Kippur War (1973) and its immediate aftermath. Israel had won the war but at a very high cost. Could they recover and resist any further attack? He ended his book with these words (page 835):

Was there yet time? The Jews surely had come too far, had endured too much, to forfeit this last gallant citadel of their reborn sovereignty. Even so, the race would be mortally close, for it was to be waged less against the surrounding enemy than against the incipient blight within the Israeli people themselves. They knew it well by now, as Yitzhak Lamdan had known it in his exhortation to the Third Aliyah:
 In the hands of a few on the wall
 This dream and its solvent were stored.
 If this time you are merciless, Lord,
 And desire not this dream at all,
 Its sacrificial answer do not regard –
 Even now,
 God,
 Save Masada!

LEFT Storerooms, cisterns, and synagogue at the northern end of Masada. Many broken storage jars which once contained quantities of oil, wine, grains and other foodstuffs have been found in the storerooms.

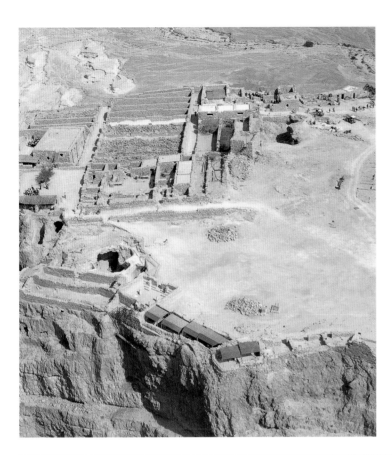

BELOW Interior of a tannery. Tanneries were used to tan skins for leather and to make parchment. They were usually built well away from towns and the prevailing wind.

BOTTOM View west from the top of Masada to the largest of the Roman legionary camps. It is just outside the seven mile-long circumvallation wall built to connect the eight camps and prevent escape.

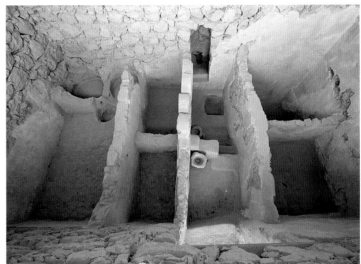

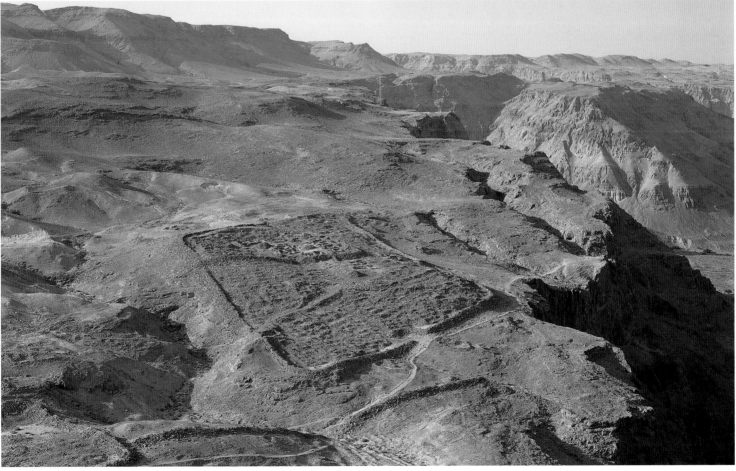

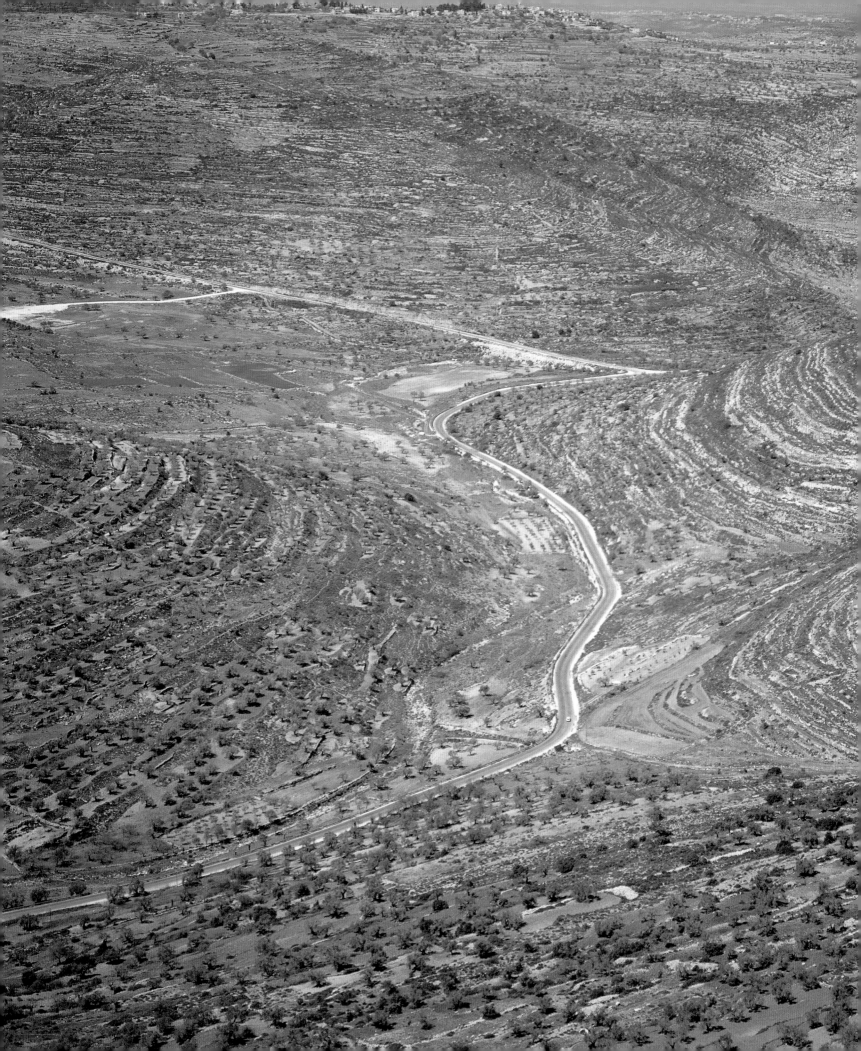

2 THE HILL COUNTRY

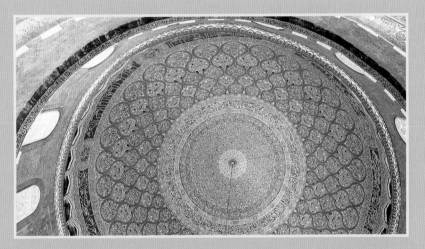

Running down the length of the Holy Land is a spine of mountain and hill country. The mountains and hills are not continuous. There are important passes through them, and they themselves are often broken up by valleys. In the North are the mountains of north Galilee including the Meron mountains. In south Galilee the hills lie in the form of east/west ridges, and are more gentle, though they include the isolated Mount Tabor. The central hill country connects to the coast through the hills leading to Mount Carmel. The central mountains and hills, often called the hill country of Ephraim, include Samaria (with Mount Gerizim) and the Bethel hills until they reach the Judaean hills which embrace Jerusalem. South of Jerusalem are the Hebron hills (to the West they are called the Shephelah) which lead eventually to Beer Sheba and the Negev. The southern hills are also called the hill country of Judah.

MOUNT TABOR

HAR TAVOR

The hilly and mountainous backbone running down the Holy Land is dominated in the north by Mount Tabor. Tabor is not a high mountain, but it stands alone in the plain of Esdraelon and from its summit it is possible to see Mount Carmel to the west and Mount Hermon to the north. It was therefore grouped with them as the high and strong places that demonstrate the power of God in creation. Psalm 89 celebrates the steadfast love with which God keeps his covenant with David, and it does so by pointing to the equally steadfast way in which God sustains his creation:

> O Lord God of hosts, who is as mighty as you,
> O Lord?
> Your faithfulness surrounds you ….
> The north and the south – you created them;
> Tabor and Hermon joyously praise your name
> (Psalm 89.8, 12).

For the prophet Jeremiah, the indestructible strength of Tabor and Carmel is like the power of Babylon coming to destroy the Egyptians (on the Babylonian defeat of the Egyptians, see page 16):

> …One is coming like Tabor among the mountains,
> and like Carmel by the sea.
> Pack your bags for exile, sheltered daughter Egypt!
> For Memphis shall become a waste,
> a ruin, without inhabitant. (Jeremiah 46.18–19)

LEFT Mount Tabor, standing out from the plain of Esdraelon (the Jezreel valley) in Lower Galilee, is one of the traditional sites of the Transfiguration of Jesus. The limestone plateau has been crowned by commemorative churches since Byzantine times.

Mount Tabor is just over 1900 feet high, with a shape like an inverted bowl. It was known in biblical times that it had been a place of Canaanite worship. The prophet Hosea in the 8th century could still refer to Tabor as a place where the Israelites were snared in the net of Baal-worship (5.1).

The presence of the Canaanites and the worship of Baal is not surprising, since the area around the Sea of Galilee was inhabited from the earliest prehistoric times. North of Tabor and closer to the Sea of Galilee, there are several caves which show how long ago humans were inhabiting the area, long predating the Canaanites. The Amud Caves (Mearat Amira) show traces of Neanderthal and human habitation going back for about 200,000 years (see pages 63–4).

During the settlement of the Land, Mount Tabor was on the boundary of Issachar, Zebulun and Naphtali. It was therefore a key place for the rallying of help when it was needed for battle. It was thus here that Deborah and Barak gathered support for the campaign against Jabin, the Canaanite king of Hazor:

LEFT The Church of the Transfiguration, Mount Tabor, from the east. It was constructed by the Franciscans between 1921 and 1924 on Byzantine and Crusader foundations. The impressive exterior, based on Syrian church architecture of the 4th-6th centuries, is notable for the towers at the west end, which contain the chapels of Moses and St Elias (Elijah).

CHURCH OF THE TRANSFIGURATION

QARNE HATTIN

SEA OF GALILEE

MOUNT TABOR

RIVER JORDAN

NAHAL YARMOUK

Then the Israelites cried out to the Lord for help; for he [Jabin] had nine hundred chariots of iron, and had oppressed the Israelites cruelly twenty years. At that time Deborah, a prophetess, wife of Lappidoth, was judging Israel …. She sent and summoned Barak … and said to him, "The Lord, the God of Israel, commands you, 'Go, take position at Mount Tabor, bringing ten thousand from the tribe of Naphtali and the tribe of Zebulun. I will draw out Sisera, the general of Jabin's army, to meet you by the Wadi Kishon with his chariots and his troops; and I will give him into your hand.'" (Judges 4.2–7)

For Christians, Mount Tabor has a particular value because it has been identified with the Mount of Transfiguration, the occasion when Jesus led three of his disciples up a high mountain where "he was transfigured before them, and his face shone like the sun, and his clothes became dazzling white" (Matthew 17.2. See box, page 114).

None of the Gospels gives a name to the high mountain. According to the Pilgrim of Bordeaux (page 28) it was the Mount of Olives, but that cannot be right. Three other sites have been suggested: Mount Carmel, Mount Hermon, and Mount Tabor. Mount Tabor has become the traditional site, although it is not a high mountain. Mount Carmel and Mount Hermon are high enough, but Mount Carmel is not in the area where Jesus is reported to have been ministering.

Of the two, Mount Hermon and Mount Tabor, which is the more likely? A problem lies in the description of the movements of Jesus at the time. He had been in the area around Caesarea Philippi. Six (or eight, Luke 9.28) days later he arrived at the Mount of Transfiguration. Then he passed through Galilee (Mark 9.30) and reached Capernaum at the north end of the Sea of Galilee. But Luke 9.51 states that after the Transfiguration "he set his face to go to Jerusalem".

Of course there is no attempt in the Gospels to give an exact itinerary or travel diary of the movements of Jesus. But those who seek to identify the places where Jesus went have to take such hints and clues as they are. These suggest that a journey south to Mount Tabor makes little sense when there is a perfectly good (and high) mountain at hand – and that is why Mount Hermon has been suggested as the more probable site.

On the other hand, the position of Mount Tabor, rising as it does out of the plain, makes it look like a mountain – and in fact its

———— � ————

BELOW The Church of the Transfiguration, Mount Tabor, and the adjoining Franciscan monastery. To the right is the 19th-century Greek Orthodox Church of St Elias (Elijah), built on 12th-century foundations.

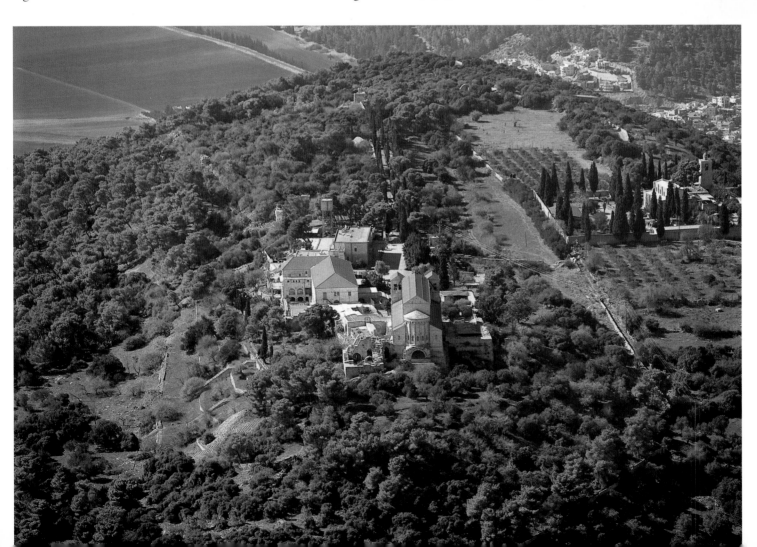

THE TRANSFIGURATION

Now about eight days after these sayings Jesus took with him Peter and John and James, and went up on the mountain to pray. And while he was praying, the appearance of his face changed, and his clothes became dazzling white. Suddenly they saw two men, Moses and Elijah, talking to him. They appeared in glory and were speaking of his departure, which he was about to accomplish at Jerusalem. Now Peter and his companions were weighed down with sleep; but since they had stayed awake, they saw his glory and the two men who stood with him. Just as they were leaving him, Peter said to Jesus, "Master, it is good for us to be here; let us make three dwellings, one for you, one for Moses, and one for Elijah" – not knowing what he said. While he was saying this, a cloud came and overshadowed them; and they were terrified as they entered the cloud. Then from the cloud came a voice that said, "This is my Son, my Chosen; listen to him!" When the voice had spoken, Jesus was found alone. And they kept silent and in those days told no one any of the things they had seen (Luke 9.28–36; see also Matthew 17.1–8; Mark 9.2–8).

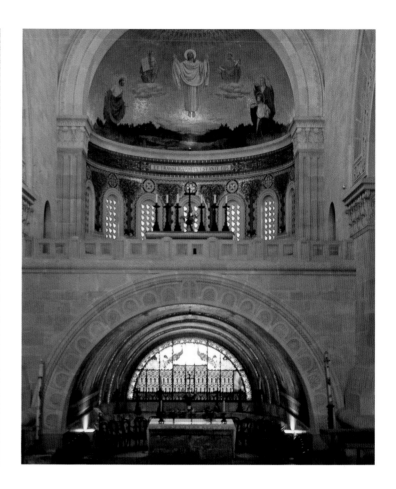

Arabic name, atTor, means exactly that, "The Mountain". That is also the name given in Arabic to Sinai, Gerizim, and the Mount of Olives. In the early 4th century, the church historian, Eusebius, thought it could have been either Tabor or Hermon, but he only mentioned those because they are the mountains that praise God in Psalm 89. The earliest clear testimonies are those of Cyril (348) and Epiphanius at about the same date, and from this time on there was no longer any uncertainty.

During the Byzantine period, three churches were built on the plateau that forms the summit, corresponding to the "three dwellings" of the Gospels, and a Benedictine monastery was established on the summit in 1101.

The Muslims took over the site and fortified Mount Tabor. It was near here that they won their decisive victory over the Crusaders in 1187. This took place just over five miles north of Mount Tabor at Qarne Hittin, the Horns of Hattin. Saladin (Salah udDin) had secured his eastern frontier, and he felt strong enough to summon a Jihad against the Crusader State in the north. On 1 July, Saladin crossed the River Jordan just south of the Sea of Galilee and took up a position on the road from Nazareth to the Sea of Galilee. From there he attacked Tiberias. He also moved part of his army to the west, where he camped just south of the Horns of Hattin. The Crusaders, in strength on the coast, had no need to attack, because

even if Tiberias had fallen, prisoners could have been ransomed. Nevertheless, they decided to attack, and they moved from the coast to Sepphoris. From there they launched an attempt to relieve the siege of Tiberias.

It was a fatal error. While on the march, they were harassed by the Muslim archers, and they were extremely short of water. They were too exhausted to reach the Sea of Galilee, and instead they camped on a plateau above Tiberias. When Saladin attacked them, they were forced to fall back to the Horns of Hattin, where they were surrounded and the army was destroyed. The Bishop of Acre had been holding the rallying standard of the Crusader army, a fragment or relic of the cross on which Jesus had died, but it was torn from his dead hand.

This was the decisive battle in the Muslim recovery of the Holy Land. Saladin had in effect recovered the Land, and in under four months he had recaptured Jerusalem.

TOP The interior of the Church of the Transfiguration, Mount Tabor, looking towards the east end. The apse is decorated with a mosaic of the Transfiguration. The walls of the Grotto of Christ at the lower level survive from a Crusader church.

OPPOSITE The Arbel Pass, with the Horns (or double hill) of Hattin in the distance. The Pass was an important route between Hazor, Damascus, and Mesopotamia. This is the only possible route Jesus would have been able to take out of Galilee on his journey to Nazareth.

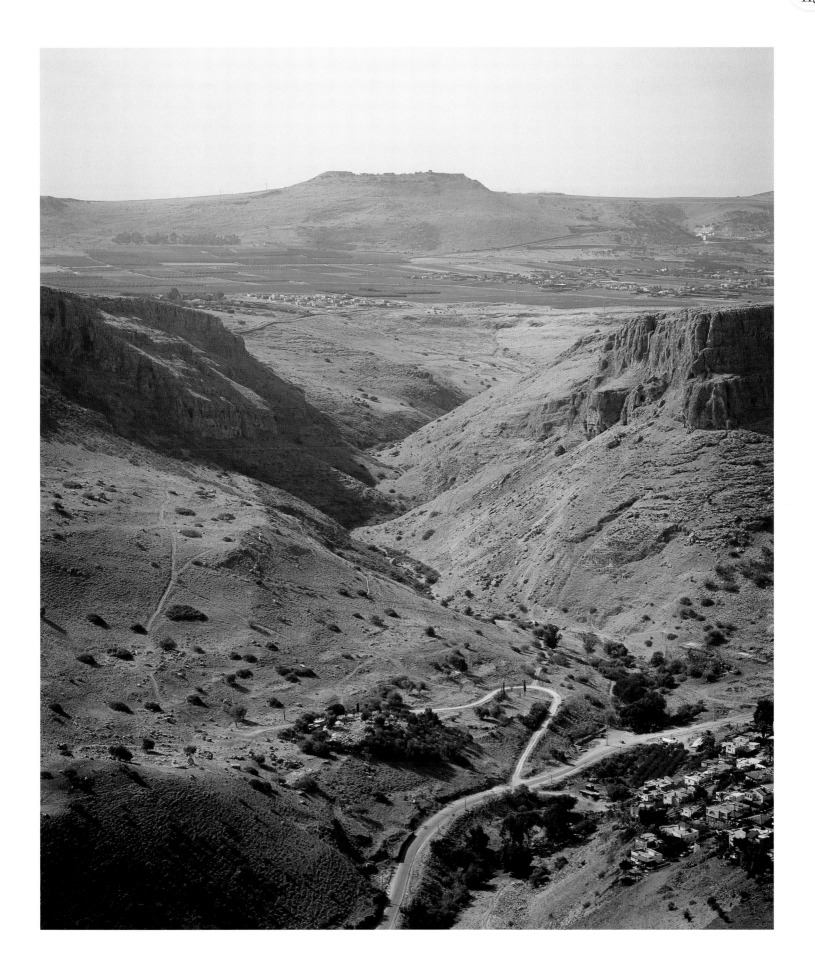

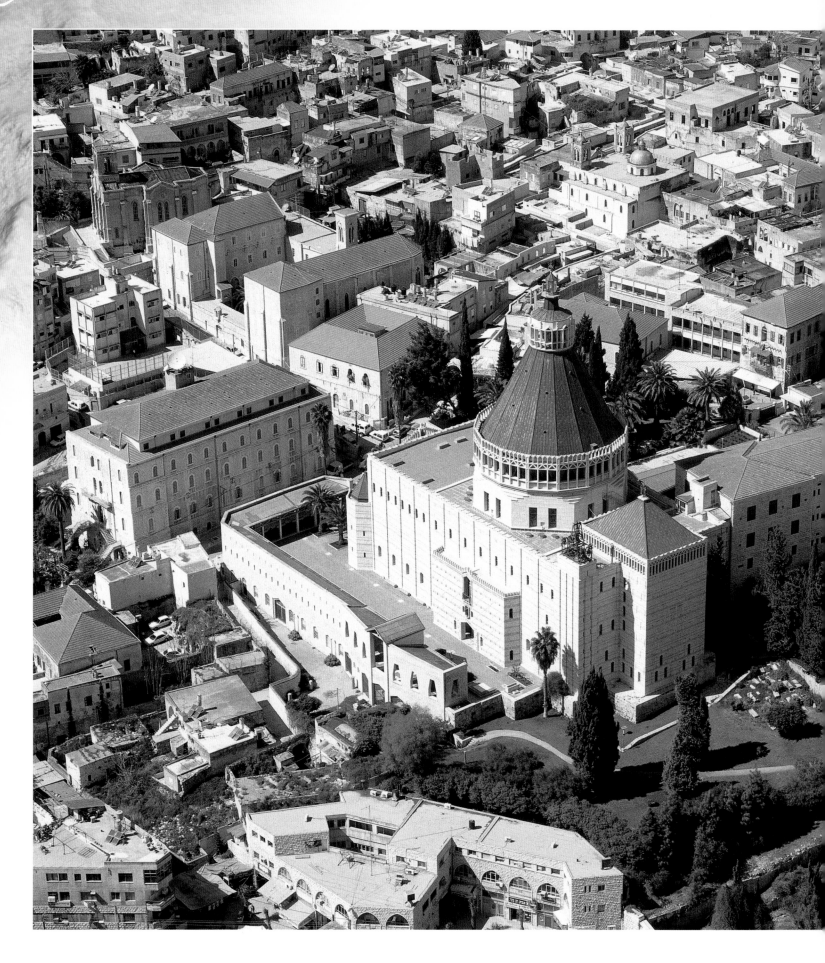

NAZARETH, SEPPHORIS, AND CANA

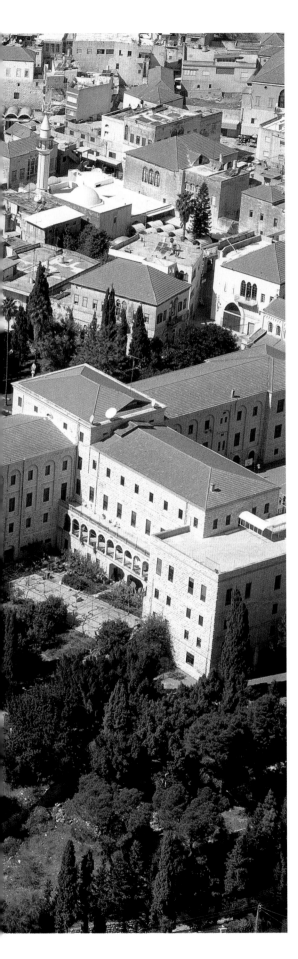

LEFT The 20th-century Franciscan Church of the Annunciation, Nazareth, dominates the town. The massive complex is on the site of Byzantine and Crusader churches built over the traditional cave-home of Mary, the mother of Jesus (see page 118).

Nazareth was the village in which Jesus grew up. It was so small and unimportant that in John's Gospel the scornful question is asked, "Can anything good come out of Nazareth?" (1.46). Eusebius, the Church historian, wrote that in his time (*c.*260–*c.*340) Nazareth was still a small village (*Onomasticon* 138.24). The more substantial place in the area was Sepphoris, only about three and a half miles distant. Nazareth was too small to support the work of Joseph, the father of Jesus: he was a *tekton*, a builder, carpenter, mason. Sepphoris, on the other hand, was an excellent source of employment when Jesus was young and was probably being taught the same skills by his father: the Romans destroyed Sepphoris in 4 BCE after a rebellion, but Herod Antipas, the son of Herod the Great and Tetrarch of Galilee and Perea, rebuilt, developed, and fortified Sepphoris, making it his main residence until he built Tiberias in 19–20 CE. Whether Cana was as close as Sepphoris to Nazareth depends on which of the possible sites is thought to be the Cana of Galilee in the ministry of Jesus.

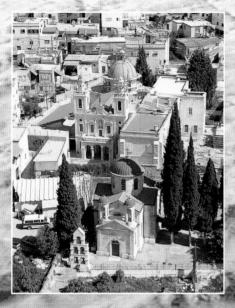

ABOVE Modern Cana, Kefr Kenna, looking
towards the Greek Orthodox Church and
the twin towers of the Franciscan Church
of the Wedding. The recently renovated
19th-century Catholic church contains a
small museum devoted to wine production.

ABOVE Ruins at Khirbet Qana, nine miles
north of Nazareth, the more likely location
of biblical Cana. The site includes a pilgrim
cave-complex built in the 5th-6th centuries and
visited by Christians in the Crusader period.

SEA
GALI

KHIRBET QANA

NAHAL YIFTAHEL

CANA

SEPPHORIS

BELOW The Church of the Annunciation,
Nazareth, from the west end. The 170 feet high
cupola illuminates the whole church. The
upper floor is the local Roman Catholic parish
church. The lower floor incorporates the Holy
Cave venerated since the 4th century as the
home of Mary, the mother of Jesus.

N

NAZARETH

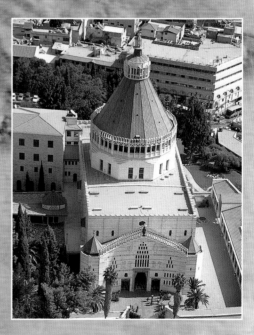

Nazareth was the home of Mary, the mother of Jesus (Luke 1.26) and the place where Jesus grew up. That is the most likely reason why Jesus is called Nazarene in Mark and Luke, or Nazoraian in Matthew, John, and Acts. Both words have been taken to mean "from Nazareth", but while that may be so in the case of Nazarene, it is difficult in the case of Nazoraian because it is hard to get to that word from the letters in Nazareth. The early Jewish Christians were called Nazoraians, and some have therefore argued, either that Jesus belonged to an otherwise unknown group, or that he was a Nazarite: Nazarites were people specially dedicated to God (Numbers 6.1–21; Judges 13.1–7; 1 Samuel 1.1–11).

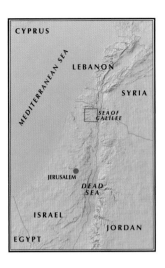

Nazareth was such an obscure and unknown place that when Philip, having just been called by Jesus to follow him, encouraged Nathanael to come and see this remarkable man, Nathanael replied scornfully, "Can anything good come out of Nazareth?"

(John 1.46). However, when he met Jesus he was so overwhelmed that he said, "Rabbi, you are the Son of God! You are the King of Israel!" (John 1.49).

Little is known of Nazareth before or after the childhood of Jesus. It was a place where one of the families of priests took refuge after the failure of the Jewish Revolt. It was not a place to which, in the early centuries, many Christian pilgrims came. Egeria was shown in 384 a large and adorned cave, and she was told that it was the home of Mary. Later, other sites associated with Mary were claimed, including Mary's Well, and a church was built in the 20th century on the remains of a Crusader church, on what was believed to be the place of the Annunciation to Mary of the birth of Jesus. The Grotto of the Annunciation remains a place of pilgrimage.

SEPPHORIS (ZIPPORI)

Sepphoris is a much more prominent place than Nazareth – and literally so. Of Sepphoris Rabbi Zeira said, "Why is it called Sepphoris? Because it is perched on the top of a mountain like a

BELOW The upper and lower cities of Sepphoris, looking towards the Crusaders' two-storey fortress. It stands beside a mansion with well-preserved mosaic pavements. A 4000 seat Roman theatre is cut into the hillside behind, just below the summit.

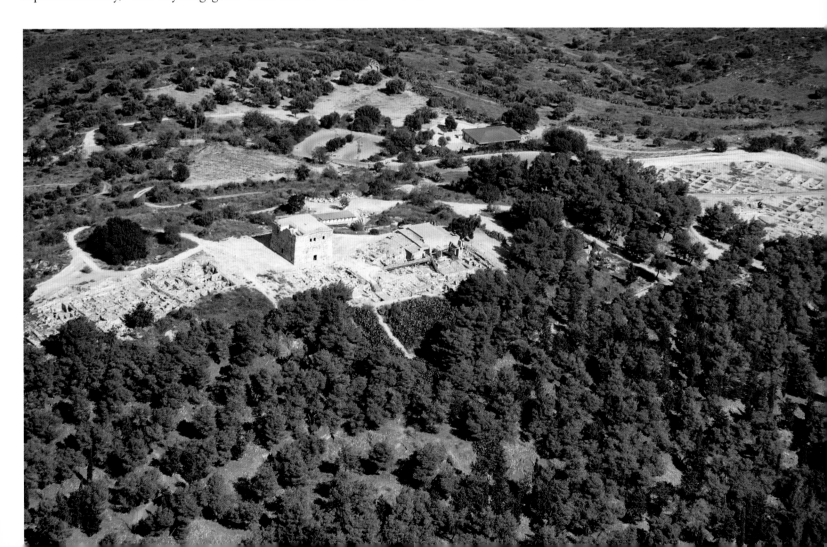

bird [*zippor*]" (B.Meg.6a). That, however, is a somewhat exaggerated description for a hill about 1000 feet high. Nevertheless, even that more modest height was enough to make Sepphoris a place of strategic importance. That is why it was one of the few cities in Galilee that was able to hold out against an Egyptian invasion in 100 BCE, and why also, after the successful Roman conquest of Palestine, Gabinius made it in 55 BCE one of the five administrative centres in Galilee. However, when Herod died in 4 BCE, some of his veteran soldiers saw the event as a chance to throw off Roman rule. Their revolt was joined by Judas, son of Ezechias, who was based at Sepphoris. The response of the Romans, according to Josephus (*War* 2.68), was vigorous: "Varus immediately sent part of his army into Galilee with Gaius his friend in command, who put to flight those who opposed him and captured and burnt down the city of Sepphoris, delivering the inhabitants into slavery."

Under Herod's will, his son, Herod Antipas, had inherited Galilee, but what would have been his capital was now a ruin. So in 3 BCE he decided to rebuild Sepphoris on the grand Herodian scale: "He strengthened Sepphoris so that it became the ornament of the whole of Galilee, and he renamed it Autocratoris" – in Latin the name was Imperatoria, so this, no doubt, was a tribute to Augustus. When Antipas moved on to create Tiberias (page 61), Sepphoris went into decline, but it was still important enough for the emperor Nero (54–68) to make a gift of it to Agrippa II (53–c.100). It was called briefly Eironopolis Neronias (the city of Nero's peace), and since it did not join in the 1st Jewish Revolt against Rome, it survived. Indeed, it maintained its special relationship with Rome and became known at the beginning of the 2nd century CE as Diocaesarea.

After the fall of Jerusalem to the Romans in 70, it was the relative peace and stability of Sepphoris that led the Rabbis to set up there the new Sanhedrin, and to begin work on the reconstruction of "Judaism without a temple". The remains of a 6th century synagogue with fine mosaics can still be seen. It was in Sepphoris that one of the supreme achievements in this period of Judaism was undertaken. This was the production of the Mishnah, which Rabbi Judah haNasi (c.135–217), who lived in Sepphoris for about 17 years, completed at the beginning of the 3rd century.

The importance of the Mishnah for the Jews is paramount. For centuries the predecessors of the Rabbis (the Hakhamim, the wise of old) had been interpreting the written law (Torah) in order to make it apply to ever-changing circumstances in a new world. The interpretations were passed on from teacher to pupil by word-of-mouth – they were not written down – and that is why there were called Oral (in contrast to Written) Torah, *Torah shebeal peh*.

By the time of the Fall of Jerusalem, there was a vast mass of this orally transmitted Torah, to which there was no access except through particular teachers or rabbis. It was the huge achievement of the rabbis in the post-Fall period to gather this material and organise it in the Tractates of the Mishnah. The Mishnah then formed the basis of the later additions and commentaries known as the Talmuds, of which the Babylonian Talmud has continuing authority among Jews to the present day. The work begun in Sepphoris made possible the survival of the Jews and Judaism.

CANA (KEFR KENNA)

The Gospel of John is the only one to mention Cana in Galilee. In the Synoptic Gospels (Matthew, Mark, and Luke) Jesus went to Galilee immediately after the arrest of John the Baptist, where "he came to Nazareth where he had been brought up" and went to the synagogue to teach (Luke 4.16–30). In John, however, Jesus left John the Baptist still preaching in "Bethany beyond the Jordan", and went to Cana in Galilee where he performed "this beginning of miracles", changing water into wine. From there he went to Jerusalem for Passover, and, while he was there, he drove the traders out of the Temple (in the Synoptic Gospels, Jesus only visited Jerusalem for Passover once, just before his crucifixion, and it was then that he "cleansed the temple").

Meanwhile, Jesus' disciples were, like John, baptizing people. Jesus decided to return to Galilee with them where, once again in Cana of Galilee, he performed his second miracle (or "sign", as John prefers to call them) when he healed the son of a ruler (John 4.46–54). Jesus then returned to Jerusalem for another festival (John 5.1).

There is no trace of this early Galilean ministry in the Synoptics, and the possibility must be that John's Gospel was drawing on a tradition from Cana or Nazareth, the two being close to each other. But how close were they? Where was Cana?

Three different places have been suggested. The first was proposed by Eusebius (see page 230), who noticed the phrase in Joshua 19.28, "Cana in the direction of Great Sidon", and stated, "Here our Lord God Jesus Christ changed water into wine: it lies in Galilee of the heathens" (*Onomasticon* 116). There is indeed a Cana near Tyre, but the distance from Nazareth is far too great for this to be John's Cana in Galilee.

There are then two possible sites closer to Nazareth. One is Kefr Kenna, the present-day Cana, 5 miles north-east of Nazareth, and this is "presented" today as the original Cana. More likely, however, is Khirbet Qana, about 9 miles north of Nazareth: the Arabic spelling, Qana, is closer to the Gospel name, and its full name, Qana al Jalil, actually means Cana in Galilee. Archaeological finds at Kefr Kenna do not predate the Byzantine period, whereas surveys at Khirbet Qana suggest that the site was occupied in the 1st century. In his careful review of the evidence, Richardson (page 120) concludes, "Recent excavations have tipped the scales decisively in favour of Khirbet Qana as the location of Cana."

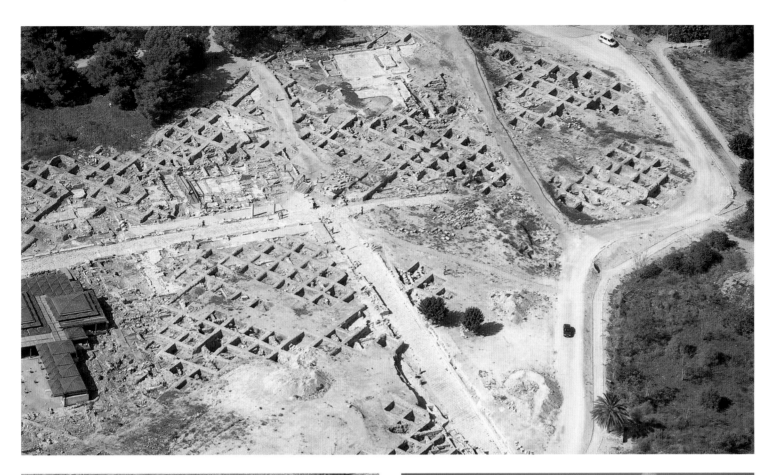

TOP The lower city of Sepphoris, with geometric blocks of houses cut through by streets paved with limestone slabs that show signs of grooves left by wagons.

ABOVE Ancient olive groves in the fertile Bet Netofa valley between Cana and Nazareth. Olive oil has been important to the country's economy since biblical times. Beam and weight presses, dating back to the Iron Age, have been found on several sites.

RIGHT The yellow-domed mosque at modern Cana, Kefr Kenna.

SAMARIA, NABLUS, AND MOUNT GERIZIM

LEFT Terraces between Bethel and Shiloh. The underlying limestone produces poor soil that makes agriculture difficult away from the valley bottoms and irrigation schemes.

Samaria and Mount Gerizim are the home and sacred sanctuary of the Samaritans. The tensions, and at times hostility and hatred, between Jews and Samaritans were well-known at the time of Jesus, though they predated that time and continued long after. When Jesus wished to make the point that even those who are popularly regarded as the worst kind of people are capable of a true faith and good deeds, it was to the Samaritans that he turned as an example. The parable of the man who fell among thieves on the road from Jerusalem to Jericho (Luke 10.29–37) contrasts the good actions of a Samaritan with the selfish behaviour of a priest and a Levite. The origin of the Samaritans and of this tension may go back to the split between the south and north after the death of Solomon, though the historical origins of the religious group known as the Samaritans are contested, with sharply different accounts being given by the Samaritans and the Jews. Present-day Samaritans, now greatly diminished in numbers, still live on or near their sacred mountain, Mount Gerizim, and they regard themselves as the guardians of the true faith revealed by God in the Torah.

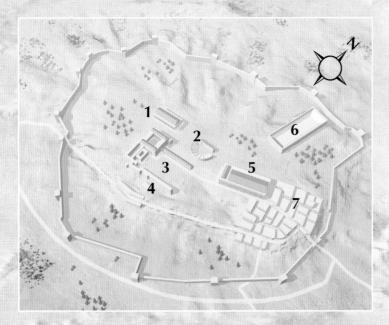

TEL AL-FARAH

ABOVE An artist's reconstruction of
Samaria/Sebaste in Roman times, based
on archaeological finds.

1 TEMPLE
2 ROMAN THEATRE
3 ACROPOLIS
4 BYZANTINE CHURCH
5 FORUM
6 STADIUM
7 TOWN OF SEBASTE

SAMARIA

TEL BALATA

NABLUS

MOUNT GERIZIM

LEFT A stone watchtower in
Samaria. Many had sleeping
quarters so that fields and
vineyards could be protected
from thieves day and night at
harvest time.

SHILOH

Samaria occupies a key position in the hill country to the west of the River Jordan, about midway in distance between the Sea of Galilee and the Dead Sea. It has good access in all directions, to the west to the coastal plain, to the north to Megiddo, to the east and south to the River Jordan and to Jerusalem. It is close to the early and very important shrine and sanctuary of Shechem.

The territory known from the name of the city as Samaria became part of the Northern Kingdom when Omri (king of the Northern Kingdom *c.*876–869) purchased the hill of Samaria from Shemer for two talents of silver: "He fortified the hill, and called the city that he built, Samaria [Hebrew *Shomron*], after the name of Shemer, the owner of the hill" (1 Kings 16.24).

Samaria became the capital of the Northern Kingdom until the Assyrian invasion that led to the fall of Samaria in 722–721. Until then, Samaria was a successful and wealthy city. Amos, one of the prophets of the Northern Kingdom just before the Assyrian invasion, denounced its luxuriant extravagance (see box page 126).

Not surprisingly, therefore, archaeologists have found rich remains – over 500 fragments of ivory, for example, some of which no doubt came from those "beds of ivory" denounced by Amos.

When Israel made efforts to secure greater independence, Assyria moved rapidly to assert its authority. After a long siege, the city was captured in 722 by Shalmaneser V (according to 2 Kings 17.6; in Assyrian records it was his successor Sargon II). After the fall of Samaria to the Assyrians, many of the Israelites were deported: Assyrian records suggest about 27,000. According to 2 Kings 17.24–41, the king of Assyria resettled the area with non-Jews, and 2 Kings says of these, in a fierce polemic, that they totally abandoned Yahweh and went over to the worship of other gods:

They went after false idols and became false; they followed the nations that were around them, concerning whom the Lord had commanded them that they should not do as they did. They rejected all the commandments of the Lord their God and made for themselves cast images of two calves; they made a sacred pole [Asherah], . . . and served Baal Therefore the Lord was very angry with Israel and removed them out of his sight; none was left but the tribe of Judah alone. (2 Kings 17.15–16, 18)

But the turn of Judah and Jerusalem was to come. The dominant power of Assyria was threatened by Medes (from present-day Iran) and Chaldean (see Ur of the Chaldees, page 195) Babylonians. Nineveh, the Assyrian capital, fell in 612, but the Assyrians continued to resist. They sought an alliance with the Egyptians who moved north along the usual coastal route in order to help them. Josiah, the king of Judah, who welcomed anything that threatened Assyria, attempted to stop the Egyptians at Megiddo, and although he lost the battle, he did weaken the Egyptian army. As a result the Assyrians were defeated by the Babylonians under Nebuchadnezzar II at Carchemish in 605, one of the truly decisive battles which changes subsequent history.

The Babylonians were the new power in the whole area, and they moved against Jerusalem, capturing and destroying the city in 587.

The Temple was destroyed and many of the people were taken into exile in Babylon.

The Babylonians now reorganised the administration of this part of their empire. They made Jerusalem and the northern part of Judah a part of an enlarged province of Samaria. When the Persians replaced the Babylonians, they restored Judah to its status as a separate province – a move strongly opposed by Sanballat, the governor of Samaria, but strongly reinforced by the Jewish leaders of the returned exiles in Jerusalem when they refused to let the Samaritans take any part in the rebuilding of the Temple, even though they claimed to have continued in the worship of Yahweh (1 Esdras 5.66–73).

In the 4th century BCE, the people of Samaria resisted the expansion of the Macedonians under Alexander the Great (356–323). They killed the Macedonian governor, but in response Alexander the Great captured Samaria and destroyed it. It was turned into a Greek city in which Alexander the Great settled Macedonian veterans as a reward for their service. It was again destroyed during the Maccabean period and then rebuilt by Herod the Great and called Sebaste.

———— ✠ ————

BELOW Recent excavations on Mount Gerizim have revealed over 400 Aramaic, Hebrew, and Samaritan marble inscriptions and 13,000 coins, which archaeologists are still evaluating.

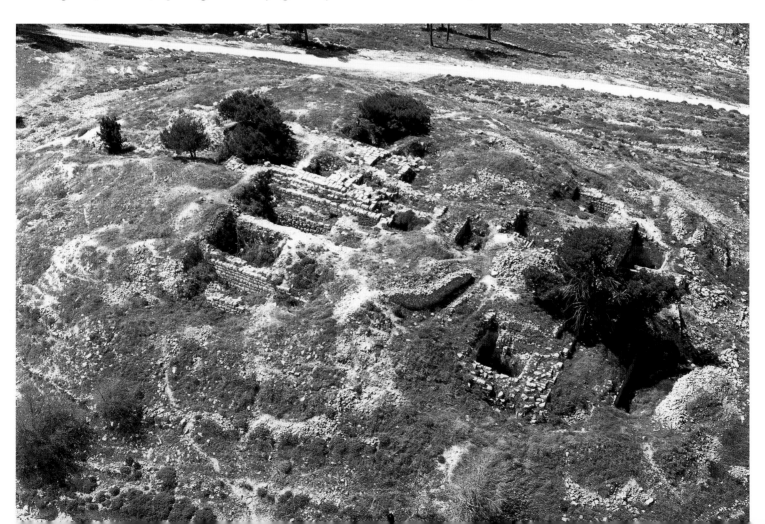

MOUNT GERIZIM

Mount Gerizim is nearly 3000 feet high and is linked by a saddle to Mount Ebal to the north. In the saddle was the ancient cultic centre of Shechem. In the book of Deuteronomy, the choice was offered to the people of following either Yahweh or false gods (the Baalim of Canaan), with a blessing or a curse following the choice. According to Deuteronomy 11.29, the blessings were pronounced from Mount Gerizim and the curses from Mount Ebal.

When the returned exiles refused to let the people of Samaria help to rebuild the Temple in Jerusalem, the Samaritans in response built their own Temple on Mount Gerizim. The exact date is uncertain, though the historian Josephus put it in the 4th century BCE. This Temple was destroyed during the Maccabean period.

Much later, the Roman emperor Hadrian (117–38) built a Temple there dedicated to Highest Zeus, Zeus Hypsistos. It was famous for a marble staircase leading up to it of 1500 steps.

As Christianity permeated the Roman Empire, the Byzantine emperor, Zeno, built a church on the site in 485 dedicated to Mary Theotokos (the One who bore God). Although this was destroyed by the Samaritans who had continued to live there, it was rebuilt and fortified by Justinian in about 530. All this, however, was yet again destroyed by the Arabs in their conquest of Palestine in the 7th century.

Under the Muslims, the area was ruled first from Damascus by the Umayyad caliphs (661–750), then by the Abbasids from Baghdad, and the Samaritans were denied access to the summit of their holy mountain. However, in the 18th century they purchased a piece of land for their worship and rituals. Permission for these

THE DECADENCE OF SAMARIA

Alas for those who are at ease in Zion,
and for those who feel secure on Mount Samaria,
the notables of the first of the nations,
to whom the house of Israel resorts! …
Alas for those who lie on beds of ivory,
and lounge on their couches,
and eat lambs from the flock,
and calves from the stall;
who sing idle songs to the sound of the harp,
and like David improvise on instruments of music;
who drink wine from bowls,
and anoint themselves with the finest oils,
but are not grieved over the ruin of Joseph!
Therefore they shall now be the first to go into exile,
and the revelry of the loungers shall pass away.
(Amos 6.1–2, 4–7)

was cancelled but then renewed in the 19th century. They did not attempt to rebuild their Temple, but they began to celebrate their major festivals on the mountain, as they still do to the present-day. Very few Samaritans now survive, but they remain tenaciously proud of their tradition which they regard as the true worship of God – in contrast to the Jews whom they regard as having apostasized by abandoning God long ago.

THE SAMARITANS

The origin of the Samaritans, as a religious group that is connected with the Jews but is antagonistically different from them, is difficult to recover. There are two major problems. The first (established in a detailed way by Egger) is that the phrase "the Samaritans" may refer both to people living in the area and also, much more specifically, to the adherents of the cult of Yahweh focused on Mount Gerizim. The second problem is that the accounts of the Samaritans and the accounts in the Bible (and of early historians like Josephus) were written from the point of view of the hostile and conflicting parties. That can be seen in the account given in 2 Kings (page 125).

In some way the conflict clearly goes back to the split between the Northern and Southern Kingdoms after the death of Solomon, when the northern parts of the kinship group broke away from the south and from Jerusalem. The Northerners saw no point in giving allegiance to one family (the family of David) in the South, and although they explored the possibility of an alliance, in the end they broke away under their leader Jeroboam from Rehoboam (Solomon's son and successor; see box page 128).

The Samaritans (meaning the religious group in contrast to the Samaritans as simply the people who lived in the area or under the jurisdiction of Samaria) developed as those who believed that they alone have preserved the true inheritance and faith handed down from Abraham and Moses.

But when did they emerge as a specifically distinct religious movement? The question is impossible to answer. The heart of the problem is that the northern members of the kinship group, the Bene Israel, continued to hold and follow the same religious beliefs and practices as they had always done – both before and after the time of David. From their point of view, they were not a "new religion": they simply refused to accept the innovations introduced by David and his successors. Of course the Judaeans took David and his successors to be the continuation intended by God of the long sequence of covenants made with their ancestors.

Thus the tension has always been both political and religious, but it is difficult to say when exactly the Samaritans were identified as a distinct religious group. In his *A History of Israelite Religion*, Rainer Albertz summarizes the problem and the wide range of suggested solutions as follows (II, page 524):

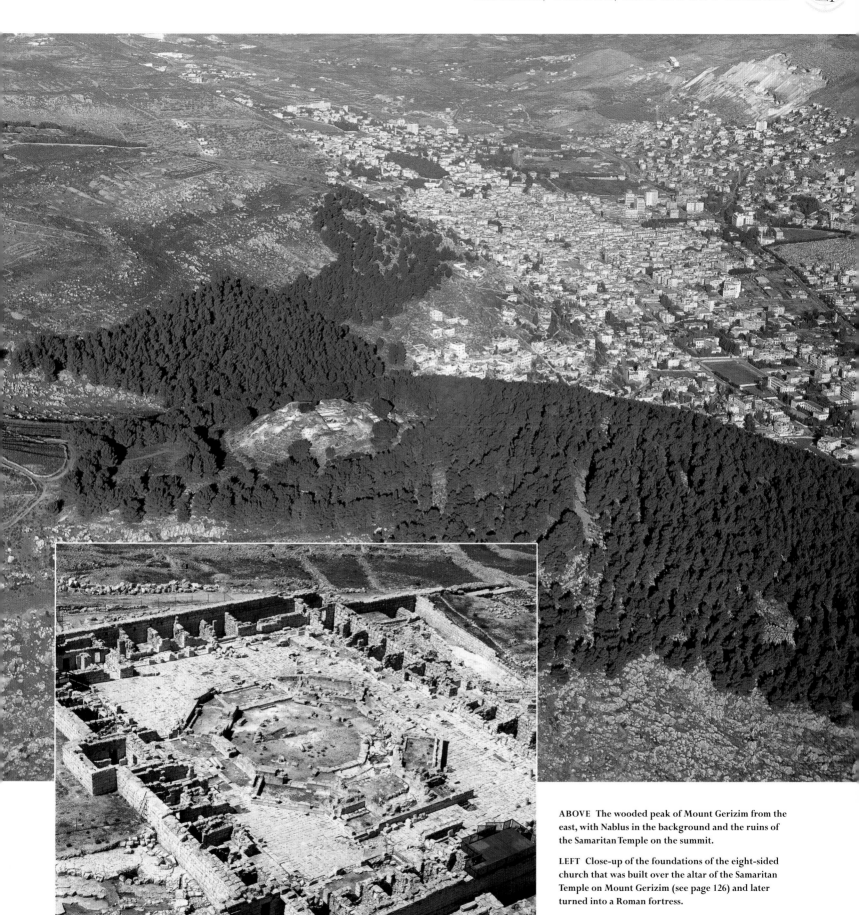

ABOVE The wooded peak of Mount Gerizim from the east, with Nablus in the background and the ruins of the Samaritan Temple on the summit.

LEFT Close-up of the foundations of the eight-sided church that was built over the altar of the Samaritan Temple on Mount Gerizim (see page 126) and later turned into a Roman fortress.

One discrepancy in present scholarship is striking: whereas a majority... begin as a matter of course from a conflict between Jews and Samaritans from the time of the first great waves of returns from the exile (520 BCE) and interpret texts like 2 Kings 17.24–41; Ezra 4.1–5.7ff. on this basis, ... more recent scholars are increasingly firmly denying that these texts have anything to do with the later religious community of this name and are dating its constitution and separation later and later: at the earliest with the building of the sanctuary on Gerizim in the late Persian or early Hellenistic period (c.330), and more likely in the 2nd century BCE in connection with the destruction of the Temple on Gerizim by John Hyrcanus (128), or even only in the Christian period.

In a sense, however, the actual date of the emergence of an organized group able to be called "the Samaritans" is far less important than the sense the Samaritans had of being the true descendants and defenders of the faith that God intended.

In line with that belief they produced their own Pentateuch (the first five Books of the Bible, the Books of Moses), and this is the Samaritan Pentateuch. It is preserved in a copy that the Samaritans

THE BREAK BETWEEN NORTH AND SOUTH

Rehoboam went to Shechem, for all Israel had come to Shechem to make him king. When Jeroboam son of Nebat heard of it (for he was still in Egypt, where he had fled from King Solomon), then Jeroboam returned from Egypt. And they sent and called him; and Jeroboam and all the assembly of Israel came and said to Rehoboam, "Your father made our yoke heavy. Now therefore lighten the hard service of your father and his heavy yoke that he placed on us, and we will serve you." The king answered the people harshly. He disregarded the advice that the older men had given him and spoke to them according to the advice of the young men, "My father made your yoke heavy, but I will add to your yoke; my father disciplined you with whips but I will discipline you with scorpions." ... When all Israel saw that the king would not listen to them, the people answered the king,

"What share do we have in David?
We have no inheritance in the son of Jesse.
To your tents, O Israel!
Look now to your own house, O David"
(1 Kings 12.1–4, 13–16)

believe goes back to Aaron. Basically, the text is the same as that in the Jewish Pentateuch, with most differences having to do with grammar and spelling, though a few are designed to favour Mount Gerizim over against Jerusalem.

The far more important difference is that the Samaritans have *only* the Pentateuch, and none of the many other books in the Jewish Bible. That arises from the belief of the Samaritans that the Jews abandoned the true faith and worship of God even before the post-Solomon break. The apostasy, in their view, began when the sons of Eli corrupted the shrine and sanctuary at Shiloh (1 Samuel 2.11–17, 2–5). This means that according to the Samaritans all the books in the Jewish Bible are the writings of an apostate sect. Only the Pentateuch, and the Samaritan Pentateuch at that, is the true word of God.

NABLUS (SHECHEM) AND TEL BALATA

When the Samaritans could no longer live in Samaria, they moved to nearby Shechem, present-day Nablus, on the saddle connecting Mount Ebal and Mount Gerizim. People had lived there long before the Samaritans. It was inhabited during the Chalcolithic period (c.4500–3100), and Tel Balata (site of the later town of Shechem) is a good example of a Bronze Age town.

It was here (or in the neighbourhood) that Abraham received the promise of the land (Genesis 12.6–7) and that Joseph was buried (Joshua 24.32). It became a powerful city-state, rivalled only by Megiddo (pages 232–7) and Gezer (page 184).

It was at Shechem that the Bible records an event of major importance in Jewish history. This was the drawing together of all the families/clans in the kinship group, the Bene Israel, into a covenant of allegiance to Yahweh and to each other (on this see further page 14). Shechem remained a major cultic centre for the Bene Israel.

Shechem was also the place where Jacob bought a plot of land and where he camped and set up an altar dedicated to El-Elohe-Israel (God of the Gods of Israel, or God, the God of Israel). On the eastern side of Nablus, there is a deep well identified as Jacob's Well. This traditionally is the site of the well where Jesus met the Samaritan woman (John 4.6). John 4.5 also claims that the well was at a place called Sychar, which some have thought to be a confusion with "shechem"; others suggest a village called Askar, about five and a half miles south-east of Samaria, because the name is closer and because Tel Balata at the time of Jesus seems to have been scarcely inhabited: archaeologists have found only a few fragments from the period.

JESUS AND SAMARIA

Jesus was well aware of the hostility between Jews and Samaritans. When he sent out his 12 disciples to announce the good news that the kingdom of heaven has come near, he joined Gentiles and

ABOVE **Nablus, a Palestinian town on the West Bank, incorporates the remains of Shechem and Samaria. It sprawls along the Wadi Nablus between Mount Gerizim and Mount Ebal.**

Samaritans together in contrast to Israel. He told his disciples: "Go nowhere among the Gentiles, and enter no town of the Samaritans, but go rather to the lost sheep of the house of Israel" (Matthew 10.5–6). In the account in John 4 of the encounter between Jesus and a Samaritan woman, the point is specifically made (though not in all ancient texts) that "Jews do not share things in common with Samaritans". Moreover, in Mark 10.1, the fact that Jesus went from Galilee to Jerusalem via the River Jordan suggests that he was following the usual pilgrims' route that avoided Samaria.

On the other hand, Jesus certainly travelled in the area, and he had no hesitation in speaking directly with the Samaritan woman in such a way that she went back to her town and told others, "Come and see a man who told me everything I have ever done! He cannot be the Messiah, can he?" (John 4.28–9). Equally, when, in the parable of the man who fell among thieves on the road from Jerusalem to Jericho, Jesus needed an example of what true faith in

action means, he took as his example a Samaritan in contrast to a priest and Levite (Luke 10.29–37). In this, as in so many other ways, Jesus was completely turning around the ordinary, everyday attitudes of his time.

SHILOH

During the early settlement of the Israelites in the land of Canaan, Shiloh was of great importance. It was the earliest cultic centre where the Ark of the Covenant was first settled (Joshua 18.1). At the battle of Aphek (1 Samuel 4; on Aphek see page 216) the Ark was captured by the Philistines who shortly after destroyed Shiloh.

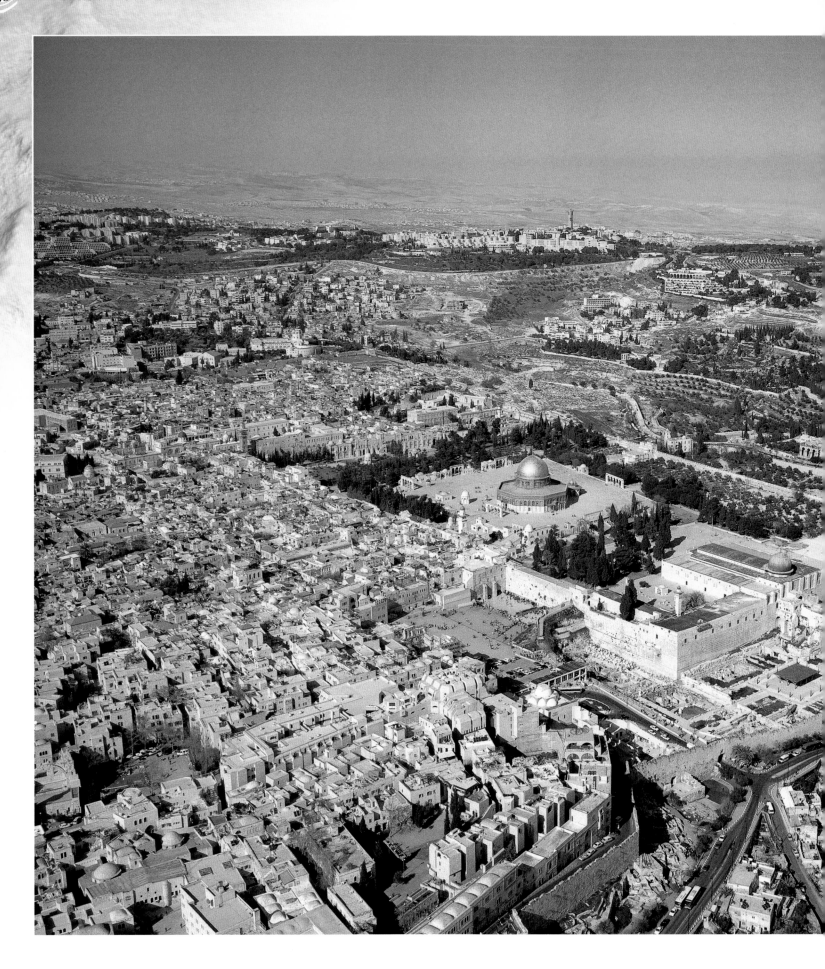

JERUSALEM

For Jews, Christians, and Muslims Jerusalem lies at the centre of both faith and pilgrimage. For centuries it lay also at the centre of the earth – exactly where early maps placed Jerusalem, as in Hereford's famous Mappa Mundi. Morgan describes it (in Alexander and Binski, page 215): "The upper semicircle contains Asia, and Europe, and Africa. Jerusalem is in the centre, at the top in the extreme east is Paradise, and at the bottom the ocean beyond the Straits of Gibraltar The world has, at the four diagonal points of the perimeter, extensions containing the letters MORS-Death."

LEFT Jerusalem from the south-west, looking towards the Kidron Valley and the Judaean hills. The city is dominated by the walls of the Temple Mount and the Dome of the Rock.

RIGHT The Mappa Mundi at Hereford Cathedral, dating from c.1300, places Jerusalem at the centre of the known world.

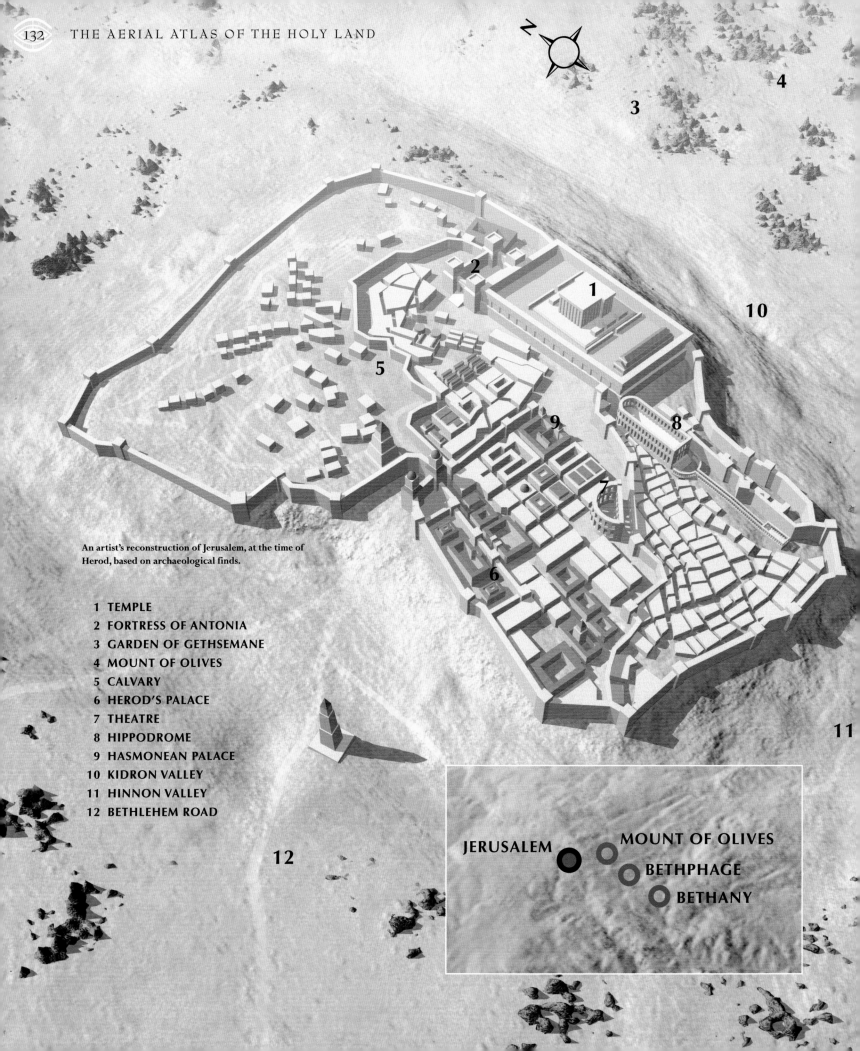

An artist's reconstruction of Jerusalem, at the time of Herod, based on archaeological finds.

1 TEMPLE
2 FORTRESS OF ANTONIA
3 GARDEN OF GETHSEMANE
4 MOUNT OF OLIVES
5 CALVARY
6 HEROD'S PALACE
7 THEATRE
8 HIPPODROME
9 HASMONEAN PALACE
10 KIDRON VALLEY
11 HINNON VALLEY
12 BETHLEHEM ROAD

JERUSALEM MOUNT OF OLIVES
BETHPHAGE
BETHANY

Jerusalem is a place that anyone can find without difficulty on a map or in a book of this kind. It stands on the central plateau or ridge of the Judaean mountains, between Beth-El to the north and Hebron to the south. At the same time, though, there is another sense in which Jerusalem cannot be found on a map because it exists even more in the faith and imagination of the three related religions: Judaism, Christianity, and Islam.

In this other sense, Jerusalem is the centre of the earth. From the Bible, the *Book of Jubilees*, and Josephus it is possible to reconstruct the map of the world as it was understood in the centuries before the 1st Jewish Revolt (see Schmidt in Kasher and Rappaport, pages 119–34). In biblical terms it is *tabbur haAretz*, the navel of the earth, and *eben shetiyyah*, the foundation stone on which the whole earth was built and

established. In medieval T/O maps (maps in which oceans surround land in the shape of a T: see Edson and Savage-Smith) such as the Mappa Mundi (see page 131) Jerusalem is placed centrally at the conjunction of the two parts of the T. It was believed that the key moments of God's dealings with the human race have taken or will take place here, from creation to the end of the world in judgement.

In a profound sense, therefore, Jerusalem is "A Tale of Two Cities". It exists as much in the mind as on a map, as much in the imagination of the faithful as in the geography of the planet. It is a tale of literal geography and history, but it is a tale also of conceptualizations which go beyond the literal. Immense numbers of people see it supremely as the point of connection between heaven and earth.

The ways, however, in which the three religions understand Jerusalem and their relationships with each other mean that Jerusalem has also been a place of conflict. The conflicts have left their obvious mark on Jerusalem itself.

BELOW Sunrise on the walls of the Temple Mount and the Dome of the Rock, Jerusalem.

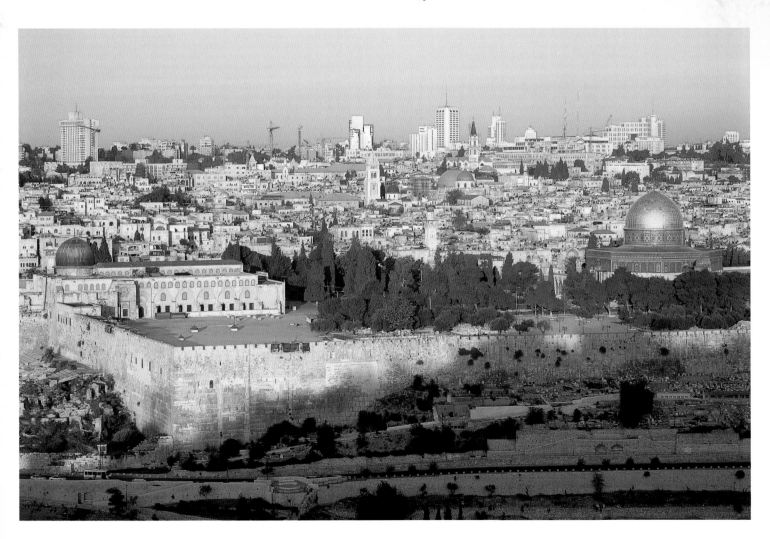

JUDAISM

It seems strange that Jerusalem was not a place of any importance in the early conquest and settlement of the Bene Israel in Canaan. In the period of the early settlement, Jerusalem (Urushalim, its Canaanite name, "Foundation of the god Shalem") was not occupied by the kinship group at all. At that time, the families or tribes were pursuing their own histories, only coming together in cooperation if there was some threat or crisis. In that case, there was certainly expectation that the group would cooperate together (hence the scorn of the Song of Deborah when that did not happen; for this see pages 49–50), but even then, drastic action might be required to bring that cooperation into effect, as the would-be king, Saul, discovered (1 Samuel 11).

One reason why the tribes remained fairly independent was that a wedge of Jebusite territory lay between them, of which Urushalim was the capital. It was the major achievement of David that he succeeded in unifying the tribes (though events after the death of his successor, Solomon, show how fragile the unity was: see pages 15–16). Decisively important in that achievement was David's capture of Urushalim: he removed the literal division between the tribes, and he adapted institutions from the city, especially temple-worship and kingship.

Those innovations were fiercely contested by conservatives, as the Historical Books of Tanach (Jewish Scripture) make clear. Yet they were in fact a supreme achievement, because nothing that David introduced belonged to any one part of the kinship group. If, therefore, the changes were accepted and adopted, there was no loss of face because they were entirely neutral.

As a result, Jerusalem could become the centre of a new kind of unity in the kinship group. Jerusalem became the means through which the members of the kinship group might gain for the first time a strong and practical sense of being "Israel".

Certainly there were some who felt that none of this was justified in terms of their knowledge and experience of God as Yahweh up to this point: God had not needed a house in which to live in the wilderness, so why should he need a Temple now? When David felt that he should build a Temple for God, the prophet Nathan raised exactly that question:

Thus says the Lord: Are you the one to build me a house to live in? I have not lived in a house since the day I brought up the people of Israel from Egypt to this day, but I have been moving about in a tent and a tabernacle. (2 Samuel 7.5–6)

This argument has left an intriguing trace in the Book of Genesis, where a story was retained of the way in which Abraham had acted reverentially in relation to Melchizedek, the king of Salem (identified as Jerusalem), in contrast to his dealings with other kings of the area. Thus what David was doing in taking over elements of an alien and pagan culture had good precedent (Genesis 14; cf. Psalm 110).

Urushalim was equally important because it was already a holy city – or at least, its inhabitants regarded it as such. To them the city was so sacrosanct that they thought they could never be defeated when David attacked them:

The king and his men marched to Jerusalem against the Jebusites, the inhabitants of the land, who said to David, "You will not come in here, even the blind and the lame will turn you back" – thinking, "David cannot come in here." Nevertheless David took the stronghold of Zion, which is now the city of David. (2 Samuel 5.6–7)

Having captured Jerusalem, David moved rapidly to make it the new sacral centre of the kinship group by bringing to it the Ark of the Covenant (2 Samuel 6; see page 64). Psalm 132 celebrates the recovery of the Ark, and the bringing of it to Zion – perhaps as an annual festival of the renewal of the commitment of God to the House of David. The question of Nathan (above) was answered by the claim that this move was simply the next step in the unfolding purposes of God for his people: "Your house and your kingdom shall be made sure forever before me; your throne shall be established forever." (2 Samuel 7.16). So began the Jewish hope that the anointed king (haMashiach, the messiah) in Jerusalem will be the instrument and agent of God.

From this point on, Jerusalem and Mount Zion become the holy and sacred city, although after the schism between the Northern and Southern tribes, it was the one holy city only of the Southern tribes, and especially of Judah, the line which leads into the Jewish people.

"Zion" is a word meaning perhaps "fortress" or "stronghold", and in that sense it is used of Samaria in Amos 6.1. Its uses in the Bible in relation to Jerusalem vary:

• It may simply be another name for Jerusalem, as when 2 Samuel 5.6–10 records how David and his men climbed through a tunnel and thus "took the stronghold of Zion, which is now the city of David".

———————— ✳ ————————

OPPOSITE TOP Jerusalem from the south, with the Church of the Dormition on the summit of Mount Zion, top left, which lies outside the Ottoman-era city wall.

OPPOSITE BOTTOM Excavations in the City of David area outside the main city walls of Jerusalem include a well-preserved stretch of 8th-6th-century BCE wall, 15 feet wide and 9 feet high.

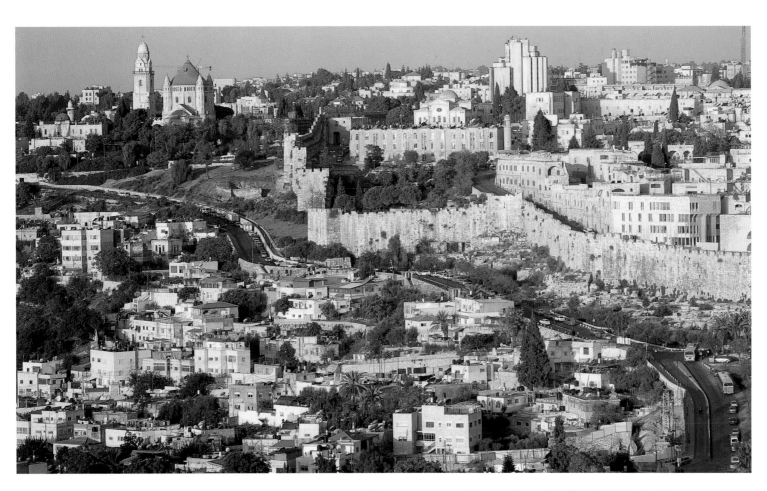

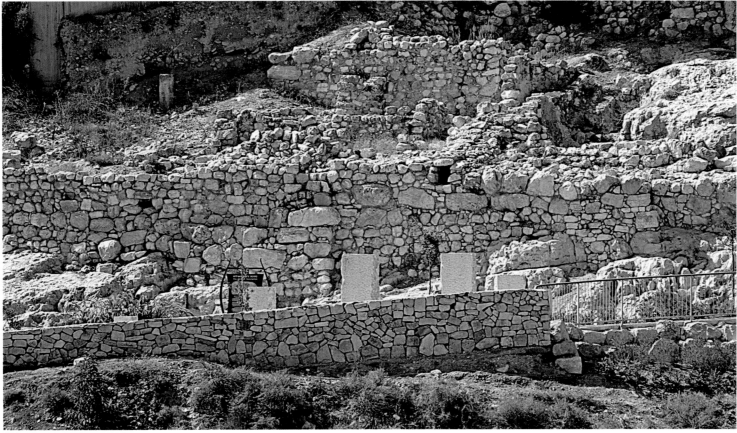

• Archaeology has shown that the pre-Israelite fortress was built on the ridge south of the current Temple Mount complex, and may therefore be the area meant by Zion.

• The Temple Mount area whose construction was begun by Solomon is also called Zion.

Much later, in the Byzantine period, an entirely different area was identified as Zion: this is a hill to the south of the south-western corner of the Old City, and although this is often referred to as Zion, this cannot be the meaning intended by the Bible. It is, though, an area in which the traditional sites of the Last Supper and of David's tomb are found.

Even though Jerusalem was so important at least to Judah, it was not the only religious centre, even of the Southern tribes, for nearly four centuries after its capture by David. But the fall of Samaria (the Northern capital), combined with the miraculous deliverance of Jerusalem from the Assyrians, reinforced the sense of an inviolable and sacrosanct city (2 Kings 18.13–19.36). Psalm 48 records the feelings of exaltation and relief:

> Great is the Lord and greatly to be praised
> in the city of our God.
> His holy mountain, beautiful in elevation,
> is the joy of all the earth
> Mount Zion, in the far north,
> the city of the great King.
> Within its citadels God
> has shown himself a sure defence. (Psalm 48.1–3)

But already the prophets were beginning to warn that God was perfectly able to withdraw his protection of the city and its people if they proved unfaithful to him – God would be that "deity laying about with the bludgeon of correction" (see page 14). Isaiah in the 8th century was a great exponent of the supreme importance of Zion for the safety and salvation of Judah; and if Judah keeps faith with God, that good purpose of God will extend to the whole world.

But Isaiah also warned that the protection of Jerusalem cannot be taken for granted. Repeatedly the people and their kings failed in their vocation until another threat, that of the Babylonians, developed. Under Josiah, a major reform was attempted, which made a decisive shift of religious allegiance towards Jerusalem and its Temple, making this alone the place where God had caused his name to dwell, and making it also the exclusive centre for pilgrimage feasts (no longer were pilgrimages to be made to the local shrines or sanctuaries). But despite the warnings of Jeremiah (e.g. 7.14) and Ezekiel (11.1–12; 24.1–14), too few paid attention; Jerusalem fell to the Babylonians, and the Exile began.

THE SIGNIFICANCE OF JERUSALEM

> In the days to come
> the mountain of the Lord's house
> shall be established as the highest of the mountains,
> and shall be raised above the hills;
> all the nations shall stream to it.
> Many peoples shall come and say,
> "Come, let us go up to the mountain of the Lord,
> to the house of the God of Jacob,
> that he may teach us his ways
> and that we may walk in his paths."
> For out of Zion shall go forth instruction,
> and the word of the Lord from Jerusalem.
> He shall judge between the nations,
> and shall arbitrate for many peoples;
> they shall beat their swords into ploughshares,
> and their spears into pruning hooks;
> nation shall not lift up sword against nation,
> neither shall they learn war any more. (Isaiah 2.2–4)

The Exile raised in a new way three questions:

• How is Jerusalem related to the covenant promises of God?

• How are those in defeat and captivity to understand what it still means, even in these circumstances, to be a people chosen to carry out the purposes of God?

• How can they be faithful to God when they cannot centre that faith on Jerusalem?

Clearly God does not depend on Jerusalem, any more than he had in the period of wanderings in the wilderness; but do the people and their faith depend on Jerusalem? It is premature to talk of Judaism, but using that word as a shorthand: can there be a Judaism without the Temple? – a question that came to dominate the formation of Jewish faith throughout the world.

The Jews were entirely clear that the promises of God concerning Jerusalem could not be regarded as a mistake. That conviction led them to respond to those questions in three key ways:

• First, they began to find ways of being faithful when they were far away from Jerusalem (see Introduction, page 17).

———————— ✳ ————————

OPPOSITE TOP The Kidron Valley and the Tomb of Absalom, top left. The city wall here is punctuated by the bricked-up Golden Gate (see page 141).

OPPOSITE BOTTOM LEFT The so-called Tomb of Absalom is almost completely cut out of rock. It dates from the 1st century BCE and may have been a funerary monument for the 8-chambered complex behind known as the Tomb of Jehoshaphat.

OPPOSITE BOTTOM RIGHT Rock-cut tombs in the valley of Hinnom (Gehinnom), originally the city rubbish dump, a place of outcasts, hence in Greek Gehenna.

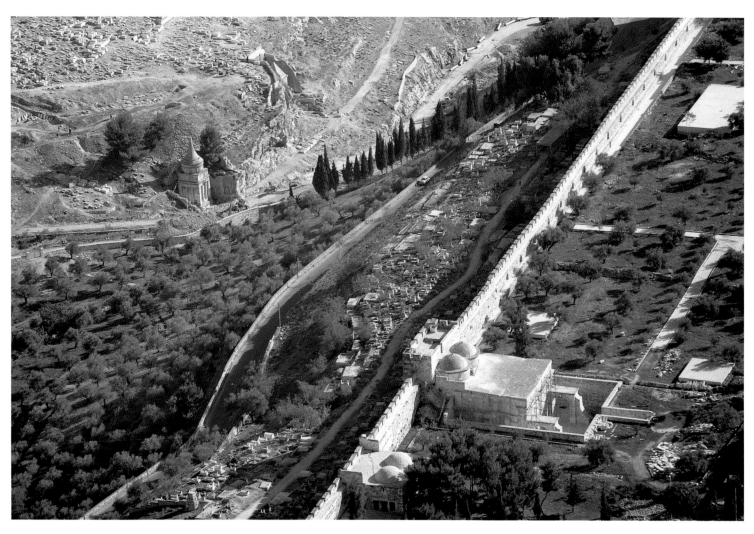

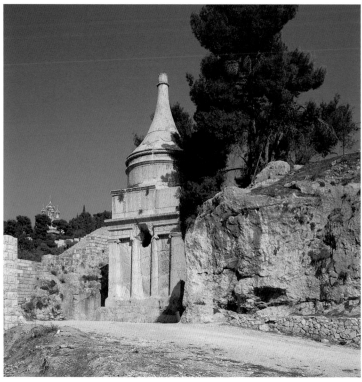

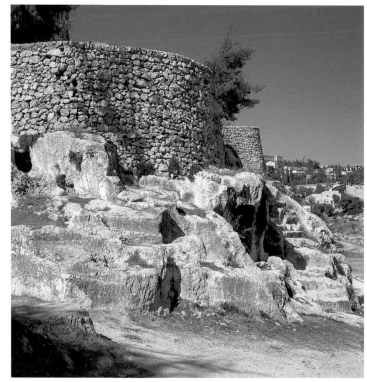

• Second, they continued to hope that God would bring about a return to Jerusalem, and that the Temple would be rebuilt; Psalm 137, quoted on page 17, expresses this longing. It was in that same spirit of longing for restoration that the last chapters of the Book of Ezekiel (40–48) were written during the Exile as a visionary blueprint of what the Temple will be like when it is rebuilt. The exilic chapters of Isaiah 40–55 contain moving descriptions of how Jerusalem has drunk the cup of God's wrath and how its people have become the Suffering Servant that pays the price for the sins of others before them (chapter 53). But the day is near when it will put on its finest clothes once more (51.17–23) and will be magnificently rebuilt ("the stones laid on agates and the foundations on sapphires"). Jerusalem will be once more the bride of Yahweh, and her children will be so numerous that their dwelling space will have to be enlarged (54.1–3). By a play on words, *shalim* (from Urushalim) becomes *shalom*, "peace", and in Psalm 122 the rebuilt city becomes the pilgrimage centre of all the people, where the prayer for peace and prosperity is uttered: "Pray for the peace of Jerusalem: May they prosper who love you." This desire for Jerusalem continues to the present day in Jewish prayer: the thrice-daily Amidah prayer (which for the Rabbis replaced the Temple sacrifices) has a section devoted to this plea; and even more immediately, the Passover Seder and the Day of Atonement service both end with the words, "Next year in Jerusalem!"

• Third, they realized that those dreams could only be realized if they paid far more attention than their ancestors had in the past to the commands and prohibitions that God had given to them in Torah. In the period after the Exile, the Jews were anxious to avoid anything like the Exile happening again, and so they took extreme care to understand and keep the commands of God in Torah (see Introduction, page 18)

All this meant that in the period after the Exile, it became important to defend the holiness of Jerusalem and its Temple (when it was rebuilt in the time of Ezra and Nehemiah) from the contamination of outsiders and Gentiles; and that is why they refused to accept the offer of the Samaritans to help in the rebuilding of the Temple (see page 125).

Even so, the vision of Jerusalem fulfilling its religious role in relation to the whole of humanity continued to be developed, but that fulfilment lies in a future yet to be realized. To put it in their more technical terms, that future becomes increasingly eschatological (the word *eschaton* means "last thing"), so that it belongs to the end of time and history when God completes his purpose with the sending of his Messiah.

That future may include vengeance on the nations who have done "violence to the people of Judah" (Joel 3.9–21), but it includes also the vision of all nations together acknowledging Yahweh as God. So, for example, Psalm 87 describes Zion as the mother of all nations and all people as its citizens; in Isaiah 25.6 a feast of joy is offered there for all peoples; or again, "In those days, ten men from nations of every language will take a Jew by the sleeve and say, 'Let us go with you, for we have heard that God is with you'" (Zechariah 8.23).

From this time on Jerusalem becomes the place where the completion of the purposes of God will begin, as in Zechariah 14.1–5 quoted on page 152. From that last text, it came to be believed that the faithful dead will rise from Jerusalem on the last day – hence the importance of being buried near Jerusalem, on the Mount of Olives, if possible (see page 236).

In the post-biblical period, the two themes of the realized/realizable Jerusalem and the unrealized/ideal Jerusalem continue, depending somewhat on the political circumstances of the Jews in relation to Jerusalem.

Thus during the period of the independent Hasmonaean rulers, and even during the period when Judaea was either directly or indirectly under Roman jurisdiction (until the 1st Jewish Revolt, 66–70 CE), Jerusalem was not only an ideal but a fact, not least because it was the centre of pilgrimage and of gifts to the Temple. The three pilgrimage festivals of Passover, Weeks (Pentecost), and Booths (Sukkot) were times of splendid celebration: "He who has not seen Sukkot in Jerusalem has not seen life."

But after the 1st Revolt, and even more after the failure of the 2nd Revolt (132–5 CE), Jerusalem became an increasingly Roman city that Hadrian called Aelia Capitolina. Jews were allowed to reside there, although immediately they were not allowed to do even that. In subsequent centuries, until the formation of Israel after World War II, Jerusalem was no longer a major capital city. The freedom of Jews to live (particularly to live religiously) in Jerusalem varied greatly during this long period.

This brief outline makes it clear that Jerusalem exists for Jews on three levels of reality:

(1) the reality of the historical Jerusalem, whether controlled by Jews or by others

(2) the reality of the destroyed Jerusalem

(3) the truth of God's promises and continuing commitment Jerusalem: this came to be summarized in the heavenly Jerusalem, which cannot be destroyed.

1. The reality of the actual Jerusalem continued to be monitored in Halakah (the oral transmission of Torah, applying Torah to every conceivable circumstance of life, eventually gathered together in Mishnah and Talmud: on this see further page 120). Thus even when

———————— ✠ ————————

OPPOSITE The Western Wall, Jerusalem, is a surviving part of Herod's retaining wall, close therefore to the second Temple. It is sacred for Jews "since the Gate of Heaven is near the Western Wall." (Ettinger, 19th century).

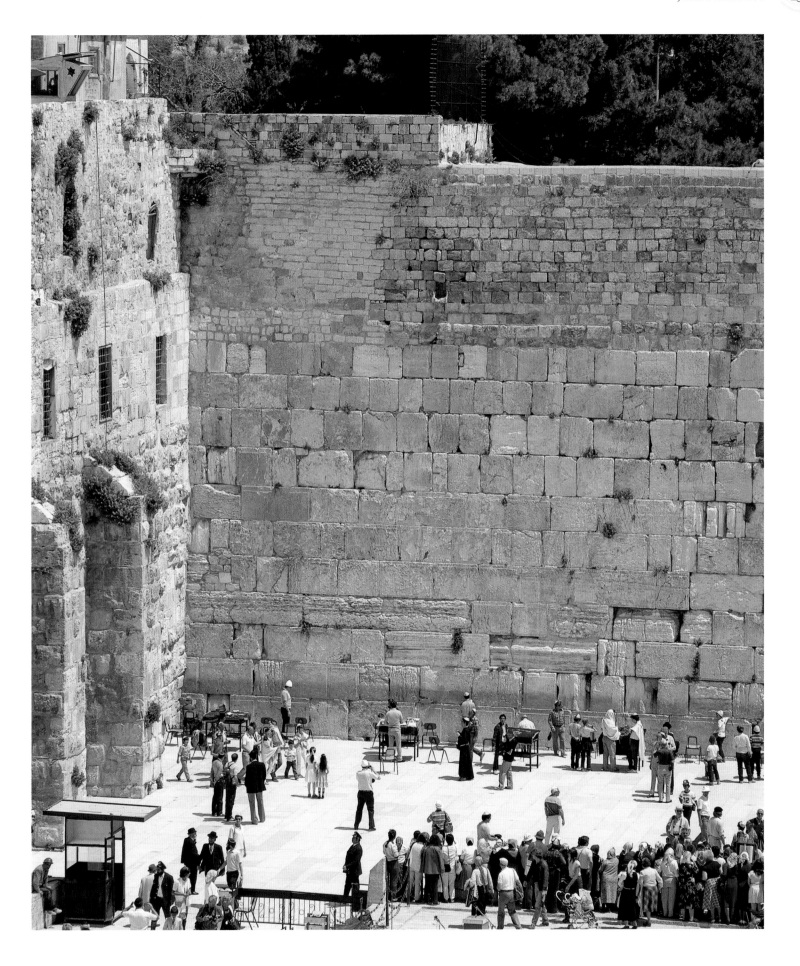

Jerusalem and the Temple had been destroyed, the Rabbis continued to work on the proper ordering of worship and life wherever Jews were living, and as it should be in Jerusalem. At the same time, attention to Tanach (Scripture) offered immense opportunity to extol Jerusalem, even to the extent that such exegesis took leave of any actual reality that the city may have had.

It was this interpretation of Scripture that led to some of the most brilliant imaginations of Jerusalem: on the basis of Isaiah 2.2 it was believed that Jerusalem is raised above all other places on the earth; on the basis of Ezekiel 38.12 it was claimed that Jerusalem is the centre or navel of the world (*tabbur haAretz*), from which benefits to all nations will flow, and Jerusalem was powerfully reaffirmed as the mother of all nations; on the basis of Psalm 48.2 (and many other texts), the beauty of Jerusalem was said to exceed all other beauties – of the 10 measures of beauty that came down to the world, Jerusalem took nine (B.Kiddushin 49b); here all the great events of history took place, from creation on the Temple Mount where *eben shetiyyah*, the foundation stone of the world, can still be seen), through the Aqedah (Binding) of Isaac and the establishing of the Holy of Holies, to the final Day and the resurrection of the dead. 2. But the reality has also included, for most of Jewish history, the

fact that the Temple has been destroyed with Jerusalem under the control of non-Jews. Jews long for Jerusalem in the words of Psalm 137 written in the Exile: "If I forget you, O Jerusalem, may my right hand wither away! Let my tongue cling to the roof of my mouth if I do not remember you, if I do not set Jerusalem above my highest joy." Prayer is made in the direction of Jerusalem, and in synagogues (to the west of Jerusalem) the ark is erected on the eastern wall. When the Temple was destroyed, some extreme mourners vowed to eat no meat and drink no wine. Rabbi Joshua said;

> Not to mourn is impossible, because the blow has fallen. To mourn excessively is equally impossible, because we do not impose a burden on the community which the majority cannot sustain. For so it says, If I forget you, Jerusalem, may my right hand wither away. (B Baba Bathra 60b, quoting Psalm 137.5)

This mourning is consummately expressed on Tisha B'Av, the ninth day of the month Av, when the two destructions of the Temple (by the Babylonians and the Romans) took place, and when it is believed that other catastrophes also occurred – for example, the

fall of the last stronghold at the end of the Bar Kokhba Revolt, and the beginning of the expulsion of the Jews from Spain in 1492 CE. 3. But in another way, Jerusalem has not been, and cannot be, destroyed, because the heavenly Jerusalem is as much a reality as the earthly. The name of Jerusalem was also written as *yerushalaim*. In Hebrew that form is a dual (ie it is the form used to express two of something, like "two arms", in distinct contrast to a general plural, "arms"). This was taken to mean that there are *two* Jerusalems, the earthly and the heavenly. Based on the vision of the prophet Isaiah (chapter 6), the imagination of the heavenly Jerusalem was greatly elaborated: it was believed, for example, that the heavenly Jerusalem was prepared at the foundation of the earth, and that it exists immediately opposite, or just above, the earthly city. It is the guarantee of the restoration of Jerusalem on earth.

OPPOSITE TOP The Damascus Gate in the northern wall of Jerusalem is the largest of the city gates. It was built by Suleiman in 1542 on the site of earlier gates constructed by Herod and Hadrian.

ABOVE St Stephen's Gate, in the eastern wall of Jerusalem, was built by Suleiman. It is also called the Lions' Gate after the lions carved on the side of the entrances.

RIGHT The Golden Gate in the eastern wall of Jerusalem at sunrise. According to Jews and Muslims, it will be used by the righteous on Judgement Day. Hence the two arches, bricked up by Saladin, are known as the Gate of Mercy and the Gate of Grace.

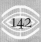

CHRISTIANITY

The fundamental importance of Jerusalem for Christians lies in the fact that it was in Jerusalem that Jesus spent his last days, and that it was just outside Jerusalem that he was crucified. Much of the ministry of Jesus took place in Galilee, and if he had stayed there, there would not have been the same conflict. But Jesus deliberately moved to Jerusalem knowing that the issue of his authority to speak and act as he did would be inevitable – as indeed it proved to be.

The Gospels are interpretations of the life of Jesus and of its continuing importance. They are interpretations of faith arising from and for communities of faith. For that reason, they bring different insights and emphases into their accounts of Jesus. This means that the Christian understanding of Jerusalem is deeply entangled in the ways in which the four Gospels interpret *differently* Jesus' own relationship to Jerusalem. In part those differences may depend on whether a particular Gospel account was written with knowledge of the Fall of Jerusalem to the Romans in 70 CE.

The Gospels share the same basic pattern, clearly established in the Gospel according to Mark, of Jesus' relation to Jerusalem: the ministry and teaching of Jesus began in Galilee and only moved to Jerusalem when Jesus foresaw conflict over his teaching with the highest authorities and could thus foretell the outcome in suffering and death. He therefore moved deliberately to complete his sacrificial rescue of those who felt estranged from God (Mark 10.32–45). In conformity with Scripture, he entered Jerusalem and challenged Temple practise and authority; and he was already predicting, in apocalyptic style, the final end of all things (Mark 13). Duly condemned and rejected, he was crucified outside the city (Mark 15.21ff.), and at the moment of his death, the veil of the Temple was split in two (Mark 15.38).

To that basic scheme, each other Gospel adds its own emphasis or insight. Thus *Matthew* and *Luke* both involve Jerusalem in the earliest moments of this sacred drama (Matthew 2.3; Luke 2.22–38). *John* sets much more of the ministry in Jerusalem, with several visits, and not simply one culminating visit; yet in doing this, *John* heightens the sense of the great refusal of Jerusalem. The Synoptic Gospels (Matthew, Mark, and Luke in conjunction with the Book of Acts) then portray the disciples moving from Jerusalem, to Galilee, and to the ends of the earth in the missionary movement of the Church.

Not surprisingly, from this perspective, the New Testament emphasizes the displacement of the earthly, historical Jerusalem by the heavenly Jerusalem – a view confirmed by the Fall of Jerusalem in 70 CE. Paul wrote to the Galatians of the Jerusalem hitherto enslaved to the Law, and of the heavenly Jerusalem which is free and which is "our mother" (Galatians 4.25–6). The Letter to the Hebrews sees the heavenly Jerusalem as already the existing reality to which those to whom the Letter is written belong: "You have come to Mount Zion and to the city of the living God, the heavenly Jerusalem, and to innumerable angels in festal gathering, and to the assembly of the firstborn who are enrolled in heaven …" (Hebrews 12. 22–3). In the Book of Revelation, "the holy city", the new Jerusalem, "is seen coming down out of heaven from God, prepared as a bride adorned for her husband" (Revelation 21.2). The heavenly Jerusalem is described in brilliant terms which share the Jewish vision of the beauty of Jerusalem. In contrast, the actual Jerusalem is known to have been destroyed, "given over to the nations" (Revelation 11.2).

From the outset, therefore, the Christian imagination of Jerusalem has been controlled by the theme of displacement: the displacement of the Jews in the earthly city, and the displacement of the earthly city by the heavenly. These two themes have had enduring, but very different consequences.

Most obviously, Christians have looked back on Jerusalem as the place where the central acts in the drama of human redemption took place, including those recounted by the Jews (see page 134), but extended also to include the decisive acts in the life, and death and resurrection of Jesus. Once Christianity became an accepted religion in the Roman empire (from the time of Constantine

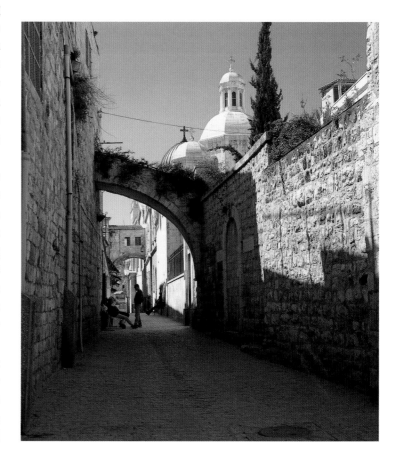

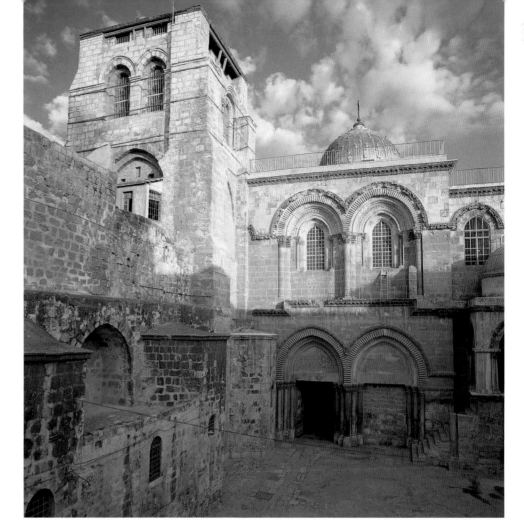

OPPOSITE BOTTOM The Via Dolorosa, Jerusalem.
The street, commemorating Jesus' final journey to his
crucifixion, the Stations of the Cross, passes the
Convent of the Sisters of Zion and several other 19th-
century buildings that incorporate parts of the
Pavement of Judgement and the chapels of
Condemnation and Flagellation.

RIGHT The Crusader bell-tower and entrance to the
Holy Sepulchre, Jerusalem. Saladin bricked up one
arch of the entrance and removed the bells. The tower
was partly destroyed by an earthquake in 1545.

BELOW The rock-hewn Garden Tomb, north of the
Old City of Jerusalem. It is also called [General]
Gordon's Tomb from his claim that this was Jesus'
tomb, but the Holy Sepulchre is far more probable.

BOTTOM RIGHT The Pool of Siloam, Jerusalem,
looking out of Hezekiah's tunnel. The Pool was
originally fed from the Gihon spring through a
short tunnel: King Hezekiah "constructed the pool
and conduit to bring water into the city"
(2 Kings 20:20).

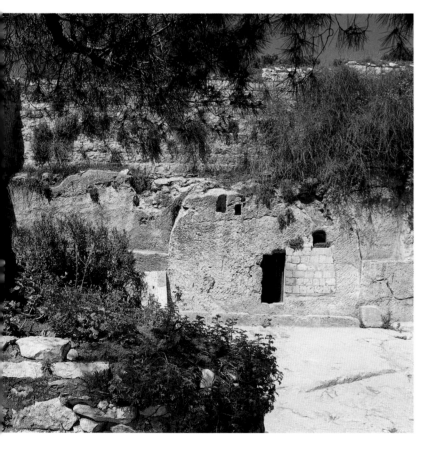

(c.280–337) onward, Jerusalem received literal attention, with churches and monasteries being built, and with Jerusalem becoming a centre for pilgrimage even more than it had already been.

Pilgrimage took Christians, not only across the face of the earth, but also backward in time, because it took them back to the places where Jesus had lived and died. However uncertain some of the identifications of particular places might be, Jerusalem became a point of contact for Christians between heaven and earth, a place where they could, so to speak, "touch the fringes of his garment" once more (Matthew 14.36). Many churches contain "Stations of the Cross", markers of the progress of Jesus to the Passion which the disciple can follow: they are but long shadows thrown from the original Via Dolorosa in Jerusalem.

Pilgrimage made Jerusalem literally central, as can be seen in the many maps which were produced that put Jerusalem at the centre of the earth. Some of them are also a reminder that the heavenly Jerusalem nevertheless remains the true goal. The Mappa Mundi of the 13th century, is a spectacular example of this (see page 131).

The Crusades were in part a consequence of these concerns for the earthly Jerusalem (on the Crusades and the complicated reasons for them see pages 218–225). But the heavenly Jerusalem, the Jerusalem of the future, was equally important. It became a summary of God's redemptive purpose and also a vision of the final state of the blessed and the redeemed.

The destruction of the earthly Jerusalem was taken to be a sign of God's judgement on "the old dispensation", but clearly the many promises of God associated with Jerusalem could not be regarded as wholly empty. There was, therefore, a transfer to the Jerusalem of the future which picked up that same Jewish theme, but heightened it: the heavenly Jerusalem would continue to displace the earthly, even at the end of time. This was in contrast to the Jewish belief (not least in resistance to the Christian) which emphasized that the earthly Jerusalem would be restored and would rise up to be *united* with the heavenly at the end of time.

The shift in Christian emphasis to the heavenly Jerusalem can be found above all in its hymns, where Jerusalem has frequently become a synonym for "heaven". Superb Latin hymns, from at least as early as the 4th century CE, were translated into other languages, not least into English through the work of J M Neale (in the 19th century), whose skill produced new splendours in religious translation and poetry. Examples are: "Chorus novae Jerusalem", "Ye choirs of new Jerusalem"; "O bona patria", "For thee, O dear, dear country"; "Jerusalem luminosa", "Light's abode, celestial Salem"; "Urbs beata Jerusalem", "Blessed city, heavenly Salem"; "Urbs Sion aurea", "Jerusalem the golden".

From this transference of Jerusalem into the future, Jerusalem as metaphor becomes (not surprisingly) prominent. In the widely

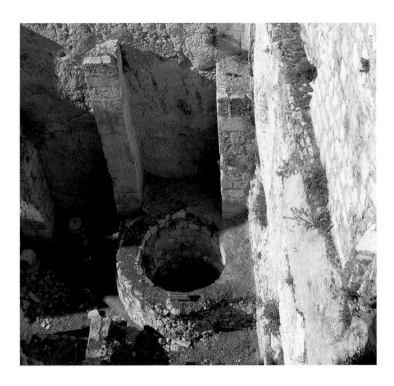

influential poem *Gerusalemme Liberata* of Torquato Tasso (1544–95), Jerusalem became the excuse for wild flights of romantic fancy; in the poetry of William Blake (1757–1827), it became a powerful metaphor of protest and change:

> I will not cease from mental fight,
> Nor shall my sword sleep in my hand,
> Till we have built Jerusalem
> In England's green and pleasant land.

Thus in Christian understanding, there is a strong sense in which the present historical and actual Jerusalem is and must be dispensable. The emphasis on the heavenly Jerusalem is tied closely to the emphasis in the New Testament on the vocation of Christians to be pilgrims, not just in the sense of visiting the Holy Land, but even more of turning away from the earthly Jerusalem and going out to the ends of the earth, taking with them the good news, or Gospel, of salvation, and knowing within themselves the truth of the words, "Here we have no abiding city".

———————— ✠ ————————

ABOVE The Pool of Bethesda in the grounds of St Anne's Church, Jerusalem, is said to be the pool by the Sheep Gate where Jesus healed a crippled man (see John 5).

OPPOSITE TOP St Anne's Crusader Church, Jerusalem, built on the site of a Byzantine church, is a particularly well-preserved Crusader church (see also page 225).

OPPOSITE BOTTOM The 20th-century Church of the Dormition of Mary from the west. It is built over the remains of a Byzantine structure and commemorates the site of Mary's final falling asleep before being taken up to heaven.

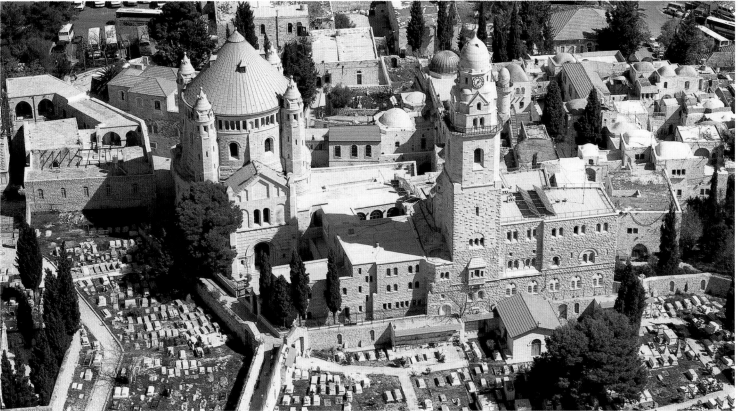

ISLAM

Muhammad lived and worked almost entirely in Arabia, far from Jerusalem. But since Muhammad believed himself to be the true successor of the Jewish and Christian prophets before him, the Land was Holy to him through its associations with those earlier religions. They may have disrupted and confused the revealed word of God entrusted to them (see General Introduction, page 30), but that did not in the least affect the way in which God had sent his servants to his intended land.

This means that Muhammad shared the sense among those Jewish tribes whom he met in Arabia that Jerusalem is the place of God's House. The first Muslims joined the Jews in turning toward Jerusalem in prayer. Jerusalem was called in Arabic alQuds, "the Holy", probably from alBayt alMuqaddas, "the Holy House", that is, the Temple. But Muhammad's experience of rejection among several of the Jewish tribes meant that the religious focus turned to Makkah (Mecca as it is known in the West). Both pilgrimage and prayer were be to made toward Mecca. Madina also became important because there the first Muslim community, or *umma*, was established. But "the third in holiness" is Jerusalem. It was known originally in Arabic as *Iliya* [ie Aelia] *madina bayt al-maqdis*, and it became known by the 4th century AH (in the Muslim calendar, which starts from the Hijra or emigration to Medina in 622 CE) simply as alQuds, The Holy.

THE DOME OF THE ROCK

The Dome of the Rock is a building of extraordinary beauty, solidity, elegance and singularity of shape. It stands on an elevation in the centre of the mosque [ie the Temple Mount] and is reached by a flight of marble steps. It has four doors. The space around it is also paved in marble, excellently done, and the interior likewise. Both outside and inside the decoration is so magnificent and the workmanship so surpassing as to defy description. The greater part is covered with gold so that the eyes of one who gazes on its beauties are dazzled by its brilliance, now glowing like a mass of light, now flashing like lightning. In the centre of the Dome is the blessed Rock from which the Prophet ascended to heaven, a great Rock projecting about a man's height, and underneath it there is a cave the size of a small room, also of a man's height, with steps leading down to it. (ibn Batuta, in Gibb, *Ibn Batttuta's Travels in Asia and Africa, 1325–54*, p. 58.)

But Jerusalem is precious to Muslims, not simply because of God's dealings with it in the past, but because of its association with Muhammad in the Night Journey and the Ascent of Muhammad to Heaven. The reference to these is found in sura 17.1. Jerusalem is not mentioned there by name in the Quran. But sura 17.5–7 (the sura whose name is *Banu Israil*, "The Children of Israel") is clearly referring to the two destructions of Jerusalem. Consequently, the reference in verse 1 can hardly be to anywhere other than Jerusalem. This is the verse which, when it is understood in that way, ties al-isra and al-mi'raj, the Night Journey and the Ascent, to Jerusalem:

> Praise to God, who took his servant on a journey during the night from the sacred mosque [ie "place of prostration" or "worship"] to the furthest mosque [*al-masjid al'aqsa*], whose precincts we blessed, to show him some of our signs: surely God is the One who hears and sees.

The Quran says extremely little about the Night Journey (see also sura 53. 12–18, where details are equally sparse), but it is much elaborated in Hadith (Tradition which records what Muhammad and his companions said and did, and which therefore has authority as a living commentary on what Quran means in practice). In brief, Muhammad was woken one night by Jibril, the archangel Gabriel, and taken to a winged mount known as Buraq. Carried to the Temple site in Jerusalem, Muhammad prayed there (or in heaven) with the prophets Ibrahim (Abraham), Musa (Moses), and 'Isa (Jesus), and others. From the Rock on the Temple Mount, where what is taken to be his footprint can still be seen, Muhammad was carried up through the seven heavens to the furthest limit (sura 53.16ff.).

The Night Journey and the Ascent thus confirm the sense in which Islam is the consummation of what the other religions

---※---

OPPOSITE TOP LEFT The richly-decorated inner dome of the Dome of the Rock is protected from variations of heat and cold on the outer dome by a layer of cork between the two.

OPPOSITE TOP RIGHT The sacred Rock at the centre of the Dome of the Rock, illuminated by the 16 stained-glass windows in the dome. Here the key events in God's purpose are believed to have happened, including Creation, the binding of Isaac for sacrifice, and Muhammad's Mi'raj (Ascent) into heaven.

OPPOSITE BOTTOM LEFT The Dome of the Rock and the Eastern Wall. The gold-leaf on the dome dates from the restoration of 1994, funded by King Hussein of Jordan.

OPPOSITE BOTTOM RIGHT One of the four entrances to the eight-sided Dome of the Rock. The brightly-coloured Turkish tiles – last restored in 1963 – reproduce 7th-century floral and decorative patterns. The tiles shield the 56 stained-glass windows that illuminate the interior.

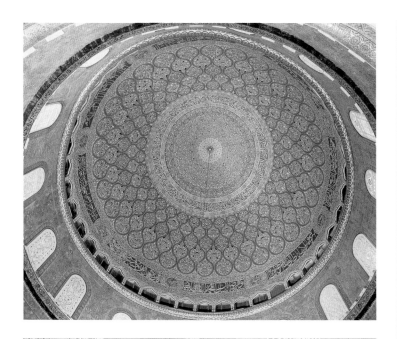

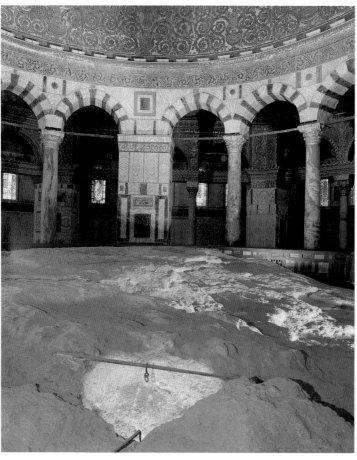

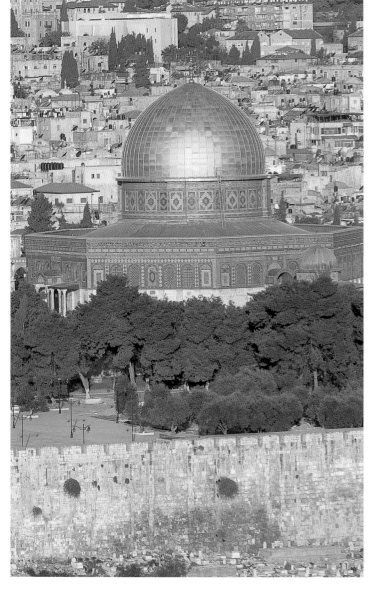

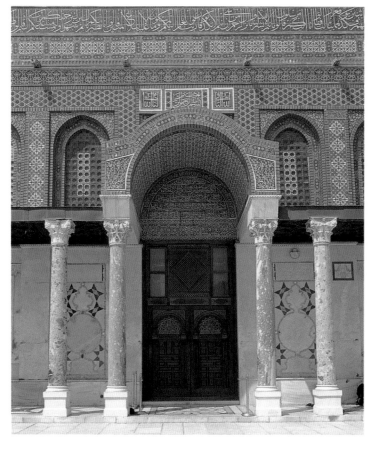

associated with Jerusalem had been aspiring, unavailingly, to achieve – the worship of God without compromise or conflict. That same sense of completion and consummation is clear also in the way in which originally the *qibla*, the direction of prayer, was towards Jerusalem not Mecca. Once again, the passage in the Quran, sura 2.136–40/142–5, does not mention Jerusalem specifically, but it is clearly referring to Jerusalem as the place from which the *qibla* was changed:

> The fools among the people will say, What has turned them from the *qibla* to which they were accustomed? Say: To God belong both East and West. He guides whom he wills to a straight path. Thus we have appointed you to be a mediating nation, that you might be witnesses to the people, and the apostle a witness to you. And we appointed the *qibla* to which you were accustomed, in order to know those who followed the apostle from him who would turn on his heels …

The way, therefore, in which Islam understands its relationship to the Ahl alKitab (the People of the Book, that is, Jews and Christians as the predecessors of Muhammad) influences the Muslim understanding of Jerusalem and its meaning: it is a place of great holiness, in which many of the great acts of God, from creation onwards, took place (exactly as the Jewish and Christians traditions affirmed); and it is therefore the place where God confirmed the choice of his prophet Muhammad to be the Seal of the Prophets, as well as being the consummation of God's purpose to guide and show mercy on those who turn to him. But equally, Mecca and Medina, and not Jerusalem, are central to the final act of God's purpose in summoning Muhammad to be his Prophet.

Jerusalem, therefore, for Muslims, is alQuds, the Holy. The two major Muslim buildings on the Temple Mount make this abundantly clear. alMasjid alAqsa' was built as the "Furthest Mosque", referred to in sura 17 (see above). Qubbat asSakhrah, the Dome of the Rock (piously, but unhistorically, also called "the mosque of Umar") covers the Rock, the foundation of the world from which Muhammad ascended into heaven: the split in the Rock which can still be seen is said to have happened at the moment of the Mi'raj, because it wanted to follow Muhammad into heaven. The splendid appearance of the Dome of the Rock was described by the traveller ibn Batuta in the 8th century AH (see box page 146).

In addition to this, Islam has accepted and extended the many traditions of Jews and Christians which associate Jerusalem with the *eschaton*, the final event, which heralds the end of the world and the beginning of the Last Judgement. The sacred shrine in Mecca, the Ka'bah will emulate Muhammad's journey to the Temple Mount, and the angel of death, Israfil, will summon the dead to the

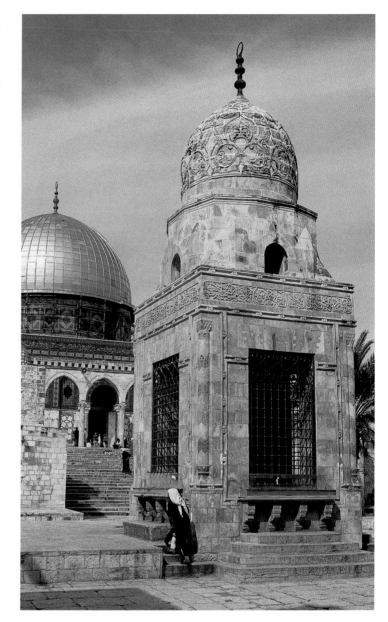

Mount of Olives. They will then cross a long bridge, as narrow as a hair and as sharp as a sword, from the Mount of Olives to the Temple Mount. At each of seven arches, each person will be asked to account for his or her actions. Those who on balance can show good works will be offered the sweet waters of paradise.

Islam, therefore, sees the consequence of Jerusalem as lying in its centrality (literally) in the whole purpose of Allah in relation to creation and judgement. Ramla (page 215) and other places may be more important politically, but religiously there is no question: Mecca and Medina are supreme, but the paramount importance of Jerusalem as "the third in holiness" is never in the least in doubt.

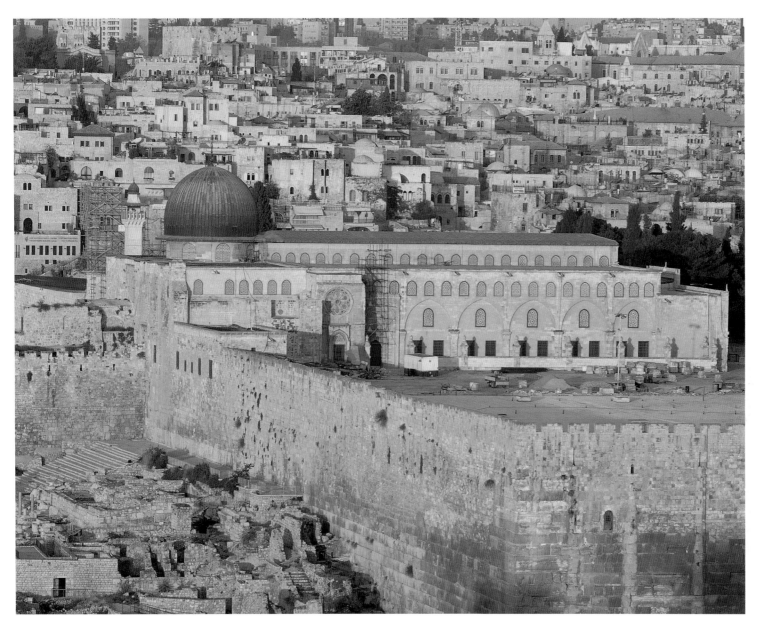

OPPOSITE The Sabil Qaytbay public fountain, close to the Dome of the Rock, was built around 1487. The Egyptian craftsmen decorated the outside with verses from the Quran, and the inside with star-pattern strapwork. It was restored in 1883.

ABOVE alAqsa mosque, Jerusalem, at dawn. The 7th-century original has undergone occupation by the Crusaders and much destruction and rebuilding. The 11th-century silver dome is almost blackened by oxidisation.

RIGHT One of the seven aisles in alAqsa mosque, dating back to Saladin's time. The floor is covered in prayer mats, allowing up to 5000 people to worship at one time.

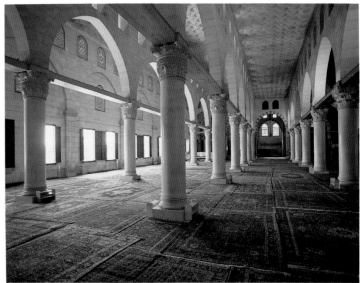

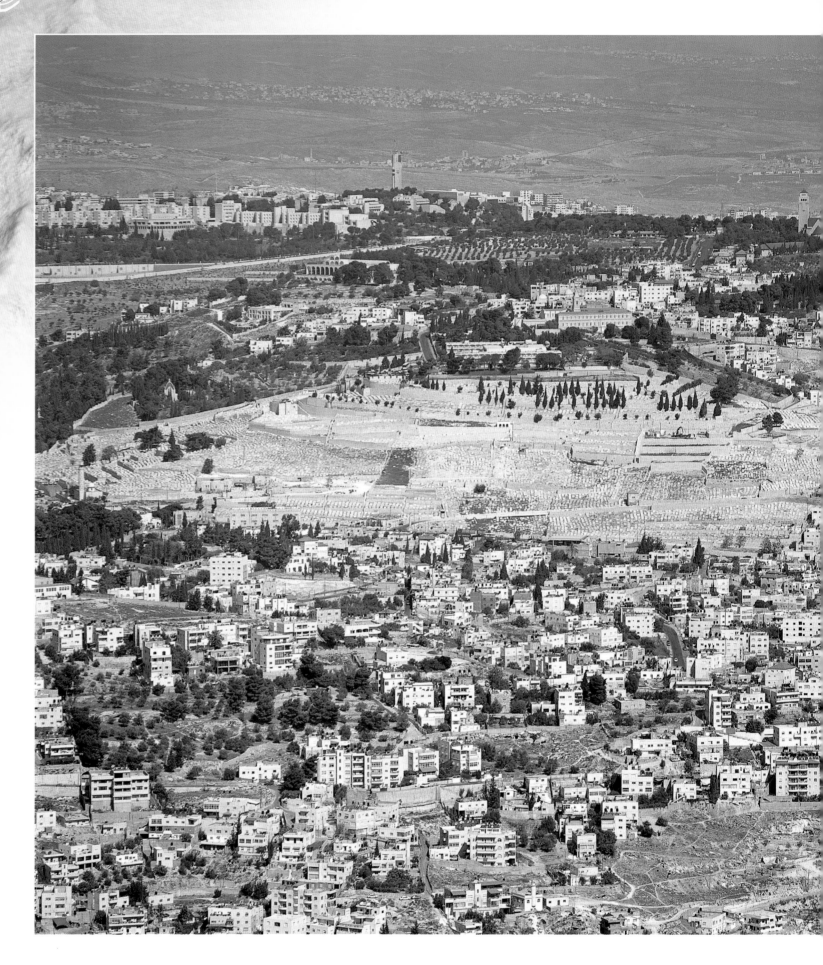

THE MOUNT OF OLIVES

LEFT The Mount of Olives, Jerusalem, from the south-east. Prominent is a Jewish cemetery. Jews, Christians and Muslims associate the Mount of Olives with resurrection and the end of all things.

The high ridge that makes up the Mount of Olives lies to the east of Jerusalem. It is separated from Jerusalem by the Kidron Valley. The village of at Tur, near the centre of the range, simply means in Arabic "the mountain": at its highest point, the Mount of Olives is more than 200 feet higher than the Temple Mount. In Jewish tradition, it was from this Mount (which the Great Flood did not cover) that the freshly plucked olive leaf was brought to Noah (Genesis 8.11). One part of the Mount, close to the city, was called Gethsemane, from the Hebrew *geth shemanim*, "oil presses". It was there that Jesus prayed before his arrest.

The Mount of Olives was important strategically in the defence of Jerusalem. Any approach from the Jordan, or from much of the south and north, could be seen. One part of the Mount to the north is called by a Latin name, Scopus, where Alexander the Great met the high priest (page 18), and where the 10th legion of the Roman army camped in 70 CE as a prelude to the final capture of Jerusalem at the end of the 1st Jewish Revolt.

The Mount of Olives was certainly important for the Jews as part of the defence of Jerusalem, but it was important also as the site of a ritual ceremony. According to Numbers 19.1–22, the carcass of a "red heifer" (*parah adummah*, a cow of a reddish colour) is to be burnt and its ashes mingled with spring water in order that it can be used to cleanse people defiled by contact with a corpse. According to Numbers, the heifer must be slaughtered "outside the camp". While the Temple stood, the red heifer was taken outside Jerusalem to the Mount of Olives to be slaughtered, and a bridge or causeway was built for the purpose from the eastern gate of the Temple Mount across to the Mount of Olives.

Because the Mount of Olives was associated with both defence and the ritual cleansing of the defiled, later prophets saw the Mount

as the place from which God will begin the final battle against Israel's enemies, a time when the Mount of Olives will be levelled because defence will no longer be needed:

> Then the Lord will go forth and fight against those nations as when he fights on a day of battle. On that day his feet shall stand on the Mount of Olives, which lies before Jerusalem on the east; and the Mount of Olives shall be split in two from east to west by a very wide valley … Then the Lord my God will come, and all the holy ones with him. (Zechariah 14.3–5)

Since burial was forbidden inside Jerusalem, many burials took place on the Mount of Olives (for the belief that burials should take place in or near Jerusalem see page 236). Tradition claims that the

———————— ✳ ————————

BELOW The 20th-century Church of All Nations, Mount of Olives. The 12 domes represent the countries who supported the project. The façade is decorated with a Byzantine-style mosaic of Christ as the link between God and humanity.

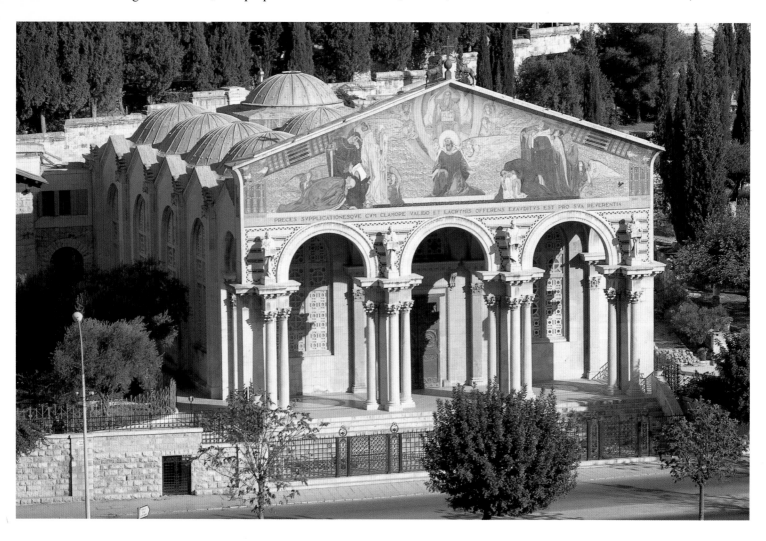

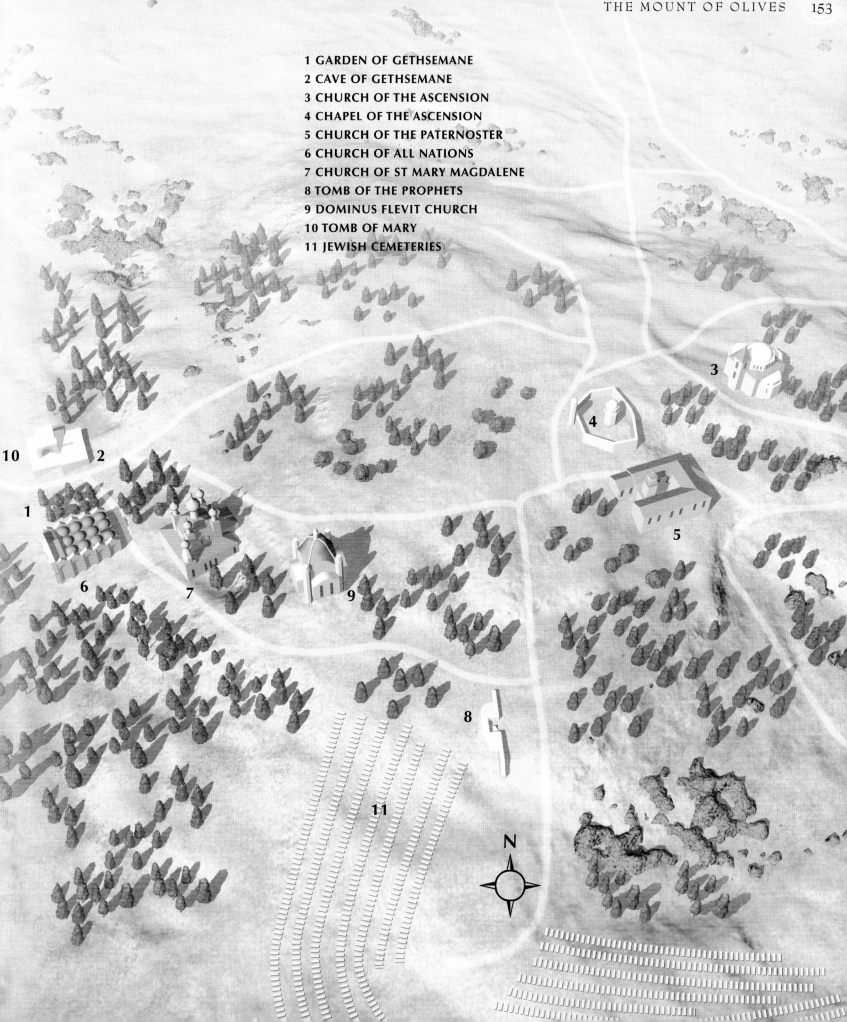

1 GARDEN OF GETHSEMANE
2 CAVE OF GETHSEMANE
3 CHURCH OF THE ASCENSION
4 CHAPEL OF THE ASCENSION
5 CHURCH OF THE PATERNOSTER
6 CHURCH OF ALL NATIONS
7 CHURCH OF ST MARY MAGDALENE
8 TOMB OF THE PROPHETS
9 DOMINUS FLEVIT CHURCH
10 TOMB OF MARY
11 JEWISH CEMETERIES

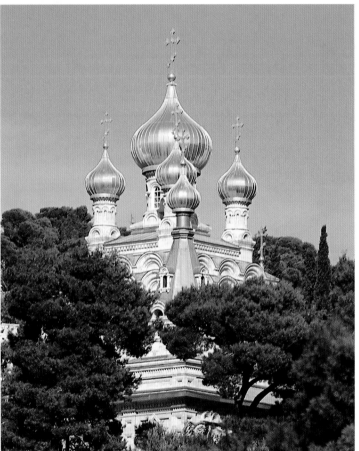

tomb of three prophets (Zechariah as above, Haggai, and Malachi) can be seen on the Mount of Olives, but the structure of the claimed tomb is clearly later in date than their own time.

Jesus was familiar with the whole area of the Mount of Olives. It was here, "sitting on the Mount of Olives opposite the temple" (Mark 13.3), that Jesus looked down on the city and spoke of its impending destruction as the "birth-pangs" of a time of great testing (Mark 13.1-37). With the same feeling of sorrow, Jesus wept: "As Jesus came near and saw the city, he wept over it, saying, 'If you, even you, had only recognized on this day the things that make for peace! But now they are hidden from your eyes'" (Luke 19.41–2). It is this sorrow that is caught in Boris Pasternak's poem "The Miracle":

> He was walking from Bethany to Jerusalem,
> Brooding over sad premonitions.

BETHANY

At Bethany (about 2 miles east of Jerusalem), Jesus stayed with his friends Martha, Mary, and Lazarus (see, for example, Luke 10.38–42; John 11.1–44). It was here, according to John 11, that he raised Lazarus from the dead, and the present-day Arabic name of the village, alAzariyeh, reflects this, taken as it is from the Greek Lazarion, the place of Lazarus. Muslims both recognize and respect the raising of Lazarus, and in the past they not only allowed Christian pilgrims to make visits to the supposed tomb of Lazarus, but also constructed on its site the mosque of alOzir. In Bethany, also, Jesus was anointed in the house of Simon the leper (Mark 14.3–9; Matthew 26.6–13).

BETHPHAGE

At Bethphage nearby, Jesus began his final and triumphal entry to Jerusalem. There is a present-day Bethphage, but it is by no means certain that this is the Bethphage of the time of Jesus. In Matthew's account (21.1–9):

> When they had come near Jerusalem and had reached Bethphage, at the Mount of Olives, Jesus sent two disciples, saying to them, "Go into the village ahead of you, and immediately you will find a donkey tied, and a

TOP LEFT The tear-shaped 20th-century Dominus Flevit Church, Mount of Olives. The name recalls the Gospel accounts of Jesus weeping over the fate of Jerusalem.

LEFT The 19th-century Russian Orthodox Church of St Mary Magdalene on the Mount of Olives. It was built by Czar Alexander III and supported by his successors. It contains icons of Mary Magdalene and the Virgin Mary.

OPPOSITE The Chapel of the Ascension, Mount of Olives. The first church was built in 390. The current chapel dates from 1150, with the dome and drum added in 1200. Inside is displayed the imprint of Christ's right foot.

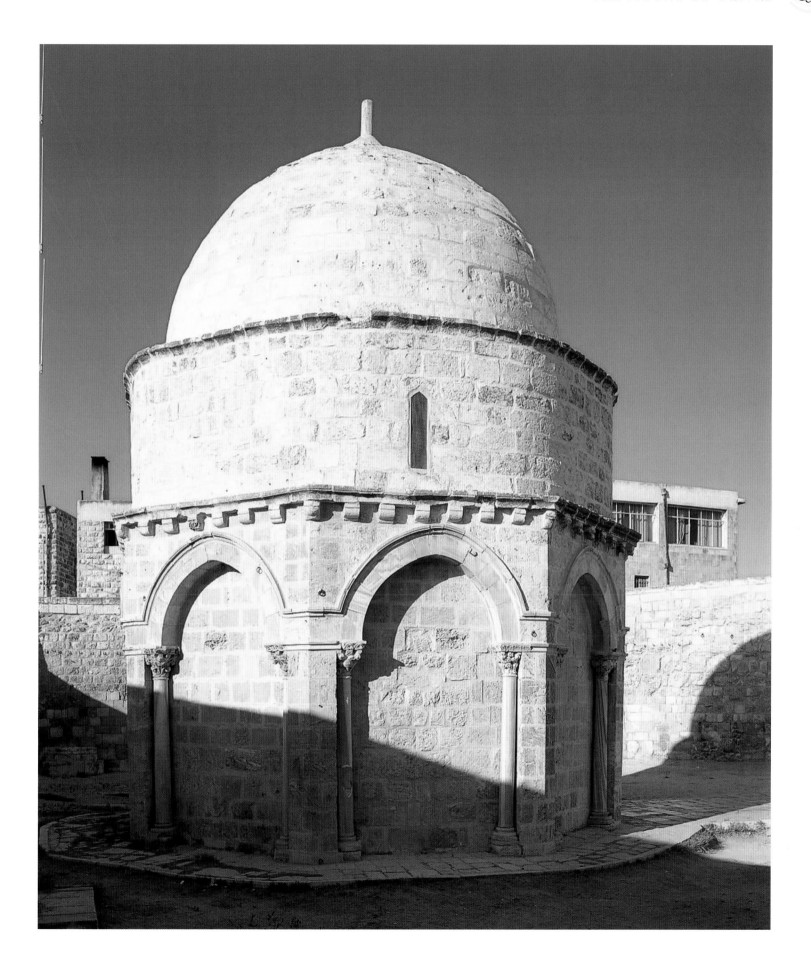

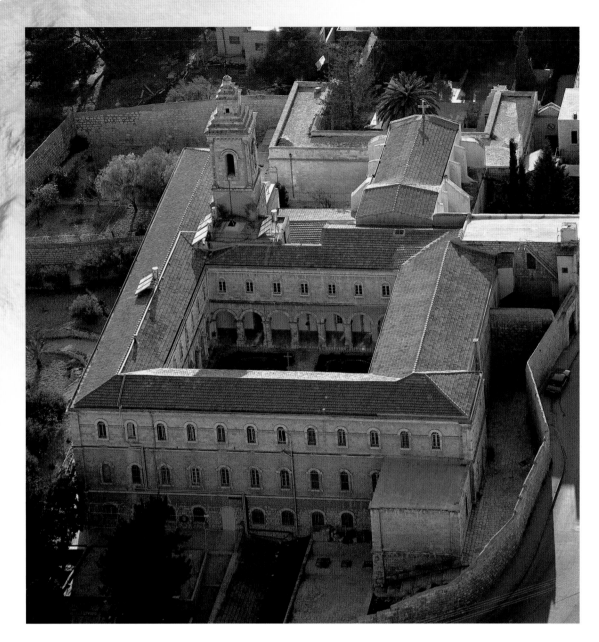

LEFT The Church of the Paternoster, Mount of Olives, built over the cave in which Jesus is said to have taught his disciples the Lord's Prayer. The current 19th-century church is the third on the site. The cloister displays the Lord's Prayer in over 60 different languages.

OPPOSITE TOP The Church of the Ascension, and adjoining convent, near the summit of the Mount of Olives. This 19th-century Russian Orthodox church is once again the focus of Russian pilgrims, although visitors can only enjoy the view of Jerusalem from the six-storey bell tower once a year, on Ascension Day.

OPPOSITE BOTTOM LEFT Steps to Mary's tomb in the Church of the Assumption, at the foot of the Mount of Olives.

OPPOSITE BOTTOM RIGHT The entrance to the Church of the Assumption. Most of the 12th-century Crusader upper church that succeeded the 6th-9th-century churches was destroyed and used for building material, but the lower church remained virtually intact. The site has since been shared by Christians and Muslims.

colt with her; untie them and bring them to me. If anyone says anything to you, just say this, 'The Lord needs them.' And he will send them immediately."

His purpose was to use them for his entry into Jerusalem in order, according to Matthew, to fulfil two prophecies from Isaiah and Zechariah. An early Christian writer, Epiphanius (750–800), wrote that the place where the ass was mounted was about 1000 paces from the Church of the Ascension, and that Bethany was the same distance further on.

Still on the Mount of Olives, it was in the Garden of Gethsemane that Jesus entered into the final struggle of his vocation. Should he allow himself to be taken before the high priest to test the truth of his teaching? The high priest was the final authority whose responsibility it was to decide whether a teacher like Jesus was true

or false. He was the one whom the Book of Deuteronomy calls "the judge who is in office in those days" (Deuteronomy 17.9; on this see further the General Introduction, page 26). Jesus had to decide whether to continue in his claim that God was in truth acting and speaking through him with power and effect, or whether he should back down and avoid the trial by returning to Galilee while he still had time to do so.

It was in the Garden that his decision was, in great agony, taken. After the Last Supper with his followers, Jesus went to a place where he often met with his disciples (John 18.2), and there he wrestled in prayer: "In his anguish he prayed more earnestly, and his sweat became like great drops of blood falling down on the ground" (Luke 22.44). He had asked three of the disciples, Peter, James, and John, to keep watch with him, but "when he got up from prayer, he came to the disciples and found them sleeping" (Matthew 26.40).

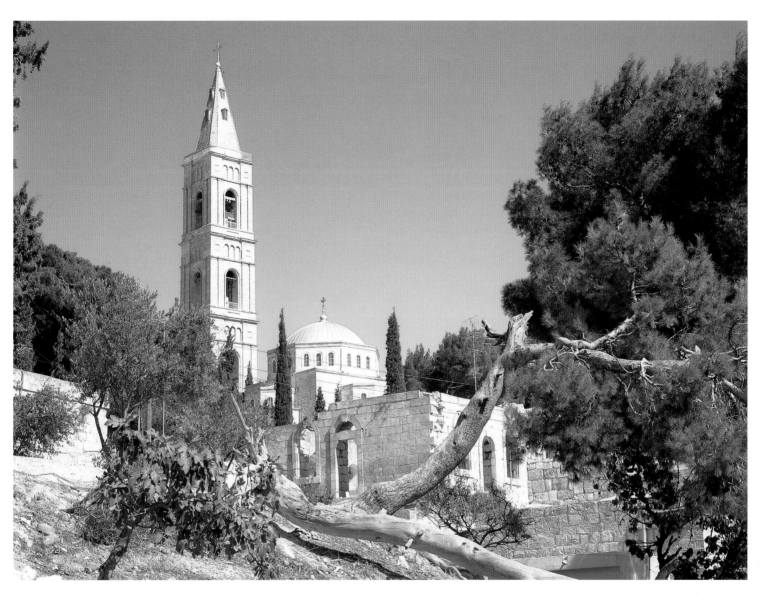

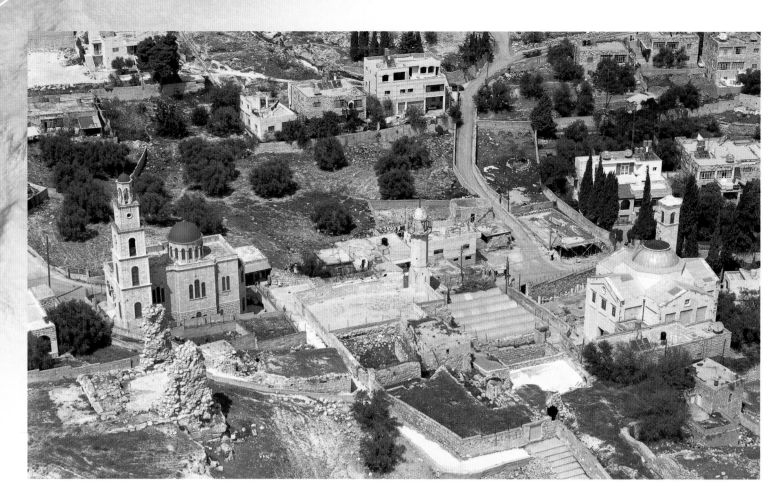

The place where the disciples are believed to have fallen asleep is known as the Cave of Gethsemane.

It was here also that Jesus was betrayed by Judas (Mark 14.43–52). Originally the place of prayer and the place of betrayal were thought to be the same, but by the 4th century two separate places were identified, and the place of betrayal was thought to have been about 100 yards further north. In the 4th century, a church was built on what was believed to be the place of prayer, but this was destroyed by an earthquake in the 8th century. The Crusaders built another church on the same site, but this was abandoned by 1345. There is now a new church, built in 1924 on the same site, called the Church of All Nations.

According to Luke 24.50, it was from the Mount of Olives that Jesus ascended into heaven – though the Greek words used by Luke to describe the Ascension are nothing like so dramatic as the portrayals of the event in many church windows. One word means "make distance", as in the drill command in the Greek army, "make distance between yourself and the next man". Another word means "bring something from a lower to a higher position", so that what Luke was describing is the way in which Jesus moved up the Mount, making a distance between himself and his followers, until they could see him no more. Some texts then add that he was raised up as an offering to God, and it is that note of

TOP St Lazarus Church and tower, Bethany (right). The site includes a 16th-century mosque (centre) and a Greek Orthodox church behind the ruins of a Crusader tower (left).

OPPOSITE TOP The Church of St Lazarus, Bethany, at dawn. The church was designed by Antonio Baluzzi, who was also the architect of the Dominus Flevit Church on the Mount of Olives.

OPPOSITE INSET Entrance to the tomb of Lazarus (see John 11). The modern entrance is about 30 yards up the hill from the present church.

OPPOSITE BOTTOM The garden of Gethsemane, Jerusalem, with the Church of all Nations (right). The church stands close to the traditional site of Jesus' betrayal and arrest.

———————— �֍ ————————

sacrificial offering which has remained important in the Christian understanding of Jesus.

Several sites have been identified as the place of the Ascension. Of particular importance is the Mosque of the Ascension, which was built on the site identified originally by Christian pilgrims. On that site a church was built of which nothing visible remains, and in 1198 Salah udDin (Saladin) made a gift of the site to two of his followers. Because Muslims believe that Jesus did not die on the cross, but was taken directly to heaven by God, this is associated with the Christian belief in the Ascension, and for that reason a Mosque was built on the site incorporating the remains of the Crusader church.

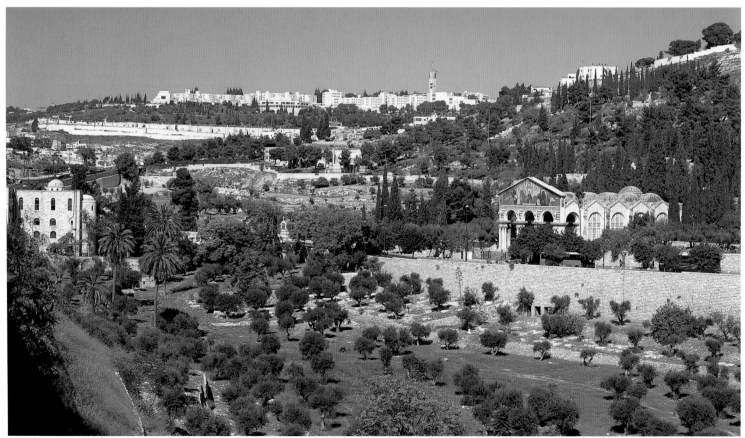

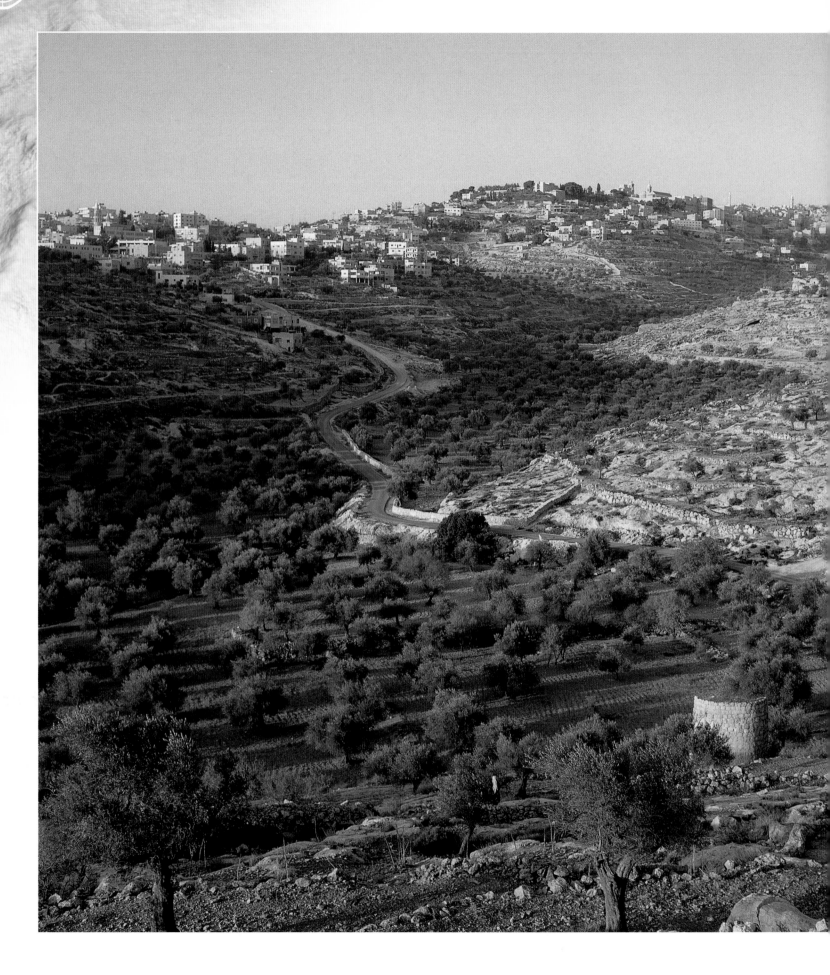

BETHLEHEM

Bethlehem, of noblest cities
None can once with thee compare.

So begins the English hymn based on the 5th-century poem of Prudentius, "O sola magnarum urbium". It seems a remarkable thing to say about a small town five miles south of Jerusalem. But Bethlehem can claim that description because it was the family home of David and the place where he was anointed king. It was also the traditional birthplace of Jesus who, for Christians, is the descendant of David and the one who completes his line. Sadly, though, Bethlehem has also been a place of divisions and disputes. It was so in the past, as when, for example, a dispute here between the Orthodox and Roman Catholic Christians was one of the causes of the Crimean War. It is so in the present, caught up as it is in the conflict between Israelis and Palestinians: in 2006, Bethlehem was separated from Jerusalem by the 400-mile wall (see page 9) designed to protect Israelis from terrorist attacks. It seems far removed from the prophecy of Micah in the 7th century BCE (Micah 5.2, 5) that Bethlehem will bring forth "one who is to rule in Israel,... and he shall be the one of peace". Ironically, the only words to survive from an early mosaic in the cave of the Nativity are *pax hominibus*.

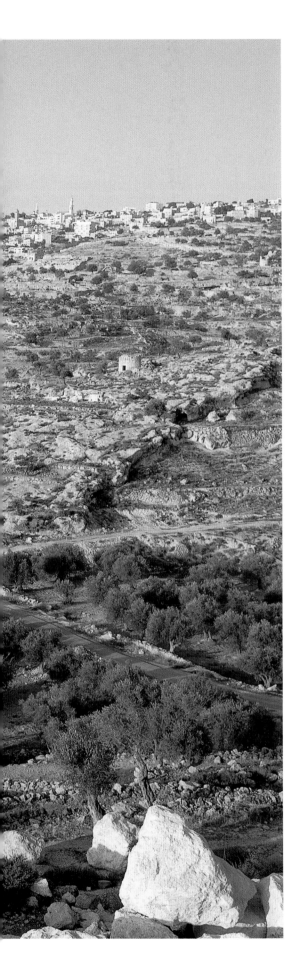

LEFT Churches on the skyline at Bethlehem, 2500 feet above sea level. Farmers, including "shepherds in the fields abiding" (Luke 2.8), built shelters to keep watch during the night (see also page 124).

The name *beth lehem* means in Hebrew "house of bread" (or possibly "of fighting" or "of the god Lahamu"); the Arabic name beit lahm means "house of meat". Bethlehem is built on the north-south ridge in the central highlands near Jerusalem.

Its importance for the Jews lies mainly in its connection with David, but there are other reasons as well. According to Genesis 35.19–20, Rachel was buried here: "So Rachel died, and she was buried on the way to Ephrath (that is, Bethlehem), and Jacob set up a pillar at her grave; it is the pillar of Rachel's tomb, which is there to this day." Rachel's Tomb is indeed still there, in the north part of the town, and it is a site of pilgrimage for Jews. However, it may be that the note in Genesis identifying Bethlehem is a mistake. There is an alternative account in 1 Samuel 10.2 which places Rachel's tomb "in the territory of Benjamin" close to a different Ephrath, north of Jerusalem.

Bethlehem is first mentioned outside the Bible in one of the letters found at Tel elAmarna. These are letters written, mainly in Akkadian, by rulers and officials in West Asia to the Pharaohs of Egypt between roughly 1400 and 1360. Some are from Palestine describing how invaders called *apiru* or Habiru are gaining success, "taking cities of the king". If the Habiru are the Hebrews, this might reflect the Israelite occupation of Canaan, but this is much disputed. Letter 290 reads in part: "The land of the king went over to the Apiru people, and now even a town of the land of Jerusalem, Bit Lahmi by name, a town belonging to the king, has gone over."

Bethlehem was the home of Ruth, from whom David was descended as her great-grandson. This is remarkable, because Ruth was originally a non-Jew, a widow from Moab. In later understanding, this shows how the purpose of God can be achieved through even the most unlikely people.

Bethlehem was David's home (1 Samuel 16.1; 17.12), and the place where he was anointed king (1 Samuel 16.4–13). The Hebrew word for "the anointed one" is *hamashiach*, from which comes the English word "messiah". David was the first "messiah", the first to introduce anointed kings into Israel. In fact, the introduction of kings to rule over the coalition of families that made up the kinship group of Israel was deeply controversial. Before the

LEFT The altar of the birth of Jesus in the grotto of the Church of the Nativity, Bethlehem. A Latin inscription and a silver star inlaid in the marble floor marks the spot where the birth of Jesus has been venerated since the 4th century.

ABOVE The tomb of Jacob's wife, Rachel, at Bethlehem. The simple domed structure of the 1620s and 19th-century restoration is now almost hidden by the 1990s fortifications. Another tradition places Rachel's tomb in north Jerusalem.

RACHEL'S TOMB

BATTIR

BETHLEHEM

SHEPHERDS' FIELDS

MAR SABA MONASTERY

SOLOMON'S POOLS

HERODION

DEAD SE

NAHAL TEQOA

N

time of Saul, each family group had its own leaders, the so-called Judges, and they felt no need to have a permanent ruler over them all. It was when the Philistines became a more-or-less constant threat that a permanent leader became necessary in order to unite the families into common action. Indeed, at one time Bethlehem was captured by the Philistines (see box, right).

After the death of Solomon, the recently established kingdom was split between the North (Israel) and the South (Judah), and Bethlehem was immediately fortified to help in the defence of Jerusalem. Bethlehem was so closely associated with David that it

DAVID AND THE PHILISTINES

Towards the beginning of harvest ... the garrison of the Philistines was then at Bethlehem. David said longingly, "O that someone would give me water to drink from the well of Bethlehem that is by the gate!" Then the three warriors broke through the camp of the Philistines, drew water from the well of Bethlehem that was by the gate, and brought it to David. But he would not drink of it; he poured it out to the Lord, for he said, "The Lord forbid that I should do this. Can I drink the blood of the men who went at the risk of their lives?" Therefore he would not drink it. (2 Samuel 23.13–17)

BELOW Manger Square (bottom right) and the Church of the Nativity, Bethlehem, surrounded by 20th-century development (bottom left). In the far distance, to the south-east, is the conical Tel at Herodion (see page 174).

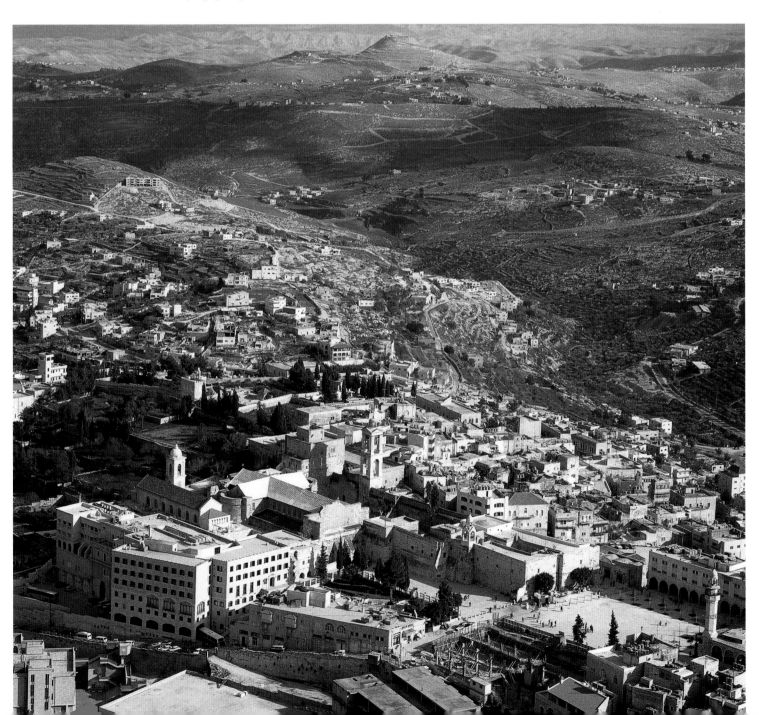

was hoped that another "messiah" (ie anointed king) would come from there to establish God's kingdom on earth. So the prophet Micah (7th century) said:

> But you, O Bethlehem of Ephrathah,
> who are one of the little clans of Judah,
> from you shall come forth for me
> one who is to rule in Israel,
> whose origin is from old,
> from ancient days
> And he shall stand and feed his flock in the strength of
> the Lord,
> in the majesty of the name of the Lord his God.
> And they shall live secure, for now he shall be great
> to the ends of the earth;
> and he shall be the one of peace. (Micah 5.2, 4)

Christians believe that that messiah prophesied from of old was Jesus, who is called for that reason Christ, since the Greek *christos* translates the Hebrew *hamashiach*. Not surprisingly, therefore, two of the Gospels (Matthew and Luke) record that Jesus was born in Bethlehem, though the story of the move of Joseph and Mary, from where they lived in Nazareth in Galilee to Bethlehem, in order to register for a census, is not at all straightforward (for example, the census mentioned by Luke took place about 10 years later than the birth of Jesus). Some, therefore, have argued that the original Bethlehem was the one near Nazareth mentioned in Joshua 19.15 as part of the territory of Zebulun; only later was it thought that it must have been David's Bethlehem in order to answer the challenge in John 7.41–2, "Surely the Messiah does not come from Galilee, does he? Has not the scripture said that the Messiah is descended from David and comes from Bethlehem, the village where David lived?"

The tradition is nevertheless secure, and it points to the site of the manger in which Mary laid the new-born Jesus in a cave under the Church of the Nativity in Bethlehem. The place is marked by a star on the ground with the inscription *Hic De Virgine Maria Jesus Christus Natus Est* ("here Jesus Christ was born of the Virgin Mary").

The Church of the Nativity was begun under the initiative of Helena, the mother of the emperor Constantine who had taken the first steps to admit Christianity into the Empire as an accepted religion (see page 28). The church was dedicated on 31 May 339. After it was severely damaged during conflicts in the early 6th century, the emperor Justinian (*c*.483–565) rebuilt it in the form in which it now stands. It might have been destroyed during the Persian invasion of 614, but the soldiers spared the building when they saw in it a mosaic of three men dressed in the costume of their own land. These were the Three Wise Men, or Magi, who travelled to the infant Jesus following a star (they were not called "kings" before the end of the 2nd century, and they did not receive their

traditional names until the 6th century; Magi are probably ritual experts of the Zoroastrian religion).

In 384, the great scholar Jerome came to live in Bethlehem, and two years later he was joined by Paula and her daughter Eustochium. Among the many caves beneath the Church of the Nativity are those that are claimed to be Jerome's study and tomb, and also the tombs of Paula and Eustochium. Already the church was richly decorated and adorned – so much so that in one of his Christmas sermons Jerome lamented, "Oh that it were granted to me to see the manger in which the Lord was laid! In the belief that we honour him, we Christians have taken away the crib of clay and replaced it with the crib of silver."

Perhaps, therefore, it is surprising that the church was not plundered when the Arab armies laid siege to Bethlehem in 634: in that year, the Christians of Jerusalem did not celebrate Christmas in Bethlehem in their usual way. But Muslims have a profound reverence for both Mary and Jesus, and they did no damage to the church. This was reinforced by the fact that they were invited to use a part of the church for their prayers. As a result, when the caliph Hakim, at the height of the Crusades, ordered in 1009 the destruction of Christian monuments, the Muslims of Bethlehem refused to obey. Later, looting did occur, and much of the marble used in the Haram ashSharif came from Bethlehem. The Church of the Nativity, nevertheless, has survived.

TOP One of the traditional sites of the Shepherds' Fields outside Bethlehem where the shepherds looking after their sheep by night were told by angels of the birth of Jesus (see Luke 2.8–20). There have been churches on two of the three possible sites since the 4th century.

OPPOSITE Mar Saba Greek Orthodox monastery, about seven and a half miles east of Bethlehem (see pages 85 and 88), is a 5th-century lavra or communal worhip centre for hermits. They spent most of their time meditating in nearby cave cells, but came together on Saturdays and Sundays.

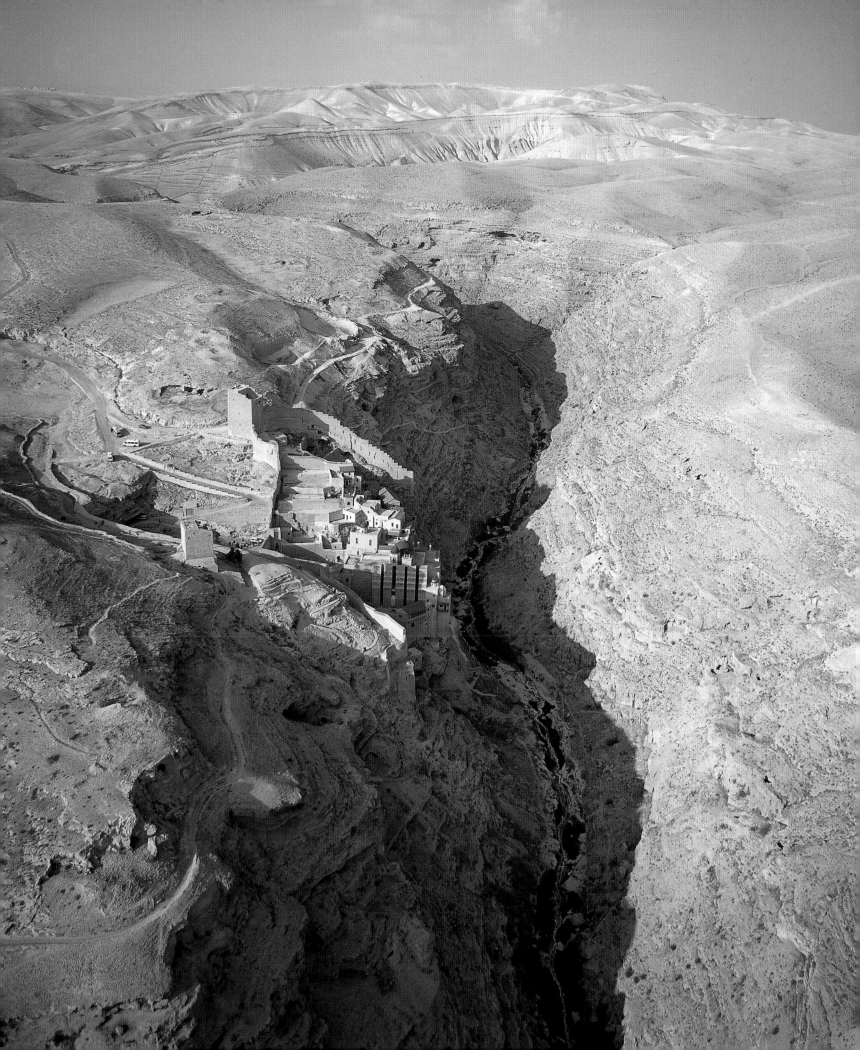

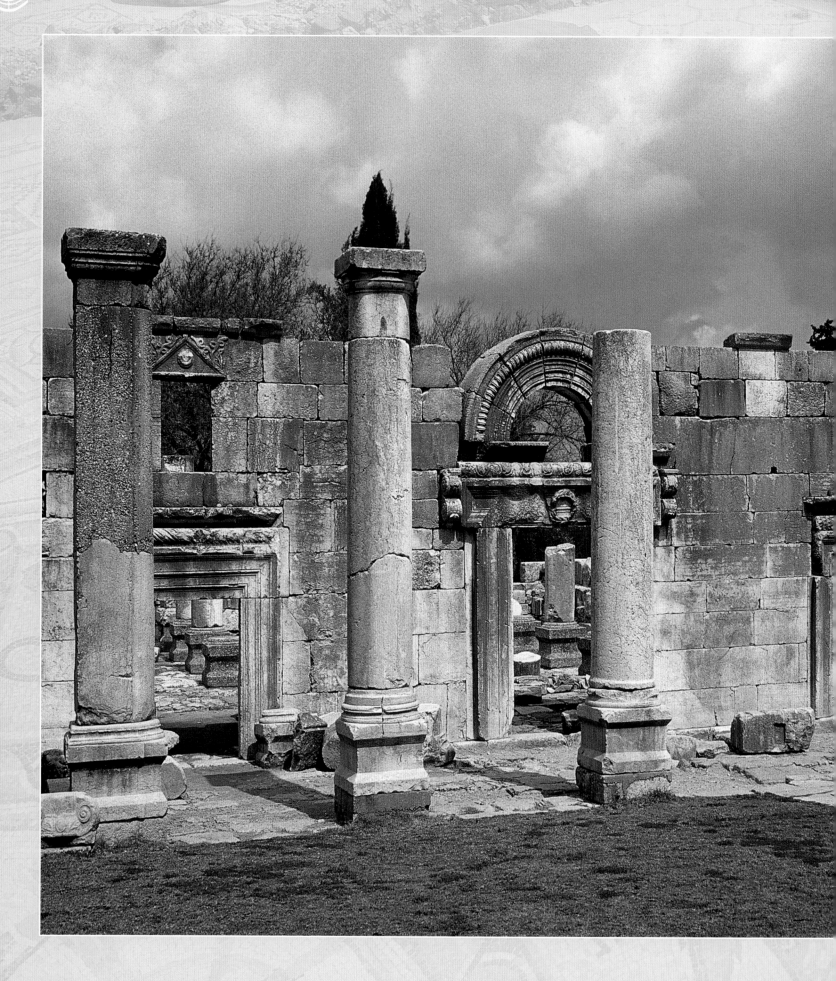

SYNAGOGUES

After the defeat of the 2nd Jewish Revolt in 135, Jerusalem and the Temple were destroyed, and for the next 1800 years the Jews had no land to call their own. In many of the places where they settled (known as the Diaspora, the Dispersion) they often came under severe discrimination and persecution. What enabled the Jews and Judaism to survive? Certainly the faith that had been formed and tested over the previous 2000 years: it was a faith sustained in the family and the Synagogue. In the Babylonian Talmud (B Yebamot 62b) there is a comment on Job 5.24, "You shall know that your tent is in peace": "The reference is to a man who loves his wife as he does himself and honours her more than himself, and who guides his children in the right path; and who makes arrangement for their early marriage." The family is so fundamental that a Jew is defined, not by creed or confession, but by having a Jewish mother. As an extension of the family, the Synagogue became the place where the community continued to gather as Israel. An English rabbi, Morris Joseph, wrote in 1903: "The synagogue is the one unfailing wellspring of Jewish feeling. There we pray together with our brethren, and in the act become participators in the common sentiment, the collective conscience, of Israel. There we pray with a mightier company still, with the whole house of Israel."

LEFT The portico and main entrance of the 4th-century CE Baram synagogue (see map, page 48 and page 51). The synagogue is traditionally held to be near the so-far-undiscovered tombs of Esther and Obadiah.

The vital importance of the Synagogue in Jewish life is certain. What is not certain is how and when synagogues began. The reason for the uncertainty is not just the lack of evidence in the earliest times, but also because the Greek word *synagoge*, which translates the Hebrew *keneset*, does not necessarily refer to a building at all. It may (and often does) mean "meeting" or "assembly".

For that reason some have argued that references in the New Testament to Jesus, Paul and others going to a synagogue may simply mean that they attended an assembly rather than a formal synagogue building. In that case (so the argument goes) the New Testament references to an actual building (in Luke 7.5 and Acts 18.7) are a mistake. There has thus been a debate about whether Jesus ever "went to synagogue" in the sense that we might say of people "they went to church".

The issue, therefore, when looking at remains of buildings in the Holy Land, is whether and when they became synagogues in the formal sense – when, that is, a place of assembly (which might well have been for religious purposes) became a *bet* keneset, a *house* of assembly, built for specific religious purposes. The problem and the clues suggesting the answer lie in the period covered in this book.

Traditionally, the origin of the Synagogue is taken back to Moses. Josephus was reporting a widespread tradition when he wrote (*Contra Apionem* 2.175):

Moses left no excuse for ignorance, because he laid out the Law to be the most excellent and necessary education, ordering that it should not be heard just once or even twice or more often, but that each week men should leave their other occupations and learn the Law with great accuracy. All other lawmakers have overlooked this.

That tradition, however, is doing nothing more than asserting that the Synagogue is a continuation of all that God intended for, and demanded of, his people. It is more likely that the origins of the synagogue in the sense of "assembly" are to be found in the period of the Exile among Jews who had (on that occasion as well long before the Romans) lost both homes and Temple.

That certainly is how later Judaism understood passages in Ezekiel, a prophet of the exilic period, in 8.1, 14.1, and 20.1. More specifically, Rabbi Isaac (B Megillah 29a) looked at the reference in Ezekiel 11.16 which speaks of God becoming for the exiles "a small sanctuary in the countries where they have gone", and stated that the small sanctuary refers to "the synagogue and houses of learning in Babylon", and by extension to the synagogues of the Diaspora. The exegesis may be fanciful, but it does reflect the fact that synagogues were particularly important for Jews who did not live close to Jerusalem and the Temple – that is, those who lived in the Diaspora.

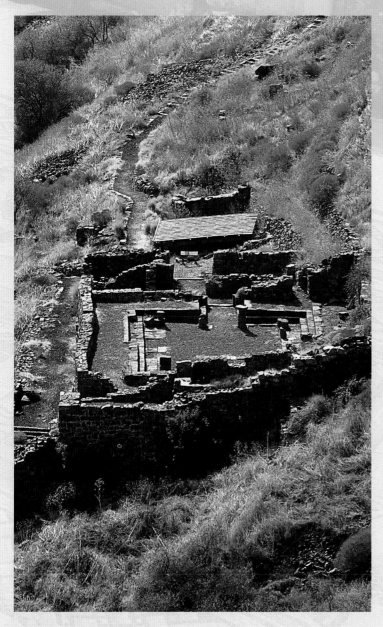

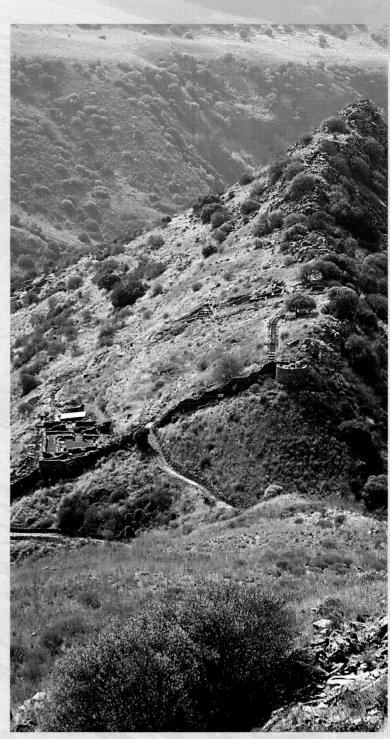

OPPOSITE A synagogue at Tiberias (see map, page 54), built next to the tomb of the 2nd-century sage Rabbi Meir, known as Ba'al haNes, the miracle worker.

RIGHT Gamla, on the Khirbet asSalam ridge, about six miles north-west of the Sea of Galilee. It has been identified with the Gamla of Josephus who describes 5000 suicides when it was taken by the Romans (67 CE), so it has been called "the Masada of the north" (see page 106). But the identification is uncertain.

ABOVE The small building near the old city wall at Gamla has no specifically Jewish features, but close by is a *Mikveh* (ritual bath), so it may be a synagogue from the first century BCE (see page 170).

Eventually (and certainly from the 2nd century CE onward) synagogues were built to house the assembly of the Jewish people for prayer, liturgy, and the reading and study of Torah, and these buildings came to contain the kind of architecture and features with which we are familiar. They include an orientation toward Jerusalem, galleries and benches round the sides, a platform (*bima*) for the reading of Torah, an Ark or chest (*aron*) to contain the Scrolls of Torah, and a lectern.

For the earliest archaeological remains, a question in determining whether a particular building was a synagogue is whether there is any trace of these features – bearing in mind that some of them may not even have existed in any permanent form: the *aron*, for example, could be a portable chest in imitation of the Ark in the wilderness, and unlikely, therefore, to have left any trace.

Of the buildings from before 66 CE, some have benches round the side, so they were clearly intended for public use and for meetings of some kind. They are often called "synagogues", but without surviving traces of any of the other features, it cannot be said with any certainty that they were the dedicated buildings now called synagogues. The earliest building to qualify in that way is at Nabratein (Kefar Neburaya: see Chiat, pages 41–5), which has benches, a *bima*, and marks of where a lectern might have stood, and its date is no later than the middle of the 2nd century CE.

However, the dating of the first synagogue buildings does not only depend on finding the accompanying features. An inscription from Cyrenaica in North Africa at Bernike (modern Benghazi) in the Diaspora is precisely dated to 55/6, the second year of the emperor Nero's reign. While it refers to "the synagogue of those in Bernike" (which might mean simply "the assembly"), it also commemorates 18 people who contributed "to the repair of the synagogue". Assembly and building are thus united during the 1st century CE, and before 66 CE. They are united also in Philo (*Quod omnis probus sit* 81): "The seventh day is set apart as holy so that when they have stopped their ordinary work, they go to their sacred places to which they give the name 'synagogues'....". However, Philo was writing here of the Essenes, not of the Jews in general.

Small hints only, and Benghazi is a long way from Jerusalem and Palestine. Critical, therefore, becomes the Theodotos Inscription (*Corpus Inscriptionum Judaicarum* ii.1404) which was found at the southern end of the Ophel (the ridge south of the Temple Mount):

Theodotos Vettenos [Outtenos] priest and archisynagogos [ruler of the synagogue] son of an archisynagogos grandson of an archisynagogos built the synagogue for reading of [the] law and for teaching of [the] commandments, and the room for strangers and the rooms and the fittings for water for lodgings for those in need from distant parts, [the synagogue] which his fathers founded and the elders and Simonides.

The adjectival clause at the end ("which his fathers founded . . .") has to be connected grammatically with the word "synagogue", so there can be no doubt that the Inscription is referring to a building, not an assembly, in which most of the traditional activities of a synagogue (though not specifically that of prayer) are described.

But what is the date of the Inscription? After it was found in the Weill excavations on the Ophel, 1913–14, it was initially dated to the immediate pre-66 period, but that date has been challenged more recently by those who place it much later (to the 2nd or 3rd centuries). But John Kloppenberg, after an extremely detailed analysis, has shown the flaws in that challenge. His own conclusion ("The Theodotos Inscription", page 278) is that this Inscription "attests a synagogue building in Jerusalem, probably constructed in the early 1st century CE or perhaps the latter part of the 1st century BCE [It] confirms that *synagoge* was used of buildings not only in Egypt [where Philo lived] and Cyrenaica but also in early Roman Palestine." It is not a conclusion that would surprise the early rabbis who reported, immediately after the Fall of Jerusalem, that there had been more than 400 synagogues in Jerusalem alone!

This increases the probability that the early public buildings found at Masada, Herodion, Gamla, Magdala, Jericho, and Kiriyat Sepher were synagogues in that stronger sense of buildings that were constructed for religious purposes. Undoubtedly many of the synagogue remains in this book are later in date, from the 3rd century CE onward, but the buildings properly called synagogues were being constructed much earlier.

In addition to the purposes listed in the Theodotos Inscription (including hospitality), Levine has, in his book *Ancient Synagogues Revealed*, listed others of which prayer and liturgy were paramount. Important also were community meals, education (for which a separate Bet haMidrash came increasingly often to be built), the collection and guarding of community funds (especially for the purposes of charity), the holding of lawcourts, accommodation for synagogue officials, and meetings of special Assemblies, especially at times of crisis.

In the rabbinic period (post-Yavneh: see page 216) synagogues were thought to gather up the holiness of the now-destroyed Temple and extend it into the world. They were regarded as a part

OPPOSITE TOP The synagogue at Capernaum from the south-east (see map, page 54, and page 64). The main entrance opposite the palm tree leads into the prayer hall. Stone benches for the worshippers can be seen along the side wall.

OPPOSITE BOTTOM Part of the mosaic floor at Hammath synagogue (see map, page 54). The menora and other traditional Jewish symbols in the rectangular top panel (see page 11) are at the edge of a central Zodiacal circle.

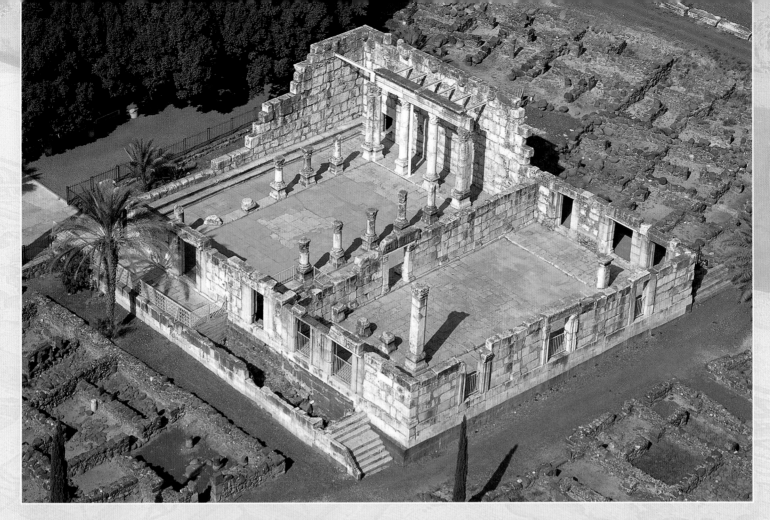

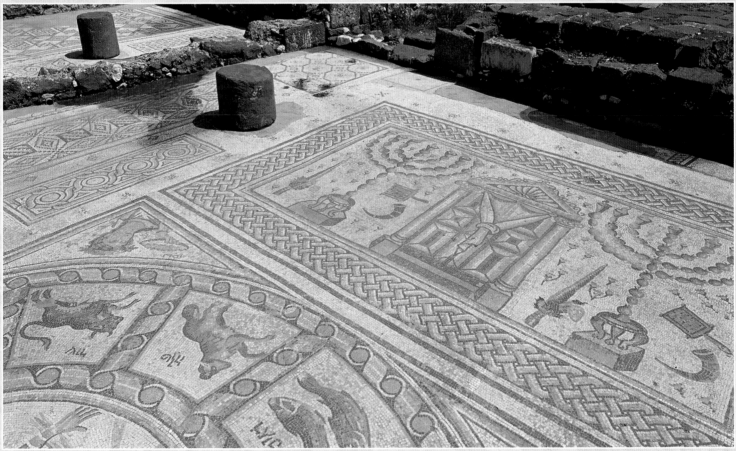

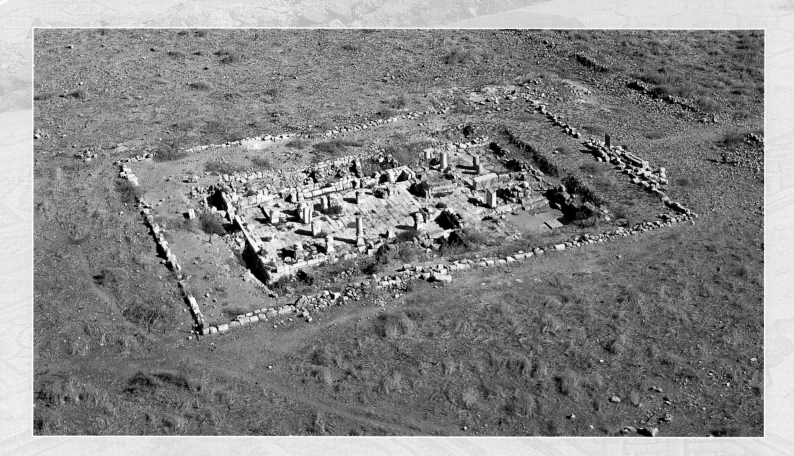

of the Holy Land itself – so much so, indeed, that it was believed that the day will come when the synagogues of the Diaspora will be transferred to the Holy Land:

R. Eleazar haKappar said:
The synagogues and the houses of study in Babylon will, in the time to come, be set in the land of Israel, as it is written, "As Tabor among the mountains and Carmel by the sea came" [Jeremiah 46.18: tradition claimed that Tabor and Carmel moved to Mount Sinai to attend the giving of Torah to Moses]. If on one occasion only Carmel and Tabor went for the setting of Torah in the land of Israel, how much more will this be the case for the synagogues and houses of study where Torah is read and learnt. (B Megillah 29a)

In addition to the provision of hospitality, synagogues were places of study, and increasingly a separate Bet haMidrash, "house of study", was built in conjunction with a synagogue. They became the centres of community for the Jews, who met there especially for the sabbath and the great festivals. An early commentary on the Book of Exodus (*Mekilta* on Exodus 20.21) says that the Holy Presence of God, the so-called Shekinah, is present in the synagogue even if only one person is there – despite the fact that in general a minimum of 10 men is required to constitute a congregation.

In the Holy Land itself, synagogues continued to be built well into the 4th century, when Christianity was becoming increasingly paramount in the empire, although they were mainly on the edges of the Holy Land (in Galilee, the Golan Heights, and the extreme south) rather than in Judaea and Samaria. From this Stemberger concluded that "in general we should assume peaceful coexistence of Jews and Christians in the fourth century, in largely separate spheres of life" (page 159; for an account of synagogue building in this period see Stemberger pages 121–60).

More often synagogues were built in the Diaspora (the Dispersion of the Jews), where their importance for the Jews was so great. In the synagogue began the long history of the Jews in exile which enabled the Jewish historian, Louis Finkelstein, to write "If Jewish life survived the destruction of the Temple, that was because the synagogue had been prepared to take over the whole burden and carry it onward for generations to come."

For Chorazain see page 67.

———————— ✠ ————————

ABOVE Excavations at the 4th-5th-century CE synagogue at Meroth (see map, page 48) revealed a mosaic floor under the paved stone floor and above the original floor. A bronze amulet found under the threshold of a doorway asks God to give its owner power over the villagers.

OPPOSITE The ruins of the village of Biria's synagogue (see map, page 48), one of the oldest in Galilee. The village was abandoned for nearly 200 years after an earthquake and the synagogue was not rebuilt until 564.

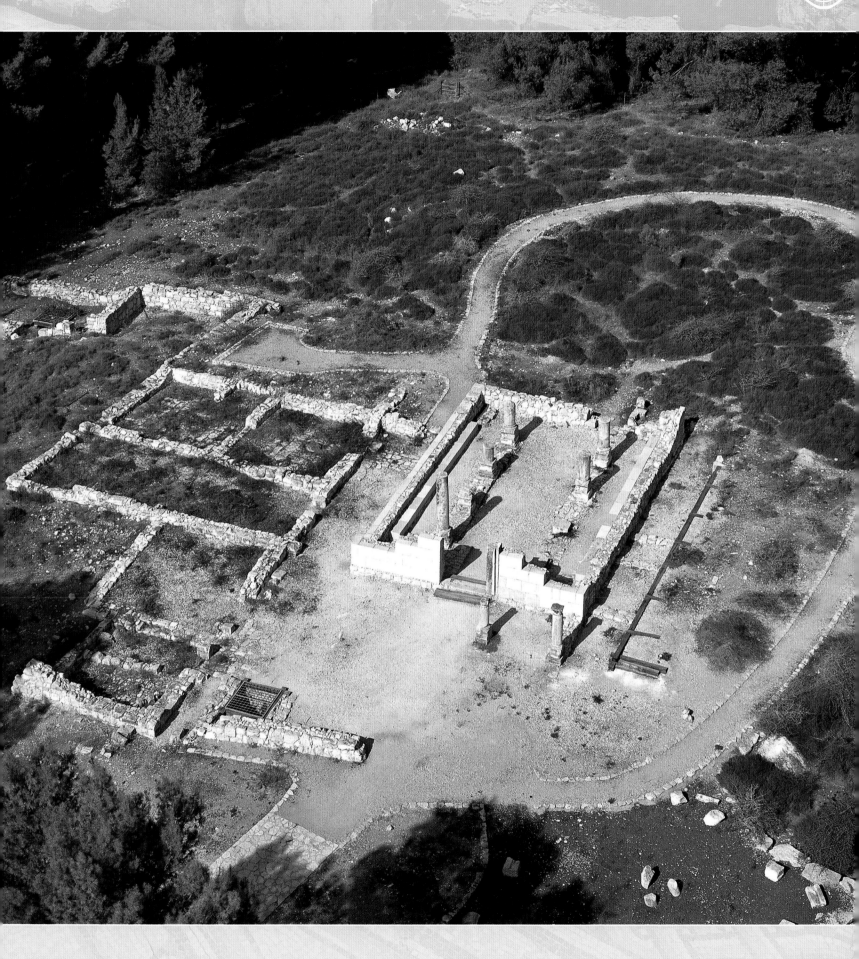

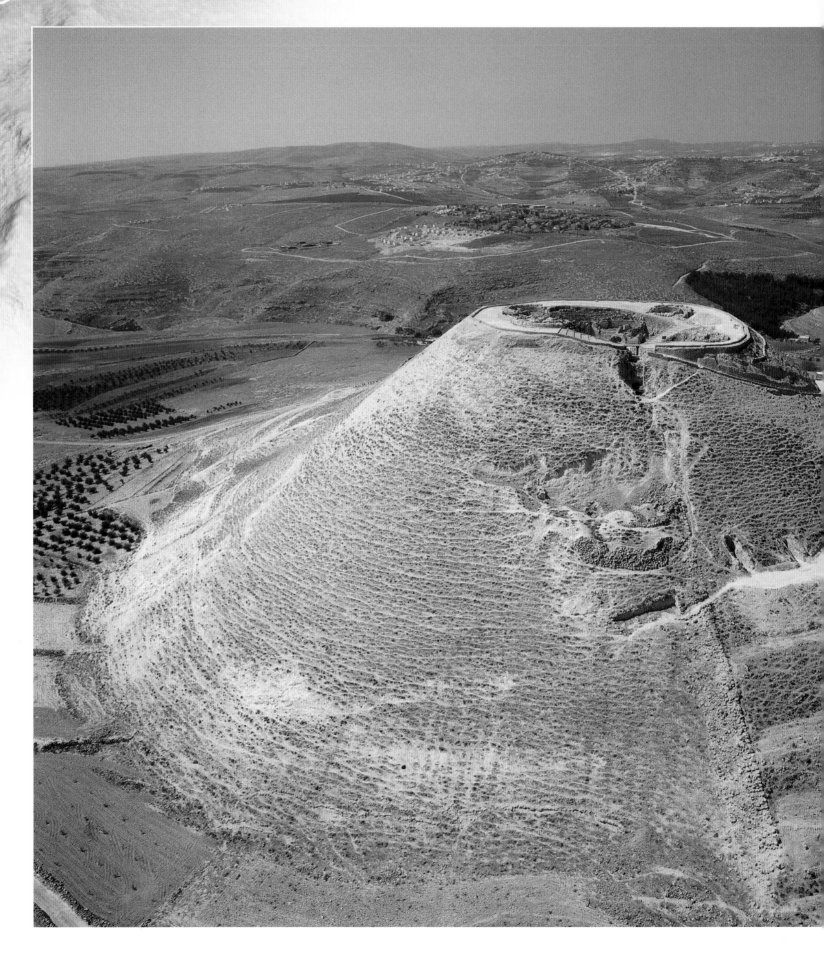

HERODION

HAR HODROS

Few people, if any, have had such a huge impact on the towns and buildings of the Holy Land as Herod. Not that he had any exclusive respect for the land of Palestine as holy. True, his most spectacular project was the rebuilding of the Temple in Jerusalem, but he also built elsewhere temples dedicated to pagan deities, and he built entire towns dedicated to Roman rulers. At Herodion, just south of Jerusalem, Herod celebrated himself, as the name implies – or to put it more precisely, he celebrated his escape after a battle in 40 CE, when Antigonus, a descendant of the Hasmonean rulers, took advantage of the Parthian invasion of Syria. Antigonus persuaded the Parthians to send cavalry to help him, and with their help he became the last independent Hasmonean king, ruling from 40–37. Herod escaped to Masada and from there to Rome. With Roman support, Herod defeated Antigonus, and at Herodion he built both a fortress and a palace to celebrate his success. It was at Herodion (according to Josephus) that he was buried, after his death in Jericho.

LEFT The semi-artificial 200 feet high hill on which upper Herodion stands is clearly visible from Jerusalem, about seven and a half miles to the north. Fortified upper Herodion was linked with lower Herodion by an underground passage.

The way in which Herod, an Idumaean and outsider, rose to power in Judaea has been summarised in the General Introduction (see pages 23–25). Herodion was built between 24 and 15 BCE in order to commemorate his successful delaying action in 40 BCE against Antigonus and the Parthians, as a result of which he was able to escape, first to Masada, then to Rome.

Herodion was built as a summer palace between Bethlehem and Wadi Khareitun. He made it an administrative centre, but also a place of entertainment. For example, he received there in 15 BCE Agrippa, the son-in-law of the emperor Augustus. It consists of two main parts. Upper Herodion is a fortress set on what Josephus calls "a breast-shaped hill" (*War* 1.419):

He adorned the top with round turrets; and round about it he built princely houses, gallantly adorned both within and without. He also brought water from a great distance, with great cost and charges, and he made a staircase of pure white marble to go up, which had 200 steps. For the whole hill was made by design, and was of an exceeding height.

Upper Herodion has mainly disappeared, and the surviving parts are largely underground. From the summit of the mound, it is possible to look down on the lower Herodion, a complex of what Josephus called "other palaces for the accommodation of his household goods and his friends." Herod built a large colonnaded pool supplied with water from a source near Solomon's Pools (page 162). In the centre was a circular building from which could be seen an extended garden. From a corner of the garden stretched a stadium overlooked by the palace for his guests. According to Josephus (*War* 1.667–73), Herod was buried here, but his tomb has never been found.

Herodion was only one among Herod's many building projects. Some were forts and palaces like Herodion. Examples of these are at Jericho (page 80), Callirrhoe (page 93) and Masada (pages 102–107); others, like Gaba in Galilee and Heshbon in Peraea, were mainly forts.

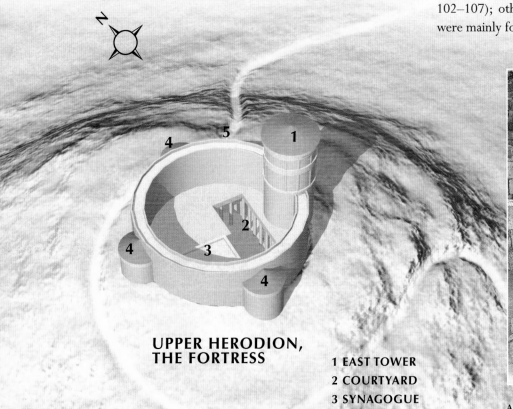

UPPER HERODION, THE FORTRESS

1 EAST TOWER
2 COURTYARD
3 SYNAGOGUE
4 SEMI-CIRCULAR TOWERS
5 ENTRANCE

ABOVE Stone ammunition balls found at upper Herodion.

LEFT An artist's reconstruction of Herodion, based on archaeological finds

OPPOSITE Close-up of the east tower of upper Herodion from the north-west. The tower adjoins a rectangular courtyard, baths, hall, and synagogue.

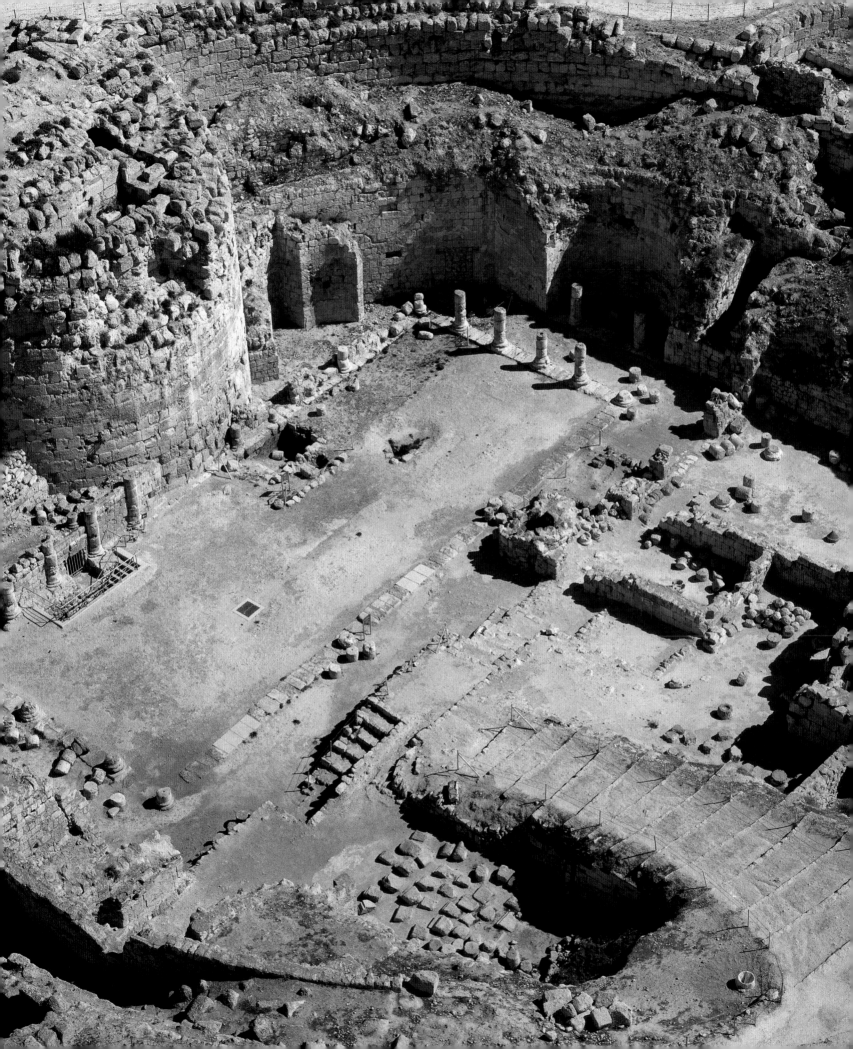

Even more spectacular were the cities which he either rebuilt or began as entirely new cities. Often these were built in honour of the emperor or of some other important Roman figure. Thus he began the construction of Panias with the dedication of a temple to Augustus (the city was completed by his son Philip, hence its name Caesarea Philippi, pages 42–3), and he completed the rebuilding of Samaria which Gabinius had begun after its destruction by John Hyrcanus: in honour of Augustus, Herod called it Augusta, or in Greek Sebaste (page 124). He then rebuilt other forts destroyed by Gabinius, including Alexandrium and Hyrcanus. He also rebuilt Anthedon and called it Agrippium in honour of Agrippa.

Even more dramatically, he took a small and dilapidated harbour on the Mediterranean coast, called Strato's Tower, and turned it into a magnificent harbour and city which he dedicated to Caesar, calling it Caesarea (pages 226–231). According to Josephus (*War* 1.408), "This [Tower] being very old and ruined, … he repaired it with white stone and built a very royal palace therein, in which work, more than in any other, he showed how great and high his mind was".

The Romans were not alone in being commemorated: he did not forget his own family. He chose to commemorate his father, Antipater, by reconstructing a very ancient town called Aphek, later Pegae, and re-named it Antipatris (see page 216).

In the Jordan Valley, north of Jericho, he chose a new and fertile site for a town which he called Phasaelis, after his brother. At Jericho, before he built his palaces, he strengthened an existing fort and dedicated it to his mother Kypros (page 76).

These are only some of the many building projects that Herod undertook (for another example see Hebron, page 190): to read them in summary is to get the impression that he turned the habitable part of Palestine into a vast building site – and even far beyond Palestine, Herod's buildings were going up. Yet magnificent though many of these projects were, the greatest by far was his rebuilding of the Temple in Jerusalem (on Jerusalem, see pages 132–141). According to Josephus (*Antiquities* 15.380), Herod believed "that the accomplishment of this task would be the most notable of all the things achieved by him, as indeed it was, and would be great enough to assure his eternal remembrance".

Initially Herod's plans were greeted with suspicion: he had to show that he had all the stone and other materials for the building in place before he was allowed to start the work of demolition. He had first to level a site large enough for his project, and to achieve this he built the immense retaining walls on the east, south, and west sides. It was this that created the Temple Mount that so dominates Jerusalem. According to Josephus (*Antiquities* 15.412):

This work was one of the most famous pieces that was ever seen under the sun. For the depth of the valley was so great that it was impossible for a man to see the bottom if he looked downward from a higher part, yet notwithstanding that, he erected here this porch of so great a height that just to look from the top thereof, and to consider the depth as well of the valley as the height of the porch, it would make a man giddy, and his eye could not pierce to the bottom of the same.

Very little of Herod's immense project apart from the foundation of the walls has otherwise survived. The Temple was not actually completed until 64 CE, but even before its completion, its magnificence amazed those who saw it, and a saying became common: "Anyone who has not seen Herod's building has never seen anything beautiful." Six years after its completion it was destroyed by the Romans at the end of the 1st Jewish Revolt (70 CE). The little that survived was finally devastated at the end of the 2nd Jewish Revolt. Fortunately, Josephus made a very full description of what Herod built (*Antiquities* 15.380–425; *War* 5.184–247), and it is from this that the models of Herod's Temple have been constructed.

In addition to the Temple, Herod built a fortress just to the north of the Temple Mount. In honour of his friend and supporter Mark Antony he called it the Antonia. It held out to the last at the end of the 1st Jewish Revolt, but when it fell to the Romans it was completely destroyed.

Herod also built a palace on the west side of Jerusalem known as the Citadel. When the emperor Augustus decided in 6 CE to rule Judaea through procurators (page 23), the procurators were based at Caesarea Maritima (pages 226–231). However, they used the Citadel whenever they were in Jerusalem, so that it was here, and not in the Antonia Fortress, that Pontius Pilate judged Jesus. The Stone Pavement mentioned in John 19.13 was used in exactly the same way by the procurator Florus in 66. Having been insulted by a mob, he had a platform placed in front of the Citadel, summoned before him the leading citizens, and ordered them to be scourged and then crucified (Josephus, *War* 2.301–8). This was one of the immediate causes of the 1st Jewish Revolt.

At the end of the 1st Jewish Revolt, Titus, the Roman general, destroyed what remained of the Citadel but kept the huge towers as a tribute to his troops: the site remained a camp for the Roman legions for the next 200 years.

———————— ✠ ————————

OPPOSITE TOP Herod's palace at upper Herodion, showing the double circular wall linking the circular east tower and the three semi-circular towers.

OPPOSITE BOTTOM LEFT Corridor leading to the underground water cistern at Herodion. The water supply for upper Herodion came from rainwater.

OPPOSITE BOTTOM RIGHT Ruins of the colonnaded pool at lower Herodion, with a round, possibly thee-storey, pavilion in the middle. The water supply for the pool, garden, and baths in lower Herodion came from Solomon's Pools, south of Jerusalem.

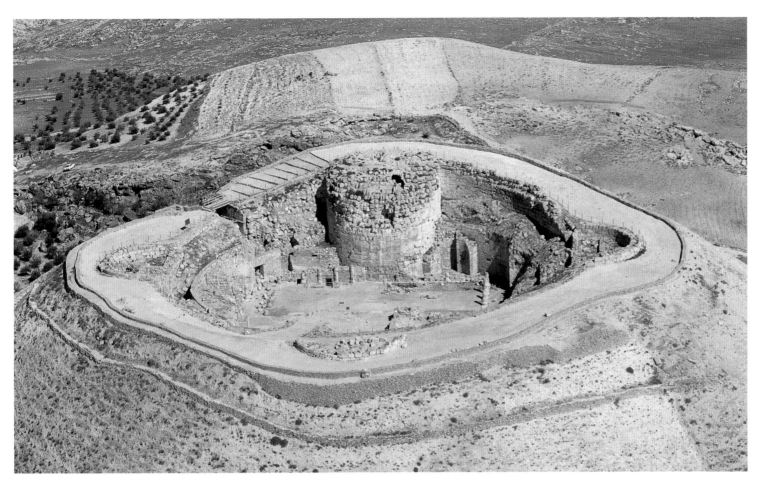

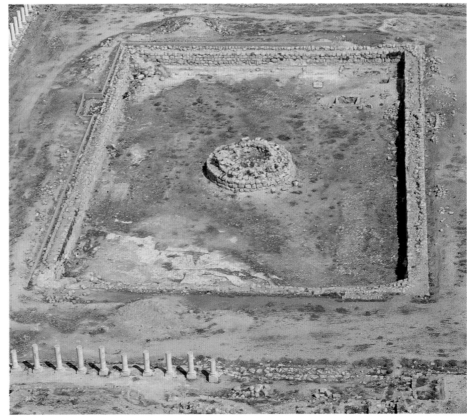

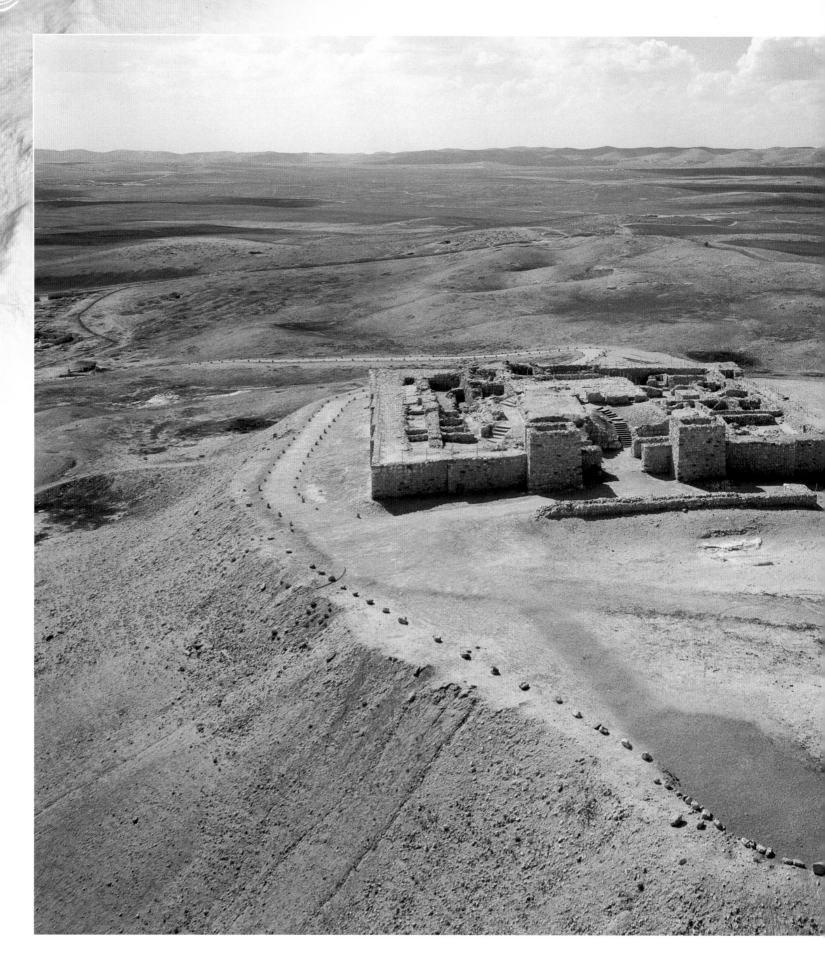

LEFT Tel Arad citadel
and temple from the
east. Tel Arad is an early
Bronze Age city. It was
occupied by the
Israelites and includes a
temple that was
abolished during the
reforms of Hezekiah
(2 Kings 18.4, 22).

LACHISH, TEL MIQNE, GEZER, AND TEL ARAD

The early Israelites were well aware how many people had lived before them in the area that became Israel. Exodus 3.17 mentions Canaanites, Hittites, Amorites, Perizzites, Hivites, and Jebusites. Later, the Philistines landed on the coast and spread inland. The sites where these people lived have been explored by archaeologists: the remains can often still be seen. In this section, four sites south of Jerusalem are included. For others, see Caesarea Maritima (for Ramat Hanadiv), Samaria (for Shechem and Tel Balata), and Jericho (for Tel esSultan).

The Israelites were commanded to destroy the Canaanites: "You shall annihilate them, – the Hittites, and the Amorites, the Canaanites and the Perizzites, the Hivites and the Jebusites – just as the Lord your God has commanded" (Deuteronomy 20.17). Yet they received much from the Canaanites; and anyone who reads the words and letters on this page should be grateful as well, since it was the Canaanites who invented the alphabet.

L achish (south-west of Jerusalem) was the centre of a prominent Canaanite city-state. It was well known in the ancient world (its name appears, for example, in the Tel elAmarna Letters, for which see Bethlehem, page 162). It was one of the cities that fell to Joshua (Joshua 10.31–2). Its capture was rapid because at that time Lachish was not fortified, no doubt because it is surrounded by natural defences.

Lachish was left in ruins until it was fortified by Solomon's successor, Rehoboam (928-911), because he was anxious to secure Jerusalem from attack in the south and west (2 Chronicles 11.5–12; cf. Bethlehem, page 163). It was clearly a strong place, because Amaziah (c.800–773), king of Judah, took refuge there when there was a rebellion against him in Jerusalem. Even more to the point, the Assyrian king Sennacherib, when he invaded Judah in 701 BCE, made Lachish his base (2 Kings 18.13–17). When he returned to his own capital, Nineveh, he commanded carved reliefs to be made depicting his campaign against Judah, and in particular the siege of Lachish. Under one relief the inscription reads: "Sennacherib, king of the world, king of Assyria, sat upon a high throne viewing the booty from La-ki-su [Lachish]."

By the time that the Babylonians invaded Judah under Nebuchadnezzar in 587 BCE, Lachish was once more an outpost for the defence of Jerusalem. The actual moment of the attack on Lachish is recorded in the so-called Lachish Letters. These are 18 fragments of pottery on which urgent messages from Lachish to Jerusalem were written in black ink. One of them (Ostracon 4) reads: "Let my Lord know that we are watching for the signals of Lachish, according to all the signs which my Lord has given, but we cannot see Azekah." Azekah had already been overwhelmed, and it was the turn of Lachish next.

TEL MIQNE (EKRON/KHIRBET AL-MAQANNA)

About 22 miles west of Jerusalem is Tel Miqne, though not much of a Tel (mound) is any longer visible. Nevertheless, it was once the important town of Ekron, mentioned in Joshua 13.3 as one of the five city-states of the Philistines, the others being Gaza, Ashdod, Ashkelon, and Gath. There was a settlement in this place long before the Philistines, but it was they who made it a strong centre. When they captured from the Israelites the precious Ark of the Covenant, they first took it to the temple dedicated to Dagon in Ashdod, then to Gath, and finally to Ekron (1 Samuel 5.10). After

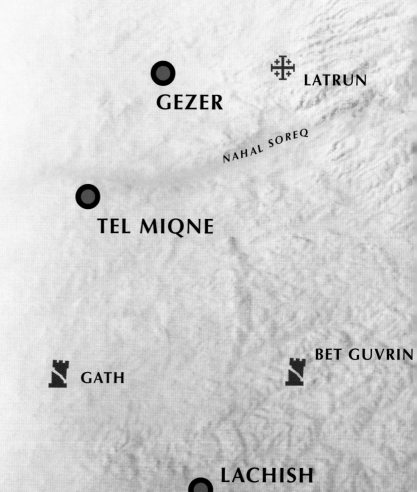

GEZER

LATRUN

TEL MIQNE

NAHAL SOREQ

GATH

BET GUVRIN

LACHISH

BELOW Ruins at Gezer. The 30-acre site includes four city-wall systems, a water supply tunnel, and a mortuary shrine.

N

DEAD SEA

ABOVE The siege ramp of Sennacherib from 701 BCE at Lachish, and the outer and inner gates where the Lachish Letters dating from Nebuchadnezzar's attack of 587 BCE were found.

NAHAL ARUGOTH

NAHAL HEVER

○ **HEBRON**

RIGHT The Holy of Holies in the temple at Tel Arad, showing two standing stones to the rear and two square incense altars at the entrance.

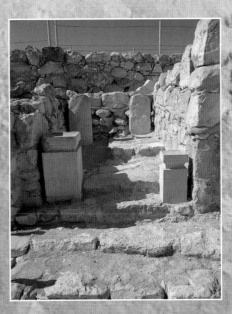

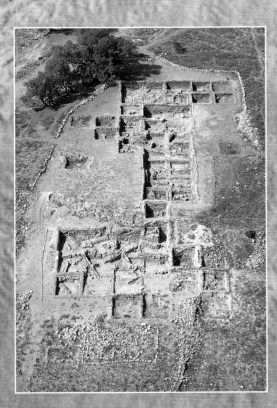

● **TEL ARAD**

LEFT Ruins at Tel asSafr, one of several sites identified with the Philistine Gath. A potsherd found here has an inscription that may be connected with the Philistine name Goliath.

David killed Goliath, the Israelites "pursued the Philistines as far as Gath and the gates of Ekron" (1 Samuel 17.52).

Although Ekron became part of Israelite territory, it did not lose its Philistine character. When Ahaziah, king of Judah (c.850–849), injured himself, it was not to the God of Israel, but to Baal-zebub, the god of Ekron, that he sent to find out "whether I shall recover from this injury" (2 Kings 1.2), thereby provoking the anger of the prophet Elijah – an anger that later prophets still had to voice, since the attraction of Baal-zebub did not diminish (see, for example, Amos 1.8; Jeremiah 25.20; Zephaniah 2.4; Zechariah 9.5, 7).

The original form and meaning of the name of this god is uncertain. It probably meant "Lord of the highest place". The Hebrew form Baal-zebub derides the god by making the name mean "Lord of the flies", and a further revision to Baal-zebul diminishes him even further, since it means "Lord of shit". This was part of the same campaign to emphasise the abhorrence felt for the worship of Baal and other false gods (on this see page 126). By the time of the Gospels, Baal-zebub (Beel-zebul) has become quite simply "the Prince of Demons". The opponents of Jesus could not possibly deny that he was saying and doing extraordinary things, particularly through his acts of healing, so they simply claimed that he must be doing these things through the power of the devil: "The scribes who came down from Jerusalem said, 'He has Beel-zebul, and by the ruler of the demons he casts out demons'" (Mark 3.22).

Ekron continued to be occupied, known now by its Greek name Akkaron, but it was no longer a centre of much importance.

GEZER

Slightly further west than Ekron is Gezer. It was one of the most strongly fortified Canaanite cities, with a mud brick wall that in places is 50 feet thick. Excavations have revealed a line of 10 pillars from about 1800 BCE which may be the kind of "high place" which is denounced so frequently in the Bible as exactly the kind of worship that seduces people from the worship of Yahweh (see, for example, Jeremiah 32.35).

Gezer was sufficiently near the coast to be of interest to Egypt, whose constant presence in the area was inevitable, given its need to control and keep open the coastal route from Egypt to the north and to the Fertile Crescent. Egypt could not allow any strong and independent cities in the area. Thus the original city of Gezer was captured and destroyed by the Pharaoh Thutmose III in c.1482 BCE, and a record of his victory is inscribed on a temple wall at Karnak.

Gezer appears also on the so-called "Victory Stele" of another Pharaoh, Mareneptah, who partially destroyed the city in 1208 BCE. Mareneptah even gave himself the title "the one who binds Gezer".

Despite its subordination to Egypt, Gezer (equally under Philistine influence) remained a Canaanite outpost that the Israelites did not capture. It was at about this time that a child

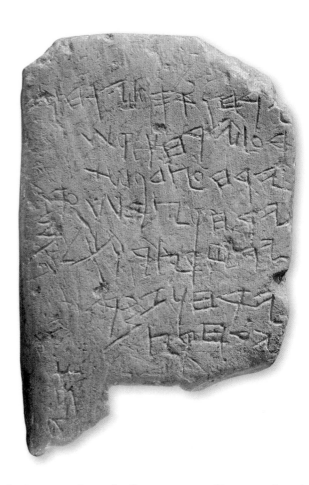

scratched on to a piece of soft stone a way of learning the calendar and its seasons. This is the so-called Gezer Calendar, not easy now to translate but meaning something like:

Two months of ingathering
Two months of sowing
Two months of late sowing [? spring growth]
Month of pulling flax
Month of barley harvest
Month when everything is harvested
Two months of pruning
Month of summer fruit

In 950 BCE, the Egyptians again had to capture Gezer, but this time the Pharaoh handed Gezer over to Solomon as part of his dowry gift when Solomon married one of his daughters (1 Kings 9.16–17). The magnificent way in which he undertook to rebuild it is increasingly being revealed by archaeology.

TEL ARAD

Tel Arad is about 18 miles north-east of Beer Sheba, and the Tel (mound) is prominent in the surrounding plain. The town was flourishing during the Early Bronze Age (c.3100–2650), and the Israelites made the higher part into a fortress from the 10th to the

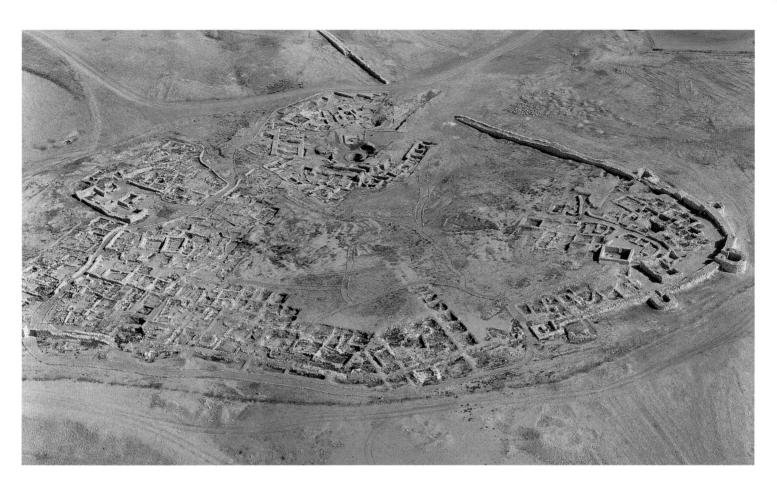

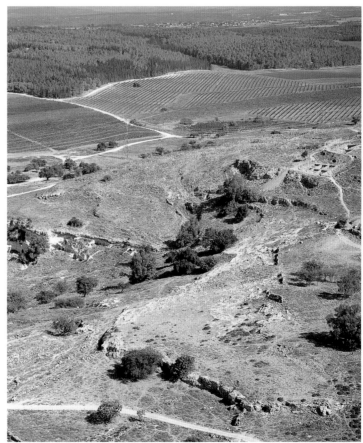

OPPOSITE The Gezer Calendar, from the late 10th century BCE, is one of the earliest known Hebrew inscriptions. It is made of soft limestone and is about four inches high and three inches wide.

ABOVE The lower Canaanite city of Arad from the south-west. The Byzantine-era wall is 4000 feet long and reinforced by semi-circular towers.

RIGHT Ruins at Tel asSafr, possibly the Philistine Gath. They are located in central Israel, approximately half way between Jerusalem and Ashkelon, on the border between the southern Coastal Plain of Israel and the Judaean foothills.

7th centuries. Excavations have revealed a complex, well-planned town with important remains of Canaanite religion, including an incised stele that suggests worship of the god Dumuzi (Sumerian "proper son"; in Hebrew Tammuz). From Mesopotamia to the Mediterranean Dumuzi was revered as the controller of death and new life: in other words, he was a fertility god. Among the four sins of the Jerusalem Temple denounced in the 6th century by Ezekiel, the third (8.14) was that of women continuing this fertility cult.

The Canaanite king of Arad "fought against Israel and took some of them captive" (Numbers 21.1), but in the end he was unsuccessful, because Arad is included in the list of conquered cities in Joshua 12.14. Even when Jerusalem became the central and supposedly single sanctuary for all Israel (2 Kings 23), the sanctuary and altar at Arad continued in use. Tel Arad is a particularly fine example of an Early Bronze Age city.

HEBRON

AL-KHALIL

LEFT Terraced vineyards near Hebron. The renowned grapes grown here are converted into jams, raisins, and molasses, and their leaves are used in the making of a signature Palestinian dish: stuffed vine leaves.

Hebron is one of the main cities in the southern hill country of Judah. It is just over 20 miles south-west of Jerusalem. It is one of the oldest cities in Palestine to be continuously inhabited (though the ancient city was on Jebel arRumeideh across a small valley). The Bible is well aware of its age, since Numbers 13.22 says that Hebron was built seven years before Zoan in Egypt. That is the town of Avaris, later called Ramases, which was built at some time around the 17th century BCE. The original name of Hebron was Kiriath-Arba, which means "the fourfold city", perhaps "four-sided". It is a city of great importance for Jews, Christians, and Muslims, because of its close association with Abraham. There is a monumental shrine, later a mosque, over the cave in which Abraham was buried, the cave of Machpelah, which is an important site of pilgrimage. It was a place equally important for David, for there David was anointed king and became the "shepherd of the people of Israel" (2 Samuel 5.1–3). Hebron, long contested between Jews and Arabs, is as important for Arabs in the south of the Israeli-occupied West Bank of the Jordan as Nablus is in the north.

The name Hebron or Hevron may possibly come from the Hebrew *haber*, "friend" or "companion". It is known in Arabic as alKhalil, and the two names at once demonstrate its close association with Abraham (or in Arabic Ibrahim). alKhalil means "the friend", that is, of God, and this is the name by which Abraham is known by Jews, Christians, and Muslims. In Isaiah, Israel is called "my servant whom I have chosen, the offspring of Abraham, my friend" (Isaiah 41.8; cf. 2 Chronicles 20.7); in the New Testament, the letter of James, quoting Genesis 15.6, says, "'Abraham believed God, and it was reckoned to him as righteousness', and he was called the friend of God" (James 2.23);

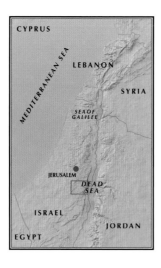

and in the Quran Ibrahim is recognized as "the friend of God" and as a true believer in the One God (a *hanif*): "Who is better in the way of God [*din*, "life-way", often translated as "religion"] than one who gives his whole self in allegiance [*islam*] to God, does good, and follows the way of Ibrahim, *hanif*? For God took Ibrahim as a friend" (4.124–5). The Hanifs (*hunaf'un*, page 29) were those in Mecca before and at the time of Muhammad who, like Ibrahim, refused to engage in polytheistic idolatry (for the refusal of Abraham to practise idolatry, see page 195). This was "the religion of Abraham" with which Muhammad associated himself before he began to receive the revelation of the Quran: "the religion of Abraham" is thus the *din* or life-way that God intended for all people through all time which is now made finally clear in the Quran.

The importance of Hebron for Abraham can be seen in the fact that he purchased from the Hittites the Cave of Machpelah in order to use it for his family tomb (Genesis 23.1–20). It was for Abraham the end of his long and many journeys in obedience to God:

OPPOSITE The Haram alKhalil mosque enclosure, showing the two surviving minarets. The walls are 9 feet thick and over 50 feet high. Their crenellations were added in the 13th century CE.

LEFT Entrance to the room regarded as the Tomb of the biblical matriarch Leah, inside Haram alKhalil.

> The rivulet-loving wanderer Abraham
> Through waterless wastes tracing his fields of pasture
> Led his Chaldean herds and fattening flocks
> His mind was full of names
> Learned from strange peoples speaking alien tongues,
> And all that was theirs one day he would inherit.
> He died content and full of years, though still
> The Promise had not come, and left his bones,
> Far from his father's house, in alien Canaan."
> (Edwin Muir, "Abraham")

Not only were Abraham and Sarah buried there, but so also were Isaac and Jacob and their wives – though Rachel was buried elsewhere (see Bethlehem page 162). In Muslim belief, Joseph was

DEAD SEA

NAHAL ARUGOTH

NAHAL HEVER

HARAM AL-KHALIL

KING DAVID'S POOL

HEBRON

N

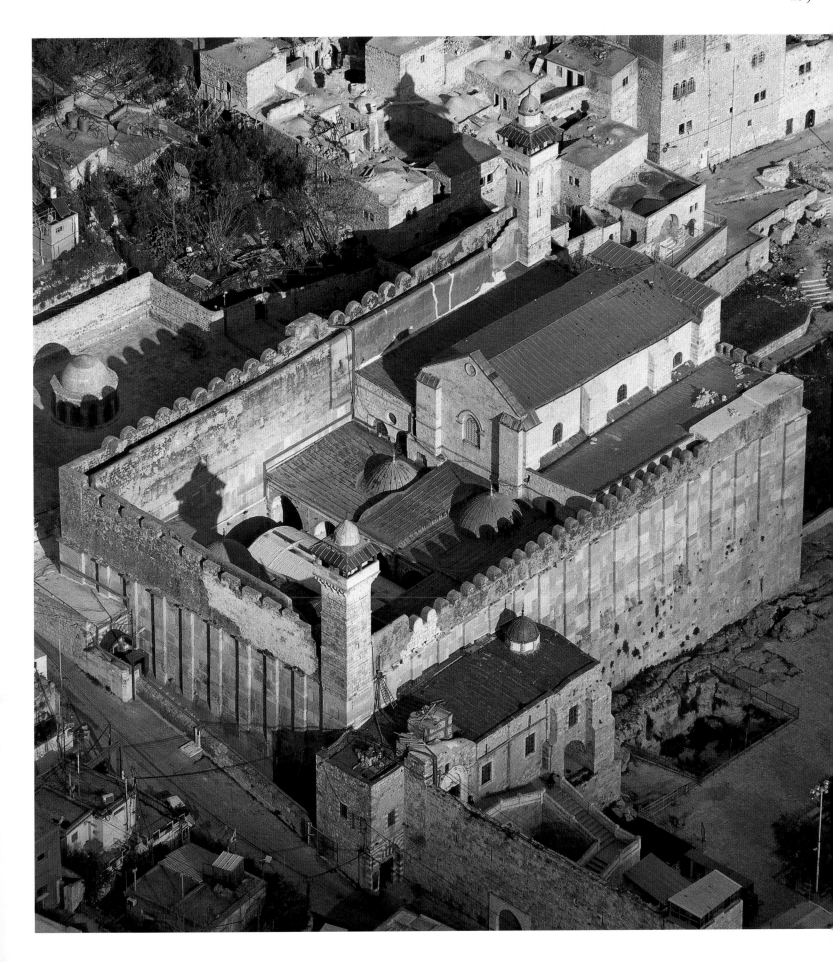

buried here, but according to the Jews, his remains were brought from Egypt, not to Hebron, but to Shechem (Nablus). The impressive building, Haram alKhalil (The Sacred Place of the Friend), was erected by Muslims over the site.

The Haram alKhalil was built on the foundations of a building begun by Herod the Great, and parts of his impressive walls survive. In the 14th century, the great traveller, ibn Batutah (1304–78) visited the sacred site (*haram* means "forbidden", ie sacred: for centuries Christians and Jews were forbidden to enter the Haram alKhalil). At the end of his life, ibn Batutah put together an account of his travels (including the account in the box below).

During the Israelite conquest and settlement, Hebron fell only after a long struggle. It was assigned to Caleb of the family of Judah (Joshua 14.13–14). It then became one of the six cities of refuge (Joshua 20.7–9) – cities in which anyone who had caused a death accidentally could take refuge from those seeking his own life in revenge.

Hebron played an important part in the early life of David. When David was a hunted fugitive, he found refuge in Hebron (1 Samuel 30.31), and it was here that he was eventually anointed king (2 Samuel 2.4; 5.1–5). This was before his capture of Jerusalem with all its dramatic changes in the understanding of kingship and its relationship with God.

When the kingdom divided between North and South, Rehoboam strengthened his defences in the South (as with Bethlehem and Lachish, pages 160–5 and 182), and this included the strengthening of Hebron. Nevertheless, Hebron was occupied

IBN BATUTA'S VISIT TO HARAM AL-KHALIL

The Haram at Hebron is built of hewn stone, and one stone is 37 spans in length. The Haram is said to have been built by Solomon aided by Jinn [the Jinn are the wild spirits of the desert who, so the opponents of Muhammad maliciously said, had taken possession of Muhammad]. Within it is the holy cave, where are the tombs of Abraham, Isaac, and Jacob; opposite lie the tombs of their wives. To the right of the pulpit, and close to the southern outer wall, is a place where you may descend by solidly built marble steps, leading to a narrow passage, and this opens into a chamber paved with marble. Here are the cenotaphs of the three tombs. They say that the bodies lie immediately adjacent beneath, and nearby was originally the passage down to the blessed cave. At the present time, however, this passage is closed.

during the Exile (587–*c.*538) by the Edomites, known later as the Idumaeans from whom Herod the Great came. After the Exile, Jews continued to live in the area (Nehemiah 11.25), but it was regained only during the Maccabean revolt by Judas Maccabeus in 164 BCE (1 Maccabees 5.65): "Then Judas and his brothers went out and fought the descendants of Esau in the land to the south. He struck Hebron and its villages and tore down its strongholds and burned its towers on all sides." Hebron then became part of the Hasmonean kingdom under John Hyrcanus I.

Herod did some of his usual rebuilding in Hebron, as much, no doubt, because of its connection with his ancestors as because of its important strategic position. Josephus (*War* 4.530–2) certainly admired in the 1st century CE what Herod had done:

The inhabitants report that Hebron is not only more ancient than all cities of that land, but also than Memphis in Egypt, for they affirm it to have been built 2300 years ago. They also say that this was the place where Abraham, the father of the Jews, dwelt after he forsook Mesopotamia, and that his posterity departed from here to Egypt. The tombs are still seen in the city, richly wrought in fine marble.

The walls built by Herod are the still-surviving foundation of the Haram alKhalil, though one of the walls to the east was knocked through to accommodate the sarcophagus of Joseph. For the Jews, Hebron is one of the four holy cities in the Land, the others being Jerusalem, Safed, and Tiberias.

In 1100, the Crusaders captured Hebron and expelled the Jewish population. They also turned the mosque into a church. It became a mosque once more when the Mamlukes recaptured Hebron in 1260, after which, in 1266, Jews and Christians were banned from the holy places. The Jews were finally expelled by the Ottomans in 1517. However, in 1540 Jews came to Hebron from Spain and built the Abraham Abeinu ("Abraham our father") Synagogue: the name comes from a legend that when there were too few Jews to make up the necessary number for a particular service in the synagogue, Abraham appeared and made up the number.

By the mid 20th century the Jewish population was about 700. In 1929, the Jews were attacked by the local Arabs, and in 1936 the British, attempting to keep the peace, evacuated the remaining Jews. In 1948, Hebron was occupied by the Jordanian Arab Legion, destroying much of the old Jewish quarter. During the Six Day War in 1967, Israel regained Hebron, establishing a new settlement nearby at Kiryat Arba and rebuilding properties in Hebron. The combined Jewish population is now about 7000; the Arab population is around 120,000.

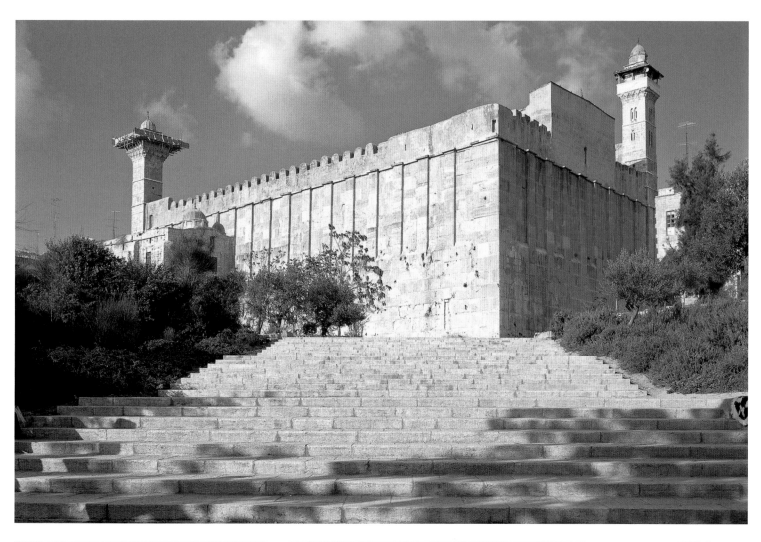

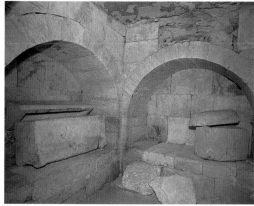

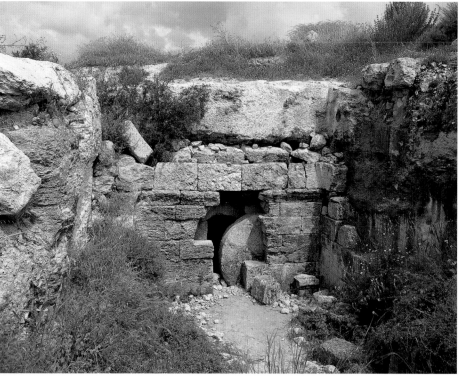

TOP Haram alKhalil from the west, showing the 14th-century stone steps.

ABOVE Interior of a rock-cut tomb near Hebron, showing the niches where the bodies would be placed.

RIGHT A rock-cut tomb, 15 miles from Hebron at Khirbet Midras. It is closed by a rolling stone, probably similar to the one at Jesus' tomb (see Matthew 28.2; Mark 15.46, 16.3–4; Luke 24.2).

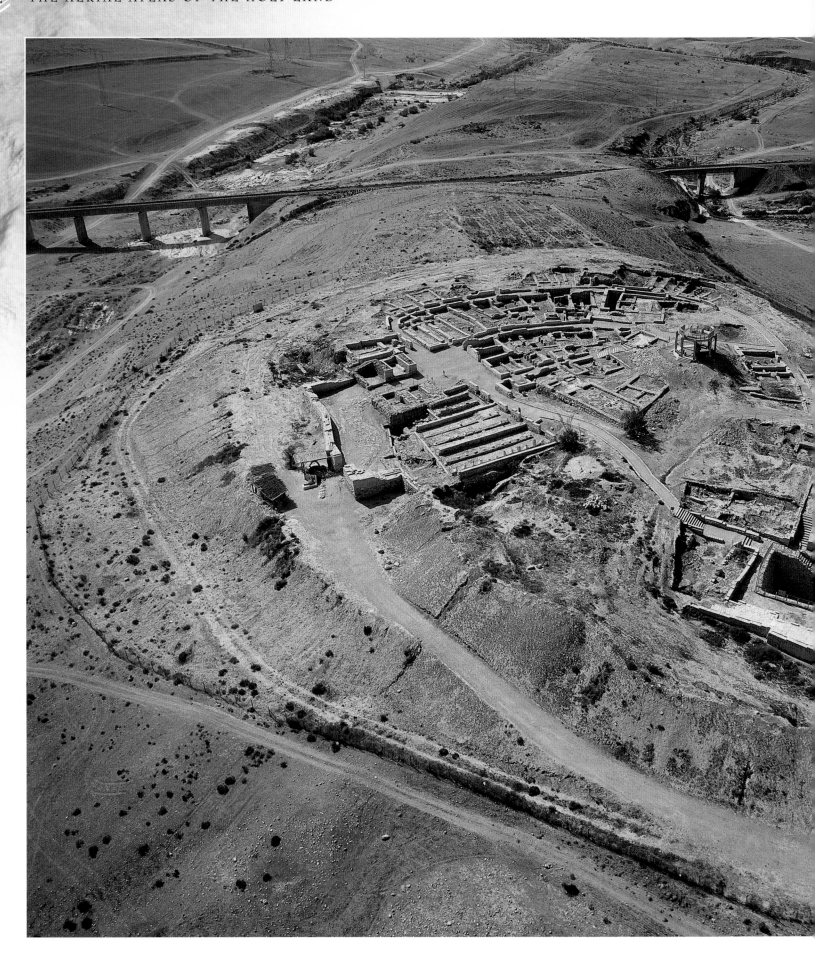

BEER SHEBA AND THE SOUTH

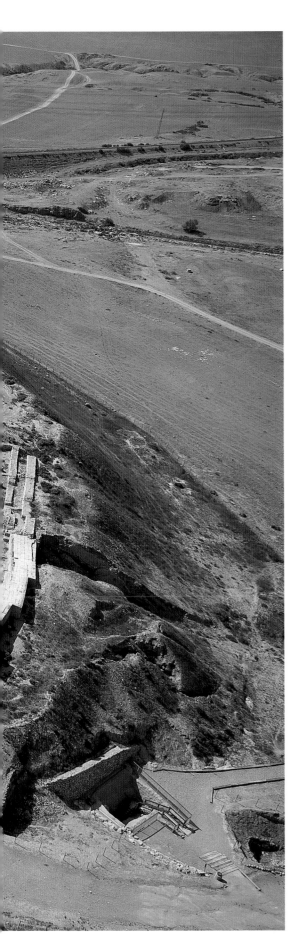

LEFT Tel Beer Sheba from the south-east, with the water reservoir (bottom right). The access road runs up to the 10th-century BCE inner gate and connects with a road running around the inside of the walls.

The extent of the land of Israel is often described in the Bible as stretching "from Dan to Beer Sheba" (see, for example, Judges 20.1, "Then all the Israelites came out, from Dan to Beer Sheba, including the land of Gilead …"). Beer Sheba (also Beer Sheva) is in the Negev in the South, and is important for Jews, Christians, and Muslims because of its connection with Abraham. It was here that Abraham entered into a covenant with a local ruler, Abimelech, and also planted a tamarisk tree to commemorate the covenant and called upon God as El Olam, God who is Everlasting. When the Egyptian ruler, Shishak, made a list in 925 BCE of the towns he had conquered, Beer Sheba was still called "fortress of Abram".

Still further south are the settlements of Shivta, Avdat, and Mamshit. These were important staging posts for trade, and each in its own way exhibits the ingenuity needed to secure a supply of water in an area where very little rain ever falls.

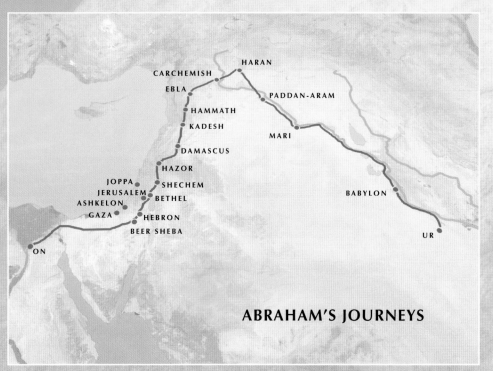

ABRAHAM'S JOURNEYS

BEER SHEBA

NAHAL BEER SHE[...]

ABOVE View from the observation tower at Beer Sheba, looking south to the main gate. Nine levels of occupation have been identified at the site, dating from the 13th century BCE to the 8th century CE.

NAHAL BESOR

ELUSA

REHOVOT

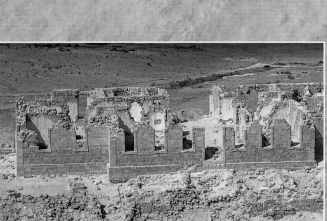

ABOVE Nizzana, 17 and a half miles south-east of Beer Sheba, was founded by the Nabataeans in the 3rd century CE as a trading post. The fortress was built in the late 4th century CE.

NIZZANA

SHIVTA

RIGHT The 5th-century Southern Church at Shivta, looking towards the apse. It was part of a monastic complex that catered for pilgrims.

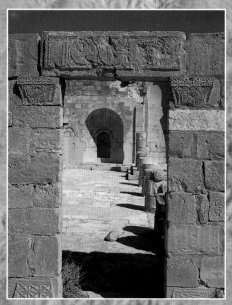

NAHAL ZI[...]

AVDAT

N

MAMSHIT

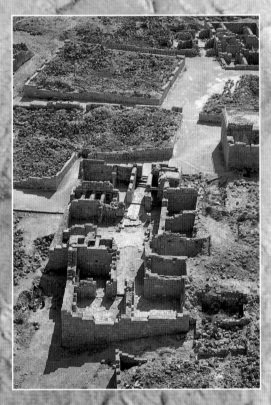

ABOVE A typical house (centre) and a tower (middle right) in the 1st-century BCE – 1st-century CE Nabatean town of Mamshit. The wealthy 10-acre town, which is about 30 miles south-west of Masada, stood on the Incense Road caravan route between Petra and Gaza.

Abraham is regarded by Jews, Christians, and Muslims as the "father of the faithful" and "the friend of God", a title that appears in the Jewish and Christian Scriptures and also in the Quran (where the name is Ibrahim). His fundamental role began when he obeyed the command of God, recorded in Genesis 12.1–2, "Go from your country and your kindred and your father's house to the land that I will show you. I will make of you a great nation, and I will bless you, and make your name great, so that you will be a blessing."

THE JOURNEYS OF ABRAHAM

In Hebrew the basic command is expressed in two simple words, *lek leka*, "get you gone". But from where was Abraham to depart? The Bible tells us that it was from Ur of the Chaldees. Ur was a town in Mesopotamia, on the river Euphrates, not far from present-day Basra (claims that Ur was in the far north of Mesopotamia are not convincing). Ur, however, was destroyed in 1740 BCE, and it virtually disappeared until the excavations of Leonard Woolley between 1922 and 1934.

For centuries, therefore, those who read the Bible had no idea that Ur was the name of a place. Since the same Hebrew letters, *ur*, make the word "fire", they thought that Abraham had been commanded to depart "from the fire of the Chaldaeans". What was the fire? They took it to be the fire offered in idolatrous worship, and also the fire in which those worshippers of (to the Jews) false gods burned those who refused to worship idols with them.

So began the many splendid stories of Abraham's refusal to worship other gods, and of how he escaped the fire of persecution – stories that do not appear in the Bible, but nevertheless inspired Jews, Christians, and Muslims to refuse to worship other gods even if that refusal led to torture and death. These stories appear in the Targums, the early synagogue interpretations of the Bible that Jesus himself would have heard, and also in the Quran. It is this fundamental faith in the one God that appears in the Muslim Shahada, Witness, "I bear witness that there is no God but God." It is the foundation of the three so-called "monotheisms", the religions of Judaism, Christianity, and Islam.

Abraham, therefore, set out in obedience to God, travelling on the route now known as "the fertile crescent". Genesis 12.4–9 describes briefly his journey down the "backbone" of what was then the land of Canaan. At Shechem (an important local centre of cult

and ritual until Jerusalem much later was made central) he changed a tree of divination, *moreh*, into an altar of God, because to him at that place "God appeared" (*nireh*, a play on words to show how the faith of Abraham transformed local religion). From there he went to the hills east of Bethel, where again he built an altar to God, and he then moved by stages into the Negev.

After time in Egypt, Abraham returned to the altar he had built near Bethel. He then "moved his tent, and came and settled by the oaks of Mamre, which are at Hebron" (Genesis 13.18), and here also he built an altar. Mamre became a place of contact between Abraham and God, especially in the episode recorded at the beginning of Genesis chapter 18, when Abraham's generous hospitality to three strangers (later taken to be "entertaining angels unawares", Hebrews 13.1, Authorized Version, since they turn out not to be ordinary humans) led to the promise that a son, Isaac, will be born to Sarah despite her advanced age.

Mamre was so important to Abraham that he bought a cave nearby for the burial of himself and Sarah. This was the cave of Machpelah, east of Mamre.

BEER SHEBA

The modern city was established by the Ottomans in 1900 as a defence against attack from Egypt. Its present development, based on the Roman, Byzantine, and early Muslim site, is just under half a mile west of the ancient city.

In Genesis, two explanations are given for the origin of the name Beer Sheba. Abraham and Abimelech, the local king of Gerar, had a dispute over a well (the vital importance of knowing who has access to a well was vividly portrayed in the opening sequence of David Lean's film *Lawrence of Arabia*). The Hebrew word for "well" is *beer*. The dispute was settled when they swore (*nishbeu*, the same letters that occur in Sheba) a covenant of agreement and sealed it with the offering of seven (Hebrew *sheba*) ewes. What is claimed to be the well of Abraham is on display in the modern town of Beer Sheba, which has been built to the west of the original Tel. A generation later, another dispute was resolved by an oath at Beer Sheba (Genesis 21.22–32).

Although the whole area was included in the territory of the clan or tribe of Simeon (Joshua 19.2), the Negev was captured and taken over by the Edomites in the late 7th century BCE. It was regained for a while under Nehemiah (6th century BCE: see Nehemiah 11.26), but went back to the Idumaeans, a form of the name Edomite. Herod the Great was an Idumaean, and for that reason (among many) was held in suspicion by the Jews.

In the earlier period, David greatly strengthened the fort that had been established by Saul, and made it into a fortified town. Excavations recovered a large stone altar with prominent protuberances or horns on it, which clearly does not conform to the command in Deuteronomy 27.5–6 that an altar must be built with "stones on which you have not used an iron tool: you must build the altar of the Lord your God of unhewn stones". The possibility that the local people were not keeping closely to the laws may explain why the prophet Amos forbade those who seek the blessing of God to go to Beer Sheba (Amos 5.5), and predicted the downfall of those who use the oath "as the way of Beer-sheba lives" (Amos 8.14). Beer Sheba was destroyed by Sennacherib in 701 BCE, and thereafter became a series of forts, culminating in a Muslim fort in the 7th century.

SHIVTA (SUBEITA)

About 35 miles south-west of Beer Sheba is the town of Shivta or Subeita. The site was first settled by the Nabataeans in about the 1st century CE, and is remarkable for its reservoir, divided into two parts, in order to store as much of the little rain in the area as possible. There was a Christian presence here with two churches in the north and south. The town had no defensive walls, so that its capture by the Muslims in the 7th century was more like an agreed take-over: certainly they seem to have been careful not to damage the South Church when they built a mosque in the 9th century. The town, however, only lasted another two centuries. The problem of conserving water proved too great and the town was abandoned.

AVDAT (ABDAH)

Slightly further south than Shivta is Avdat, another Nabataean town with impressive remains. Under a king called Obodas (from whom the name Avdat is derived), the town flourished: Obodas (30–9 BCE) was regarded as a divine presence and was worshipped in this deified form in an Acropolis that was later turned into the Church of St Theodore. In 106 CE, the Romans conquered the area and absorbed it into the empire as part of the province of Arabia Petraea. The Byzantine emperor Justinian (527–64) encouraged monasteries in the Negev, and the monks did much to develop irrigation and agriculture. All this, however, came to an end after the capture of Avdat by the Persians in 614 and by the Arabs in 634. The site was abandoned and the irrigation system fell into disrepair.

———————— ✳ ————————

OPPOSITE TOP The ruins of Shivta, abandoned in the 11th century CE. The 4th-century Northern Church (bottom left) was enlarged in the 6th century. It appears to have been part of a monastery, whose monks may have used the nearby workshops and wine press.

OPPOSITE BOTTOM The mainly Byzantine ruins at Avdat, looking towards the surviving Nabatean temple and entrances at the south-west end. Below the acropolis (bottom right) is the house and cave of a wine merchant.

OPPOSITE INSET The apse and columns of the Byzantine North Church at Avdat (foreground) are at right angles to the portico of the Nabatean acropolis. The South Church (just behind) housed relics of St Theodore and other martyrs.

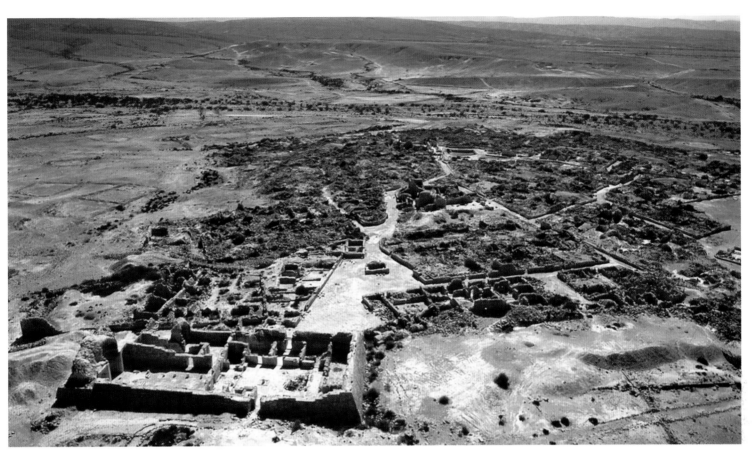

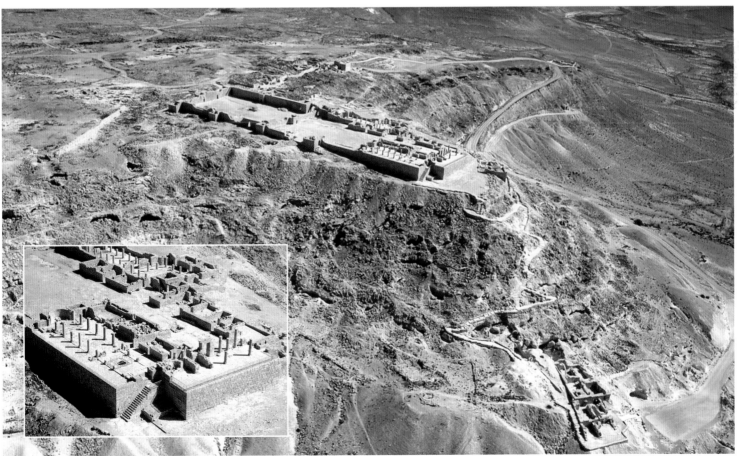

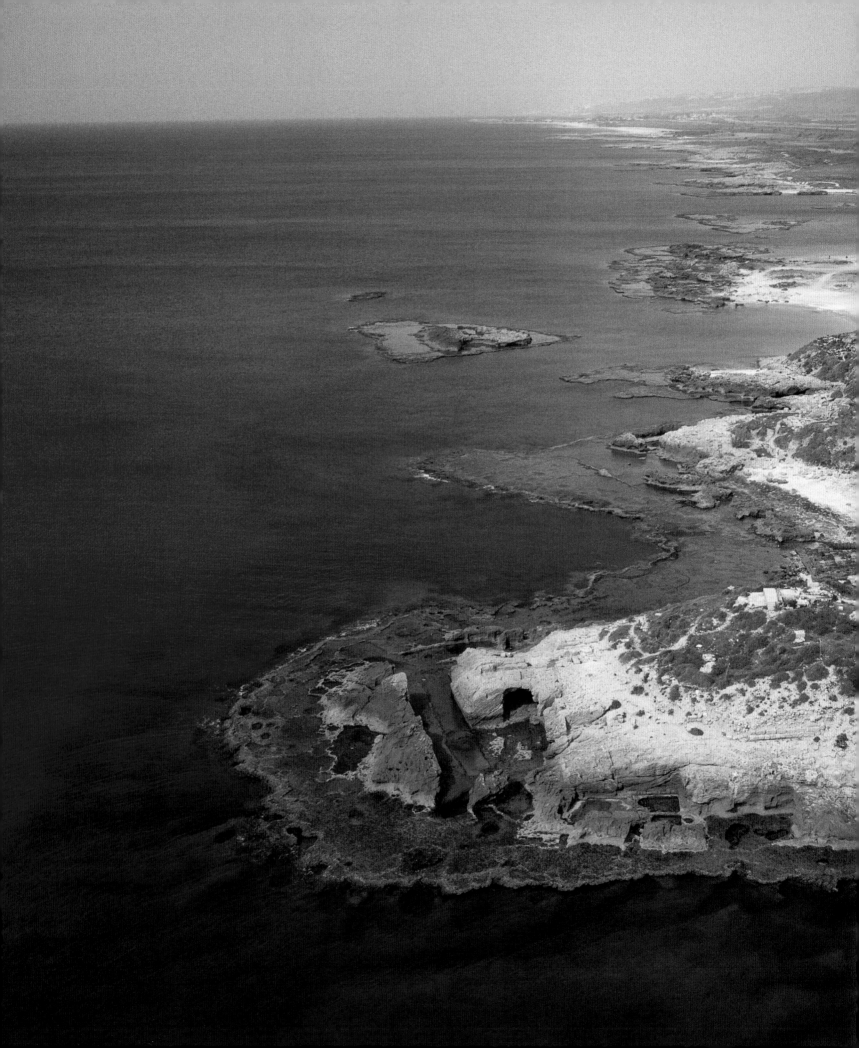

THE
3
COASTAL
PLAIN

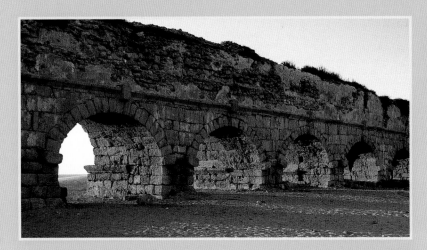

From Gaza in the south to the promontory of Mount Carmel the coastal plain offers no natural harbour. The shore seems to be an endless sequence of sand dunes. Its harbours were constructed to take advantage of trade and fishing in the Mediterranean. Some of the towns around these harbours were fortified for the defence of that other vital route for trade, the land route from Egypt in the south to Asia Minor and Mesopotamia in the north. This was the great Via Maris, the Way of the Sea. Clearly, none of these settlements and harbours could be sustained without water, and the natural supply of water became in consequence the major constraint in determining where the settlements were established.

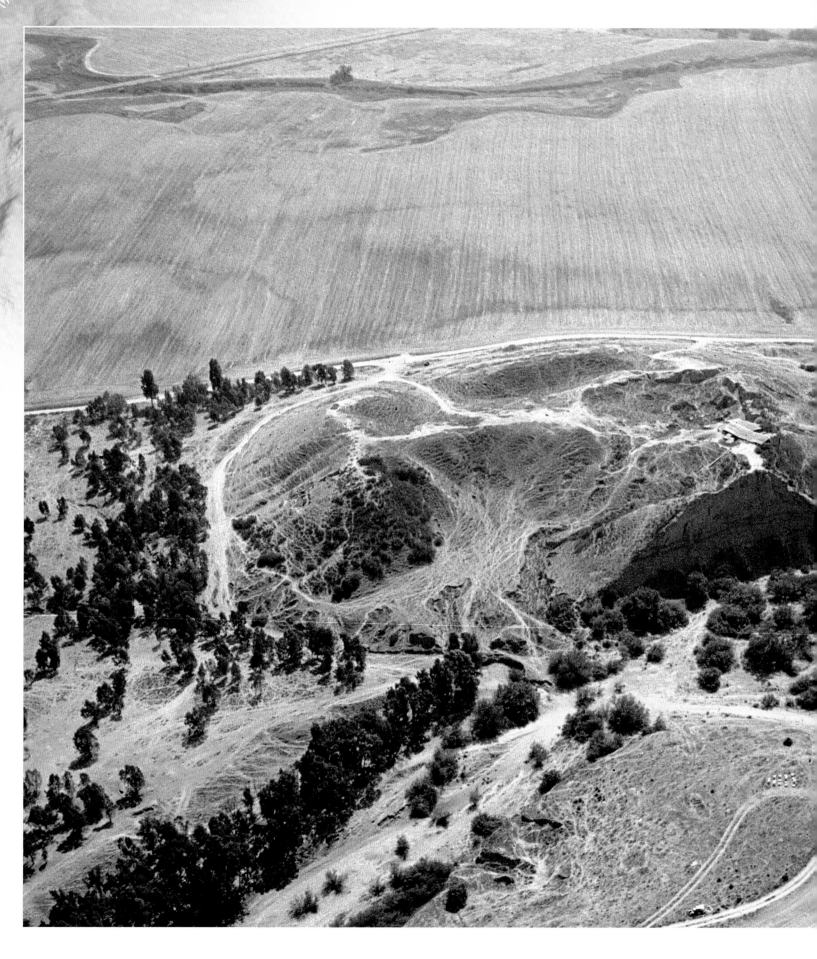

GAZA AND THE PHILISTINES

Ancient Gaza lies about three miles from the Mediterranean coast, at the southern end of the territory occupied by the Canaanites. It was part of the territory settled by the Philistines when they, with other people called the Sea Peoples, migrated from the Aegean basin in the 12th century BCE. Gaza was one of their principal settlements from which they attacked the Israelites. Judges 15–16 tells how Samson defeated the Philistines but was then captured by them through the wiles of Delilah and was made captive in Gaza: "They brought him down to Gaza and bound him with bronze shackles; and he ground at the mill in the prison" (Judges 16.21). It was this that was so dramatically described by Milton in his epic poem:

Why was my breeding ordered and prescribed
As of a person separate to God,
Designed for great exploits, if I must die
Betrayed, captived, and both eyes put out,
Made of my enemies the scorn and gaze;
… Promise was that I
Should Israel from Philistian yoke deliver;
Ask for this great Deliverer now, and find him
Eyeless in Gaza at the mill with slaves,
Himself in bonds under Philistian yoke.
(*Samson Agonistes*, ll. 30–42)

LEFT Tel Gama or Tel Jemmeh is about six miles south of Gaza. Early excavators identified it with the biblical Gerar, but it is now thought to be an Egyptian town called Yerza. There are three other nearby tels that could be Gerar.

ncient Gaza has been identified with modern Tel Harube, about three miles from the Mediterranean coast. It was a place of great strategic importance for the Egyptians, lying as it does at the southern end of the coastal plain leading up to Caesarea Maritima, Dor, and Carmel. It was captured by Thutmoses III in c.1468, when it was called "a prize city of the governor". It is also mentioned in the Tel elAmarna letters (page 162) as a centre of Egyptian administration.

At the time of the Israelite settlement, it was included in the territory allocated to Judah, but it was only insecurely held: "Judah took Gaza with its territory, Ashkelon with its territory, and Ekron with its territory. The Lord was with Judah, and he took possession of the hill country, but could not drive out the inhabitants of the plain, because they had chariots of iron" (Judges 1.18–19). In fact, the area was overrun and held by the Philistines (on this see below) until its capture by the Assyrians under Tiglath-Pileser III in 734.

In subsequent centuries Gaza changed hands many times. It remained vital for the Egyptians who occupied Gaza briefly in 609, but the Egyptians could not hold it. It became a Babylonian and Persian stronghold, mentioned by Herodotus who gave it the name Kadytis. It was then retaken by the Egyptians, and it was one of the few places that was sufficiently strong and independent to resist the advance of Alexander the Great, though it was eventually destroyed after a long siege in 332.

The Egyptians returned, but Gaza nevertheless fell to one of Alexander's Seleucid successors, Antiochus III, in 198, and although it was attacked by Jonathan, one of the Hasmoneans, in 145, it did not become part of the Hasmonean empire until it was captured by Alexander Jannaeus in 96.

The advance of Pompey brought Gaza under Roman control in 58, and Gabinius rebuilt the city in about 57. In 34 Gaza fell briefly to the ambitions of Cleopatra (on this see page 22), but it was passed as a reward to Herod the Great who held it for a short time before his death, when it came under the jurisdiction of the Roman proconsul of Syria.

During the Roman period, it became preeminently a Roman city, with a renowned school of rhetoric, and with many temples dedicated to Roman deities. It remained, though, sufficiently cosmopolitan for Jews and Christians to live there together throughout the period of the Roman Empire. The Romans extended Gaza beyond the original Tel until it reached the Sea where they built the port of Maiumas Neapolis.

During the Byzantine period, the name was changed to Constantia. In the 5th century, a large church was built known as the Eudoxia Church after the empress Eudoxia who commissioned it. In 1996, another extensive and early (c.5th century) church

BELOW Khan Yunis, a city about 20 miles south of Gaza, was established during the 14th century CE. Its purpose was to protect caravans, pilgrims, and travellers on the Via Maris. Today it shares its name with a nearby refugee camp.

OPPOSITE Excavations of the 14th-13th-century BCE cemetery at Deir alBalah, about seven miles south-west of Gaza. The site is about a mile from the sea and was hidden by 45 feet-high sand dunes.

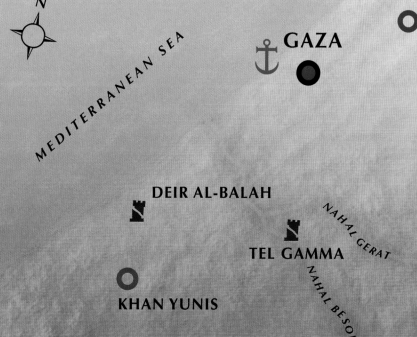

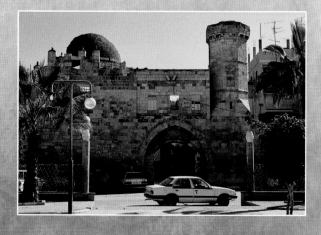

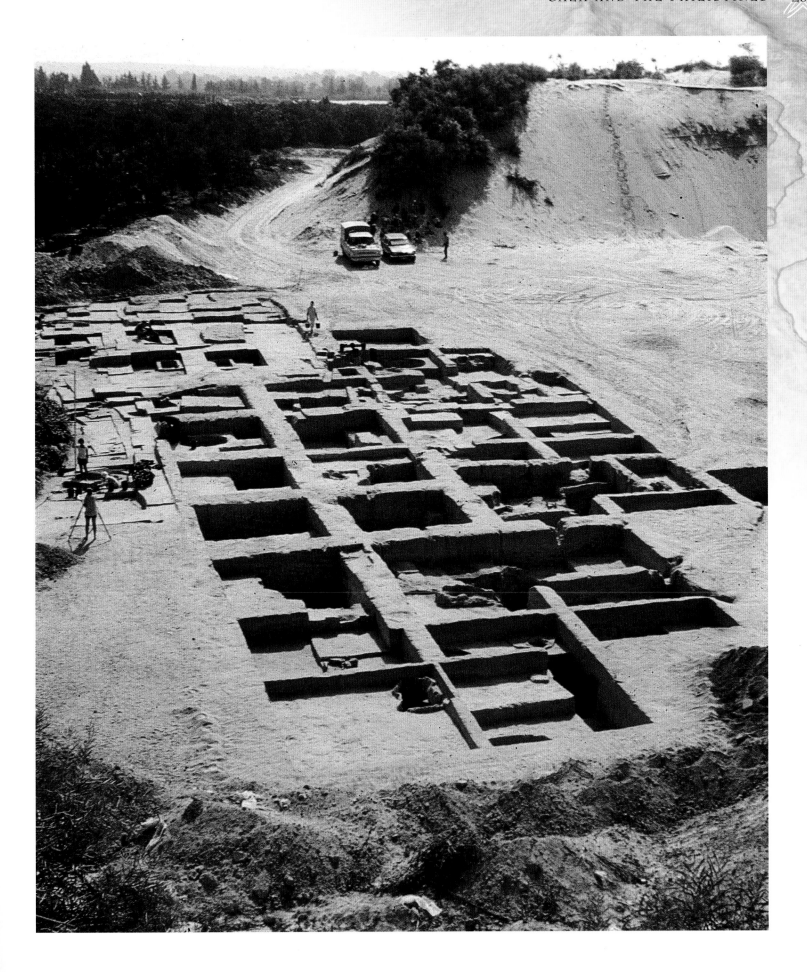

complex was found at Jabaliyah, a village then slightly north of Gaza but later incorporated in it.

The Muslims defeated the Byzantines in the area in 635–6, and Gaza came under Muslim rule. It was a place of scholarship, and the founder of one of the four major schools of Islamic jurisprudence (Sharia), ashShafi, was born here. Even so, Gaza's key position as the link between south and north meant that once again it was a recurrent battle-ground, this time between conflicting Muslim dynasties. After World War I and the collapse of the Ottoman Empire (Gaza fell to the Ottomans in 1516 and was made capital of the province of Palestine), the territory of Gaza became part of Palestine under the British Mandate. After World War II it came under Egyptian administration but remained autonomous. Occupied briefly by Israel in 1956, it was then occupied more permanently in 1967, until the Jewish settlements were withdrawn in 2005. The pain and disastrous conflict continue.

GAZA AND THE PHILISTINES

The word "philistine" has come to refer to a person or an attitude caring nothing for things of beauty or civilization, and engaging in fairly wanton destruction – an attitude thought by Matthew Arnold (1822–88) to be typical of the English: "Philistinism! –We have not the expression in English. Perhaps we have not the word because we have so much of the thing." The word itself he blamed on the Bible, where the Philistines are portrayed as the consistent enemy of the Israelites: "Philistine must have originally meant, in the mind of those who invented the nickname, a strong, dogged, unenlightened opponent of the chosen people, of the children of the light." In fact, the Philistines were a sophisticated and technologically civilized people, who left a major mark, not just on the Mediterranean coast, but wherever they went in their invasions further inland.

The exact origins of the Philistines are uncertain because the name is used loosely of a range of associated peoples. In the Bible the land of the Pelishtim (Philistines) is called Eretz Pelishtim, or Peleshet (Philistia). The Greek and Latin forms led to the modern name of Palestine.

The Philistines were part of a widespread movement of the Sea Peoples (or "foreigners from the Sea") who spread from the Aegean basin into the Mediterranean in the last decade of the 13th century BCE and in the 12th century, settling where they could. Ramases III fought two groups of the Sea Peoples, the Tjekker and the Philistines, in c.1190: his victory is described in carvings on the walls of his funerary temple at Thebes (Madina Habu). After his success, he settled the Philistines along the southern coast of Canaan, and their new home became the region known as Philistia.

The Philistines established a strong position on the Mediterranean coast, in an area extending from roughly Gaza in the south to modern Tel Aviv in the north. They did this through a linked alliance of five city-states, the so-called Philistine Pentapolis (Greek, five cities). The five cities were Gaza, Ashdod (page 210), Ashkelon (pages 208–9), Gath (page 182), and Ekron (page 182).

The strength of the Philistines and their skill in warfare can be seen in the fact that Judges 3.31 lists them among the nations that the Lord left (3.4) "for the testing of Israel, to know whether Israel would obey the commandments of the Lord, which he commanded their ancestors by Moses."

The Bible records constant conflict between the Philistines and the various families/tribes in the kinship group of the Bene Israel, including the famous episode of Samson and Delilah (Judges 15–16). At one point the Philistines succeeded in destroying Shiloh and capturing the sacred Ark of the Covenant – the recovery of the Ark of God from the Philistines and the procession leading to its installation in Jerusalem is celebrated in Psalm 132.6–8:

We heard of it in Ephrathah;
we found it in the fields of Jaar.
"Let us go to his dwelling place;
let us worship at his footstool."
Rise up, O Lord, and go to your resting place,
you and the ark of your might.

Under Saul, "there was hard fighting against the Philistines all the days of Saul" (1 Samuel 14.52). David killed the Philistine champion, Goliath, and routed the Philistines (1 Samuel 17.41–54), but that provoked the homicidal jealousy of Saul. As a result, David took flight and for a while became a mercenary vassal of the Philistines (see page 15). When Saul was killed, David broke free from the Philistines and set up his own rule in Hebron (see page 190). Ultimately he drove the Philistines back, but they remained an independent power in Philistia. The Assyrians subdued them and then used them to create a buffer-zone against the Egyptians. The Egyptians nevertheless took control of Philistia after the collapse of the Assyrians. After this the Philistines merged into the Palestinians.

———— ✠ ————

OPPOSITE TOP Fishing boats in the harbour at Gaza.

OPPOSITE BOTTOM LEFT alOmari Mosque (Great Mosque) in downtown Gaza. It occupies the site of an ancient temple and the 5th-century Greek Orthodox Eudoxia Church. The mosque was also the site of a 12th-century Norman church built by the Crusaders.

OPPOSITE BOTTOM RIGHT Detail of a mosaic showing a zebra, from the 6th-century CE synagogue at Gaza, which was found south of the present harbour.

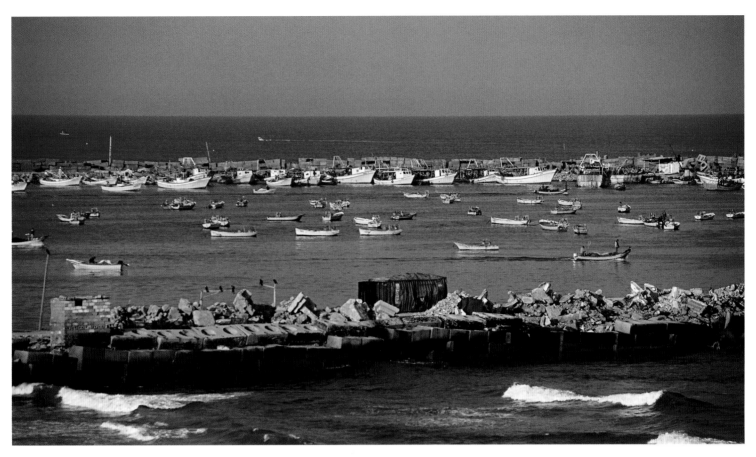

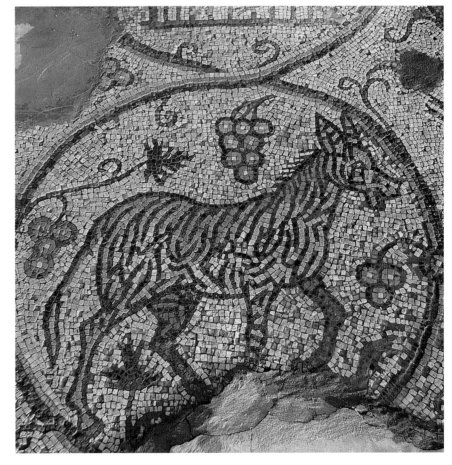

ASHKELON AND ASHDOD

LEFT Modern Ashkelon
in the distance from the
south. It is Israel's
largest port and fifth
largest city, with a
population of over
200,000. Building
began in 1956 and
has followed a
development plan.

During World War II food in Britain was so scarce that nothing, of anything grown, could be wasted. Fox's *Gardening for Good Eating* therefore advised in 1943, "When the onion seedlings are thinned [and might in better years be simply discarded], they can be eaten as scallions." Scallions (roughly speaking a kind of spring onion) seem far removed from the eastern Mediterranean coast, but that is where originally they came from, from the harbour and city of Ashkelon. Its onion was famous throughout the Mediterranean world and it was known as the Ascalonian (Latin, *ascalonia*) onion, hence the word "scallions". Ashkelon was famous for far more than its onions. Its wine was exported as far as Germany and Roman Britain and its production was a major industry until the arrival of Islam in the 7th century, with its prohibition against alcohol. It may seem strange that a settlement surrounded by sand and dunes should have been renowned in the ancient Mediterranean world for its produce, since at Ashkelon there are no springs or obvious streams. There is, however, an underground river into which wells were sunk, and on this basis at Ashkelon grew to become one of the most substantial and prosperous cities in the Holy Land

ABOVE A 14th-century CE mosque minaret at Ashkelon.

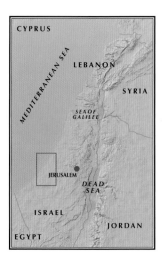

The earliest traces of human habitation in the area go back to the Neolithic period.

Ashkelon is mentioned in the 19th-century Execration Texts of Egypt – the Execration Texts are small figures or shards of pottery on which have been inscribed or scratched the names of cities or rulers, together with a curse against them; the names are an extremely important access to the early geography of the Holy Land.

Before the arrival of the Philistines (see page 15), Ashkelon was one of the Canaanite city states, and like them it resisted the overrule of Egypt. The city, however, was vital for Egypt's trade and defence, and its subjugation by Ramases II (c.1304–1237) is shown in the reliefs at Karnak where Ashkelon is represented as a fortified tower. It then appears in the Tel elAmarna letters indicating its subordination to Egypt.

By the time of the Israelite settlement the Philistines were well established in Gaza and Ashkelon, and Ashkelon became part of the Pentapolis (see page 204). Judges 1.18 says that the Israelites captured Ashkelon, but the Septuagint (a Greek translation using a much earlier Hebrew text than any others) states the exact opposite: it says that the Israelites did *not* capture Ashkelon, and that is certainly the truth. Ashkelon remained a strong,

TEL MOR

ASHDOD

NAHAL LACHISH

MEDITERRANEAN SEA

ASHKELON

RIGHT The old harbour wall at Ashkelon, with Roman columns embedded in the wall to strengthen it.

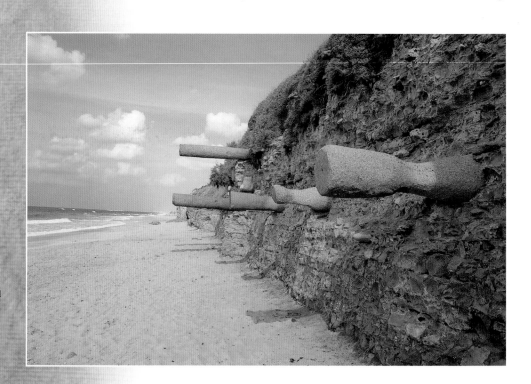

independent kingdom, recognized by the Assyrians in the 8th century as extending as far north as Joppa.

The Assyrians nevertheless reduced the power of Ashkelon until it was finally conquered in 701 when its king was deported to Assyria. Ashkelon then served as a base for their campaigns against Egypt, and its wretched condition became an example for the prophet Zephaniah (7th century) of God's judgement and of his promise that even this part of the Land will be given to the remnant of his people (see box right).

Despite the promise, Ashkelon remained out of reach. It was conquered by the Babylonians in 604, but after the fall of Babylon it became an autonomous city owing allegiance to Egypt, and all attempts by the Hasmoneans to take it and add it to their expanding empire failed. Herod the Great in his usual way entered into friendly relations with Ascalon (as Ashkelon was now known) and

JUDGEMENT AND PROMISE

For Gaza shall be deserted,
and Ashkelon shall become a desolation;
Ashdod's people shall be driven out at noon,
And Ekron shall be uprooted
The word of the Lord is against you,
O Canaan, land of the Philistines;
and I will destroy you until no inhabitant is left.
And you, O seacoast, shall be pastures,
meadows for shepherds and folds for flocks.
The seacoast shall become the possession
of the remnant of the house of Judah,
on which they shall pasture,
and in the houses of Ashkelon
they shall lie down at evening.
For the Lord their God will be mindful of them
and restore their fortunes. (Zephaniah 2.4–7)

BELOW Excavations found at Ashkelon. The exact nature of the building and its use have yet to be identified.

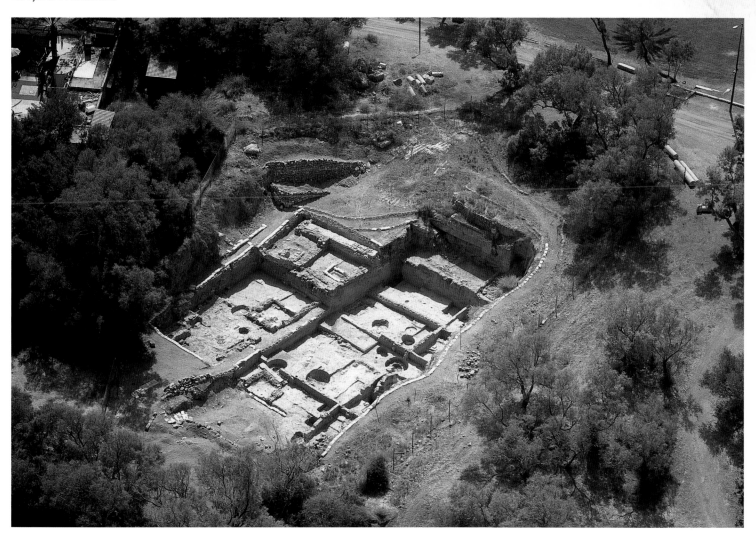

he built temples and palaces as well as a stoa, a roofed colonnade where (especially in Athens) philosophers taught and debated; the stoa at Ascalon became particularly famous for this.

Ascalon remain loyal to Rome during the 1st Jewish Revolt, and it was rewarded with both privileges and investment. It thus became a prominent Hellenistic and Romanized city, though Jews certainly lived there, and the remains of a synagogue from the Byzantine period have been found there.

The Muslim caliph Umar captured Ascalon in 636 CE when, because of its resistance, it was badly damaged. It was rebuilt by Abd alMalik in 685 when its splendour and beauty led to it being called *urus ashShams*, "the bride of Syria". It was finally destroyed in 1270 as a consequence of its repeated involvement in the Crusades.

ASHDOD (AZOTUS)

Ashdod lies about 22 miles north of Gaza. Originally it was about two and a half miles inland from the Mediterranean, but it came to consist of two parts, Azotus Paralus on the coast with its ancient harbour, and Azotus Mesogeius further inland. Traces of early occupation have been found from the Chalcolithic and Early Bronze Age periods, and it has been excavated several times. About four miles north-west of Ashdod is another early settlement, Tel Mor, on the northern bank of the River Lachish. The stream as it flows into the Mediterranean offered a place of anchorage, and it seems to have served that purpose for Ashdod until the harbour was built. The two places were closely connected, and the settlement at Tel Mor had its own substantial buildings.

There was continuous occupation of Ashdod and Tel Mor until Ashdod became a part of the Philistine Pentapolis (page 204). Although, therefore, it was allocated to Judah in the Israelite settlement, it was not taken. Indeed, to the contrary, it remained a powerful enemy of the Israelites, and when the Philistines captured the Ark of the Covenant it was brought to the Temple in Ashdod dedicated to Dagon.

Ashdod maintained its independence including a constant opposition to the Assyrians until it was finally defeated and made a part of the Assyrian Empire. The fall of Assyria brought the Egyptians back into the area, but with only, at the most, a weak control.

During the Hellenistic period (333–63) its name was changed to Azotus. It was attacked by Jonathan and his brother Simon when their Seleucid enemies took refuge there (1 Maccabees 10.82–5):

> Then Simon brought forward his force and engaged the phalanx in battle (for the cavalry was exhausted); they were overwhelmed by him and fled, and the cavalry was dispersed in the plain. They fled to Azotus and entered Beth-dagon, the temple of their idol, for safety. But Jonathan burned Azotus and the surrounding towns and plundered them; and the temple of Dagon, and those who had taken refuge in it, he burned with fire. The number of those who fell by the sword, with those burned alive, came to eight thousand.

The Hasmoneans continued to hold Azotus (and other places) until the arrival of Pompey and the Romans. According to Josephus (*War* 1.155–7):

> Having taken away from the Jews the towns in Coele-Syria which they had conquered, Pompey placed them under a Roman governor appointed in that region. He thus confined them to their own territory alone. He also rebuilt Gadara (page 58) which had been destroyed by the Jews, thereby pleasing Demetrius, a native of Gadara, one of his own freedmen. From them he also set free the towns in the interior which they had not completely destroyed, Hippos, Scythopolis, Pella, Samaria, Jamnia, Marisa, Azotus and Arethusa – and similarly the coastal towns of Gaza, Joppa, Dora and the town formerly called Strato's Tower, later, after it had been rebuilt with the most magnificent buildings by King Herod, called Caesarea. All these towns he gave back to their native inhabitants and attached them to the province of Syria.

Augustus restored the city to Herod the Great who in turn gave it to his sister. In Acts 8.40 Philip is said to have passed through Azotus on his way to Caesarea, on one of his missionary journeys.

———————— ✠ ————————

OPPOSITE TOP The 8th-century Umayyad fortress at Ashdod Yam, three miles north-west of Ashdod. The fortress, which is about 130 feet wide and 200 feet long, is protected by round towers and massive gateways.

OPPOSITE BOTTOM RIGHT The basilica at Ashkelon. Nearby in the Forum area are 2nd-century CE bas-reliefs representing the Egyptian goddess Isis and a winged victory resting on the shoulders of Atlas.

OPPOSITE BOTTOM LEFT Ruins of St Mary the Green church, Ashkelon. The Crusader church incorporates fragments of earlier sculpture.

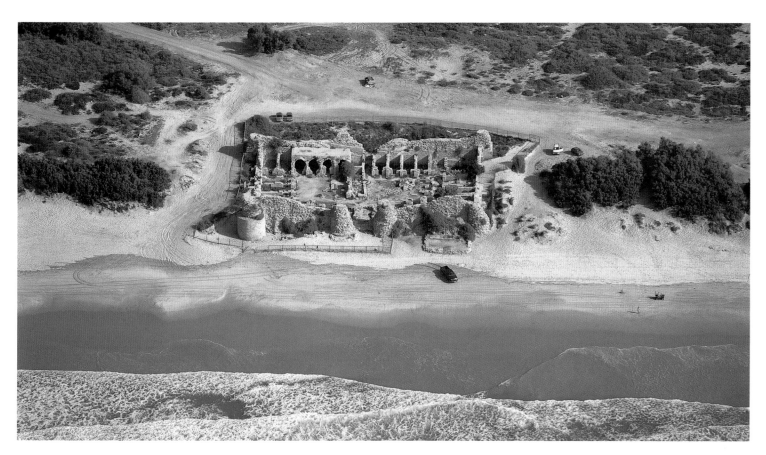

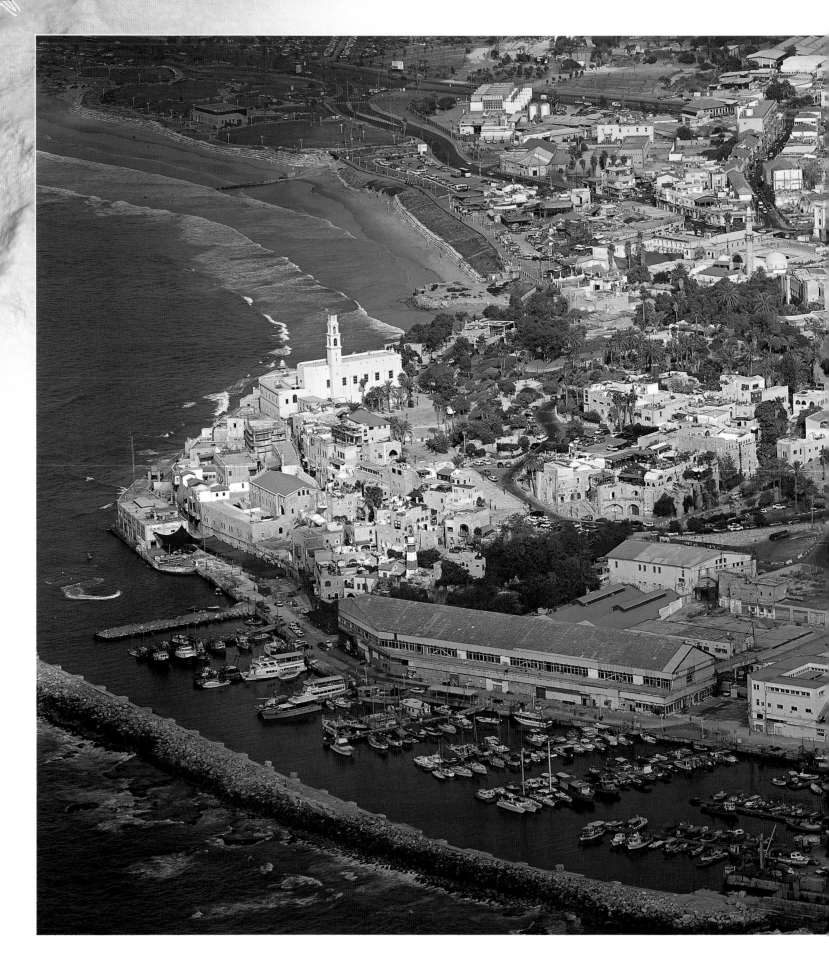

JOPPA AND APHEK

JAFFA AND ANTIPATRIS

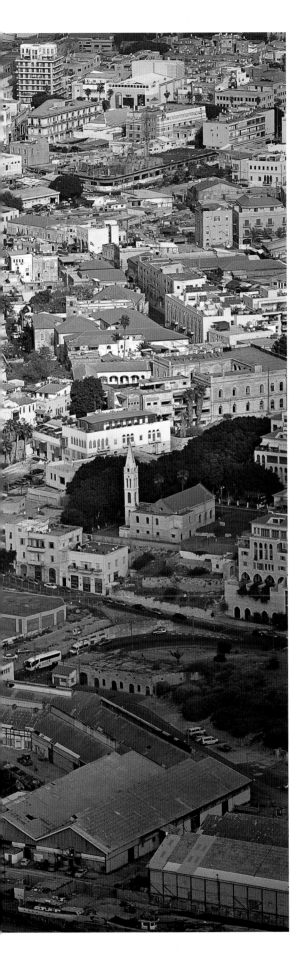

LEFT Jaffa harbour, looking towards the sun-lit Church of St Peter. This 19th-century Franciscan church, built on earlier remains, is the traditional site of Peter's vision that encouraged him to take Christianity to all peoples (see Acts 10).

In 1909, 60 Jewish families decided to build a garden suburb north of the town of Yafo or Jaffa on the Mediterranean coast. The site chosen was a raised area known as Tel Abib, better known now as Tel Aviv. Tel Aviv soon outgrew Jaffa to become Israel's largest conurbation and its most important commercial port. The two are now known as Tel Aviv-Yafo. For Jews, the founding of Tel Aviv was emotionally dramatic because, after centuries of persecution in Europe, it was their own creation. Hayyim Bialek (1873–1934) was a poet from Russia where the persecution of Jews had been, at times, particularly severe. He wrote:

> I love Tel Aviv because all of it, from the foundation to the coping, was established by our own hands, because we need not feel under obligation to anyone for its good points or apologetic for its bad points. Is not this the whole aim of our redemption, to be owners of our body and soul, masters of our spirit and creation?

Another refugee, Rabbi Ehrenpreis (1869–1951) expressed equally delighted relief: "Something perfectly new and peculiar has come forth here from a desert: a Jewish city that is not a ghetto."

KAFR SABA

APHEK

NAHAL SHILLO

MAZOR

NAHAL YARQON

APOLLONIA

TEL QASILE

BELOW The history of Apollonia, originally a Phoenician trading city on the Via Maris between Jaffa and Caesarea, is indicated by the other names it has been known by: Sozusa (Byzantine period), Arsuf (Arabic/Muslim), and Arsur (Crusader). A Muslim city from 640, it was captured by the Crusaders in 1101 and destroyed in 1265 after a 40-day siege by Mamluke sultan Baibars.

JOPPA

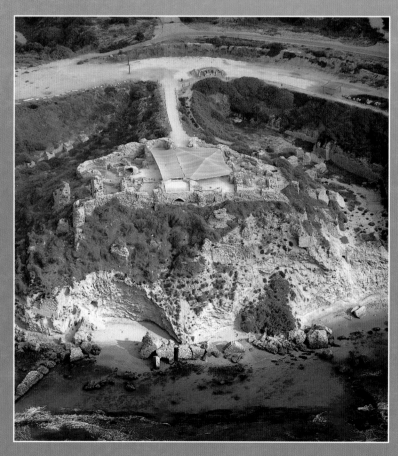

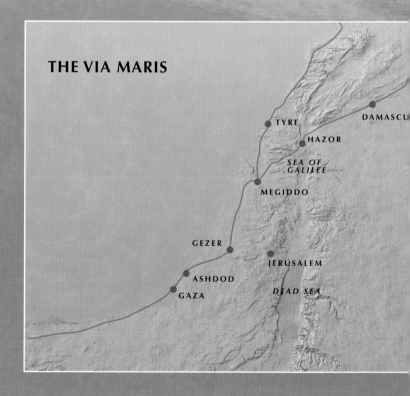

THE VIA MARIS

TYRE

DAMASCUS

HAZOR

SEA OF GALILEE

MEGIDDO

GEZER

JERUSALEM

ASHDOD

GAZA

DEAD SEA

ABOVE The 90 feet high "Tower of Forty" on the plaza at Ramla may have originally been topped by a dome. The nearby White Mosque, dating from 1318, was converted from a Crusader church.

RAMLA

NAHAL SOREQ

YAVNEH

MEDITERRANEAN SEA

LEFT The Via Maris or "Way of the Sea" (see Isaiah 9.1) was an ancient international trade and military route running from Egypt along the Mediterranean coast to Asia Minor and to lands in the north and north-east.

Joppa (the name means "beauty") was occupied as early as the Middle Bronze Age (1900–1500 BCE) with the construction of an enclosure surrounded by an earth rampart. Its name first appears in the list of the victories of the Egyptian pharaoh Thutmoses III in about 1468. A famous Egyptian story tells how the Egyptians captured Joppa by smuggling in soldiers in 200 baskets offered as tribute – a kind of early version of the Trojan horse. Joppa is also mentioned (as Iapu) in the Tel elAmarna letters as an Egyptian stronghold.

The Egyptians defended the place for as long as they could, and the excavation of a gate into the stronghold found inscribed stones on one of which the name of Ramases II (c.1304–1237) appears. However, an Assyrian inscription on the Prism Stele states that both Joppa and Ashdod were under the control of Sennacherib in 701: "In the continuation of my campaign I besieged Beth-dagon, Jaffa, Bene-Berak, Asor, cities belonging to Sidqia [king of Ashkelon] who did not bow to my feet quickly enough. I conquered them and carried their spoils away."

In the Israelite settlement, Joppa was allocated to the family of Dan, but once again that allocation was largely theoretical, since the area was controlled by the Philistines. The harbour, however, was able to be used, perhaps because it was located at Tel Qasile to the north of Joppa (it is now part of a northern suburb of Tel Aviv). It is close to the River Yarqon and to the sea, and it was a substantial and important place where extensive excavations have taken place.

The harbour was used to bring in cedar for the building of the first Temple (2 Chronicles 2.16, which records a letter sent from the king of Tyre to Solomon saying, "We will cut whatever timber you need from Lebanon, and bring it to you as rafts by sea to Joppa; you will take it up to Jerusalem") as also of the second Temple (Ezra 3.7).

After the campaign of Alexander the Great in 332–331, Joppa became a Greek colony. In the Book of Jonah, the prophet is called by God to speak out against Nineveh, the capital of the much-hated Assyrians, in order to show that God has command of even the worst nations. Jonah tried to avoid the commission, and in order to escape from God he fled to Joppa in order to catch a ship for Tarshish (Jonah 1.3).

Joppa was much involved in the fighting during the Maccabean Revolt, and Judas Maccabaeus burned the harbour down after an act of treachery (2 Maccabees 12.3–7). It was conquered by Jonathan in 144 and made a part of Judaea by his brother Simon, who drove out the inhabitants and settled his soldiers there in order to secure an access to the sea. Pompey restored its independence when he invaded in 64–63 BCE, but Julius Caesar returned Joppa to Jewish control. It became a part of Cleopatra's scheming designs (page 22), and Mark Antony gave it to her, but when she died in 30 BCE Augustus gave it to Herod the Great.

Herod reduced the importance of Joppa greatly when he decided to build the splendid new port of Caesarea Maritima (pages 226–31), but it was still a popular Hellenistic city. The early Christian communities in Joppa were a sufficient size for Peter, in his journeys among all believers, to respond to an invitation to come there from Lydda to raise Dorcas from the dead; he stayed for some time in Joppa with a namesake, Simon, a tanner (Acts 9.32–43). It was at Joppa also that he saw the vision which made him realize that the gospel must be taken to the Gentiles as well as to the Jews (Acts 10.3–48).

YAVNEH (JAMNIA)

At Yavneh Judas had won another victory immediately after his burning of Joppa for its treachery: "But learning that the people in Jamnia meant in the same way to wipe out the Jews who were living among them, he attacked the Jamnites by night and set fire to the harbour and the fleet, so that the glow of the light was seen in Jerusalem, thirty miles distant" (2 Maccabees 12.8–9).

After the destruction of Jerusalem by the Romans many Jews migrated to Joppa, among them some of the rabbis and scholars who set about the recovery and restoration of "Judaism without the Temple". They were led by the great Johanan ben Zakkai whose spiritual practices and visions help us to understand the vision of his contemporary, Paul, on the road to Damascus. When, at the end of the 1st Jewish Revolt, it looked as though Johanan would be starved to death along with the rest of the defenders, he had himself smuggled out of Jerusalem disguised as a corpse on a bier. He went to the victorious Vespasian and addressed him as "king", much to the displeasure of Vespasian who said that he was not emperor yet. At that moment a messenger came from Rome to say that he had been made emperor. In his astonishment, Vespasian said that Johanan could make any request and that he would grant it. Johanan said, "Give me Yavneh and give me the Hakhamim" (B Gittin 56b).

In those terse terms it must seem a strange request. What Johanan was requesting was permission from Vespasian to go to a town to the south of Joppa known as Yavneh (or in its Latin form as Jamnia), and to take with him the Wise scholars who would help him to rebuild Judaism (the word Hakhamim means "those who are Wise", and it was used to refer to the scholars who preceded the rabbis).

At Yavneh Johanan set up the first of the Academies that eventually spread to Babylonia in the East and Rome in the West (see Scythopolis pages 68–73, and Tiberias page 61–2). The Academy took on the structure and functions of the now disappeared Great Sanhedrin of Jerusalem so that the debates could be held and the decisions made that would keep Judaism in being. The Temple no longer existed on earth, but ways were found to continue all that the Temple stood for. As Johanan put it himself, "Charity is as powerful for atonement as the offerings of the altar" (Abot deRabbi Nathan 4).

APHEK (ANTIPATRIS/RAS AL-AIN)

Aphek is perhaps near Joppa to the north-east. The word "perhaps" is necessary because the site is uncertain. According to Josephus, Antipatris was near a village called Kafarsaba, known in rabbinic texts as Kefar Saba, and therefore likely to be the present-day Kfar Saba. Elsewhere, however, Josephus places it on the edge of the hill country on the road from Caesarea to Lydda. Eusebius' Onomasticon places it a few miles south-east of Kfar Saba, and that is more likely since that area is much better supplied with water. In the Hellenistic period it was known as Pegae (The Springs) and then as Arethusa, and that has led to the usual present-day identification with a site at Tel Aphek known also as Rosh ha'Ain/Ras alAin, "source of the spring water". So far, though, there are few signs of Herod's city of Antipatris.

Aphek was a staging-post on the Via Maris and was therefore important to the Egyptians: it is mentioned in the list of Thutmoses III. The ruler of Aphek was one of the 31 Canaanite kings conquered by Joshua (Joshua 12.18). Nevertheless, it remained under Philistine control, and they used Aphek as a centre for gathering their army for their campaigns (1 Samuel 4.1; 29.1). It, or somewhere near, became the site of one of the many building projects of Herod the Great and he built a city which he named Antipatris in honour of his father Antipater. The city was destroyed by an earthquake in 363 CE. A small settlement continued, and in the 16th century the Turks built a fort, the remains of which can still be seen.

———— ✼ ————

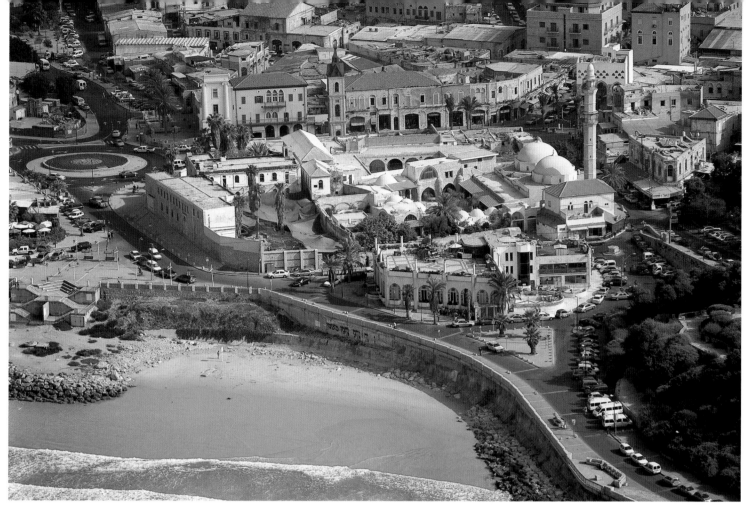

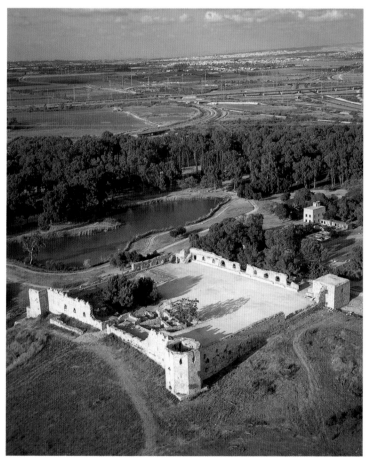

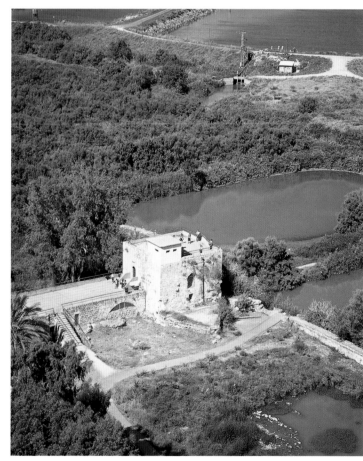

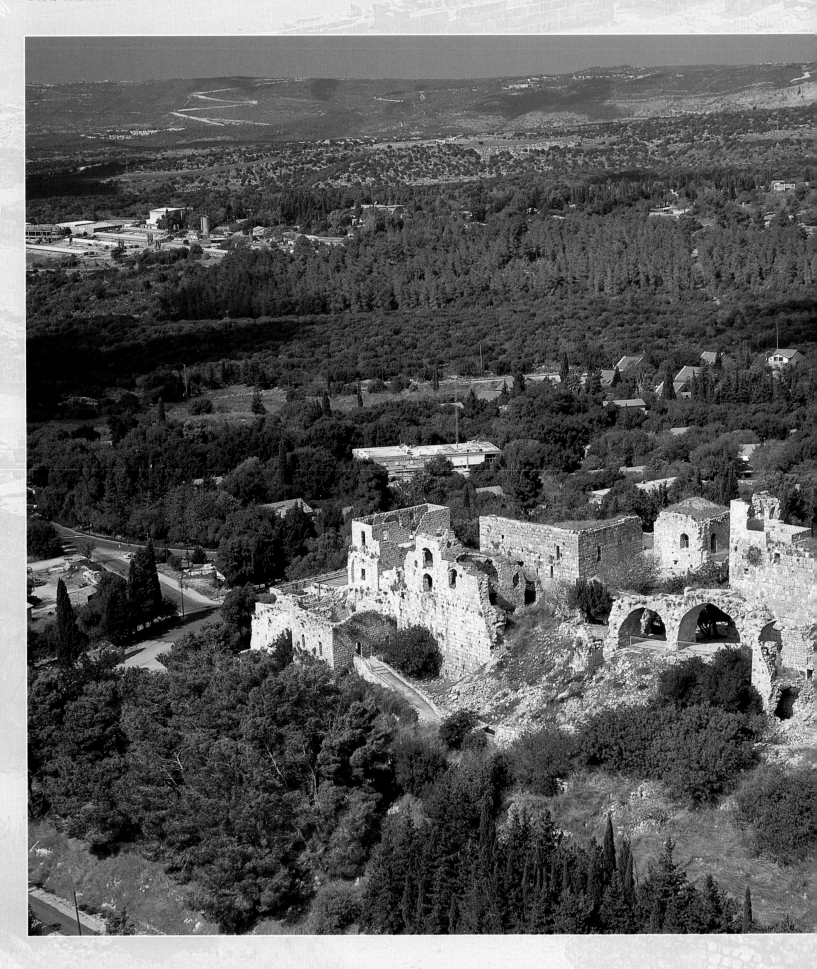

THE CRUSADES

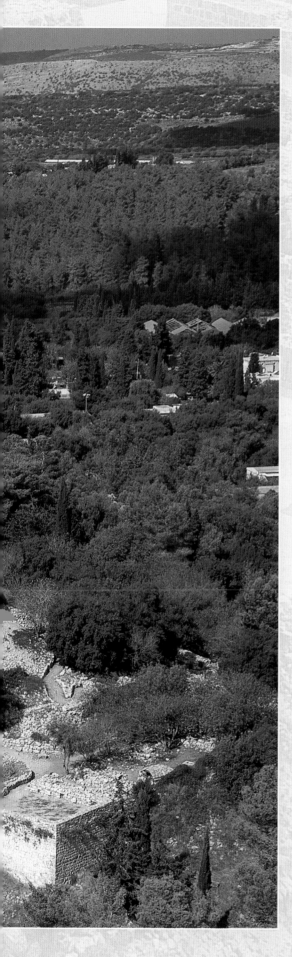

LEFT Yehiam (or Judin) Crusader and Ottoman castles, about six miles south of Montfort Castle (see page 221), and 12 miles west of Meron (see page 48) near Kibbutz Yehiam. Built on the site of a Roman fort and a Byzantine farm or monastery, the Crusader castle was destroyed in 1265 by the Mamluke sultan Byars. Parts of it were rebuilt in the 18th century by Shaikh Mahed Al Hussein.

The Crusades are often described in a simple way as wars and campaigns fought in the Holy Land between 1095 and 1291, undertaken under a vow and under the sign of the cross to recapture Jerusalem. Certainly the Crusaders who fought them (though originally they were not called "crusaders") left an obvious mark on the Holy Land, not least in their fortifications and castles. However, the Crusades were in fact an extremely complex succession of events, the reasons for which are very much debated. They were campaigns launched mainly from Western Europe to recover the Holy Land from the Muslim invaders who had taken the land in the 7th century, but they were also events ocurring in Europe with its own conflicts and rivalries. This book can only offer a brief background, but the superb work of historians in the past 50 years needs to be much more widely known, since the Crusades, inadequately understood, lie as an angry scar between the Muslim and non-Muslim worlds. The concept of "the Crusades" will remain a blind word of hostility unless historians are allowed to indicate a wiser understanding of what they originally were and what they meant.

The first pebbles whose movement led to the avalanche of the Crusades were shaken loose neither in Europe nor even in the Holy Land itself, but far off in a part of the world which the Greeks called Transoxania but which would now be described as a part of Central Asia. From this area came the steppe-dwelling Oghuz Turks, among whom the most important clan was that of the Seljuqs. They had converted to Sunni Islam at the end of the 10th century. They began to move into the Muslim lands on their borders, and especially into the empire of the Ghaznavids which at that time stretched from Iran into north-west India.

Observing their skills as raiders, a Ghaznavid ruler, Mahmud, invited the Seljuqs in 1025 to serve him as mercenary soldiers in Khurasan. Instead the Seljuqs seized Khurasan for themselves. In the ensuing war, the Seljuqs were successful, and in 1050 the Sunni caliph in Baghdad, who saw them as potential allies against his Shia rivals, conferred on the Seljuq leader, Tughril Beg, the title of Sultan. This recognition enabled more of the Oghuz Turks to migrate westward into Azerbaijan and Anatolia.

This brought them to the western edge of the Muslim world. That put them into the position of *ghazi* warriors (ie those who were entitled to fight against non-believers and Christians; on this see the General Introduction. page 31). Their *maghazi* raids provoked the Byzantine emperor, Romanus Diogenes (who ruled 1068–71) to march against the Seljuqs with such a vast army that before the battle in 1071 the Seljuq Sultan, Alp Arslan, put on his own burial shroud. Nevertheless, at the battle of Manzikert in South Armenia the Seljuqs won a total and crushing victory. They then made a somewhat haphazard advance toward the Bosphorus. It was slow enough to give the Byzantine emperor time to appeal for help to the Pope in Rome.

In making his appeal for help, Alexius had hoped for an army that would come under his command in order to hold back the Turks — theoretically a joint command, but one in which one partner, the Byzantines, would clearly be the senior. The Western rulers and knights had something very different in mind. In 1095, a new Pope, Urban II (1088–99), made his famous appeal at Clermont in the Auvergne. The appeal was described as "an eloquent appeal", and from it came the 1st Crusade.

What did Urban so eloquently say? What did he ask people to do, and why did he ask them to do it? We cannot be sure because six different accounts have survived.

Fulcher of Chartres set the whole address in the context of an account of the wretched state of the Church in Europe at that time. Urban's main purpose was to start a campaign in the Holy Land in order to reform "the faith of Christendom, greatly degraded by all, by the clergy as well as by the laity, with peace being totally disregarded"; there was, in short a kind of brutal land piracy taking

place. Only after setting that scene did Urban turn to "another trouble", the threat of the Turks to Roman territory which, he argued, could best be met by helping "your brethren dwelling in the East".

According to Robert the Monk, Urban emphasised the savage and destructive cruelty of "the Persians" – as those coming from across the River Oxus (Transoxania) were habitually called, since it was from there that the Persians had so continuously threatened and raided the Roman Empire. They were, in Urban's view, "an accursed race, a race utterly alienated from God". Having offered some examples of their savagery, Urban (on this account) then appealed for Jerusalem: "Jerusalem is the navel of the world [see page 130]; the land is fruitful above all others, like another paradise of delights. This the Redeemer of the human race has made illustrious by his Advent ..., therefore she seeks to be liberated." As an incentive, Urban added an offer to those who were prepared to go on this campaign: "Undertake this journey for the remission of your sins, with the assurance of the imperishable glory of the kingdom of heaven." He then laid down rules to govern the selection of those who were allowed to go and those who were not. To all this the assembled people shouted in response, *Deus lo volt, Deus lo volt*, God wills it, God wills it.

Balderic of Bourgeuil says that Urban concentrated on the sufferings of the Holy Land and then urged the importance of reforming the nature and purpose of military life. Urban extended his offer of a spiritual reward by saying that the heavenly reward open to those who die in this war of liberation is equally open to those who die on the way to it. Those who confess their sins in preparation will receive "instant pardon". Furthermore there will be rewards on this side of the grave as well:

The possessions of the enemy will be yours, since you will make spoil of their treasures and return victorious to your own; or made noble by your own blood, you will have gained everlasting glory So let neither property nor the alluring charms of your wives entice you from going, nor let the trials that are to be borne so deter you that you remain here.

According to Guibert of Nogent, Urban emphasized the holiness of the land and then urged the importance of turning from unjust conflicts among themselves to a just war. He then added a reminder that the Last Day is at hand, and that the end of the world is approaching. The final conflict against the Antichrist will take place

OPPOSITE Montfort Castle, about 13 miles west of Baram (see pages 48, 51 and 166), is located on a steep rock crest overlooking the River Keziv. Originally a fortified farm, it became the main Crusasder fortress of the Knights of the Teutonic Order in the early 13th century. It was captured in 1271 and the site was abandoned.

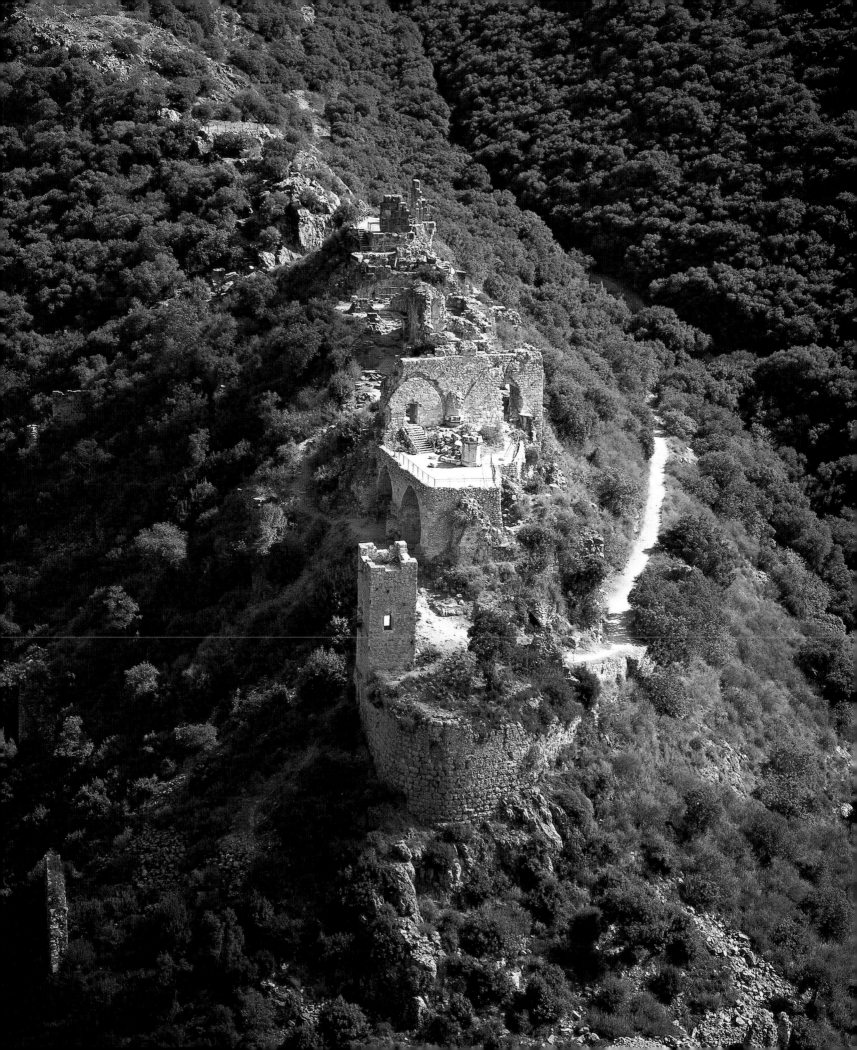

in the Holy Land (see Megiddo, page 232), but that cannot happen until there are Christians in the Holy Land to fight against the Antichrist. By retaking the Holy Land, this present generation will bring closer the final day and the End of all things (the *Eschaton*, from the Greek word meaning "last thing"). While the Holy Land was occupied, pilgrims had to pay taxes and tolls every step of the way. The liberation of the Holy Land would open up the ways of pilgrimage again.

Even from this brief account it can be seen how many and how varied were the reasons that led people to go on the campaigns that came to be called "the Crusades", and all these are reflected in the debates among historians about what the Crusades were and why they took place.

• There was a genuine desire to liberate the Holy Land in general and Jerusalem in particular. That desire was linked to a widespread belief at that time that the end of the world was at hand: whether the rush to Jerusalem was a consequence of that belief or a creation of it is one of the debates.

• The Pope was involved in a fierce contest with the kings, emperors, and other rulers in the West about his and their authority, a contest focused in what is known as the Investiture Controversy; so the organization of a campaign of this dramatic sort under the ultimate control and organization of the Pope was an important assertion of the Pope's authority.

• The in-fighting in Europe and the dire state of a Church so urgently in need of reform meant that a campaign like this might be a recall to a common endeavour.

• There was a good prospect of booty and plunder, and beyond that of new lands for occupation.

• The Turks were indeed a threat, but supposing they could be "seen-off": might not this campaign give Rome and the West a major advantage over their more ancient rivals, the Church in the East and the Byzantine Empire?

• The spiritual rewards were great: death on the way or death in battle would lead to the Lord's welcome in heaven to his "good and faithful servants" (see Matthew 25.21) – later translated into a belief that such death might count as martyrdom, though the Church was extremely cautious about conferring that technical status.

• The Church, on the other hand, was not at all cautious about promising to those who took part forgiveness of sins and the alleviation of the penalties attached to them (Indulgences).

Pilgrimage was equally important, so that a crusade to the Holy Land was seen (and controlled) by the Church as a penitential war combined with pilgrimage. That is why these expeditions were described initially, not as "a crusade", but as a pilgrimage (*peregrinatio*), a way (*via*), an expedition (*expeditio*), a journey (*iter*), and the like, while the event itself was called a war (*bellum*), work of God (*opus Dei*), cause (*causa*), and those engaged on it were

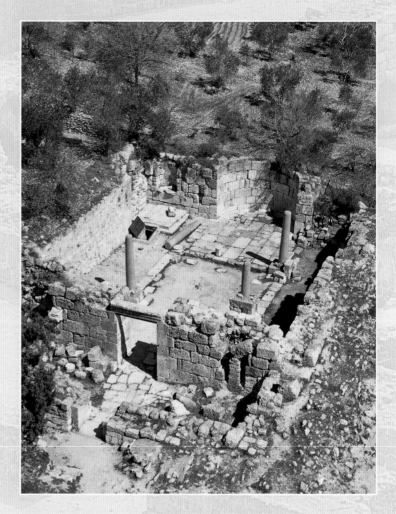

pilgrims who contributed to "the army" or "the soldiers" "of God" or "of Christ".

There were, therefore, certain marks in common that marked out these campaigns, and it was this perhaps that changed them from "a sacred war" into something that can be called "a crusade". They were controlled with formal rules by the Church which offered specific benefits; those who took part took vows and received those benefits, and they took upon themselves the sign of the cross – hence they were called *crucesignatus*, from which the word "crusade" is most likely to have been developed.

This, however, in whole or in part applied to many other campaigns against those who attacked Christians, or who had conquered lands that had once been Christian. Thus the campaigns

———————— ✠ ————————

ABOVE Ruins of the Crusader church of St John the Baptist at Samaria/Sebaste (see map, page124). It was built on the ruins of a Byzantine basilica in 1165, and later turned into a mosque. Both church and mosque honoured John the Baptist, whose tomb is traditionally held to be located in the city.

OPPOSITE The 12th-century Belvoir Castle sits 1640 feet in a commanding position above the Jordan valley (see map, page 70). This view from the west shows the drawbridge over the moat that protects three sides of the fortress. Saladin captured Belvoir from the Crusaders in 1185 from the steep but unprotected east.

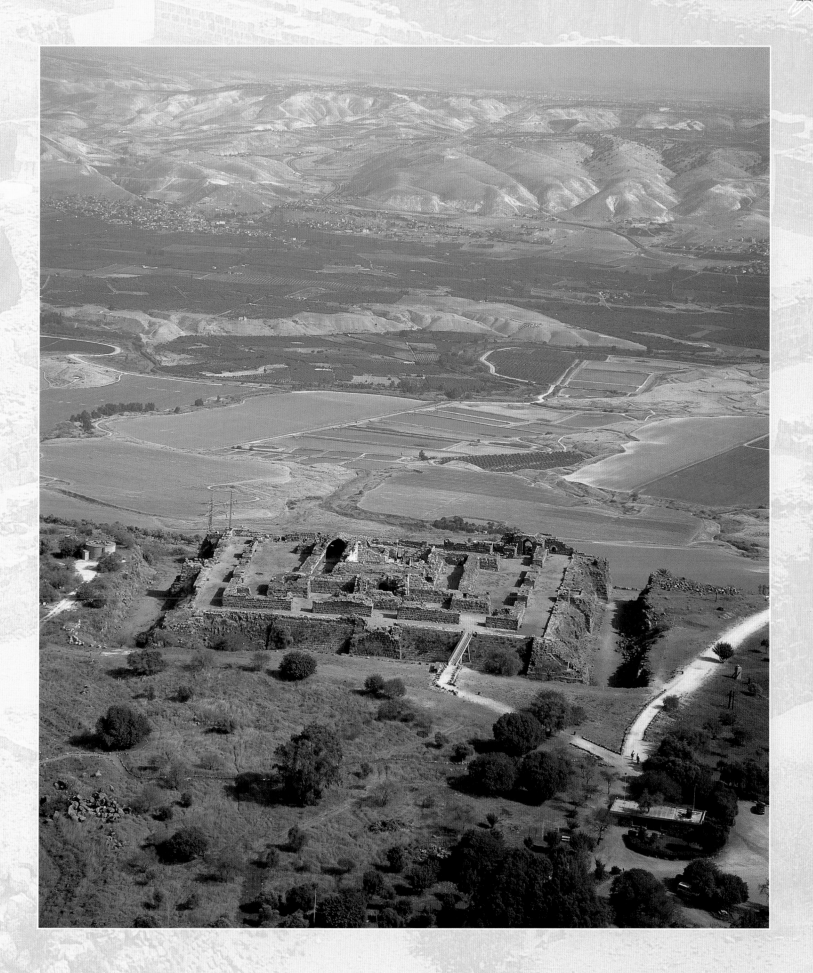

to recover from the Muslims Spain (the *reconquista*), Sicily, and Cyprus, to secure the frontiers in the Baltic, and even to suppress a heresy within Europe itself (the Albigensian) have all been called "crusades" – whether rightly so or not is one of the many debates. From the point of view of Muslim historians, they are simply bracketed together. Thus the Muslim historian ibn alAthir wrote of the invasions of the Franks having begun in 478 AH (1085–6 CE) with beginning of the *reconquista*, continuing with the conquest of Sicily, and culminating in the invasion of Syria in 490 (1096–7).

What at least is clear is that "the Crusades" were not a single, simple phenomenon, and that it is unwise, indeed futile, to look for a single "cause of the crusades". As the list above makes clear, there were many different constraints controlling these events into their outcome – into what actually happened.

The 1st Crusade was, according to Riley-Smith, "a violent and brutal episode during which the crusaders cut a swathe of suffering through Europe and Western Asia" (*The First Crusaders, 1095–1131*, page 12; see also his account in *The First Crusade and the Idea of Crusading*), but from the point of view of the first Crusaders it was immensely successful leading to the recapture of Jerusalem in 1099. Contrary to the hopes of the Byzantines, the Westerners installed themselves as kings of the Latin kingdom of Jerusalem and as bishops in that kingdom and in Syria, though the Eastern Church was not excluded. Pilgrimage became much easier, and two Military Orders were set up to care for and to protect pilgrims. They were the Knights Hospitaller (the Hospitallers, more fully the Knights of the Order of the Hospital of St John of Jerusalem, later known as the Knights of Rhodes and the Knights of Malta; in 1888 they created in the spirit of their foundation the St John's Ambulance Brigade) and the Knights Templar (the Templars, more fully the Poor Knights of Christ and of the Temple of Solomon). The Hospitallers came into being just before the 1st Crusade, and were established in Jerusalem at the abbey of St Maria Latina to become (their fourth vow) "the serfs and slaves of your masters the sick"; their fighting component was developed in the middle of the 12th century. The Templars were brought together in about 1119 in order to protect pilgrims on the roads of the Holy Land; they were given a base on the site of Solomon's Temple, and from the middle of the 12th century they took over responsibility for several castles.

The 2nd Crusade was a response to the Muslim capture of Edessa in 1144. It was led by Louis VII of France and Conrad III, king of the Romans. However, in 1187 Salah udDin, known in the West as Saladin, defeated the army of the kingdom of Jerusalem, recaptured Jerusalem and took back most of the Latin possessions in the Holy Land. Saladin achieved the reputation among his enemies of being a fair and even generous opponent. After the capture of Jerusalem, the Church of the Holy Sepulchre only survived because Saladin refused to follow the advice of those who said that he must destroy it in order to stop Christians coming there on pilgrimage. Instead he listened to those who said that what Christians worship is "the place of the Cross and the grave, not the buildings which can be seen. They would not stop coming even if the earth [on which it stands] was scattered in the sky" (Lyons and Jackson, page 276).

The 3rd Crusade, 1189–92, was a response to this defeat. This was the Crusade in which Richard I (Richard Lionheart) took part. Richard was initially (1190–1) involved in securing Sicily and recapturing Cyprus. He did not arrive in the kingdom of Jerusalem until June, 1191, after which he recovered the entire coast from Tyre to Jaffa, but not Jerusalem itself. Plots and treason in Europe led him to open negotiations with Salah udDin which secured free access to Jerusalem for Christian pilgrims. As Gillingham comments (pages 719–20), "Considered as an administrative, political and military exercise, his Crusade had been an astonishing success."

The 4th Crusade set out in 1202 to achieve that further goal of capturing Jerusalem by attacking the base of Muslim power in Egypt. However, on its way it turned aside to secure its own base and lines of communication. It did this by attacking and taking Constantinople in 1204. For a while the Western and Eastern Churches were reunited, at least in theory. In practice, this act of what was, from the Eastern point of view, treachery deepened the division between East and West beyond immediate repair.

Between 1204 and 1291 further campaigns were undertaken to secure possessions in Syria and to limit the power of Egypt. For a short time (1229–44) Jerusalem was recovered through negotiation, but the appeal of the Crusades was diminishing, and in 1291 the last of the Latin possessions was lost. Or, to look at it from the other point of view, the last of the lost possessions was regained. From the Muslim point of view, the Farangis, the Franks or Europeans (*afrunji* remains the Arabic word for "European"), were invaders and enemies who had to be dealt with as strength and opportunity allowed, and as the Quran commands in relation to the lesser Jihad (on the distinction between the greater and the lesser Jihad, and for the rules governing the lesser Jihad, see Bowker, *God: A Brief History*, pages 360–1). The accounts of the wars as they were understoood and recorded by Muslims are gathered in Maalouf and Gabrieli.

For Nimrud Castle, see page 40.

OPPOSITE TOP St Anne's Crusader church, Jerusalem(see map, page 32) is built on the site of a Byzantine church. It is a well-preserved Crusader church, possibly because it was used as a Muslim theological school from the end of the 12th century until the Ottoman period (see also pages 144–5).

OPPOSITE BOTTOM The walls of Apollonia Crusader fortress, on the Mediterranean coast between Jaffa and Caesarea (see map, page 214). Apollonia (Arabic name Arsuf) was captured by the Crusaders – who named it Arsur – in 1101 and again in 1191, but was razed by Mamluke sultan Byars in 1265 and abandoned.

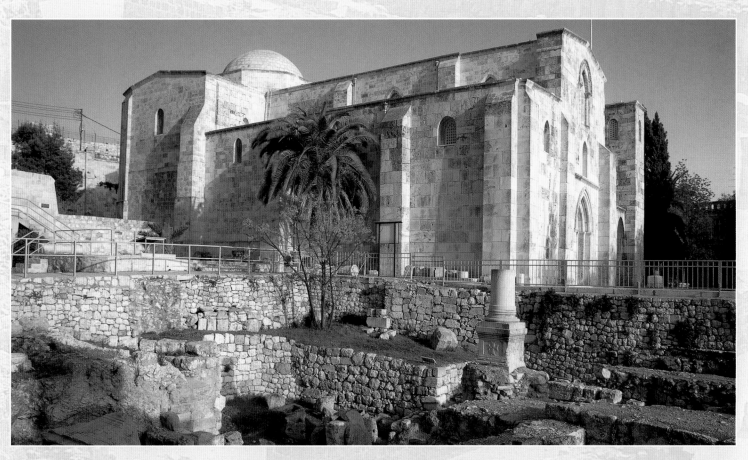

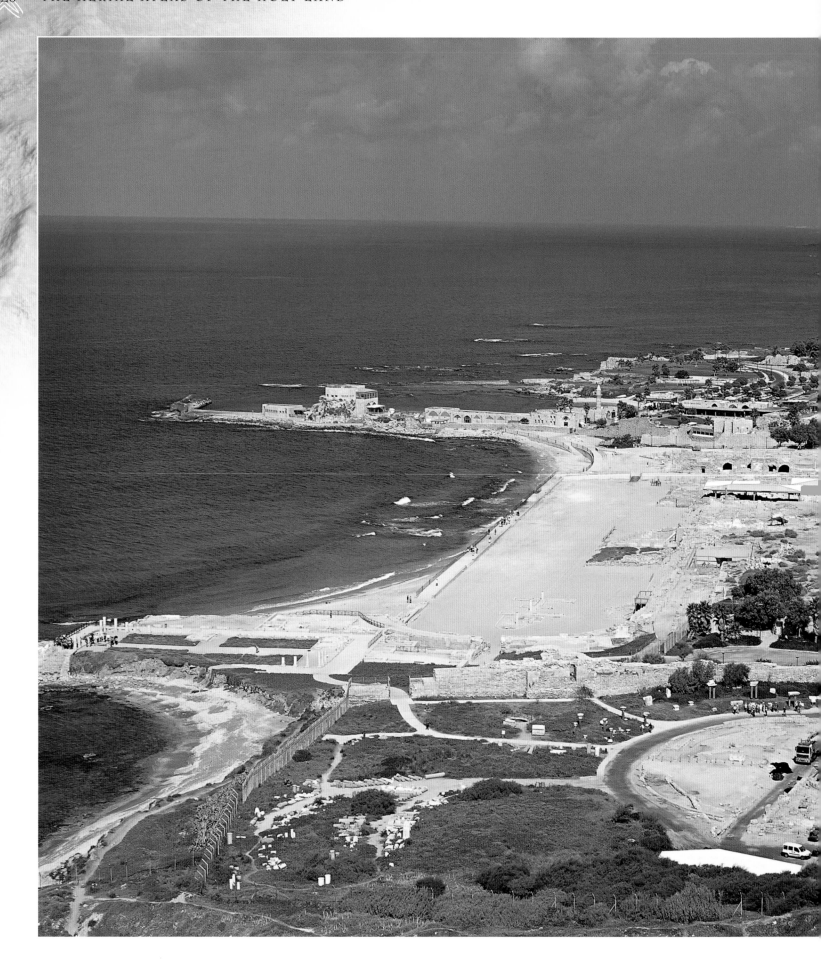

CAESAREA MARITIMA

STRATO'S TOWER

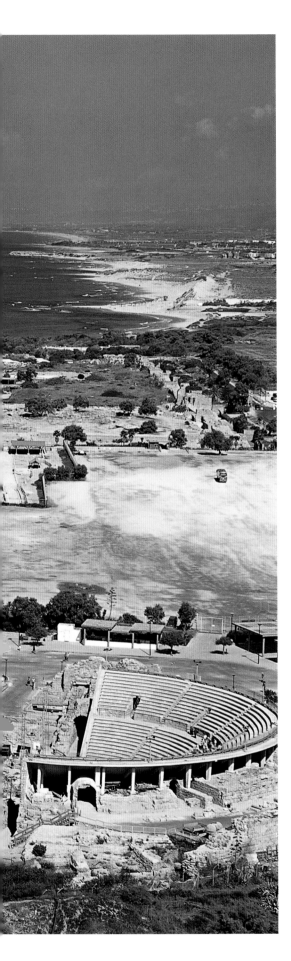

LEFT An aerial view of Caesarea Maritima looking north along the eastern Mediterranean coast. There are no visible remains of Herod's port (see page 229), but the ruins of his palace sit on a promontory opposite the restored Roman theatre (see page 231).

On the sea route along the eastern Mediterranean coast, there was no natural harbour between Joppa and Dora, and even those were "villages situated upon the sea-coast, unfit either for landing or harbour, by reason of the wind blowing from Africa and driving the sand of the sea upon the shore". So Josephus tells us, who knew this area well (*Antiquities* 15.333). But then he goes on to say how all this was changed by one of the greatest of the building projects of Herod outside Jerusalem:

> Herod noticed that among the cities of the seacoast there was one called Strato's Tower, which, being very old and ruined,… he repaired with white stone, and built a very royal palace there; in which work, more than in any other, he showed how great and high his mind was. For this stands in the midst between Dora and Joppa, in a coast where there was no port or haven, so that they who sail from Phoenicia into Egypt are in great danger, by reason of the violent winds that blow from Africa; whose blasts force the water with such violence against the rocks on the shore, that the waves, rebounding back again a good way within the sea, make the whole sea tempestuous. (*War* 1.408–9)

Much of Herod's magnificent solution to this challenge has been recovered by archaeologists.

ABOVE The ancient port town of Dor lies on a dramatic promontory jutting into the Mediterranean, eight miles north of Caesarea Maritima. Excavations of the 30-acre site have revealed walls dating from the 11th century BCE.

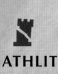

ATHLIT

DOR

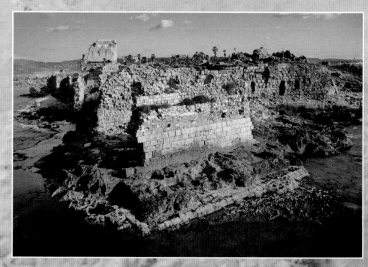

ABOVE The Crusader castle of Athlit lies on a rocky peninsula 10 miles south of Haifa, between Dor and Carmel. It was built in 1218, following the loss of Jerusalem to Saladin in 1187. It was called Castrum Perigrinorum or Château des Pèlerins (Castle of the Pilgrims) as it protects the pilgrim route from Acre to Jerusalem.

MEDITERRANEAN SEA

RAMAT HANADIV

Ramat Hanadiv features a perfectly preserved section of a Roman street. An additional aqueduct to Caesarea ordered by Emperor Hadrian runs down one side. There is also a roman theatre and bath-house and a restored 1st century farm.

CAESAREA MARITIMA

N

1 ROMAN THEATRE
2 HIPPODROME
3 HEROD'S PALACE
4 CRUSADER WALL
5 HARBOUR
6 LIGHTHOUSE
7 AQUEDUCT

An artist's impression of Roman Caesarea Maritima, based on archaeological finds.

The small fortified anchorage that became in the 1st century BCE the splendid city and harbour of Caesarea was originally called (by the Greeks) Strato's Tower. Strato was the Greek attempt to make something of the name Abdashtart. That name goes back to the 3rd century BCE when the Persians gave the territory to the Phoenicians. One of their number was Abdashtart who built the anchorage here. At the end of the 2nd century BCE, Caesarea and Dora were briefly controlled by Zoilus, a raider on ships in the eastern Mediterranean. His piracy so disrupted Egyptian trade that his career was brought to an end by Ptolemy Lathyrus, and Caesarea was handed over to the Hasmonean Alexander Jannaeus who established there the Jewish community.

In 63, Pompey took the city and it became non-Jewish once more. Most of the inhabitants were Syrian Greeks, but a strong Jewish population remained: there was considerable friction between the two communities, culminating in the massacre of virtually all the Jewish inhabitants at the start of the 1st Jewish

Revolt in 66. However, before that date, Augustus had given Strato's Tower to Herod the Great in recognition of his support, and in return Herod built the new harbour and city. In honour of Augustus, he called it Sebastos Limen (Harbour): Sebastos is the Greek for Augustus and thus it acquired its more usual name of Caesarea. Even that was qualified by words like "Palestina" or "Maritima" to distinguish it from the inland Caesarea of Philip (see page 43). The splendour of the new construction, both above and below ground, was caught well by Josephus (see box page 230).

With its strong Roman connections, it is not surprising that Caesarea became the headquarters of the Roman legions stationed in Judaea, or that it was the main base for the Roman procurators of Judaea – the first procurator mentioned by name in an inscription at Caesarea is Pontius Pilate. The Roman historian Tacitus simply called it (*History* 2.78) *Iudaeae caput*, the capital of Judaea. For that reason, Vespasian used Caesarea as a safe headquarters in his campaign to suppress the 1st Jewish Revolt and capture Jerusalem. It was, therefore, at Caesarea that the legions proclaimed Vespasian emperor at the end of "the year of the four emperors". To mark the occasion, he granted to Caesarea the status

BELOW Although nothing is visible of the original port of Caesarea on land, underwater surveys have revealed extensive breakwaters that confirm the contemporary historian Josephus' descriptions of its scale.

JOSEPHUS' DESCRIPTION OF CAESAREA

The King, by his liberality and cost, overcoming nature, built stations for ships. And although the nature of the place was altogether contrary to him, yet he so overcame all difficulty, that the sea could do his building no harm. It was so goodly and beautiful to behold that one would have thought there had been no difficulty in this admirable work. For having measured out a fit place for the fort, he laid a foundation 20 fathoms deep of stone, most of which were 50 feet long, 9 feet thick, and 10 feet broad, and some bigger. [Josephus' account in *Antiquities* says "not less than 18"] and all the bottom of the haven, where the water came, was laid with these stones. Which done, he raised a mole of 200 feet, of which 100 feet served to break the violence of the waves, the other hundred served for a foundation of the wall with which the haven was compassed about. On this were built many goodly towers, the greatest and fairest of which he called Drusion after the step-son of Caesar No less cunning was showed in the vaults and conduits underground than in those buildings that were above them: some of them were conveyed toward the port, and discharged themselves into the sea; but there was one that went diagonally across the rest to the end that by it the rainwater and the cleansings of the city might be conveyed into the sea, and that when the sea should flow in, it might wash and cleanse all the city. All this he did in honour of Caesar, after whose name he called it Caesarea. (*War* I.408–15; *Antiquities* 15.331–41)

of "colony" (*colonia*) though without the full "rights of Italy" which granted exemption from certain taxes.

Caesarea remained an important centre for Jews and for Jewish scholars after the two Jewish Revolts, and the remains of many synagogues have been found. It was important also for Christians, who had a Bishop of Caesarea by the 2nd century. According to Acts 10.1, an early convert to Christianity was a man in Caesarea called Cornelius who was a Roman centurion. Paul passed through Caesarea several times on his missionary journeys and was held in Caesarea until he made his appeal to Rome and the emperor (Acts 23–6). Later on, Christian scholarship flourished as much as Jewish: one teacher in Caesarea was Eusebius whose *Onomasticon* is quoted frequently in this book in order to help in the identification of uncertain sites. Another brilliant scholar who arrived in Caesarea in 231 was Origen (*c*.185–*c*.254).

The Muslims took Caesarea in 639–40 and held it until it was recaptured by the Crusaders in 1101. By this time the harbour had fallen out of use, and since the Crusaders were using Akko and Yafo (Jaffa, page 214–5), they only partially restored it. It was, nevertheless, a rich and prosperous city because of the fertility of the land around it. Salah udDin (Saladin) captured Caesarea in 1187, and although it was temporarily recaptured, it was finally and completely destroyed in 1265 by Sultan Baybars who was determined to prevent any reoccupation by Christians.

DOR (TANTURA, KHIRBET AL-BURJ)

The name of Dor appears in an Egyptian inscription of the 13th century BCE according to which it had fallen into the hands of the Sikil, one of the Sea Peoples (on these see page 240). It was an extensive town halfway between Caesarea Maritima and Athlit. It was one of the Canaanite city-states in alliance with Jabin (Joshua 11.2, 23; see page 50). Although it was all allocated to Asher in the Israelite settlement, it was not conquered by them (Judges 1.31–2). It became one of the districts of Solomon's kingdom (1 Kings 4.11), but in the Persian period (6th–4th centuries) it was a self-governing colony of Sidon further up the coast. Alexander Jannaeus acquired Dora (as it was then called) for the Hasmoneans by negotiation, but under Pompey it reverted to its independence, though a Jewish population continued there with its own synagogue (see the incident in Josephus, *Antiquities* 19.300). The Crusaders built a small fort on the southern edge of the mound. There have been extensive excavations of the site.

ATHLIT

Athlit is about half way between Dor and Carmel. There are traces of human habitation in the Late Bronze Age, and it was an important Phoenician settlement. It was a staging post on the Via Maris, and it became known to the Greeks as Bucolon Polis, the town of the herdsman. It is notable now for the remains of a crusader castle, Castellum Peregrinorum, Pilgrims' Castle.

———————— ✳ ————————

OPPOSITE TOP The restored Roman theatre at Caesarea just outside the Herodian walls seated 4000 people. According to Josephus, this is where the death of Herod Agrippa occurred (see Acts 12).

OPPOSITE MIDDLE RIGHT A city the size of Caesarea could not survive on collected rainwater alone. Water was brought in on this Herodian arched aqueduct from the springs on Mount Carmel, 10 miles north.

OPPOSITE BOTTOM RIGHT The Crusader city at Caesarea covered about 40 acres and was surrounded by a magnificent 13 feet thick wall, some one and a half miles long. It was also protected by towers and a deep moat.

OPPOSITE LEFT The remains of the private wing of Herod's palace at Caesarea. It was two-storey built around a fresh-water swimming pool. The public wing of the palace was south of this, close to the theatre.

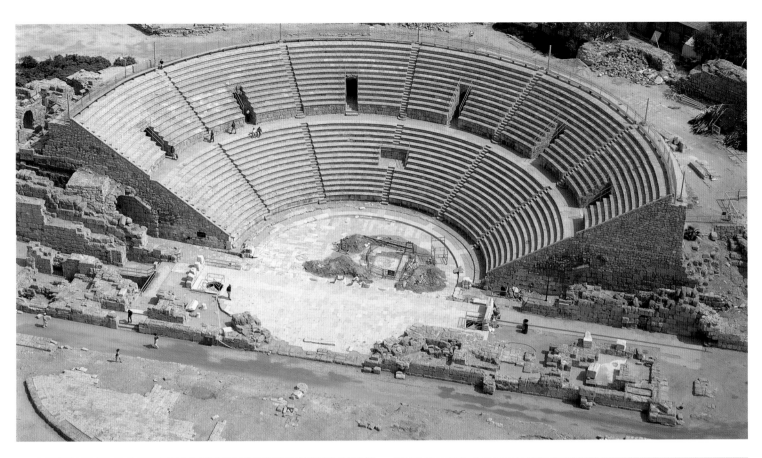

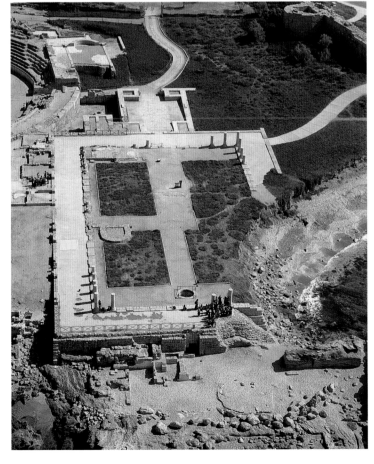

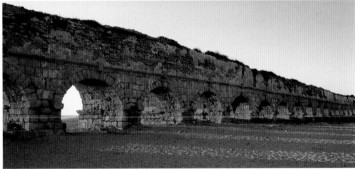

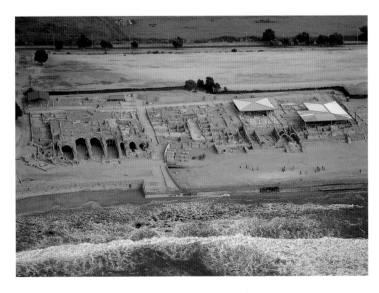

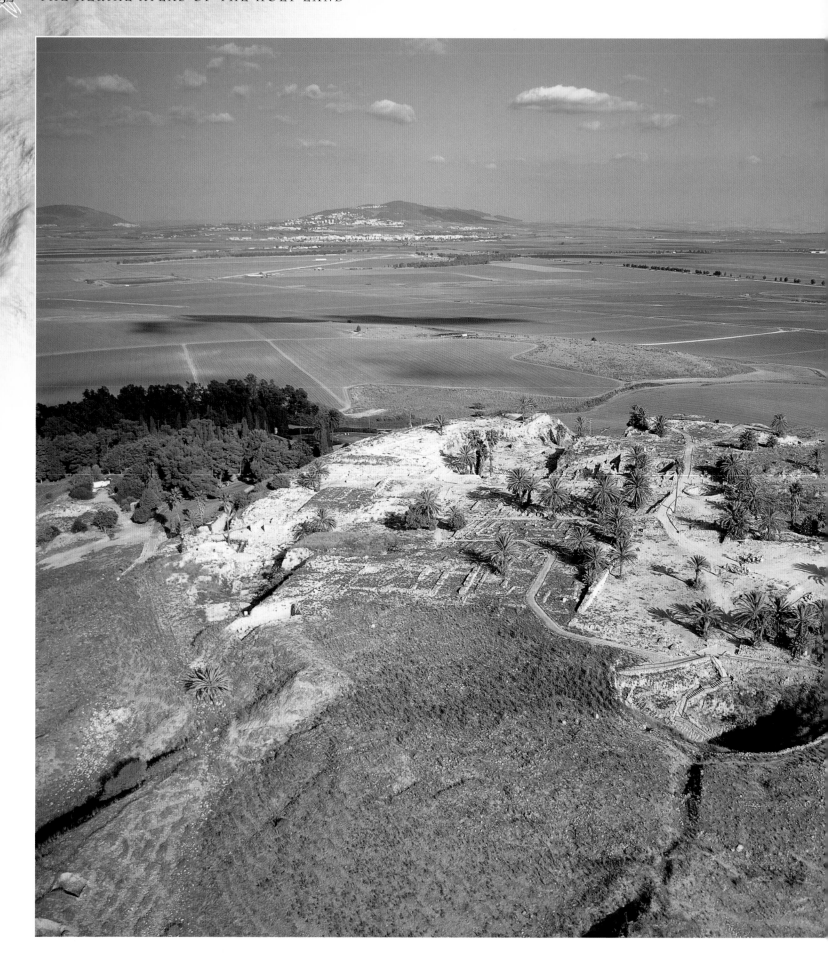

MEGIDDO

"We stand at Armageddon, and we battle for the Lord!" So said Theodore Roosevelt in 1912. He was about to fight (unsuccessfully) for the Republican nomination against William Howard Taft, whom he called "flub-dub", "fathead", and "puzzlewit". It hardly seems the kind of battle destined to take place at Armageddon according to Revelation 16.13–14, 16:

> And I saw three foul spirits like frogs coming from the mouth of the dragon, from the mouth of the beast, and from the mouth of the false prophet. These are the demonic spirits, performing signs, who go abroad to the kings of the whole world, to assemble them for battle on the great day of God the Almighty And they assembled them at the place that in Hebrew is called Harmagedon.

The name Armageddon, the final cosmic battle between the forces of good and evil after which the world will end, is taken to be the Greek form of the Hebrew which means "the mountain of Megiddo". Since Megiddo is not a mountain, and the name occurs nowhere else, it has been suggested that the original was Hirmegiddo, the city of Megiddo. Megiddo was the scene of many battles, one of which was decisive in the history of Judah (see page 235).

LEFT Megiddo from the west, looking towards Mount Tabor (far left). The pit in the foreground is the 75 feet deep water shaft linked by a tunnel to the natural spring at the foot of the Tel.

Megiddo is the present-day Tel alMutesellim. It stands on the plain of Esdraelon, about 20 miles south-east of Haifa. The name Esdraelon is the Greek version of the Hebrew Jezreel, the name therefore by which it is known in the Bible (eg 1 Samuel 29.1; 2 Samuel 2.9).

Megiddo, well supplied with water, lies in a fertile valley. But its supreme importance lies in its position: it occupies the key pass through the Carmel mountains where two roads have to go. One is the road from Jerusalem, through Shechem, on to Acco and north to Tyre and Sidon. The other is the vital coastal road from Egypt to the north and also west to Syria and Mesopotamia. Isaiah 9.1 calls this "the way of the sea", which became in Latin the famous Via Maris. The pass was thus strategically vital. Not surprisingly, many battles were fought in and around Megiddo.

A striking example occurs in one of the earliest mentions of Megiddo outside the Bible. It appears in the 15th-century inscription of the Egyptian ruler, Thutmoses III, on the temple wall at Karnak. It describes the defeat of Megiddo in 1468 together with the capture of many prisoners and other booty, including 924 chariots and more than 2000 horses. The Barkal stele erected on the Nile also records this campaign.

Egyptian control is reflected in the many mentions that Megiddo receives in Egyptian records, including the Tel elAmarna Letter 244 (for these letters, see page 162). When Shoshenq I (c.931–910) made a raid on Palestine, 1 Kings 14.25–26 records how "King Shishak of Egypt came up against Jerusalem; he took away the treasures of the house of the Lord and the treasures of the king's house; he took away everything"; but 1 Kings does not record any attack on Megiddo. However, on the walls of the Amun-Re temple at Karnak, Megiddo is listed among the conquests of Shoshenq, and part of a stele bearing his name has been found at Megiddo. From the 13th century, an Egyptian letter has survived describing the road from Megiddo to the coastal plain.

ABOVE A 9th-8th-century BCE storehouse at Megiddo. The ruins have also been identified as stables (if the blocks were used to tether horses), a marketplace or barracks.

MEDITERRANEAN SEA

LEFT The 210 feet long tunnel between the water shaft and the spring at the foot of the Tel at Megiddo. It was probably completed in the 9th century BCE, in the reign of Ahab.

BET SHEARIM

NAHAL QISHON

MEGIDDO

Megiddo was inhabited from a very early date. Archaeologists have found tools and bones from the Early Neolithic period before pots were made. Many more remains, including those of mud-brick-buildings, have been found from the Chalcolithic period to the Early Bronze Age (*c*.3200–2000). From the later period comes one temple bearing some resemblance to the one at Ein Gedi (see page 92), and at least three others. Nearby is a court with a stone pavement on which a hunting scene has been scratched.

According to the list in Joshua 12.21, Megiddo was part of the conquest of Joshua, and the territory was allocated to Manasseh (Joshua 17.11), but Joshua 17.12 makes it clear that the Canaanites were too strong to be driven out; Megiddo was taken probably in the time of David, and it was fortified by Solomon along with Gezer (see page 184) and Hazor (see page 46–59). It was at Megiddo that Deborah and Barak defeated Sisera, the general of the Canaanite Jabin of Hazor. This was the episode in which Jael took a tent peg and smashed it through the head of Sisera (Judges 4 and 5: for this episode see page 113).

During the Assyrian invasion in the 8th century (see page 16), Megiddo was largely destroyed. A new city was built which, to judge from the remains, was spacious and well designed, and it was made into the administrative centre of an Assyrian province.

In 609 a decisive battle was fought near Megiddo that contributed to the downfall of Assyria. In the final struggle of the Assyrians against the emergent power of the Babylonians (see page 16), an Egyptian army went to help the Assyrians. They had to go through the pass at Megiddo, where Josiah, the king of Judah, tried to stop them. He failed, but the Egyptians were fatally weakened.

The town of Megiddo failed also. In the 7th century it became a small fort, and by the 4th century BCE it was uninhabited. After the Romans had put down the Bar Kokhba Revolt (136 CE), the Romans made Legio the defensive centre of the area; Legio is now identified with the village of alLajjun.

There have been many other battles at Megiddo. In 1918, it was one of the last major battles of World War I when Allenby drove the Turks back to their key position of alLajjun (ie near Megiddo), and on 20 September the 2nd Lancers broke through their lines. The battle of Megiddo destroyed two Turkish armies.

———— ✳ ————

BELOW The ruins at Megiddo with the sunken granary in the top left corner. Archaeologists have discovered over 20 layers of occupation.

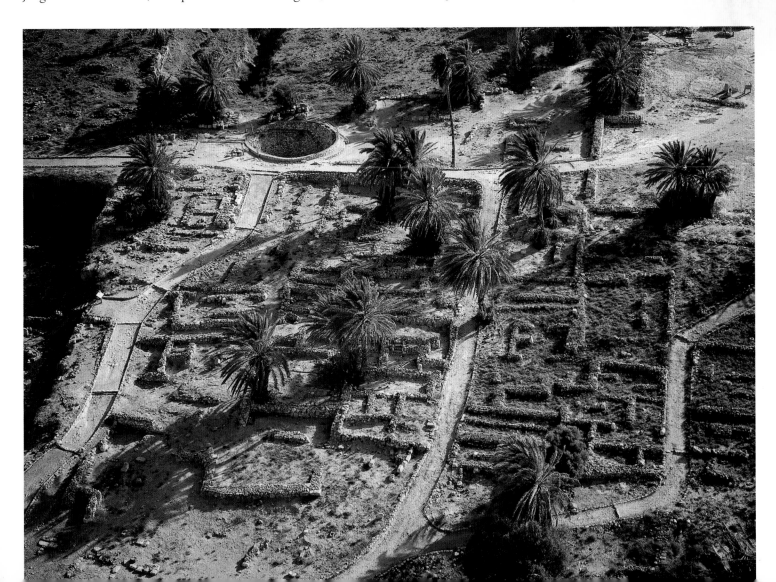

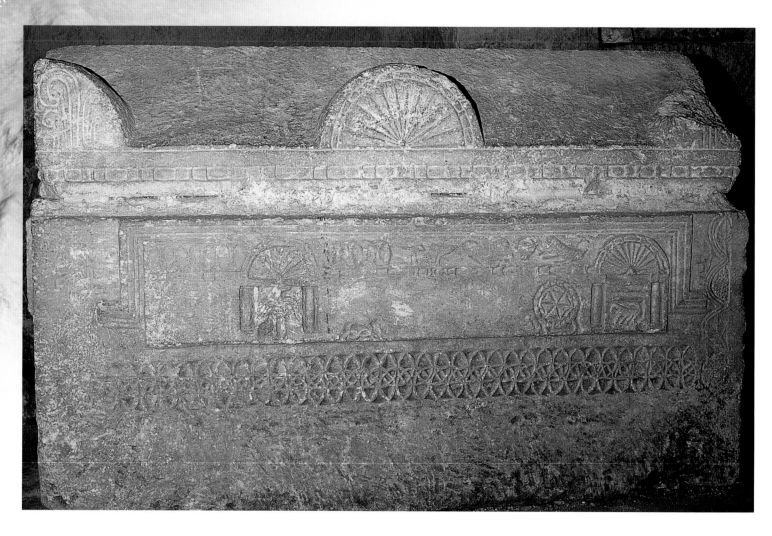

Although their German allies tried to create a new defensive line from the River Yarmuk (see page 33 for the battle on that river in 636) and the Sea of Galilee up to Lake Huleh, the whole position disintegrated, and Allenby continued his advance on Damascus.

The name of Megiddo underlies the word Armageddon, though that word is increasingly used to denote a more general, though equally cataclysmic, disaster. In two films called *Armageddon*, the first depicts a former CIA agent being brought back to life to take revenge on his killer, while the second sends a gang of oil-drillers out into space in order to put a nuclear bomb on an asteroid that threatens to destroy the earth. But the biblical sense persists: for those who take the words in Revelation 16.16 literally, there is one more battle yet to be fought in this place, the final battle that will end the world. It is by no means an idle speculation. There are those who support Israel in its conflicts with its Arab neighbours, and are by no means dismayed when war breaks out between them. It is to them an indication that the end is near.

BET SHEARIM

Bet Shearim lies about halfway between Megiddo and Carmel. According to Josephus (*Life* 118–19), Bet Shearim, or in Greek Besara, was an estate owned by the descendants of Herod the Great, though after the failure of the 1st Jewish Revolt, it passed to the Roman emperors. One of them, Marcus Aurelius (161–80) made a gift of it to Rabbi Judah haNasi (*c.*135–217), the compiler of the Mishnah (see page 61). He brought the Sanhedrin to Bet Shearim and it became a lively and important centre of Jewish learning.

It became also an important centre of Jewish burial. In Rabbinic belief, the final resurrection will be of those buried in the Holy Land, preferably near Jerusalem (see Mount of Olives, page 152), although that became impossible after Hadrian banned Jews from Jerusalem and its neighbourhood. According to J Kethubim 35b, God will construct tunnels for those buried elsewhere, so that "their bodies will roll through the excavations like bottles" until they reach the land of Israel. Judah haNasi was himself buried at Bet Shearim, as were his sons, even though he spent the last 18 years of his life in Sepphoris.

Bet Shearim thus became a major centre for Jewish burials, from the Diaspora (dispersion of Jews) as well as from the Holy Land. The necropolis and catacombs at Bet Shearim are extensive and often elaborate.

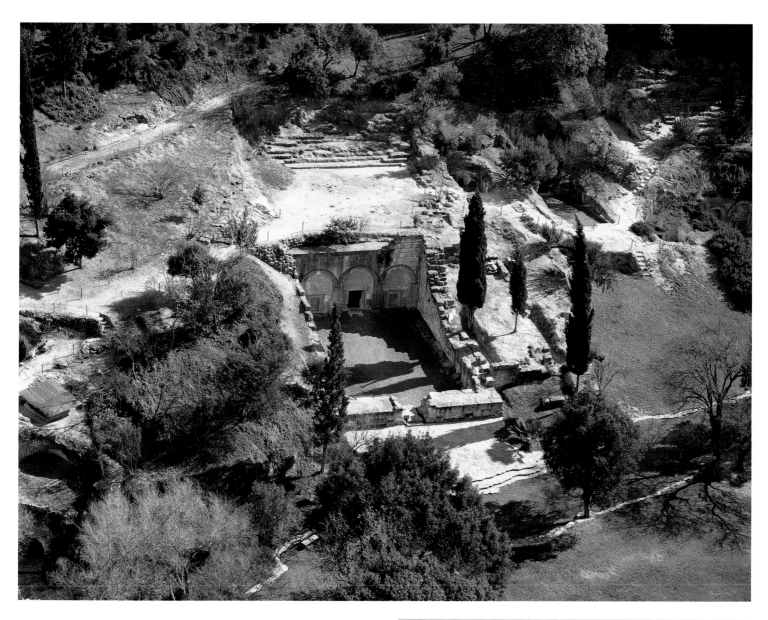

OPPOSITE A sarcophagus at Bet Shearim, one of several hundred found in the catacombs cut into the limestone slopes of the hill. The decoration on this one includes representations of the Ark of the Covenant.

ABOVE The hillside entrance to one of the 30 or so catacombs in the Jewish necropolis at Bet Shearim.

RIGHT The doorway to the burial caves. Many of the entrances have façades and doors which turn easily on their stone hinges. The three stone doors here are carved to imitate ordinary wooden ones.

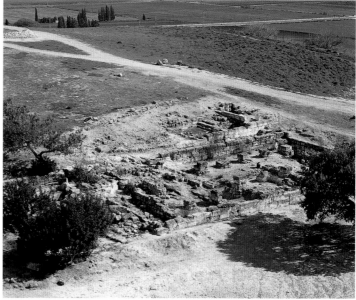

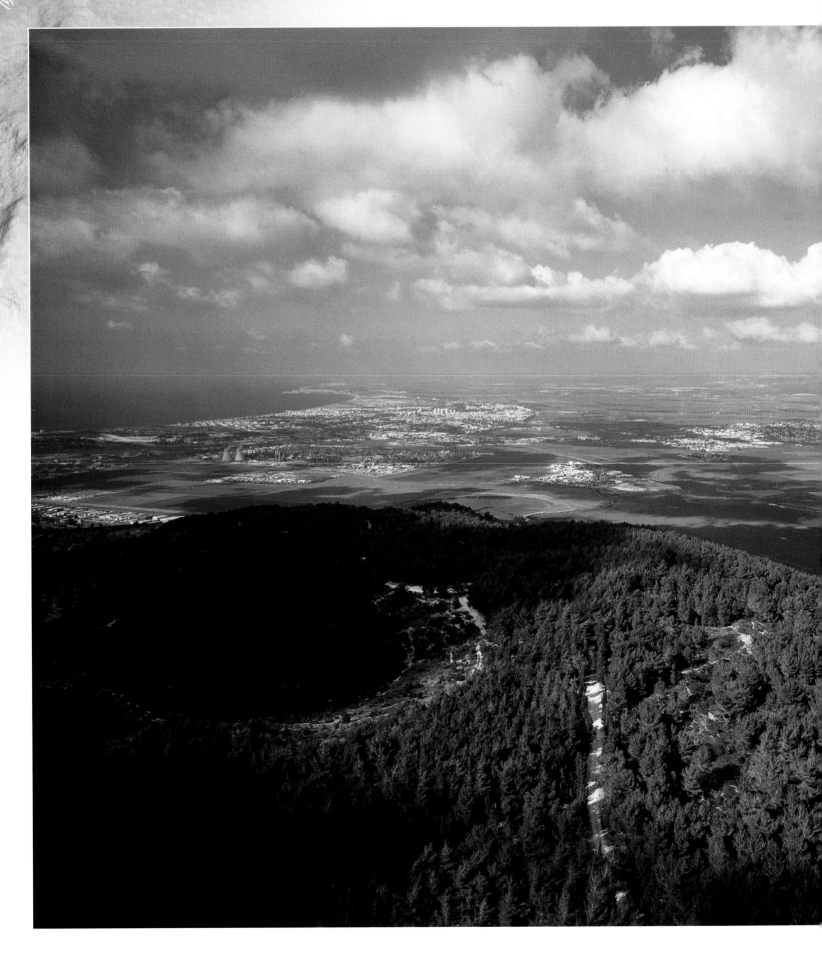

MOUNT CARMEL AND HAIFA

HAR CARMEL AND HEFA

Mount Carmel is the highest point (just over 500 feet high) in a ridge of fertile hills close to the Mediterranean coast. Hefa (the modern name is Haifa) is built on its slopes, and the promontory or headland of Mount Carmel (already known in 15th century BCE texts from Egypt as "the holy headland") creates the Bay of Haifa. Mount Carmel was so renowned for its fertility that for the Prophets the withering away of Mount Carmel and the land around illustrated God's anger:

> The Lord roars from Zion,
> and utters his voice from Jerusalem;
> the pastures of the shepherds wither,
> and the top of Carmel dries up. (Amos 1.2; cf. Isaiah 33.9; Nahum 1.4)

Mount Carmel is a key place in the history of Israelite and Jewish religion, because it was here that the prophet Elijah engaged in a contest of fire between Yahweh and Baal, the Lord God of the Canaanites: which of the two is truly God? "Elijah came near to all the people, and said, 'How long will you go limping with two different opinions? If the Lord is God, follow him; but if Baal, then follow him' " (1 Kings 18.21).

LEFT The wooded summit of Mount Carmel with Haifa in the background. The narrow, wedge-shaped range reaches almost to the coast.

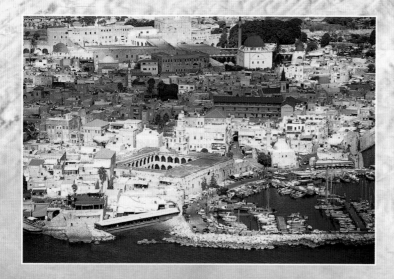

The area around Mount Carmel was well supplied with water and was extremely fertile, so it was inhabited long before the biblical period. Traces of these early settlements have been found nearby in the Caves of Carmel on the bank of Wadi alMughara. In three caves, Tabun, alWad, and Skhul, the remains show that humans have inhabited them for over 400,000 years. In a fourth cave, Gamal, no remains have been found, though it was surely in use with the others. Today it is used to exhibit what life was like for the people in the Mousterian period (100,000–40,000 BCE).

AKKO

ABOVE Akko/Acre, the harbour and old city. The courtyard building by the harbour is the Khan alUmdan or merchants' Inn of Columns. In the background is the 18th-century White Mosque.

N

NAHAL EVLAYIM

HAIFA

CAVE OF ELIJAH

BAHAI SHRINE AND GARDENS

MOUNT CARMEL

STELLA MARIS MONASTERY

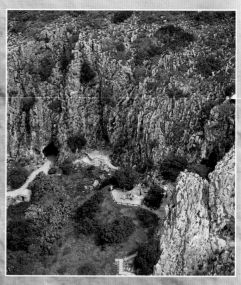

ABOVE Some of the many caves on Mount Carmel that were occupied in prehistoric times.

CARMEL CAVES

ATHLIT

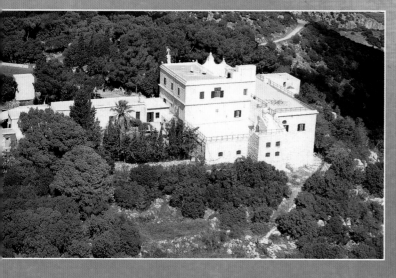

MEDITERRANEAN SEA

LEFT St Elias monastery, Mount Muhraka, Carmel, on the traditional site where Elijah defeated the prophets of Baal.

OPPOSITE The Carmel range stretches about 38 miles northwest – south-east from the Bay of Acre to the plain of Dothan. It rises to 1650 feet above sea level.

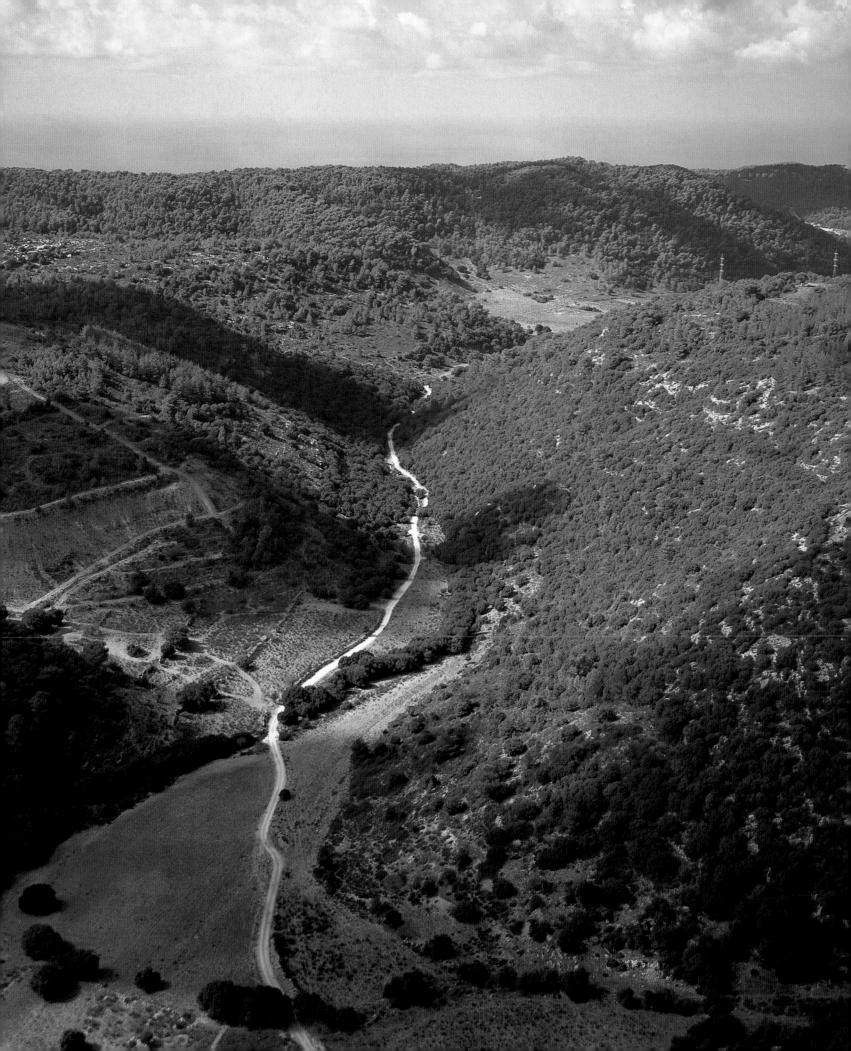

MOUNT CARMEL

The name Carmel is a contraction of Kerem-el, the vineyard or orchard of God. Carmel was renowned, not only for its fertility, but also for its beauty. In the Song of Solomon, the poet says of his loved one, "Your head crowns you like Carmel" (7.5).

Carmel was the scene of the dramatic battle between Elijah, the prophet of Yahweh, and the prophets of Baal. It sets in sharpest possible focus the long contest between the religion of Canaan and the religion of Yahweh. This was a battle that had to be won if the religion of Yahweh was to prevail.

The contest was by no means straightforward. Canaanite religion was well established and was attractive to the Israelites as they settled in the land. The Canaanites believed that there is a supreme God, El, who delegates whatever has to be done to his subordinates, deities who were known as Lords or Baals (the plural form is Baalim). The Baalim looked after particular places, or natural phenomena like storms and lightning, or activities on which life depends like growth and fertility. It was common for a Baal to have his responsibility attached to his name, like Baal-Hadad (Lord of the storm) or Baal-berith (Lord of the covenant).

The early Israelites found it prudent to seek the help of these local deities – after all, perhaps they really could help crops to grow and bring fine weather. This, however, was in total conflict with the belief that *this* group of clans, this kinship group, the children of Abraham, Isaac and Jacob, had only one God to look after them. This was Yahweh, the God who had indeed "looked after" his people during the Exodus. There could be no compromise. Moses said (Deuteronomy 30.19–20):

> I call heaven and earth to witness against you today that I have set before you life and death, blessings and curses. Choose life so that you and your descendants may live, loving the Lord your God [Yahweh your El], obeying him, and holding fast to him; for that means life to you and length of days, so that you may live in the land that the Lord swore to give to your ancestors, to Abraham, to Isaac, and to Jacob.

The spokesmen for "the choice for Yahweh" were the prophets, among whom Elijah of Mount Carmel was one of the earliest and most outspoken.

The prophets of Yahweh developed from the kind of prophets who were found in other parts of the Ancient Near East. They were people with a cult and ritual that enabled them to receive special gifts from God, to utter oracles and to see things that ordinary people could not see. Those who came to be called "prophets" were originally called "seers" (*roeh*, "one who sees", see 1 Samuel 9.9). Thus when Saul's father lost his asses (1 Samuel 9.3–10.14), he sent Saul to a group of prophets to tell him where they were, much as we might go to a lost property office.

It was from this background that the prophets of Israel began to emerge, but a massive change was made: instead of being a kind of walking lost property office, they became spokesman for the God of Israel, Yahweh. It no longer mattered what they looked like, it mattered what they said. They began to start their oracles with the words, "Thus says the Lord [Yahweh]". That is why Elijah came into conflict with Ahab, a king of Israel who much preferred the Baalim to Yahweh: "He took as his wife Jezebel …, and went and served Baal, and worshipped him" (1 Kings 16.31). Elijah went after him as the enemy of God (see especially 1 Kings 18.17).

That is the context in which Elijah challenged the prophets of Baal. The issue was completely fundamental, the issue of which God they would serve (1 Kings 18.20–40): "Elijah then came near to all the people, and said, "How long will you go limping with two different opinions? If the Lord is God [if Yahweh is El], follow him; but if Baal, then follow him" (18.21). Then Elijah challenged the prophets of Baal to get their "god" to consume their offering of a bull:

> They called on the name of Baal from morning until noon, crying, "O Baal, answer us!" But there was no voice, and no answer. They limped about the altar that they had made. At noon Elijah mocked them, saying, "Cry aloud! Surely he is a god; either he is meditating, or he has wandered away [to relieve himself], or he is on a journey, or perhaps he is asleep and must be awakened." Then they cried aloud and, as was their custom, they cut themselves with swords and lances until the blood gushed out over them. As midday passed, they raved on until the time of the offering of the oblation, but there was no voice, no answer, and no response. (18.26–9)

Then Elijah built an altar and called on Yahweh who sent down fire to consume the burnt offering and everything with it, the wood, the stones, and the dust. The basic step had been taken that led to the Jewish people and the Jewish faith.

HAIFA (HEFA)

Haifa was a harbour from ancient times, but the name of Haifa (or Hefa) did not emerge until the 3rd century CE. It is, perhaps, a contraction of Hof Yafe, "beautiful coast".

The connection with Elijah can still be seen in the Cave of alKhadir, also known as the Cave of Elijah. It was originally a place where Baal-Adonis was worshipped, but it was taken over as the cave in which Elijah took refuge when Ahab was pursuing him. It is a site deeply revered by Muslims who identify Elijah with alKhadir.

ABOVE Bahai shrine and gardens, Haifa, the international headquarters of the Bahai faith. The domed shrine of its founder, the Bab, Baha' Allah (1817–92), is surrounded by nine concentric terraced gardens that lead towards the summit of Mount Carmel.

alKhadir appears in Quran 18.64: "They [Moses and his attendant] found one of our servants on whom we had bestowed mercy from ourselves, and one whom we had taught knowledge from our own presence."

The personal name of alKhadir is not given. alKhadir means "the Green One", and that was taken to mean "one who brings the green, fresh renewal of the knowledge of God". He is widely known and revered in the Muslim world as the one who brings a profound knowledge of God into the human soul. This is especially important for Sufis, those who seek to enter into a union of soul and spirit with God. One of them, Ibrahim ibn Adham (d.783 CE) wrote: "I lived in the wilderness for four years, and God supplied me with food without my having to labour for it. alKhadir was my companion throughout, and he taught me the Great Name of God."

Others who learned to love God on Mount Carmel were Christians in the 13th century, who became the first Carmelites. Warfare in the area compelled them to leave, but they took from the mountain a focus on silence and solitude that remains fundamental: "Silence and solitude are essential conditions for listening … Silence and solitude become interior conditions which make all the activity of our lives open to God's spirit." (Welch page 144).

BIBLIOGRAPHY

BOOKS QUOTED FROM, OR REFERRED TO, IN THE TEXT

Abu Sitta, S, *The Return Journey: A Guide to the Depopulated and Present Palestinian Towns and Villages and Holy Sites*, London, Palestinian Land Society, 2007.

Adams, R M, "The Origins of Cities", in Lamberg-Karlovsky, pp. 137–43.

Albertz, R, *A History of Israelite Religion in the Old Testament Period*, 2 vols., London, SCM Press, 1994.

Alexander, J, & Binski, P, eds., *The Age of Chivalry*, London, Royal Academy of Arts/Weidenfeld & Nicholson, 1987.

alWaqidi, *Kitab alMaghazi*, ed. M Jones, Oxford, Oxford University Press, 1966.

Antony: see Vivian.

Arav, R, & Freund, R, *Bethsaida*, Kirksville, Truman State University Press, 2004.

Athanasius, *Life of St Anthony*: see Vivian.

Basil: see Wagner.

Bernbaum, E, *Sacred Mountains of the World*, Berkeley, University of California Press, 1997.

Bethlyon, J W, "Egypt and Phoenicia in the Persian Period: Partners in Trade and Rebellion", in Knoppers & Hirsch, pp. 455–77.

Bowker, J W, *God: A Brief History*, London, Dorling Kindersley, 2002.

Bowker, J W, *Beliefs that Changed the World*, London, Quercus, 2007.

Bowker, J W, *Jesus and the Pharisees*, Cambridge, Cambridge University Press, 1973.

Bowker, J W, *The Complete Bible Handbook: An Illustrated Companion*, London, Dorling Kindersley, 1998.

Bowker, J W, *The Religious Imagination and the Sense of God*, Oxford, Oxford University Press, 1978; reprint Oxford Scholarly Classics, 2000.

Brenner, L, *The Iron Wall: Zionist Revisionism from Jabotinsky to Shamir*, London, Zed Books, 1984.

Cassian: see Ramsey.

Charlesworth, J H, ed., *Jesus and Archaeology*, Grand Rapids, Eerdmans, 2006.

Chiat, M J, *Handbook of Synagogue Architecture*, Chico, Scholars Press, 1982.

Colenso, J W, *The Pentateuch and Book of Joshua Critically Examined*, London, Longman & Green, 1862.

Crane, S., *The Red Badge of Courage*, ed. J.Katz, Gainesville, Scholars' Facsimiles, 1894–1967.

Di Segni, L, "Epigraphic Documentation on Building in the Provinces of Palaestina and Arabia", in Humphrey, pages 149–78.

Duncan, A, & Opatowski, M, *War in the Holy Land from Megiddo to the West Bank*, Stroud, Sutton Publishing, 1998.

Edson, E, & Savage-Smith, E, *Medieval Views of the Cosmos: Picturing the Universe in the Christian and Islamic Middle Ages*, Oxford, Bodleian Library, 2004.

Egger, R, *Josephus Flavius und die Samaritaner*, Göttingen, Vandenhoeck & Ruprecht, 1986.

Fischer, T, *Selukiden und Makkabaer*, Bochum: N. Brockmeyer, 1980.

Gabrielli, F, *Arab Historians of the Crusades*, London, Routledge, 1969.

Gibb, H A R, *Ibn Battuta's Travels in Asia and Africa, 1325–54*, London, Routledge, 1929.

Gillingham, J, "Richard I", in H C G Matthew & B Harrison, eds., *Oxford Dictionary of National Biography*, 46, pages 714–24.

Godden, R, *A Time to Dance, No Time to Weep*, London, Corgi, 1991.

Guidi, I., ed., *Tarikh arRasul wa alMuluk*, in M J Goeje, ed., *Annales quos Scripsit Abu Djafar Mohammed ibn Djarir at Tabari*, Lugd. Batavorum, Brill, 1879–1901.

Historia Monachorum: see Russell.

Hoerth, A J, Mattingly, G L, & Yamauchi, E M, *Peoples of the Old Testament World*, Grand Rapids, Baker Books, 1996.

Humphrey, J H, ed., *The Roman and Byzantine Near East: Recent Archaeological Research*, Supplementary Series 14, *Journal of Roman Archaeology*, 1999.

Ibn Batuta, *Tuhfat anNuzzar fi Gharaib alAmsar waAjaib alAfsar*, Cairo, alMatbaah alAmirya, 1934.

Ibn Hisham Sirat anNabuyya, ed. Mustafa asSaqqa, Ibrahim alAbyari & 'Abd alHafiz, Cairo, 1955.

Itinera Hierosolymitana, in *Corpus Scriptorum Ecclesiasticorum Latinorum*, Cetedoc Library of Christian Latin Texts, Turnhout, Belgium, 1991–2000.

Jewish Publication Society, *Tanakh: a New Translation of the Holy Scriptures According to the Traditional Hebrew Text*, Philadelphia, 1985.

Kaegi, W E, *Byzantium and the Early Islamic Conquests*, Cambridge, Cambridge University Press, 1992.

Kasher, A, Rappaport, U, & Fuks, G, *Greece and Rome in Eretz Israel: Collected Essays*, Haifa & Tel Aviv, The Israel Exploration Society, 1990.

King, A, *Jerusalem Revealed*, Ely, Boxer, 1997.

Kloppenberg, J, "The Theodotos Inscription", in Charlesworth, pages 236–82.

Knoppers, G N & Hirsch, A, eds., *Egypt, Israel and the Ancient Mediterranean World*, Leiden, Brill, 2004.

Lamberg-Karlovsky, C C, *Old World Archaeology: Foundations of Civilisation*, San Francisco, Freeman, 1979.

Levine, L I, *Ancient Synagogues Revealed*, Jerusalem, The Israel Exploration Society, 1981.

Lyons, M C, & Jackson, D E P, *Saladin: The Politics of the Holy War*, Cambridge, Cambridge University Press, 1997.

Maalouf, A, *The Crusades Through Arab Eyes*, London, Al Saqi, 1984.

Neusner, J, *Major Trends in Formative Judaism*, Chico, Scholars Press, 1985.

Nun, M, *The Sea of Galilee and its Fishermen in the New Testament*, Kibbutz Ein Gev, 1989.

Palmer, G E H, *et al.*, *The Philokalia*, I, London, Faber, 1979.

Petersen, A, *Dictionary of Islamic Architecture*, London, Routledge, 1996.

Petersen, A, *The Towns of Palestine under Muslim Rule, AD 600–1600*, Oxford, Archaeopress (BAR International Series 1381), 2005.

Pharr, C, *The Theodosian Code and Novels and the Sirmondian Constitutions*, Princeton, Princeton University Press, 1952.

Philokalia: see Palmer.

Ramsey, B, *John Cassian: The Institutes*, New York, Newman, 2000.

Richardson, P, "*Khirbet Qana (and Other Villages) as a Context for Jesus*", in Charlesworth, pages 120–44.

Riley-Smith, J, *The First Crusade and the Idea of Crusading*, London, Athlone, 1986.

Riley-Smith, J, *The First Crusaders, 1095–1131*, Cambridge, Cambridge University Press, 1997.

Russell, N, *The Lives of the Desert Fathers: The* Historia Monachorum In Aegypto, London, Mowbray, 1980.

Sacher, H M, *A History of Israel*, Oxford, Blackwell, 1977.

Sanctity Denied: A Report on the Destruction and Abuse of Muslim and Christian Holy Places in Israel, Nazareth, Arab Association of Human Rights, 2004.

Schick, B R, *The Christian Communities of Palestine from Byzantine to Islamic Rule: A Historical and Archaeological Study*, Princeton, Darwin, 1995.

Schmidt, F, "Jewish Representations of the Inhabited Earth during the Hellenistic and Roman Periods", in Kasher et al., pages 119–34.

Schoville, K N, "Canaanites and Amorites", in Hoerth, pages 157–82.

Schwartz, B, *et al.*, "The Recovery of Masada: A Study in Collective Memory", *Sociological Quarterly*, XXVII, 1986, pages 147–64.

Shehadeh, R, *Palestinian Walks; Notes on a Vanishing Landscape*, London, Profile, 2007.

Songs of Zion: Supplemental Worship Resources, Nashville, Abingdon Press, 1981.

Stemberger, G, *Jews and Christians in the Holy Land: Palestine in the Fourth Century*, Edinburgh, T & T Clark, 2000.

Stevenson, J, *A New Eusebius: Documents Illustrative of the History of the Church to AD 337*, London, SPCK, 1957.

Stone, M E, *Scriptures, Sects and Visions*, Oxford, Blackwell, 1982.

Vivian, T, & Athanassakis, N, *Life St Antony by Athanasius of Alexandria*, Kalamazoo, Cistercian Press, 2003.

Wagner, M M, *Ascetical Works of St Basil*, Washington, Catholic University of America Press, 1970.

Ward, B, *The Sayings of the Desert Fathers: The Alphabetical Collection*, London, Mowbray, 1981.

Welch, J, *The Carmelite Way*, Leominster, Gracewing, 1996.

Whitelam, K W, *The Invention of Ancient Israel: The Silencing of Palestinian History*, London, Routledge, 1996.

Wilkinson, J, *Jerusalem Pilgrims before the Crusades*, Warminster, Aris & Phillips, 2002.

Yadin, Y, *Masada: Herod's Fortress and the Zealots' Last Stand*, London, Weidenfeld & Nicholson, 1966.

Zerubavel, Y, "The Death of Memory and the Memory of Death: Masada and the Holocaust as Historical Metaphors", *Representations*, XLV, 1994, pages 72–100.

Zias, J E, "The Cemeteries of Qumran and Celibacy", in Charlesworth, pages 444–71.

GENERAL READING

The works listed in the bibliography are those mentioned in the book. Some are technical and focused on particular points, and others are texts. Several are of a more general nature, but they are not repeated here.

The purpose of this book is to show important historical sites from the air, and to give an indication of the history that lies behind them. It is not a guide to the Holy Land, but there are many extremely good travel guides which supplement this book, for example:

AA Baedeker, *Israel*, 1995

Jerusalem and the Holy Land, Eyewitness Travel Guide, Dorling Kindersley, 2007.

Fodor's Israel, Fodor Travel Publications, 2006.

Frommer's Israel, John Wiley and Sons, 2006.

Among the archaeological guides, indispensable are:

Bourbon, F, *The Holy Land: Guide to the Archaeological Sites and Historical Monuments*, New York, Barnes & Noble, 2004.

Murphy-O' Connor, J, *The Holy Land: An Oxford Archaeological Guide from Earliest Times to 1700*, Oxford, Oxford University Press, 1998.

For background, the following are useful:

Achtemeier, P J, *The HarperCollins Bible Dictionary*, San Francisco, HarperCollins, 1996.

Bowker, J, *The Cambridge Illustrated History of World Religions*, Cambridge, Cambridge University Press, 2002.

Cleave, R, *The Holy Land, A Unique Perspective,* Cyprus, Rohr Productions, 1993.

Cross, F L and Livingstone, E A, eds., *The Oxford Dictionary of the Christian Church*, Oxford, Oxford University Press, 1997.

Glassé, C, *The Consise Encyclopaedia of Islam*, London, Stacey International, 1989.

Hirschfeld, Y, *Judean Desert Monasteries in the Byzantine Period*, USA, Yale University Press, 1992

Joyce, M, & Chiat, S, *Handbook of Synagogue Architecture,* USA, Brown University Press, 1982.

Negev, A, & Gibson, S, *Archaeological Encyclopaedia of the Holy Land*, New York, Continuum, 2001.

Robinson, F, *The Cambridge Illustrated History of the Islamic World*, Cambridge, Cambridge University Press, 1998.

Shanks, H, ed., *Ancient Israel: A Short History to the Roman Destruction of the Temple*, London, SPCK, 1989.

Walker, P, *In the Steps of Jesus; An Illustrated Guide to the Places of the Holy Land*, Oxford, Lion Hudson, 2006.

Wigoder, G, *The Encylopedia of Judaism*, New York, Macmillan, 1989.

The novel, *Exile*, by Richard Patterson, makes an unusual and serious attempt to reflect the emotions and fears of both Israelis and Palestinians, as well as emphasising the fact that there are conflicting and competing voices in both communities.

INDEX

Images and illustrations are in *italic*

A

Abbasids 62, 126

Abdah 196

Abimelech 193, 196

Abraham 8, 13–14, 21, 29, 103, 126, 128, 134, 187, 188, 190, 193, 194, 195–6

Abraham Abeinu 190

Abraham's journeys 194

Absalom 136

Abu Sitta, S. 33

Academies 216

Achemenians 17

Achish 72

Actium, battle of 22

Acts of the Apostles 62, 119, 142, 168, 210, 216, 230

Adams, R.M. 10

Adham ibn, Ibrahim: see Ibrahim ibn Adham 243

Aelia Capitolina 25, 27, 138

Agony: see Gethsemane

Agrippa I 23–4, 62, 63, 176, 178; II 61, 62, 120

Ahab 79, 242

Ahad ha'Am, 17

Ahaziah, King 184

Ahl alKitab 10, 30, 148

Ain Feshkha 98

Ajnadayn, battle of 31

Akko 230, *240*

alAqsa 32 146, 148, *149*

 alAraj 56

 alAthir, ibn 224

 alAzariyeh 154

 alKhadir 243

 alKhalil 187–190

 alMahmudiyya 216

 alMalik, Abd, 210

 alMes'adiye: see Khirbet alMes'adiye

alMuqaddasi 33, 72

alOmari 204

alQuds 146,148

alOzir 154, 158

alWaqidi 31

Albertz, Rainer 126, 128

Alexander the Great 8, 17, 18, 125, 151, 202, 215

Alexander Jannaeus 19–21 *passim*, 56, 58, 79, 104, 202, 229, 230

Alexandria 18

Alexandrium 178

Alexius, Emperor 220

Allenby, General 235–6

alphabet 181

Amaziah, King 182

Amorites 8, 14, 42, 50, 181

Amos 124, 126, 134, 184, 196, 239

Amud caves 64, 112; Nahal 64

Amun 18

Anastasius the Sinaite 33

anchorites 86–88

Andrew, disciple 56, 66

Anthedon (Agrippium) 178

Antigonus I 18, 42, 64, 175, 176; II 22

Antioch 19, 22

Antiochus III 18, 42, 202; IV 18–19

Antipater 21, 22, 178, 216

Antipatris 178' 216

Antonia 132, 178

Antony, Mark 22, 178, 216

Aphek (Antipatris) 178, 216, *217*; battle of 72, 129

Apollonia *214*, *224*, 225

Apple of Sodom *93*

Aqeda 140

Aqiba 25

Aqsa: see alAqsa

Arabia 29, 30

Arabs 8–9, 29, 31–3, 58, 72, 126, 164, 187, 190, 196

Arav, R. 56

Arbel caves **64**

Arbel Pass 115

Archelaus, tetrarch 22

Aristobolus I 19

Ark of the Covenant: see Covenant

Armageddon 233, 236

Arnold, Matthew 204

arRamlah: see Ramla

arRuqqad, river 58

Arslan, Alp 220

Arugoth, Nahal 93

Ascension 158

Ascent 146

Ashdod 20, 182, 204, 210, *211*, 215

AshdodYam 210

Asher *15*, 230

Ashkelon 20, 33, 182, 202, 204, 206–10, *206–9*, *211*

ashShafi 204

Askar 128

Assyria/Assyrians 8, 16, *16*, 47, 49, 50, 55, 56, 124, 125, 136, 204, 209, 210, 215, 235

Athanasius, bishop, *Life of Antony* 86

Athanasius, Emperor 73

Athlit *228*, 230

Athos, Mount: see Mount Athos

Augustus, Emperor 21, 23, 43, 78, 210, 216, 229

Avdat 193, 196

Azekah 182

Azotus: see Ashdod

B

Baal/Baalim 13, 14, 42, 112, 125, 126, 184, 239, 242

Baal-zebub: see Beelzebub

Babylon/Babylonians 8, *16*, 16–17, 111, 125, 136, 140, 182, 202, 209

Bacchides 64

Bahais 243

Balaam, prophet 25

Balderic of Bourgueil 220

Banias *see* Caesarea Philippi

Banu Qurayza 30

baptism 69, 73, 79,

Bar Kokhba: see Simeon bar Kokhba

Barak 112–13, 235

Baram 48, 50, *51*, 166

Basil 86

Batuta, ibn: see ibn Batuta

Baybars, Sultan 33, 230

Beatitudes, Mount of 64

Beelzebub 25, 184

Beer Sheba 13, 109, 192–7, *192*, *194–7*

Begin, Menachim 9

Beisan 72

Belvoir *222*

Bene Israel 13–15, 44, 49, 126, 128, 134, 204

Bene Jacob 44

Benedict, St 88

Benjamin 14

Berenice, Mount 62, *62*

Bernbaum, Edwin 41

Bernike 170

Bet haMidrash 170, 172

bet keneset: see *keneset*

Bet Shearim (Besana) 236–7, *236–7*

Beth Shan 68–73, *68–9*; battle of 19

Beth Yerah (Khirbet alKerak) 58

Beth-Zecheriah, battle of 19,

Bethabara 69, 73

Bethany 132, 154, *158*, *159*

Bethel 13, 44, 63, 79, 109, 196

Bethlehem 28, 88, 160–5, *160–1*; Church of the Nativity 28, *163*, 164

Bethphage 154

Bethsaida 55–6, *57*

Bethylon, J.W. 8

Bialek, Hayyim 213

Bible, Jewish 10–13, 128, 133

Binding of Isaac: see Aqedah

Biriah *172*

Bithynia 27

Blake, William 144

Bordeaux pilgrim 28, 113

Bowker, John 11, 12, 21, 28, 30, 33, 224

Brenner, Lenni 9

British mandate 204

burials 98, 152, 153, 162, 164, 188, *191*, *203*, 236, *237*

Byzantines/period 28, 29, 31, 33, 55, 58, 72, 75, 114, 136, 202, 204, 220, 222, 224

C

Caesar, Julius 21–2, 216

Caesarea Maritima 24, 33, 43, 178, 210, 226–31, *226–7*, *229*, *231*

Caesarea Philippi 42–4, 113, 178, 238–42, *240–1*

Caleb 190

Caligula, Emperor 23

Callirrhoe 92, 93, 176

Calvary 132

Cambyses II 17

Cana (Kefr Kenna) 26, 117, *118*, 120, *121*

Canaan/Canaanites 8–10, 13, 14, 42, 49, 70, 77, 112, 134, 162, 181, *184*, 185, 195–6, 201, 239, 208, 235, 242

Canatha 58

Capernaum 56, *65*, 66, 113; synagogue *65*, *171*

Carchemish, battle of 16, 125

Carmel, Mount 14–15, 20, 42, 109, 111, 113, 230, 238–42, *238–41*; caves 240, *240*

Carmelites 243

Cassian, John, *The Institutes* 88

Cassius 22, 63

Castles

 Aphek 216

 Appollonia *224*

 Ashdod Yam 210

 Athlit *228*

 Belvoir *222*

 Caesarea Maritima 230

 Kursi 88

 Montfort 218, *220*

 Nimrud 41

 Ramla 33

 Samaria/Sebaste *222*

 Sepphoris 119

 Yehiam *218*

Cave of Horrors/Letters 94

caves: see Amud, Arbel, Carmel, Mount; Galilean; Gethsemane; Machpelah

Chaldeans 125

Chiat, M.J. 170

Chorazin (Khirbet Karaze) 56, 66; synagogue 67

Christianity/Christians 8–10, 25–30, 84, 86, 131, 133, 142–5, 195, 230: see also Jesus

Chronicles 182, 188, 215

Chrysopolis, battle of 28

Churches 28

 All Nations *152*, 153, *158*, 158

 Annunciation *11 6*, 119

 Ascension 153, *154*, *156*

 Assumption *157*

 Capernaum 66, 73

 Dominus Flevit 153, *154*

 Dormition 134, *144*

 Eudoxia 202, *204*

 Gaza 204

 Holy Sepulchre 28, 32, *143*

 Jabaliyyah 204

 John the Baptist 73

 Kefr Kenna 118

 Loaves and Fishes 64

 Mary Magdalene 153, *154*

 Mount Berenice 62

 Mount of Olives 28

 Nativity 28, *162*, *163*, 164

 North 196

 Paternoster 153, *156*

 Resurrection 64

 St Anne 144, *225*

 St John the Baptist *222*

 St Lazarus 158

 St Mary the Green *210*

 St Peter 212

 St Theodore *197*

 Sermon on the Mount 54, 64

 South 196

 Transfiguration *112*, *113*, *114*

circumcision 19, 25

Citadel 32, 178

city 10, 56, 190

Claudius, Emperor 23, 24, 27

Cleopatra 22, 106, 202, 216

Clermont 220

Clermont-Ganneau, 98

coastal plain 8,15, 16, 18, 19, 31, 35, 124, 198–243,

coenobite 86

Colenso, J.W. 11

conquest 8, 14, 15, 31, 33, 58, 72, 114, 120, 162, 181, 190, 209, 215

Conrad III 224

Constantine, Emperor 28, 142, 164

Constantinople 28, 224

Cornelius, centurion 230

Covenant/s 9, 14, 17, 18, 20, 21, 25, 27, 111, 126, 128, 136, 192; Ark of 64, 65, 129, 134, 170, 182, 204, 210, 237

Crane, Stephen 14

crucifixion 26,142

Crusades 33, 72, 83, 114, 144, 158, 190, 210, 214, 218–25, 230; castles and forts: see Castles; churches: see Churches

Cyril 114

Cyrus II 17

D

Damascus 21, 31, 33, 41, 58

Damascus Gate 32, 141

Dan 15, 50

Daniel 44

Dar asSulh 33

Dathin, battle of 31

David, King 13, 15, 16, 20, 72, 94, 111, 126, 128, 134, 136, 161–4, 184, 187, 190, 196, 204, 235

David's lament 72

Dead Sea 20, 23, 39, 90–5, 90–2, 95, 104, 105; Scrolls 44, 97–101, 100, Community Rule 100, 101, Damascus Document 99, 100, War Scroll 101

Deborah 15, 49, 112–13, 134, 235

Decapolis 58, 72

Deir el Balah 203

Deir Halja , Our Lady of Kalamon monastery 75

Delilah 201, 204

demons 86, 184

Deuteronomy 8, 14, 15, 20, 25, 26, 42, 79, 126, 156, 181, 196, 242

Di Segni, L. 28

Diadochoi 18

Diaspora 22, 167, 168, 170, 172, 236

adDib, Muhammad: see Muhammad adDib

Diocaesarea 120

Diocletian, Emperor 28

Dion 58

displacement 8–10, 142

Domain of Peace 33

Dome of Ascent 12,

Dome of the Rock 32, 130, 133, 146, 148, 149

Doq 80

Dor/Dora 227–30, 228

Dorcas 216

Douka 80

Dumuzi 185

dunamis 25

Duncan, A. 8

E

earthquakes 33, 58, 66, 69, 70, 72, 98, 158, 216

Ebal, Mount 126, 128

eben shetiyyah 140

Ecclesiasticus 93, 94

Edessa 224

Edomites 22, 190, 196

Edson, E. 133

Egeria 28, 64, 66, 119

Egger, R.126

Egypt/Egyptians 8, 13–22 passim, 42, 78, 84, 86, 88, 99–101, 111, 120, 125, 184, 196, 202, 204, 209, 210, 215, 216, 229, 234, 235; Execration Texts 208

Ehrenpreis, Rabbi 213

Ein Boqeq 91, 97

Ein Gedi 91, 92, 93–4, 95, 97, 104, 237

Ein as-Sultan 75

Eironopolis Neronias 120

Ekron 44, 182, 184, 202, 204, 209

El 13, 14, 242; Elohe–Israel 13, 128; Elohim/ Elyon/Olam/Roi/Roeh 13

Elasa, battle of 19

Eleazer haKappar 172

Eli, sons of 128

Elijah 184, 239, 242

Ephraim 15, 109

Epiphanius 25, 66, 114, 156

Esdraelon 111

Esdras 125

Essenes 100, 170

Eudoxia, Empress 202

Eusebius 27, 28, 73, 114, 117, 120, 216, 230

Eustochium 28, 164

Evagrius Pontikos 84, 86, 88

Execration Texts 208

Exile 17, 18, 125, 136, 138, 168, 190

Exodus 11, 14, 17; Book of 14, 181

Ezekiel 93, 136, 138, 140, 168, 185

Ezra 17, 138, 215

F

Fadak 30

family, Jewish 167

Fertile Crescent 195

Filistin 33

Finkelstein, Louis 172

Fischer, T.19

Fisherman's House 57

fishing 52–4, 55, 56, 63, 64, 205

Florus, procurator 178

Four holy cities 190

Franks 33, 224

Freund, R. 56

Friend of God 8,188, 195

Fulcher of Chartres 220

G

Gaba 176

Gabinius 21, 120, 178, 202

Gabrieli, F. 224

Gad 15

Gadara (Umm Qeis) 20, 58, 210

Gaderene swine 58

Gaius 120

Galatians, letter to 142

Galilean caves 54, 63–64

Galilee 19, 21–6 passim, 29, 109, 113, 120; Sea of 39, 52–67, 52, 54, 64, 112, 114

Gamla 168, 169, 170

Garden Tomb 143

Garstang, J. 77

Gath 182, 183, 184, 204

Gaulinitis *24*

Gaza 20, 21, 33, 182, 200–5, *205*, 209

Gehenna *137*

Gehinnom *137*

Genesis 13, 91, 103, 128, 134, 151, 162, 188, 195–6

Genizah 99

Gentiles 27, 128–9, 138, 216

Geraza 58

Gerizim, Mount 19, 109, 114, 123, *125*, 126, *127*, 128; Temple 126, *127*, 128

Gethsemane, Cave 158; Garden 29, 132, 151, 153, 156, 158, *159*

geth shemanim 151

Gezer 50, 128, *182*, 184, 235; Calendar 184, *184*

Ghaznavids 220

Gibson, Miss 99

Gillingham, J. 224

Ginnosar, Plain of 64

Godden, Rumer 11

Golden Gate 141

Goliath 184, 204

Gomorrah 91

Gospels 26–7, 113, 142 *see also individual entries*

Great Sanhedrin: see Sanhedrin

Greece 17, 18, 24, 84, 86

Guibert of Nogent 220, 222

Guidi, I. 33

Gush Halav synagogue *48*

H

ha'Am Ahad: see Ahad ha'Am

Habiru 162

Hadith 146

Hadrian, Emperor 25, 27, 66, 126, 138, 236

Haggai, prophet 154

Haifa 239, 242–3, *243*

haKappar, Eleazer: see Eleazer haKappar

Hakhamin 21, 23, 120, 216

Hakim, caliph 164

Halakah 138

Hammat Gader 58, *61*

Hammath (Hamtha) 58, 61; synagogue *11, 171*

Hammurabi 49

Hanifs (*hunaf'un*) 29, 188

Hanukkah 19

Haram al Khalil *189*, 190, *191*

Haram ashSharif 164

Hasidim 19

Hasmon 19

Hasmoneans 19–23, *20*, 56, 58, 72, 75, 79, 94, 98, 99, 100, 104, 138, 175, 190, 202, 209, 210, 230

Hazor (Tel Al–Kedah) 14, 46–51, *46–7, 49, 50, 51*; sack of 50

Hebrews, letter to 26, 142, 196

Hebron 13, 109, 178, 183, 186–91, *186*, 204; Haram al Khalil *189*, 190, *191*

Helena 28, 164

Hellenism 18, 19, 22, 24, 43, 210, 216

Hellenistic period 18–19, 42–3, 55, 56, 58, 98, 128, 210

Heptapegon (Tabghe) 64

Heraclius, Emperor 31, 58

hermits 28

Hermon, Mount 20, 40–5, *40–1*, 111, 113; Nimrud fortress *40–1*

Herod Antipas 22–3, 61, 66, 117, 120, 230

Herod the Great 20, 22–3, 43, 58, 64, 66, 75, 79–80, 93, 97, 100, 105, 106, 120, *125*, 175, 176, 178, 190, 196, 202, 209–10, 216, 227, 229, 230

Herodion 100, 105, 163, 174–9, *174–5, 177, 179*

Herodotus 202

Heshbon 176

Hever, Nahal 93, 94

Hezekiah, King 16

Hiel 79

High priest 17, 18, 19, 20, 21, 99, 151, 156

Hijra 146

Hill Country, 35, 108

Hinnom (Gehenna) valley *137*

Hira, Mount 29–30

Hirmegiddo 233

Hisham ibn Abd ul Malik 80; Palace 75, *77*, 80, *80–1*

Historia Monachorum 86

Hittites 8, 14, 50, 181

Hivites 8, 181, 188

holiness 100

holy cities, four 190

Holy Headland 239

Holy Land 8–13, 114, 170, 172

Holy of Holies 21, 47, 183

Horns of Hattin (Qarne Hattin) 72, 112, 114, *115*; battle of 114

Hosea 112

Hoshea, King 16

Hospitallers 88, 224

Huleh, Lake 47, 236

Hunt, Holman 91

Hyrcanus I 19, 22, 72, 98, 128, 178, 190; II 21, 22

I

ibn Abd alMalik: see Hisham

ibn alWalid, Khalid: see Khalid ibn alWalid

ibn Batuta 146, 148, 190

ibn Ishaq 30

Ibrahim: see Abraham

Ibrahim ibn Adham 243

idolatry 188, 195

Idumaea/Idumaeans 20–3 *passim*, 176, 190, 196

Incarnation 26: see also Son of man

Investiture Controversy 222

Iron Wall 9, 161

Isaac 13, 21, 140, 188, 190, 196

Isaac, Rabbi 168

Isaiah 66, 100, 136, 138, 140, 141, 156, 188, 232

Islam 8, 10, 30–1, 131, 133, 146–8 *see also* Muslims

Israel/Israelites 8–13 *passim*, 16, *18*, 70, 72, 106, 112, 126, 134, 138, 162, 181, 184, 188, 190, 192, 204, 208, 210, 242; true 83–4; *see also* Bene Israel

Israel, state 33, 138

Issachar 112

Itinera Hierosolymitana 28

Ituraea 20

J

Jabaliyah 204

Jabin, King 49, 50, 112–13, 230

Jabotinsky, Vladimir 8–9

Jackson, D.E.P. 224

Jacob 13, 21, 128, 162, 188, 190; Well of 128

Jael 235

Jaffa: see Joppa

Jaffa mosque 216

James, letter of 188

Jamnia (Yavneh) 20, 170, 216

Jebel Quruntul (Temptation) 75, 76, 80, 82

Jebusites 8, 14, 15, 50, 134, 181

Jehoiachin, King 16

Jehoiakim, King 16

Jehovah 14

Jeremiah 16, 111, 136, 172, 184

Jericho 6, 74–81, *74–5*, 176; Hisham's Palace 75, 77, 80, *80–1*; Nabi Musa mosque 75, 76; St George's monastery, Wadi Qilt 6, *75, 78–9, 87*

Jeroboam, King 44, 126, 128

Jerome 164

Jerusalem 6, 9, 12, 13, 15–20, 23–8 passim, *26, 30–2*, 48, 50, 121, 125, 130–49, *130–1, 133, 135, 137, 139–45, 147–9*, 150, 152, 154, 161, 182, 185, 220, 222, 224; fall of 21, 24–5, 69, 105, 120, 142, 144, 167, 216; heavenly 138, 140–2 passim, 144

Jesus 9–10, 20, 25–7, 42–4, 56, 58, 64, 66, 73, 75, 79–80, 83, 84, 97, 113–14, 117, 119, 120, 123, 128–9, 142, 144, 151, 154, 156, 158, 161, 164, 168, 178, 184; ascension 158; baptism 69, 73, 79; Boat 55–6, *55*; and disciples 43–4, 56; entry to Jerusalem 154–5, nativity 161–4; resurrection 26, 140, 142; transfiguration 42, 113

Jews 9–10, 18, 19, 24, 27, 29, 30, 33, 58, 61, 66, 73, 94, 103, 120, 123, 136, 138, 152, 162, 167, 190, 195, 196, 216, 229, 230, 236, 242; Diaspora 22, 167, 168, 172; expulsion from Jerusalem 27, Rome 27, Spain 140; revolts 21, 24, 25, 27, 61, 63, 69, 72–3, 94, 98, 103, 120, 138, 140, 151, 167, 178, 210, 216, 229, 235

Jezebel 242

Jihad 224

Job, Book of 44, 167

Joel, Book of 138

Johab, King 50

Johanan ben Nappaha 61, 62

Johanan ben Zakkai 61, 216

John the Baptist 44, 69, 73, 100, 120

John of Gischala 55

John Hyrcanus: see Hyrcanus

John's Gospel 26, 56, 63, 64, 73, 117, 119, 120, 128, 129, 142, 154, 156, 164, 178

Jonah 215

Joppa 20, *212–13*, 215–16, 227, 230

Jordan, River 14, 20, 35, 38, *38, 45*, 73, 107

Joseph 14, 128, 188, 190

Joseph, father of Jesus 117, 164

Joseph, Rabbi Morris 167

Josephus 18, 19, 23, 43, 55, 56, 58, 61, 62, 66, 72, 80, 93, 98, 100, 104–6 passim, 120, 126, 133, 168, 175, 176, 178, 190, 210, 216, 227, 229, 230, 236

Joshua 8, 42, 50, 75, 77, 182, 216, 235; Book of 8, 14, 42, 44, 49, 77, 79, 128, 129, 164, 182, 190, 196, 216, 230, 235

Joshua, Rabbi 140

Josiah, King 16, 17, 125, 136, 235

Judaea 8, 17–19 passim, 21, 22, 24, 98, 100, 109, 138

Judah 15, 16–18 passim, 109, 125, 126, 128, 134, 136, 138, 163, 182, 190, 202, 209, 210, 233

Judah haNasi 61, 120, 236

Judaism 8, 10, 18, 20–1, 27, 28, 62, 120, 133, 134, 136, 138, 140–1, 167, 168, 216, 242

Judas 158

Judas, son of Ezechias 120

judge 20, 26, 156, 163

Judges 14, 15, 42, 44, 49, 50, 70, 113, 119, 193, 201, 202, 204, 208, 230, 235

Justinian, Emperor 126, 164, 196

K

Ka'aba 148

Kadytis 202

Kaegi, W.E. 33

Karnak 208, 234

Kasher, A. 133

Kefar Sabar (Kfar Saba) 216

kelalim 25

keneset 168

Kenyon, Kathleen 77

Khadir: see alKhadir

Khalid ibn alWalid 31, 72

Khan Yunis *202*

Khaybar 30

Khirbet alBurj 230

Khirbet alMafjar: see Jericho, Hisham's Palace

Khirbet alMaqanna 182

Khirbet alMes'adiye 56

Khirbet Fahil 72

Khirbet Karaze 66

Khirbet Midras *191*

Khirbet Qana *118*, 120

Khurasan 220

Kidron Valley *29, 130, 137*, 151

King, Antony 28

Kings, books of 16, 44, 50, 79, 124–6 passim, 128, 136, 182, 184, 185, 230, 234, 239, 242

kingship 15, 16, 134, 162, 190

Kinneret: see Galilee, Sea of

kinship group 13, 126, 134, 162

Kiriath–Arba 187

Kiriyat Sepher 170

Kloppenberg, John 170

Knights Hospitaller 224

Knights Templar: see Templars

Kokebah/Kosebah: see Simeon bar Kokheba/ben Kosebah

Kursi 58, 88; monastery *89*

Kypros 178

L

Lachish 182, *183*; letters 11, 182

Lamdan, Yitzhak 103, 106

Last Supper 156

Latrun monastery *88*

lavra/laura 80, 88

Lazarus 154, *158*; tomb *159*

Leah 14

Legio (alLajjun) 235

Leonidas 17

Leontopolis 20

Lepidus 22

Leshem/Laish 44

Letters: see Cave of Horrors; Lachish; Tel elAmarna

Levi 14

Levine, L.I. 170

Leviticus 14, 20, 25, 91, 100

Lewes, Miss 99

Lion Gate 141

Louis VII 224

Luke's Gospel 43, 56, 63, 66, 80, 84, 100, 113, 114, 119, 120, 123, 129, 142, 154, 156, 158, 164, 168

Lydda 33

Lyons, M.C. 224

M

Maalouf, A. 224

Macarius of Egypt 86

Maccabeans 19, 23, 43, 64, 104, 125, 126, 190, 216

Maccabeus, Jonathan 19, 104, 105, 202, 210, 216; Judas 19, 104, 190, 216; Simon 19, 210, 216

Macedonia/Macedonians 18, 125

Machaerus 105, 176

Machpelah, cave of 188, 196

Magdala (Taricheae/Migdal Nunayah) 55, 63, 63, 170

maghazi 31, 220

Magi 164

Maimonides 61

Maiumas Neapolis 202

Malachi, prophet 154

Mamre, Oaks of 28, 196

Mamshit 193, 194

Manasseh 15, 70, 235

Mandate, British: see British Mandate

Manger Square 163

Manuel Comnenus 87

Manzikert, battle of 220

Mappa Mundi 131, 131, 133, 144

maps 133

Mar Elias 87

Mar Saba 84, 85, 86, 88, 162, 165

Marcus Aurelius, Emperor 236

Mareneptah, Pharaoh 184

Mari (Tel alHariri) texts 49

Mark's Gospel 42, 43, 56, 58, 63, 66, 79–80, 84, 100, 114, 119, 120, 129, 142, 154, 158, 184, 196

Mary, mother of Jesus 26, 117, 119, 126, 164

Masada 91, 92, 97, 100, 102–7, 102–5, 107; Herod's Palace 105, 106, 176

Mattathias 19

Matthew's Gospel 9, 25, 42, 43, 56, 58, 63, 64, 66, 79, 84, 100, 113, 114, 119, 120, 129, 142, 144, 154, 156, 164, 222

Maxentius 28

Mecca 29, 146, 149

Medes 16, 125

Medina 148

Megiddo 16, 50, 125, 128, 232–7, 232–5; battles 234–6

Meir, R. 168

Mekal stele 70

Melchizedek 134

Meleager 58

Meron mountains 109; synagogue 48

alMes'adiye, Khirbet: see Khirbet alMes'adiye

Mesopotamia 16, 16, 49

messiah (haMashiach) 15, 19, 21, 23, 44, 134, 138, 163, 164

Micah 161, 164

mikveh 168

Milton, John 10, 201

Milvian Bridge, battle of 28

Mi'raj 146, 148

Mishnah 21, 61, 120, 138, 236

monasteries (see also monasticism)

of the Cross 84

Douka 80

Jebel Quruntul (Temptation) 75, 76, 80, 82

Latrun 88

Mar Elias 87

Mar Saba 23, 84, 85, 86, 88, 162, 165

Masada 104

Mount Tabor 113, 114

Our Lady of Kalamon 75

St Elias, Carmel 240

St George 6–7, 75, 78–9, 87

monasticism/monasteries 28–9, 75, 82–9, 82–5, 86, 87–9, 196

monotheism 12, 13, 29, 188, 195

Montfort 218, 220

Morgan, N 131

Moses 14, 76, 126, 168, 172, 242

Mosques 33

alAqsa 32 146, 148, 149

alMahmudiyya 216

alOmari 204

alOzir 158

Ashkelon 208

Hebron 190–191

Jaffa 216

Mount Berenice 62

Nabi Musa 75

Ramla 215

Shivta 196

White Mosque 215, 240

Mount Athos 88

Mount of Beatitudes: see Beatitudes, Mount of

Mount Berenice 62

Mount Carmel: see Carmel, Mount

Mount of Olives: see Olives, Mount

Mount Tabor: see Tabor

mountains 41, 42, 109, 114, 119, 151

mourning 140

Mu'awiyya I 58

Muhammad adDib 98

Muhammad, Prophet 10, 29–31, 58, 146, 148, 188

Muir, Edwin 188

Muqaddasi: see alMuqaddasi 33, 72

Murabbaat, Wadi 100

Muslims 33, 55, 58, 72, 114, 126, 195, 204, 230, 243–3; invasion 29–33, 126, 164, 196

Mu'ta, battle of 31

N

Nabataeans 196

Nabi Musa 75

Nablus 128, 129, 187; see also Shechem

Nabratein 170

Nakba 33

Naphtali 15, 112–13

Nathan 134

Nathaniel 119

Nazareth 117, 119, 120; Church of the Annunciation 116, 118, 119, Grotto 119

Nazarites 119

Nazoraians 119

Neale, J.M. 144

Nebuchadnezzar 16–17, 125, 182

Negev 13, 35, 109, 193, 196

Nehemiah 17, 18, 138, 190, 196

Nero, Emperor 24, 61, 63, 120, 170

New Testament 10, 26, 30, 142, 144, 168, 188

Night Journey 146

Nimrud 41

Nineveh 16, 125, 182, 215

Nizzana 194

North Africa 6, 21, 28, 170

Northern Kingdom 15–16, 18, 44, 123, 124, 126, 128, 134, 163

Numbers 11, 14, 25, 119, 152, 185, 187

Nun, M. 55

Nysa 72

O

Oaks of Mamre: see Mamre, Oaks of

Obodas, King 196

Octavian 22

Og, King 13

Old Testament 9, 10; for Books see individual entries

Olives, Mount of 29, 113, 114, 132, 138, 148, 150–9, 150; churches 152, 154–7, 158

Omri, King 124

Opastowski, M. 8

Ophel 170

Orders, religious 88, 224

Origen 230

Orthodox Church 28, 29, 86, 88, 161, 222

Ottomans 204

Our Lady of Kalamon 75

P

Pachomius 86

Palestine/Palestinians 8, 13, 18, 21–3 passim, 29, 31, 33, 86, 103, 162, 204; Secunda 72;

Palmer, G.E.H. 84, 86

Pan 43

Panias 22, 43, 178; battle of 18, 42

Parthians 22, 175, 176

Pasternak, Boris 154

Paul 27, 142, 168, 216, 230

Paula 28, 164

Pavement 178

Pegae 178

Pella (Khirbet Fahil) 27, 58, 69, 72–3, 73

People of the Book 10, 30, 148

Perea 23

Perizzites 8, 50, 181

Persia/Persians 8, 16, 17–18, 29, 31, 125, 164, 196, 202, 229, 230

Peter 26, 27, 44, 56, 64, 66, 216

Peter's House 64, 66

Peterson, A. 33

Pharisees 20–1

Pharr, C. 28

Pharsalus, battle of 22

Phasael 22

Phasaelis 178

Philadelphia 58

Philip, apostle 56, 119, 210

Philip, tetrarch 23, 43, 56, 66, 178

Philippi, battle of 22

Philistia 204

Philistines 15, 16, 44, 70, 72, 94, 129, 163, 181, 182, 184, 201–5 passim, 210, 215, 216

Philo 100, 170

Philoteria 58

Phoenicia/Phoenicians 8, 15, 21, 229, 230

pilgrimages/pilgrims 28, 31, 44, 64, 136, 138, 144, 158, 146, 162, 187, 222, 224, 228

Plataea, battle of 17

Pliny the Elder 27, 58, 94, 100

Pompey 21–3. 58, 72, 202, 210, 216, 229, 230

Pontius Pilate 23, 178, 229

Pool of Bethesda 144

procurators 22, 23, 24, 178, 229

Promised Land 8, 12, 13

prophets 10, 13, 30, 44, 136, 152, 242: see also individual entries

Prudentius 161

Psalm 137 17, 138

Psalms 13, 33, 44, 111, 114, 131, 134, 136, 138, 140, 204

Ptolemais 18, 20

Ptolemy I 18; II 58; Lathyrus 229

Q

Qarne Hattin: see Horns of Hattin

Qasr bint alMalik 62

Qibla 148

Qilt, Wadi 6–7, 75, 77; St George's monastery 6, 75, 78–9, 87

Qubbat alMi'raj 12

Qubbat asSakrah 148

Quds: see alQuds

Qumran 20, 21, 91, 92, 96–101, 96–7, 99, 101

Quran 10, 30–1, 146, 148, 188, 195, 243

R

Rabbis 21, 120, 138, 140

Rachel 14, 162, 188

Ramat Hanadiv 228

Rameses II 208, 215; III 204

Ramla/Ramle 33, 148, 214, 215

Raphana 58

Rappaport, U. 133

red heifer 152

Rehoboam, King 44, 126, 128, 182, 190

religio licita 27–8

religion 8, 13, 21, 25–8, 126, 134–41 passim, 242

religion of Abraham 188

resurrection 26, 64, 140, 142, 151

Reuben 15, 50

revelation 10–12, 30

Revelation, Book of 142, 233

Richard I (the Lionheart) 224

Richardson, P. 120

Richmond, Henry 12

Riley–Smith, J. 224

rivers: see water

Robert the Monk 220

Robinson, Edward 56

Romanus Diogenes, Emperor 220

Rome/Romans 8, 17–19, 21–30 passim, 55, 58, 66, 72, 84, 86, 94, 98, 100, 103, 105–6, 117, 120, 138, 140, 196, 202, 210, 216, 235; revolts against see Jews

Romans, letter to 27

Roosevelt, Theodore 233

Ruqqad, river: see arRuqqad, river

Ruskin, John 91

Ruth 162

S

sabbath 17

Sabil Qaytbay 149

Sacher, Howard 103, 106

Sadducees 21

St Elias, Carmel 240

St George 6–7, 75, 78–9, 87

St Sabas 88

Salah udDin/Saladin 114, 149, 158, 222, 224, 230

Salome Alexandra 21, 23

Samaria 16, 18, 19, 21, 22, 24, 72, 123–9, *122–3,* 134, 136, 178, *222*

Samaritans 16, 123, 125, 126, 128, 138; Good Samaritan parable 80; Pentateuch 128

Samson 25, 201, 204

Samuel 49, 72, 94, 119, 128, 129, 134, 162, 163, 182, 184, 187, 190, 204, 216, 242

Sanballat, governor of Samaria 125

Sanhedrin 120, 216, 236

Sarah 196

Sargon II 16, 124

Sasanian invasion 29

Saul 15, 72, 94, 134, 204, 242

Savage-Smith, E. 133

Schechter, Solomon 99

Schick, B.R. 29

Schmidt, F. 133

Schoville, K.N. 13

Schumacher, Gotlieb 56

Schwartz, B. 106

Scopas 42

Scopus, Mount 18, 151

Scythopolis 19–21 *passim,* 31, 58, *71,* 72–3, 216; battle of 31, 72

Sea of Galilee: see Galilee

Sea People 15, 201, 204, 230

Sebaste 124, 125

Sectarian Documents 98–100

Seleucids 8, 18–19, 42–3, 56, 202, 210

Seljuqs 220

Sennaberis 58

Sennacherib 16, 182, 196, 215

Sepphoris (Zippori) 61, 62, 114, 117, 119–20, *119*

Septuagint 208

Sermon on the Mount church 64

Shahada 33, 195

Shalmanezer V 16, 124

Shamir, Yitzhak 13

Shechem 13, 44, 124, 128, 190, 195–6

Shehadeh, R 33

Shekinah 172

Shema, the 14, 19

Shemer 124

Shephelah 109

Shepherds' Fields *161,* 162, *164*

Shiloh 13, 128, 129, 204

Shivta 193, *194,* 196, *197*

Shoah 33

Shoshenq I 234

Sidon 230

Sihon, King 13

Silva, Flavius 106

Simeon *15*

Simeon bar Kokh(e)ba/ben Kosebah 25, 61, 94, 140, 235

Simon 19

Sinai, Mount 114, 172

Sisera 49, 113, 235

Sodom 91

Solomon 15, 16, 44, 50, 72, 126, 136, 163, 184, 230, 235;

Solomon's Pools 162, 176, 178

Son of God 26

son of man 25, 44

Southern Kingdom *see* Judah

Sparta/Spartans 17

Stemberger, G. 28, 86, 172

Stevenson, J. 27

Stone, M.E. 21

Strabo 79

Strato's Tower 20, 178, 210, 226–31

Subeita 196

Suetonius 27

Sufis 243

Susita (Hippos) 58, *59*

Sychar 27, 128

synagoge 168

synagogues 17, 21, 24, 25, 27, 66–73, *166, 168, 169, 171–3*

 Abraham Abeinu 190

 Banias 43

 Baram 48, 50, *166*

 Berenike 170

 Beth Yerah 58

 Biria 48, *172*

 Capernaum 54, *64, 65,* 66, *170 , 171*

 Chorazain 66, *67*

 Dor 230

 Gamla 54, 168, 170

 Gaza 204

 Gush Halav *48*

 Hammath *11,* 170

 Hebron 190

 Herodion 170

 Jericho 170

 Kiriyat Sepher 170

 Magdala 170

 Masada 104, *107*

 Meron *48, 172*

 Nabratein 170

 Scythopolis 72

 Tiberias 54, *168*

Syria/Syrians 8, *16,* 16, 18, 19, 21–3 *passim,* 29, 33, 58, 84, 86, 175, 234

T

tabbur haAretz 140

Tabgha 64

Tabor, Mount 20, 42, 109–15, *110–11,* 113 172

Tacitus 229

Talmuds 21, 62, 120, 138; Babylonian 62, 120, 167

Tammuz 185

Tanach/Tanakh 10–13 *passim,* 15, 16, 25, 27, 30, 134, 140

Targums 195

Tasso, Torquato 144

taxation 27, 33

tekton 117

atTel 56

Tel alHusn 70

Tel alMuteselim 234

Tel alQadi 44

Tel Arad 180, 182, *183,* 184–5, *185*

Tel asSamrat 79

Tel asSultan 77

Tel Aviv 213

Tel Balata *see* Shechem

Tel Dan (Tel al Qadi) 42, 44, *45,* 47

Tel elAmarna letters 49, 70, 72, 162, 182, 202, 208, 215, 234

Tel Gama/Tell Jemmeh *200*

Tel Harube 202

Tel Hazor 47–51

Tel Megiddo 234

Tel Miqne 182, 184

Tel Mor 210

Tel Qedesh *51*

Templars 88, 224

Temple *12*, 15–21 *passim*, 24, 26, 47, 99, 100,
120, 125, 126, *133*, 134, 136, 138, 140, 142,
176, 178, 181, 215; destruction of 25, 125,
140, 167, 178

Temple Mount 32, *130*, *133*, 146

temptation 79

Temptation Mount monastery 75, 76, 80, *82–3*

Theodore 33, 58

Theodosian Code 28

Theodotus Inscription 170

Thermopylae, battle of 17

Third in holiness 148

Thutmoses III 70, 184, 202, 215, 216, 232

Tiberias 54, 55, 61–2, *62*, 114, 120. 216;
synagogue 54, *168*

Tiberius, Emperor 23, 61

Tiglath-Pileser III 50, 202

Titus 178

Torah 10, 13, 14, 18–22 *passim*, 27, 43, 120, 123,
138, 170, 172

torah shebeal peh 120

Tower of Forty *215*

trade 8, 18, 21, 29, 49, 56, 63, 66, 93, 193, 199,
208, 229

Trajan, Emperor 27

Transfiguration 42, 113; church of *112*, 114;
Mount of 26, 42, 113

Transjordan 23

treaties 33

Trojan horse 215

Trypho 19

Tughril Beg 220

Tulul alAlaiq 79

Turks 216, 220

U

Umar, caliph 210

Ummayyad caliphs 33, 75, 80, 126

Ur 125, 194, 195

Urban II, Pope 220, 222

Urus ashShams 210

Urushalim 134; see also Jerusalem

V

Varus. governor of Syria 23, 120

Vespasian 58, 61, 63, 216, 229

Via Dolorosa 32, *143*, 144

Via Maris 64, 199, *214*, 230, 232, 234

W

Wadi Khareitun 176, 181

ibn alWalid, Khalid: see Khalid ibn alWalid

alWaqidi 31

war 8, 16, 67; civil 19, 21; Crimean 161;
Egypt–Syria 18; Six day 190; World I 8, 204,
235–6, II 138, 204; Yom Kippur 106

Ward, B. 86

water 33, 44, 47, 50, 53, 63, 70, 75, 84, 91, 92,
94, 97, 106, 114, 143, 176, 178, 182, 196, 199,
199, 207, 216, 228, *231*, 233, 234

Way of the Sea: see Via Maris

Welch, J. 243

wells: see water

Western Wall 32, *139*, 146

White Mosque 215, 240

Whitelam, Keith 12–13

Whittier, J.G. 53

wilderness 11, 79, 100, 170

Wilkinson, J. 28

Woolley, Leonard 195

X

Xerxes I 17

Y

Yadin, Yigael 106

Yafo 213, 230

Yahweh 14, 16–18 *passim*, 20, 124–6 *passim*, 128,
134, 138, 239, 242

Yarden 35, 39

Yarmuk, river 33, 58, *60*, 236; battle of 33, 58

Yathrib 30

Yavneh *see* Jamnia

ibn Yazid, al Walid 80

Yehiam *218*

YHWH 14

Z

Zadok 20

ben Zakkai, Johanan: see Johanan ben Zakkai

Zalmon, Nahal 64

Zealots 21, 23, 24, 100, 105

Zebulun *15*, 112 ,113, 164

Zechariah 138, 152, 154, 156, 184

Zedekiah 16

Zeira, Rabbi 119

Zeno, Emperor 126

Zenodorus 43

Zephaniah 184, 209

Zerubavel, Y. 106

Zias, J.E. 98

Zion 134, 136, 138; Zionists 8–9

Zoan 187

Zoilus 8, 229

Zoroastrianism 164

Zuttiyeh cave 64

ACKNOWLEDGEMENTS

Our sincere thanks to all the following who helped to make our book a success:

Jim Power our invaluable assistant who has worked with us for ten years. Nothing has ever been too much trouble.

Ilan Arad the helicopter pilot who navigated us to obscure sites all over Israel through his intimate knowledge of his country.

El Al who arranged our flights and all the excess baggage with our cameras safely to and from Israel on several occasions.

Panorama Jerusalem for faultlessly processing all our films.

David Silverman who made all the arrangements for our stay in Israel and still continues to supply information for various sites.

Not least our office staff Alison, Christine, and Polly who listed hundreds of photographs for us.

We were also very fortunate to have John Bowker to write the text. He was a delight to work with and very approachable – unlike some authors!

Sonia Halliday and Bryan Knox

This book was a complicated and difficult enterprise. It only came into being through the extreme dedication of Peter Taylor to the project, the high skill and equal dedication of Georgina Atsiaris, on whom the burden of the work fell, and to Colin Goody for bringing together the words and images in such a splendid design. My thanks go to them, as equally to Philip Hillyer whose copy-editing was meticulous in its attention to detail.

In the background, I am grateful to Felicity Bryan and those who work with her for looking after the all important details. And of course there would be no book at all without Sonia Halliday and Bryan Knox: it has been a real pleasure to work with them.

Sarah Brunning has given her support and help, as ever.

Above all, my thanks go to Margaret, my wife. Quite apart from reading and often re-writing the text, she has been a constant source of support and encouragement from beginning to end. All of us owe a debt of gratitude to her.

John Bowker

Picture Credits

pages 73, 148, and **205** bottom right, copyright © Sonia Halliday Photographs, taken by Jane Taylor;
100, 200, 203, and **205** bottom left, copyright © Zev Radovan, Jerusalem; **131** copyright © The Bridgeman Art Library/Hereford Cathedral, UK;
184 copyright © akg-images/Erich Lessing; **205,** top, copyright © Corbis/Howard Davies; **228,** top right, copyright © Alamy/Israel Images.

Further notes on the text

Quotations from the bible come from the NRSV.

Abbreviations B., J., and M., stand for Babli (the Babylonian Talmud), Jerushalmi (the Palestinian Talmud) and Mishnah.

Translations of Arabic texts are the author's own, unless otherwise acknowledged, as are the translations of Josephus and Philo. In the case of Josephus, the author has made use, where possible (in terms of accuracy), of the 18th century translation of Thomas Lodge, simply because his robust English style makes a change.